Malice in Wonderland

Also by Hugo Vickers

Gladys, Duchess of Marlborough

Debrett's Book of the Royal Wedding

Cocktails and Laughter

Cecil Beaton

Vivien Leigh

Royal Orders

Loving Garbo

The Private World of the Duke and Duchess of Windsor

The Kiss

Alice, Princess Andrew of Greece

The Unexpurgated Beaton: The Cecil Beaton Diaries

Beaton in the Sixties

Alexis, the Memoirs of the Baron de Redé

Elizabeth, The Queen Mother

Horses and Husbands

St George's Chapel, Windsor Castle

Behind Closed Doors

The Quest for Queen Mary

The Sphinx

The Crown Dissected

Malice in Wonderland

My Adventures in the World of Cecil Beaton

HUGO VICKERS

HODDER &
STOUGHTON

First published in Great Britain in 2021 by Hodder & Stoughton
An Hachette UK company

1

Copyright © Hugo Vickers 2021

A CIP catalogue record for this title is available from the British Library

Hardback ISBN 978 1 529 33802 7
Trade Paperback ISBN 978 1 529 37640 1
eBook ISBN 978 1 529 33804 1

Typeset in Bembo MT by Hewer Text UK Ltd, Edinburgh
Printed and bound in Great Britain by Clays Ltd, Elcograf S.p.A.

Hodder & Stoughton policy is to use papers that are natural, renewable
and recyclable products and made from wood grown in sustainable forests.
The logging and manufacturing processes are expected to conform
to the environmental regulations of the country of origin.

Hodder & Stoughton Ltd
Carmelite House
50 Victoria Embankment
London EC4Y 0DZ

www.hodder.co.uk

To Jim Walker
Fellow traveller through the Commonwealth
&
Friend through all seasons

Contents

Me in a Cecil Beaton pose, 1969

Introduction

The vision of the past is a dream, 'a long-drawn sunset splintering into a thousand fires'. Edith Wharton gave me that line,[1] but it echoed in my head as I looked back over the years I spent walking in the footsteps of Cecil Beaton. In the long weeks of lockdown, it was a great joy to open the safe and pull out diaries written forty years ago to relive an exciting adventure – my good fortune to have been given a passport into a magic world quite new to me. A lost world came to life as I reread my youthful notes – the excitements, the setbacks, the extraordinary people, the occasional sense of being overwhelmed by the task of doing justice to a man of so many parts. It led to authors whose books I had never read but then devoured with glee, to meetings with stars from childhood, who had seemed impossibly beyond my orbit. It sharpened my visual taste and I, who only bought books, now bought pictures.

I have said many times that for Cecil Beaton every day was a birthday, every afternoon a matinée, the red velvet curtains opening on a new set, every evening a first night, champagne waiting in the wings. He lifted people out of humdrum worlds and gave them something to dream about.

I did not feel that my world was particularly humdrum, but I had emerged from a long, life-changing adventure in my quest for Gladys Deacon.* She was the long-lost Duchess of Marlborough, whom I was lucky to find, alive and articulate in her mid-nineties, a patient in St Andrew's Hospital, Northampton. I had talked to her for more

* Gladys Deacon (1881–1977), a beauty and intellectual, who dazzled the salons of Europe, became the second wife of the 9th Duke of Marlborough in 1921, and spent her later years as a recluse.

than two years and published her biography.* If she had been the first person to 'breathe life' into me and make me think in a different way, then Cecil Beaton guided me (albeit posthumously) into a PhD in lifestyle, new values, new experiences, new challenges.

For several weeks in those long, essentially glorious summer weeks of 2020, I went back into a lost world and lived it once more.

This book is based on the private diaries I kept during those years – some fifty-one handwritten books, covering the years between 1979 and 1985. They represent a fraction of what was written, there having been 240,000 words on the work into the biography, excluding anything more personal or irrelevant.

I had started keeping a full diary in 1975, when I was researching Gladys's life. I found I was being told things that were interesting – sometimes even historically important – which would not fit into the biography. Diary writing is a good exercise for a biographer, turning daily happenings into the written word, a bit like practising daily at the keyboard for a pianist. Diaries are particularly interesting as, unlike the historian or biographer, the diarist does not know what is going to happen next. Here was a chance to record my progress, or lack of it, the excitements and disappointments. My diary was my friend, good therapeutic company on my journey.

Perhaps inspired by James Pope-Hennessy and his notes on Queen Mary, some of which I read at about this time, I wanted to record raw what the sources told me, not all of which found its way into the published biography – what I thought of them, what they said about each other and how I started on the outside and was quickly scooped into their world.

These pages do not include the other things going on in my life at this time. The extracts focus on the work and on the characters in Cecil's world.

* *Gladys, Duchess of Marlborough*, reissued as *The Sphinx* in 2020.

Author's Note

I appreciate that the world in 2021 is a different place from what it was in the 1980s. My diaries reflect and record what was said at the time, but the world of Cecil Beaton was one where both the public and private understanding of sexuality was sometimes confused and contradictory. The people I spoke to discussed this openly, and the way they expressed themselves in those far-off days was frequently different to what is now considered acceptable. This potentially difficult material has been left in, however, as they are inextricable from Beaton's life, his social circles and my experiences and conversations during this period of time.

The Quest Begins

One telephone call changed my life completely. On 4 December 1979, I was sitting at home when John Curtis,* my editor at Weidenfeld & Nicolson, called me to say that Cecil Beaton was looking for a biographer. He had got hold of my *Gladys, Duchess of Marlborough*, and wondered if I might not be the ideal candidate to write his authorised biography. It later became clear that he had met her in the 1920s, but had not realised how interesting she was – he had been intrigued by her – a figure beyond his grasp. I had caught his curiosity. I suppose, also, that as I had been very patient, talking to Gladys, writing down all my questions, he thought I would be patient with him. He had suffered a stroke and could not always find a word or a name. The timing was crucial. *Gladys* had been published in September. I was told to ring Cecil Beaton's secretary, Eileen Hose,† and to talk about Prince George and Princess Marina‡ - I was then under commission to write a joint biography, a plan eventually dropped.

I had not lobbied to write about Cecil: I did not know a biography was being planned. But there was not an instant of hesitation. I set off on a journey that would last over five years and take me into some unusual situations, and into worlds I had never dreamt of. Nothing would ever be the same again.

As for me, in the days before the telephone call, I had paid a long

* John Curtis (1928–2005), joined Weidenfeld & Nicolson in 1962 as a book designer, appointed editor of the general list in 1975. He left in 1987 to start his own imprint, John Curtis Books.
† Eileen Hose (1919–87); see page 13.
‡ HRH Prince George, Duke of Kent (1902–42), and his wife, HRH Princess Marina of Greece and Denmark (1906–68).

overdue visit to the two Kappey sisters who later featured in my book *The Kiss*. I had tidied up a proposed book for Debrett – about Prince Charles (held back until it could be a royal wedding book). On the day before, I had written an article for Tina Brown, then editing *Tatler*. That night I had gone to a party of intolerable boredom given by Debrett. A man there 'held a cigarette in a way that the smoke went directly up my nose. I moved back; he moved forward – it was a sinister sort of dance. I tried to escape his wretched conversation about family trees.' I had dinner with a French friend in a restaurant and told her: 'I see little point to life these days.' The next day John Curtis rang.

I did not come from a family of writers, though reading was always a feature of my home. My father was a successful stockbroker. Unfortunately I have no head for figures and would have made a hopeless City man. It was my mother who encouraged me to follow my own path. She was a great admirer of Cecil Beaton, and when I was fourteen I 'stole' her copy of his *The Glass of Fashion*. In 1964 she took me to see *My Fair Lady*, for which he had designed the costumes, towards the end of its run at the Theatre Royal, Drury Lane. Zena Dare was still in the cast, though Rex Harrison and Julie Andrews had long moved on.

In 1968 I had gone alone to Beaton's National Portrait Gallery exhibition, and in 1971 to his fashion exhibition at the Victoria and Albert Museum. I had seen him in life – when he arrived with Lady Diana Cooper at the funeral of the Duke of Windsor at St George's Chapel in May 1972, and when he attended a performance of *Crown Matrimonial* at the Theatre Royal, Haymarket in October that year.

I had worked with Hugh Montgomery-Massingberd[*] on various genealogical books, and most particularly on *Burke's Guide to the Royal Family* (1973), which led me to all the royal households. In a quest for a Cecil Beaton photograph of Princess Alexandra, I was sent to 8 Pelham Place, met Eileen Hose, who was to play such an important part in the Beaton book, and was intrigued by Frank Dobson's bust of Cecil, on which he had placed one of his straw hats.

[*] Hugh Montgomery-Massingberd (1946-2007), inspired editor of *Burke's Peerage*, & later obituary editor of the *Daily Telegraph*.

In February 1975 I seized on my early obsession with Gladys, Duchess of Marlborough, and set about finding her and writing her life. Her posthumous gift to me turned out to be Cecil Beaton asking me to write his life. While I was definitely no expert on many aspects of his life, at least I was sound on the royal side and the photographs, and I had been brought up on *My Fair Lady* and *Gigi*. But I never had the chance to tell him that there was another link – the Wiltshire novelist, Edith Olivier,* who played such a crucial part in the lives of Cecil and his friends when they were starting out. In the summer of 1975 I had spent some weeks at my aunt's house in East Chisenbury, Wiltshire. At the Priory, the largest house in the village, lived Lady Harvey† who wandered round her extensive garden wearing a large straw hat. Estelle Harvey has somehow eluded most biographies of the 1920s (there are occasional cryptic references to 'Little E'), but as a young girl she had been Edith Olivier's ward. She introduced me to Edith's books and took me to the Daye House at Wilton, where Edith's niece, Rosemary, still lived. To explore the crucial role of Edith Olivier was one of the excitements of this project.

I had already met the Countess of Avon (wife of Anthony Eden)‡ in 1975, when my aunt took me to meet her in my quest for Gladys, and I had met her again a number of times in 1977 and 1979, particularly after I was taken up by Lord Weidenfeld, the doughty publisher of Weidenfeld & Nicolson, to whom I always referred as 'The Baron'. No sooner had the typescript of *Gladys* been read in the Weidenfeld office than I was summoned to a Baron dinner party. I knew nobody but recognised everybody. I sat at the same table as Dame Rebecca West without meeting her.

Lord Weidenfeld always thought by a process of a knight's move in chess. At once he set me to work with Laura, Duchess of Marlborough, helping her shape her memoirs, *Laughter from a Cloud*. Laura had been born a Charteris and had married four times, her last husband being Gladys's stepson, Bert, the 10th Duke of Marlborough. I met her in

* Edith Olivier (1872–1948), Wiltshire author living at Wilton, muse to Cecil and many of his friends, notably Rex Whistler.
† Estelle Lawford (1902–86), from Montreal. Married 1930, Sir Richard Harvey, Bt (1898–1978).
‡ The Countess of Avon (b. 1920); see page 51.

January 1979 and we soon became firm friends. Then aged sixty-three, she lived at Portman Towers in George Street, near Marble Arch and had a country house, Gellibrands, in Buckinghamshire. She had suffered various illnesses and tragedies, two of her four husbands* dying within days of each other, but she perked up when I came on the scene. She was a compulsive telephoner, and I must have spent hours that would amount to weeks, if not months, talking to her, often late into the night. She took me to stay with Robert Heber Percy,† the 'Mad Boy' at Faringdon, she invited the legendary Lady Diana Cooper to lunch and Alastair (Ali) Forbes, that most social of journalists,‡ a great talker, burst in in mid-flow, having already worked out exactly how I fitted peripherally into the scene. All of these figures would soon take on vital roles in my life and I in theirs.

Laura was a great help to me: she unravelled many mysteries about the people I met at Weidenfeld dinner parties, loaning me books on that world, and I soaked it all up, like a sponge. It was with Laura that I had a third sighting of Cecil Beaton in the summer of 1979. She invited me to the reception after her granddaughter's wedding, even though I had never met the bride. It took place on a perfect summer's afternoon at Fonthill in Wiltshire on Saturday, 19 May. I spotted Lady Diana Cooper and then, in the distance – here I resort to my diary – 'the very, very old man who wandered out onto the terrace and who turned out to be Cecil Beaton . . . [Later] Laura talked briefly to Sir Cecil, who recognised her at once. He's got much better from his stroke. At first he used to sit and cry all day apparently and Diana Cooper said she wanted to take a gun and shoot him just to put him out of his misery. Now he can use his left side very well, but still he's accompanied by a male nurse at all times.'

Following John Curtis's call, I made a plan with Eileen Hose, ostensibly to discuss the Duke and Duchess of Kent. I arrived at Reddish House on 13 December. Eileen met me at the front door:

* Laura married Viscount Long, the 3rd Earl of Dudley, Michael Canfield, and then the 10th Duke of Marlborough. Dudley and Canfield both died in December 1969.
† Robert Heber Percy (1911–87), who inherited Faringdon, an eccentric house in Oxfordshire from Lord Berners (1883–1950).
‡ Alastair 'Ali' Forbes (1918–2005); see page 79.

Sir Cecil Beaton was in the library to the right of the hall. He was seated, wearing casual clothes with a silk scarf round his neck. He looked up as I came in and became animated. He offered me his left hand. He began by saying how much he had enjoyed reading *Gladys*. This led to us looking at the album I had brought. He enjoyed it. Meanwhile Eileen Hose offered me coffee and said: 'And you will stay to lunch, Mr Vickers?'

'That would be lovely.'

The album was an icebreaker – not that there was any ice.

We discussed Prince George and Princess Marina, and he spoke of photographing La Casati, a mistress of the famous Italian poet, d'Annunzio, in her old age. Sometimes during the conversation he could not find the right word. 'A town in Italy.' So I would say, 'Rome? Venice? Florence?' and then he would say, 'Florence.' Eileen Hose joined us for sherry, followed by lunch. The house had hand-rails either side of the stairs and Cecil Beaton moved slowly to the table. We talked about Diana Cooper, Robert Heber Percy and of Laura's late-night calls. Cecil Beaton said that Emerald Cunard, hostess of his day, used to telephone him late at night and he was disappointed if he found out that he was not the last person she called.

After lunch we looked through folders of photographs of the Kents. He gave me a picture of Princess Marina that I had never seen before. When I left at three thirty I apologised to Eileen Hose for staying so long, and she said, 'He enjoyed it and it's very good for him. Sometimes he gets tired easily.' I went away, hoping I had made a good impression: 'The *mere* sight of him in the summer was terrific to me. Here I was having lunch with him, all thanks to Gladys.'

Events moved quickly. On Sunday evening I went to the Baron's Christmas dinner party:

I talked to Clarissa Avon. She said: 'I hear you're doing Cecil. I'm so pleased.' She pronounced him 'Sissel'. I asked if she'd seen him since I had. She said not, and I still did not think it was official. Yet it looked as though it was. She said she hoped that I wouldn't make him too much the centre of it. 'Keep pushing him out,' she said. 'He'll always want to be the one.' She was disparaging about his work, not considering him 'great' but seemed fond of him. 'I clock in about once a week,'

she said. She too goes through the process of finding a name he could not say: 'My age? Your age? Dark? Fair?' and so on.

The following day it was confirmed. I asked John Curtis if the plan was to publish the book in Cecil's lifetime. He said, 'You're asking me a very difficult question. The plan is not to hold it until after death.' So I was to go ahead with the knowledge that he would perhaps read it.

My extraordinarily confident agent, Gillon Aitken,* confirmed the deal as a five-figure advance (£10,000), with Cecil Beaton getting 2.25 per cent of the book. This was a great deal more than anything I had ever been paid before. Weidenfeld had bought the world rights: 'Gillon talked to me in the way people do after orgasms,' I wrote in my diary. 'The excitement for him is the deal, the climax. After that he lets one drivel on about this or that for several minutes. He should be pleased, of course. He gets a thousand pounds out of it. Gillon is now earning more [out of me] than I used to get for my early work.'

After Christmas a letter came from Cecil Beaton, confirming how happy he was. I rang Eileen Hose to make a further plan. It was Cecil's birthday on 14 January. I would visit the following day.

It proved cold and wintry. Again Cecil Beaton was in the library, but standing up: 'Conversation flowed at once from the start. He began by saying how pleased he was that I was to do this book. He wanted to know how it would be planned.' He said he was looking forward to many talks, keen to do the biography "off the cuff".– "I've written so much," he said.

An unopened tin of Turkish Delight, and the *Sunday Times* tribute to Raymond Mortimer[†] lay beside his chair. He showed me the Queen Mother's Christmas card. I noticed that her signature was just beginning to look old. She had taken to the felt-tip pen. He described her as 'marvellous' and told me he had written to ask if he might take her eightieth birthday photographs. The gardener's child came in and he

* Gillon Aitken (1938–2016), founder of Aitken Alexander. I was his client from 1977 onwards.
† Raymond Mortimer (1895-1980), effete critic and literary figure from the Bloomsbury era. I had been to see him twice, once about Gladys. He had died on 9 January.

spoke sweetly to her. He spoke of his plans for more fashion photographs. Then he said how much he wanted me to see the house in the summer. He said: 'I hate you seeing the house like this.'

After lunch he told me the first story about his early life. He hated playing games so he bought a boot, the kind worn by children with a clubfoot. He said he never had to do a thing then. They believed him deformed. But he was careful to wear normal clothes when his parents came to see him at school.

Then Eileen helped him into his coat and cap and we went over to the studio. There I saw shelves and shelves of his diaries. There were filing cabinets of papers, about fifty books of press cuttings, and many sketches and drawings. He gave me several of his books, writing in each one as he did so. Eileen then read him a letter, which had arrived that morning from Sir Sacheverell Sitwell, the last of the three Sitwells. It was a sad letter claiming they were as well as could be hoped in these grim days and hoped he was too.

Plans were made for two longer visits when I would come and stay. I left the house, and as I walked to the car I slipped on the stones and had a cracking fall. I did not know them well enough to go back in, so drove cautiously back to London, pausing for a while in Salisbury.

The following Friday, 18 January, I had just finished writing Cecil a thank-you letter when my mother telephoned me to say that she had heard on the news that he had died:

> Now all I have is regrets – had I known there was so little time, how much I would have liked to express the influence he had on me in my younger days. And there is the letter that I wrote thanking him for lunch. It was still lying on the floor, ready to be posted.

Instead I wrote to Eileen. The following week John Curtis rang to say how sorry he was, 'But now you can go ahead and do it in the way you want to.' He agreed that another six months would have made all the difference.

On Wednesday, 23 January, a fine day, I went to Broadchalke for the funeral, finding the village full of 'No Waiting' signs, with cars, policemen, press, and television cameras. The church was full and the

coffin covered with flowers, good hymns, and at the end 'the organ took on the task of "God Be In My Head" – always the most moving, the most mournful, the saddest of melodies'. Eileen followed the coffin out, clutching the arm of Cecil's sister, Lady Smiley.* Many of the figures who would later take a part in the book were in the congregation, including Lady Diana Cooper in a black dress, mink coat, white hat and white gloves, the Baron, and Clarissa Avon.

The committal took place. I embraced Eileen, though I hardly knew her. She said: 'It's now that the suffering begins.' Then Diana advanced on the arm of the artist Patrick Procktor:†

> She clasped my hand. 'Oh! It's you!' she said. 'But there's nothing to say. It's all been written. What can you say now? I'm being done but I've already written my book.'
> 'I'll find something,' I said.
> 'I hear news of you from Laura.'

Eileen replied to my letter saying she had anticipated a lot of fun for both Cecil and me. Cecil was not there to enlighten me, but neither was he there to control me. Possibly this heralded a better book, though it did not seem so at the time. Eileen was prepared to help in a way that she would not have done had an independent writer arrived after his death, landed on her by the publisher. She confirmed this in a letter to Jane Abdy:‡ 'I am most pleased that you approve of Cecil having chosen Hugo Vickers to do the biography. They got on so well together and would have enjoyed working on the book. I am filled with sadness. I will do my best, and anything I can, if he so wishes, to help Hugo. I am sure he is the right person.'[2] John Curtis wrote to Eileen saying he was pleased that the final choice had given Cecil so much pleasure.[3]

There was a bit of a lull while Eileen dealt with lawyers, accountants and others, which she later described as 'unbearable'. She invited me to come and start my work, so I returned to Reddish House on 21 February and spent many days there until 29 May. For these visits

* Nancy Beaton (1909-99), married Sir Hugh Smiley Bt (1905-90).
† Patrick Procktor (1936-2003), wild artist.
‡ Jane, Lady Abdy (1934-2015), married to Sir Robert Abdy Bt.

I was able stay in my aunt's* house at East Chisenbury, a beautiful drive of about forty minutes across Salisbury Plain.

It was strange returning. My host had gone for ever. The front door was locked and seldom used. Eileen worked in the studio. She told me that at the moment it just seemed as if Cecil were away in New York. She had to come to terms with the idea that he would never return, and that the house would be sold, the contents fall under the auctioneer's hammer. Christie's men would soon be swarming over it.

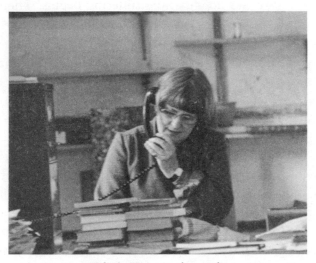

Eileen Hose in the studio

During these next weeks I discovered what a remarkable person Eileen was. Born in 1919, she was now just sixty. She had been with Cecil since 1953, mainly in London, but also joining him in Wiltshire, and since his stroke in 1974, she had lived in a cottage nearby and run his life for him. She had come to him via Hal Burton,† the theatre director, who would presently materialise. During the war she had worked for a general and later as a dentist's secretary. After the war, she wondered if she would have enough pull to be the leader of an advertising agency. She took over at Cecil's London home, 8 Pelham

* Joan Vickers (1907–94), formerly an MP, later Baroness Vickers DBE. She was sometimes there, but more often in London, where she was still an active member of the House of Lords.

† Hal Burton (1908–87), who assisted Cecil in many areas, notably on his play.

Place, from the dreadful Maud Nelson,* who had been so difficult that Cecil used to walk round South Kensington waiting until she had gone home. He could not possibly have achieved all he did without Eileen. She was one of those legendary personal assistants in the mould of Nicky Mariano,† Bernard Berenson's Villa I Tatti.

She was under no illusions about her role in Cecil's life. She knew he only loved beautiful people, but she pointed out that beautiful people would never have looked after him in the way she did. She was immensely knowledgeable about every aspect of his life. I never found a question that she was not prepared to answer. When I asked her who the people were that Cecil loved, she laughed and said, 'Well, you've asked – so you want to know.' And she filled me in.

On that first day, she showed me the last entry in Cecil's diary about the death of his cat Timothy. She showed me the boxes of letters and sat me down in the library with the first of the fifty huge volumes of press cuttings. Previously a nervous guest, it was now my duty to explore everything to piece together the jigsaw puzzle of Cecil's life. A new informality reigned in the house. If I wanted to, I could sit in his chair. There were still plants. Cecil's glasses were still by his chair, as were his matches, his paints, his books and magazines.

Eileen brought me some tea and told me about Greta Garbo, the elusive film star with whom he had had an unlikely love affair. Eileen only met her once when she visited Cecil after his stroke. She thought Garbo a silly woman, who maintained she did not want to be recognised, then turned up her mackintosh collar and put on dark glasses so everyone knew at once who she was. Eileen was not impressed by Garbo remarking, 'Sheep, I love sheep.' She took her into Salisbury to try on shoes at Russell & Bromley and was irritated when Garbo turned to her and asked of the assistant, 'Do you think she knows who I am?' Eileen said that Garbo liked to wear boy's sweaters. And when she came after the stroke and was on her way in to dinner, she said, 'You see I couldn't have married him, could I, him being like that?' It sounded cruel that she was so dismissive of him in that state.

* Maud Nelson (1904-1969), friend and companion to Olga Lynn, Cecil's secretary from 1940 to 1953.
† Nicky Mariano (1887-1968), who was so vital in the life of the art connoisseur, Bernard Berenson (1865-1959). He lived at Settingano.

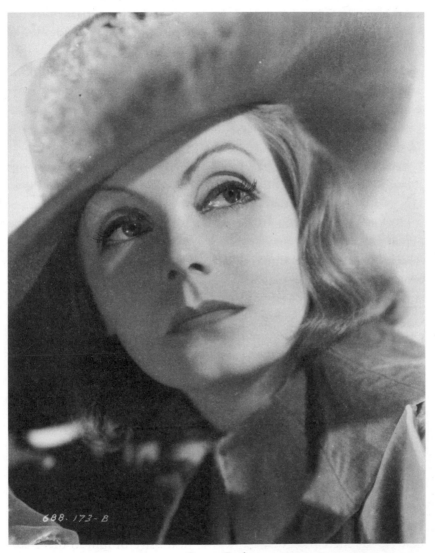

Greta Garbo

I soon realised that the Garbo affair was likely to be one of the most important features of this book, something that had to be explained. Cecil had got into trouble for publishing his account of it. He dithered for years as to whether he should, and finally decided that she had slighted him so it was fine to go ahead. Even so, when he gave his diaries to be typed, he obliterated certain passages, but thoughtfully transcribed them and I found them.

He should have left me to tell the story as his biographer – but he could not resist going into print. During my research, I would have the chance to ask many sources their views. Presently Eileen produced copies of all the letters that Cecil had written to Garbo, which even she did not know were there. They emerged from under Cecil's bed.

Eventually it got late. Grant,[*] Cecil's male nurse, came in and pulled the curtains, and the room, with its dark greens and reds, and its books bound in leather, took on a reassuring peace.

During the next days I took notes from the press-cutting books and, as a treat, would dive into the letters. I was intrigued by Garbo's letters, not for their minimal content but for their restless style. A tin box emerged from under Cecil's bed, which contained carbon copies of Cecil's letters to her, a file marked 'Greta.' This was a scoop as they had never been seen. Often he had to write two letters – an intimate one for her, and a more formal one that she could show to Georges Schlee,[†] the man described by Kenneth Tynan as 'a sort of Kafkaesque guard, employed to escort her to her next inscrutable rendez-vous'.[4]

Out poured letters including strange epistles from Stephen Tennant, and Sir Francis Rose,[‡] two of the more eccentric figures who passed through Cecil's life. Eileen told me that Rose, a painter, was a pathetic creature who had died recently on Charing Cross station, and that Stephen Tennant, a former Bright Young Thing, was alive but 'quite mad'. She told me he was now a recluse, living at Wilsford Manor, which he had decorated most eccentrically, that he who had been so willowy was now immensely fat and spent his days in a squalid

[*] William Grant, who looked after Cecil for his last five years.

[†] Georges Schlee (1901-64), Russian émigré, married to the dress designer Valentina (1899-1989); see page 211.

[‡] Sir Francis Rose (1909-79), painter and friend of Gertrude Stein, with a rackety private life.

bedroom. When Cecil died, Stephen's manservant, John Skull, had written to sympathise adding that 'Mr Tennant' associated himself with this message. Eileen said she would try to take me there.

My fascination grew. I took to driving back to East Chisenbury by the Woodford valley, passing his house. In those days you could see it from the road and I would observe a light in a window, shining across the park. 'I wondered if that was where the house was with that strange recluse living inside. And what would he be doing? Playing with his beads or jewels, reading his cine-magazines or reciting poetry as he can at great length. The whole thing becomes more and more mysterious.' As the spring came and the nights grew lighter, I got better views of the house. So keen was I to meet Stephen Tennant that one night I had a horrid dream in which he died before I achieved this.

One day Eileen showed me round Reddish House, which I thought the perfect size. Cecil's bedroom had a huge four-poster in the middle. The rose bowers and spring flowers in the garden were planted so that he could see them. There were photos of Peter Watson,[*] Kin Hoitsma[†] and Greta Garbo, his three great loves, on one side. The bathroom led to the dressing room and back to the bedroom. The drawing room was superb, with its dark red walls, very lavish; an addition had been built to this room and the famous conservatory led off that. Otherwise there were three bedroom suites – Grant's, the blue room for ladies, and a smaller room for a single man. There were many books on the landing, and the garden was much bigger than I had expected, curling round the outside.

The other person in the house was William Grant, always known as Grant, Cecil's Scottish male nurse. He stayed on until the sale. He took to popping into the library for a chat, told me he felt Cecil's death badly and that he had lost his purpose in life. One of the lenses in his glasses was broken, but he lacked the impetus to get it fixed. He had been engaged three times but had escaped each time.

[*] Peter Watson (1908–56), philanthropist and early patron of many distinguished artists.
[†] Kinmont Trefry Hoitsma (1934–2013), the boyfriend Cecil met in San Francisco in 1963 – see note on page 243.

Grant talked of the slow process of getting Cecil up in the morning, his bath, which took a long time, the massaging of his leg, how he had to strap a board to his wrist at night to stop his fingers digging into his hand. He spoke of how, in his frustration to be understood, Cecil would sometimes get angry with him, at which point Grant left the room for ten minutes or so, returning later and never mentioning the incident. He enjoyed travelling with Cecil as he was treated as an equal guest in the houses of people like Chiquita Astor.* He described Cecil paddling about in a pool in Miami – and how Grant had lowered him into the water: 'I put a towel down under his bum.'

Grant told me of his travels with Cecil, his occasional impatience and how a girl student once knocked at the door and asked to see Cecil. 'Is she attractive?' he asked.

'Well,' said Grant, 'I didn't know if his taste was the same as mine.' She had tea with Cecil in the drawing room and next day Grant noticed a small box was missing.

He told me how Cecil died. He said he was breathing badly and they called the doctor, who gave him something to make him sleep. 'He's breathing more easily now,' Grant had said.

The doctor said: 'It's not that. He's going.' And Cecil just died peacefully.

Grant liked Greta Garbo. He said that Cecil really fell for her. He said that Lady Diana Cooper used to stare into his face – 'Very alarming for someone who didn't know her.' And he, too, spoke of Stephen Tennant, who had been in shorts and a T-shirt with a huge belly hanging out in front.

When not at Broadchalke, I used every opportunity to glean what I could about Cecil, and I found people willing to help. At a lunch given by Charlotte Bonham Carter,† the veteran concert-goer, I met

* Ana Inez (Chiquita) Carcano (1918–92), married Hon John Jacob Astor, later divorced.
† Lady Bonham Carter (1893–1989), widow of Sir Edgar, inveterate concert-goer, traveller and party-giver, said to have sometimes been spotted at several different events on the same evening..

Lady Smiley, Cecil's sister, who offered to help me, though it soon became clear that she was anxious to assume editorial control over the book, which concerned me.

On 6 March, a wet, rather cold day, Cecil's memorial service took place at St Martin-in-the-Fields. I went along with Laura Marlborough in a chauffeur-driven car she had hired and we were photographed by the famous Jane Bown on the way in. The service was not especially crowded, though a number of key Cecil Beaton figures were present. There was a good moment when the effete politician Norman St John Stevas arrived and sat next to Lord Charteris, the Queen's former private secretary. Lord Charteris greeted him with a little slap on the bottom. I was surprised that there was only one royal representative – Mona Mitchell,* sent by Princess Alexandra, who had discovered at the last moment that none of the rest of the Royal Family was being represented.† Lady Diana Cooper boycotted the service because she did not like the church, wanting it at her church in Little Venice.

I did not like the address by the ballet critic, Dicky Buckle,‡ which dwelt too much on the 'courage in adversity' aspect and not enough on Cecil's transcendent gifts. As we left, the Baron joined us, his collar somewhat awry. He talked business as we walked down the aisle. 'There's a lot of interest in your book in America. Holt will get it, I suspect, but they will have to be very generous.'

Plans developed for the sale of the house and its contents. Eileen was in a quandary as to whether or not to sell the rose that Garbo had given Cecil in 1932 and which he had framed. I thought it would fetch a lot more than she did. I suggested they put Cecil's Peugeot into the sale. Both were sold.

Grant began to consider his future. The telephone rang, which he answered. 'Oh! Good morning, m'lady.' I could hear from the library that it was Lady Avon, suggesting he come and work for her. He

* (Dame) Mona Mitchell (1938-2002), Princess Alexandra's lady-in-waiting.
† The Queen Mother had resented a description of her teeth in Cecil's diary.
‡ Richard Buckle (1916-2001), ballet critic who had wanted to write Cecil's biography and was not overly thrilled when I was chosen.

decided that this would be 'on an elastic basis'. She came over to see him. He was keen to stand up to her: 'I'll give her her title, but after that, I'll talk to her as the next man.' I had the distinct impression that the meeting had gone badly, but Grant said, 'Very satisfactory,' and Clarissa later said, 'A life saver.' That day, she invited me to Alvediston for a drink:

> Clarissa was full of smiles. She had lots of advice about Cecil and the book. She said that Diana was a key figure. She talked of Grant: 'My visit to Reddish House was not a sentimental one. I had a purpose.' Evidently Grant has agreed to go into the attic as long as it is done up properly.
>
> We talked of Garbo, whom she said was 'bewitching'. She told me she kept her legs as soft as peaches and she was clearly forever exercising. She said she was very difficult. At the time of the long summer at Broadchalke [1951], the press descended and Clarissa went up onto the Downs to find her 'striding along' – she felt she should be rescued. 'She wasn't in the least bit grateful,' she said. You had to ring six times only – then she knew it was a friend but she said that after she became the foreign secretary's wife she got straight through on the telephone and was late for lunch. 'Greta was waiting on the pavement outside.' They then went shopping and bought shoes. Her feet were not as big as everyone said.

Other Wiltshire neighbours also invited me. At lunch in his house at Tisbury, Billie Henderson,* a friend of Cecil's since India during the war, spoke of the night Cecil died. He had found him depressed and unable to keep warm. Billie tried to cheer him up. 'You've got a new gardener that you like.'

'Well, yes, that's true.'

'And you've got Hugo Vickers who'll work with you on the biography.'

'Yes, that I am looking forward to enormously,' he said.

Billie spoke of David Herbert in Tangier, who owned a picture of a naked statue painted by Cecil. Cecil told him: 'The behind is Mick

* William Henderson (1903–93), one of the wartime ADCs to Field Marshal Lord Wavell when he was Viceroy of India. A painter, who used to read to Cecil after his stroke.

Jagger's.' He also spoke of the lovers: Peter Watson never reciprocated any love – that was the problem. Kin Hoitsma was intelligent. Garbo he had met, but had no idea there was anything going on at all.

Dicky Buckle was more prickly since he had wanted to write the authorised biography. Eileen was relieved that he was not chosen, since he would have woven his autobiography into it. With me, there was no fear of that. Buckle lived at Semley down a remote track, in a house in the woods. He gave me two of the largest gin and tonics I have ever had. I was able to contribute something to his knowledge of Cecil since I had seen the papers:

First, Eileen said to him that Cecil and Greta Garbo did go to bed together. He thought Cecil just had two men-friends – Peter 'Soapy' Watson and Kin Hoitsma. Kin let him down as he'd never write to him, which, as Dicky said, one needs in old age 'as I'm finding out'. He said he thought all that Cecil wrote about Garbo was an attempt at pretending to have a heterosexual relationship, but he said, along with that of Diana, it was one of the best human studies he'd done. He said that the funny thing was that Cecil, who was always described as the 'arbiter of taste' – there were things he got wrong.

Dicky said he thought Cecil would have 'misled' me. He would have said: 'Oh! Don't bother with that. It's not important.' I think that's a good point.

Dicky talked of the Patrick Procktor exhibition in Salisbury. They all went along and, coming out of the Crane Street restaurant, they saw an extraordinarily repulsive figure, obese, with a light suit and a wisp of hair that had been allowed to grow very long and was dyed purple – Stephen Tennant. 'He used to be slim like the picture of Dorian Gray.' Evidently at the opening he sat on the only chair available, right in front of the cameras. Dicky was embarrassed to be seen with him but Cecil didn't mind.

Then there were those who came to the house, imparting information of various kinds. Brian Blick was the local builder, used by everyone in that valley. He came to repair some lamps and told a funny story about John Ryden, a journalist sniffing about, asking Cecil's

taxi-man how Cecil and Garbo had behaved in the taxi together coming from Southampton. 'Well, he didn't finger her,' said the revolting old man.

Billie Henderson and his stable-mate, Frank Tait, a doctor, arrived for drinks. 'I'll ice the vodka,' said Grant. Frank Tait was an extrovert figure, full of stories. He said that Lord Olivier once came out of the shower in a theatre, stark naked, and said, 'Isn't it a pity? I'm the greatest actor in the world and I've got the smallest cock.'

On 9 April, Cecil's sister, Lady Smiley, came to lunch, and left with the visitors' book (in case someone stole it), the Rex Whistler of Ashcombe, Cecil's home in the valley, his CBE, his Legion of Honour, and the signed photograph of the Queen Mother. Her line to me was 'It's not for me to advise you but I hope it isn't going to be one of those gossipy books. There's so much more.'

Many came to look round the house, some keen to buy, others merely sightseers. The way to identify genuine buyers was to ask if they would like to see the boiler. The sightseers invariably passed on that. I suggested that Eileen should note them all in a book so that we could remember them. Some visitors got so excited that they started measuring the curtains. Others just looked. There was a pot of pot-pourri and maybe it was a tribute to Cecil or to the calibre of the visitors that a great number of them took some away surreptitiously, while nothing of value was stolen, so far as I know.

Ursula, Countess of Chichester was the most effective. She came alone and said nothing; she brought her son and daughter-in-law and they said nothing; then she sent a tiresome surveyor, who looked quizzically at the ancient bowed wall at the front of the house. At the sale an agent bid for her and she bought the house.

We were now well into May. Eileen gave me Cecil's overcoat and some books from the library. All remained more or less well until Monday, 19 May, when a pantechnicon arrived to take the books away:

> Grant stood disconsolately in the yard, his mouth quivering, tears in his eyes – and Eileen confessed, 'I said this would happen. I really do feel physically sick.' And again, there were tears in her eyes – it was awful. Suddenly the flaps were down and the packing cases were out

and men whose job it was to gather and depart were soon in the library and up the stairs, leaving the shelves sad and deserted. Worse than locusts they were. They were just doing a job, however. Eileen said: 'There's only one thing to do – go down to the pub and get drunk.' And later in the office: 'Oh! Well – shit!'

At lunch Eileen opened a bottle of Cecil's champagne. Grant had gone off but he came back later, and was suddenly rather protective of Eileen where previously there had been quiet resentment on both sides.

Eileen decided that I should take all the papers to London to work on – the boxes of letters, the albums of press cuttings and a copy of any of Cecil's published works that I did not already have. She also gave me the assignment of delivering Garbo's rose to her in New York: 'And we won't have any nonsense about you ringing three times before she answers or leaving it under a stone.'

Still the stories came. Eileen had visited Michael Pitt-Rivers (who went to prison with Lord Montagu of Beaulieu), who had told her how he asked Cecil, 'Why is it that in London you are *so* awful and in the country quite different?'

Without disagreeing, Cecil replied: 'I regard it as a challenge.'

Eileen found a skull and rescued it. It was given to Cecil by Rex Whistler and inscribed to him. It was put into the sale. On 28 May scaffolding went up in the garden for the great sale tent. The garden was beginning to look its best, the terrace bursting with everything and the roses on the walls burgeoning. That last day ended with Eileen in the drawing room. The light was coming in through the windows as at the end of many summer days – the pink roses were creeping round the windows. The next day the house would fall into the hands of the auctioneers: 'I will never forget the calm of that time.'

By the next day sticky numbers were festooned on some of the lots. Grant said he felt like a trespasser. I wanted to be alone and headed to the winter garden, but as I reached the doorway there was a Christie's man reading a paperback. There was no time for last looks. Eileen and Grant were going over to Billie Henderson's. It was time for me to go. Eileen said I had been a great comfort and I said goodbye to Grant: 'There were tears in both our eyes.' I said what I thought: a sad beginning, a sad end, but fun in the middle.

And I remember how as I waited in the yard the sun shone through the green leaves and I would see the front of the house through the trees and I thought back to that day when Cecil walked over to the studio to show me the diaries and papers. It all seemed such a long time ago, yet it was only a few months.

And presently I was off back to London and then the tears poured down my face and it was at least Wilton before I pulled myself together.

After that the atmosphere had gone. Eileen was irritated by an HP sauce bottle abandoned on the dining-room table. There were signs everywhere – 'Sir Cecil's bedroom'. The house was a museum, the flower room a buzzing office. On my last visit I spent forty-two pounds buying plants. One was a yucca, which I took to my flat. I forgot to cut it back. Forty years on it stretches above two storeys.

The sale took place on 9 and 10 June. On the first day, the house was auctioned for £225,000, though no one worked out who the new owner was. A man in the row in front of us asked, 'May we know, as the villagers of Broadchalke, who has bought the house, please?'

The auctioneer replied, 'I don't know myself. You'll find out soon enough.'

I managed to secure some Christian Bérards,* a good Stephen Tennant and an oil by Michael Wishart,† all at the maximum price I was prepared to pay. Garbo's rose went for £750 and the Giacomettis fetched good prices (the cashier in the house was sitting on a Giacometti chair). At the end of the day, Mrs Brown, the doctor's wife, said how she wished she could now go back and have tea with Cecil to tell him all about it. 'He'd want to know every detail,' she said.

As we left, torrential rain poured down.

* Christian (Bébé) Bérard (1902-49), French artist and designer, who lived with Boris Kochno.
† Michael Wishart (1928-96); see note on page 49.

1980

It was now my task to meet as many people as possible who could talk about Cecil. Concurrently I was working my way through his press-cutting albums, which gave me the chronology and a fair bit of contemporary comment, and reading – which meant deciphering – his 145 books of manuscript diaries. This took a long time, as of course did the interviews since I had to get to the sources. I had to travel. I have often thought that if you write a book about coal miners, you will spend a lot of time in coal mines. If you write about Cecil Beaton, you find yourself in London, New York, Paris, Monte Carlo and San Francisco.

The interviewing process had started even before the sale of the house.

London, Tuesday, 5 February 1980

One of the very first was Francis Goodman (1913–89), who got in touch with me after reading about the book in the Evening Standard. *I had met him briefly two years before.*

He had been born as Francis ('Franzie') Gutmann and had begun experimenting with a Box Brownie when he was six. He came back to London from Munich in 1931 and anglicised his name. He joined the studio of Peter Rose Pulham, in Berkeley Square. He took fashion photos for Vogue *and* Harper's Bazaar, *and society portraits for the* Sketch. *Over the years he photographed Cecil, Lucian Freud, Oliver Messel, Anna May Wong, Gertrude Lawrence and many more. Much of his later work appeared in the* Tatler *during the late 1940s and 1950s. This did not make him rich, but he was noted for being well dressed and retaining a fashionable London address. He bequeathed his archive to the National Portrait Gallery.*

He rang me on 30 January. He wondered how emotional Cecil was: 'I've never heard anyone say they'd hopped into bed with Cecil.'

I set off on a nasty wet day to the [Sloane Street] flat of Francis Goodman. He gave me coffee and lots of cassis – really too much. He said he expected a fat, middle-aged character. (That's how I feel at times.) He said he saw in me himself when he was young. I did not fail to realise that he wanted to be in the book and for me to use his pictures.

He's sixty-six and he claims till '53 he made no money though he worked hard. Now on his walls are a Graham Sutherland and other works. He told me he used to be known as 'the poor man's Cecil Beaton'. He related that he took photos of Cecil and went round with them to Sussex Gardens. There was crying upstairs – Cecil came down. This was to show him pictures against a background painted by the decorative artist John Banting. 'Please excuse me. My brother died in the night.' He committed suicide by throwing himself under a tube around 1932 or 1933.

Many jokes about him and Oliver Messel.* OM born a day before. Picture by Goodman in the press made Oliver look young – 'I really am not ready yet to launch out as a sixty-year-old,' said Cecil. 'Why don't you find a very young-looking photograph as you did for Oliver Messel yesterday and print that? With plenty of touching up.' After one lot of pictures, he wrote, 'You have done wonders with the subject and it's not your fault if I look like a sinister old Thespian in some of them. I wished I had washed my hair. Many thanks. Yours Cecil.'

He went on to tell me about Cecil's tailor, how unprofessional Cecil's early negatives were, his haphazard work for Zika Ascher and he introduced figures such as Simon Fleet (Juliet Duff's 'walker'), Charles James,† the dress designer, and Peter Rose Pulham, the photographer, into the story. He related how Cecil hated photographing the Lygon sisters,‡ and after posing the angular-looking Lady Oxford had not even bothered to make prints of the photos.

So the strange story developed.

* Oliver Messel (1904–78), celebrated ballet designer, one-time lover of Peter Watson, and uncle of Antony Armstrong-Jones, 1st Earl of Snowdon.
† Charles James (1906–78), Harrovian friend of Cecil and celebrated dress designer.
‡ The Lygon sisters – Lettice, Sibell, Mary (Maimie) and (Coote), daughters of the disgraced 7th Earl Beauchamp.

I saw Goodman again at Cecil's memorial service, being ignored by all and sundry. The Baron would not speak to him and Laura Marlborough had no idea who he was. I was nervous of him as I had heard he was a gossip-column informer.

London, Saturday, 8 March 1980

I had met Lady Ashton, also known as Madge Garland (1896–1990), a few times before. She agreed I could come and see her about Cecil. She had known him since his earliest days, was photographed while his sisters held up the scenery. The last time she had seen him was very recently. She said, 'We've been photographed together so many times, and not for the last time, I hope.' But so it proved to be.

Madge was originally from Melbourne, Australia, where her father had a textile business. The family came to England when she was two. She was briefly married to Ewart Garland (later the father of theatre director Patrick Garland), was an early fashion editor at Vogue, *working alongside her friend Dorothy Todd, who combined high fashion with high art and good journalism. Both were removed by Condé Nast in 1926. Madge went on to edit other magazines, to return to* Vogue *in 1934, and to write extensively about fashion. She became a professor of fashion at the Royal College of Art. Virginia Woolf wrote of her 'rather excessive charm'; Rebecca West described her as 'an exquisite piece of porcelain' while not underestimating her inner strength.* In 1952, she married Sir Leigh Ashton, director of the Victoria and Albert Museum, a short-lived arrangement.*

I arrived at Melbury Walk at four o'clock. She has a book-lined room and sits on a couch with a rug over her. I suppose she must now be about eighty. She showed me early photos of her by Cecil – one was certainly of the very earliest style; she said the sisters held the lights on the floor.

It occurred to me in the course of the conversation that Lady A. might be a lesbian. It was the way she spoke of other women – beauty in women and so on. Thus she'd have married Sir Leigh Ashton (now in St Andrews) for companionship in later life.

* There is an excellent biographical essay on Madge in Lisa Cohen's *All We Know – Three Lives* (Farrar, Straus & Giroux, 2012): 'Velvet is Very Important'.

She began by explaining the different *Vogues* to me – the Quaker Edna Woolman Chase, who took over Lucien Lelong's *Gazette du Bon Temps* in Paris in the days when French designs took days to cross the Channel. Condé Nast bought it outright and kept the staff. She thought French *Vogue* the best of all – Alison Settle,[*] she recalled, was pestered by CB in Venice in 1929 – he wanted to do one of those sketches of her. The row in New York[†] concerned something anti-Semitic: 'I saw nothing distasteful in it at all,' she said. 'I was awakened by a telephone call. Had I seen Cecil last night? Where had he been?' He was out by midday.

The resignation was in the midday press. She said, 'The difference was so extraordinary. Before that he was a painted young flusie. He came back a man, serious.' They had drinks at the Ritz together. Later Madge needed a photographer, couldn't find one, had to use a separate studio and photographer each time. Finally Condé took Cecil back. She said when Edna was persuaded to retire it nearly killed her. She spoke of Horst.[‡] He I must see. She said Cecil was 'very hard-working, polite, very charming'. Oliver Messel once failed to do the designs for a Cochran revue. Cecil worked overnight and produced the goods. 'Oliver couldn't have cared less,' she said. 'He was a dilettante gentleman.'

She knew Stephen Tennant – and said of Wilsford, 'The windows were blocked out with false views. There was a fisherman's net draped up the staircase. The pale blue taffeta curtains lined with black lace and pink roses. He had a French café bar – with the postcard stand. Once he dressed as Queen Marie of Romania. When the King died, the *Daily Mail* had a heading: "King Ferdinand dead" and "Stephen Tennant every inch a Queen". That editor was out by midday too.'

Of Charley James she said: 'He had more knowledge of fashion in his little finger than the whole world of couture put together.'

She said that Mercedes de Acosta,[§] a sister of Mrs Lydig and 'one

[*] Alison Settle (1891–1980), editor of *Vogue* 1926–35.
[†] The incident in which Cecil introduced some unpleasant anti-Semitic words into an elaborate sketch in *Vogue* in 1938.
[‡] Horst (1906–99), photographer. See note on page 119.
[§] Mercedes de Acosta (1892–1968), who made the justifiable claim 'I can get any woman from any man'; famed for liaisons with numerous famous women, including Garbo, Marlene Dietrich, Eva Le Gallienne. Her sister, Rita Lydig (1875–1929), was a famous socialite and fashion icon.

of the women I have loved most in my life', was Garbo's lover in Paris. She said that Garbo was an 'empty vessel'. She said that Mercedes used to sleep in the same bed as her, then drive her to the studio. As she reached the studio she gradually transformed into the part she was going to play. Of Cecil and Garbo she said sternly: 'I don't believe a word of it. The thought of a woman would scare the pants off him. Of course he was in love with her. Everybody was.' She thought she'd love to meet her.

She also said that beauty was a great responsibility. We discussed this at length. She spoke of Lee Miller (Mrs Roland Penrose) who became drunk and fat and did everything to destroy her beauty. She saw it as a barrier between her and reality.

London, Friday, 21 March 1980

Lady Diana Cooper (1892–1986) was a vital figure in Cecil's life. A legendary beauty, once described as 'the least dumb blonde', she was the daughter of Violet, Duchess of Rutland, and possessed a unique and original approach to life. As Lady Diana Manners, she was much sought after by a generation of young men, many of whom lost their lives in the First World War. She starred in Max Rheinhardt's play, The Miracle. *Her marriage to Duff Cooper brought her into politics and later to the British Embassy in Paris. She had been immortalised in novels by Evelyn Waugh, Nancy Mitford and Enid Bagnold. In widowhood, she was living in Little Venice, and was then eighty-seven.*

She did not hesitate to address questions to strangers, so my first encounter with her had been after an Order of the Garter ceremony in 1972, when she turned and asked me a random question. I then met her at lunch with Alan Pryce-Jones in 1976, when I was writing* Gladys, *and later with Laura Marlborough and Ali Forbes at Portman Towers in the summer of 1979.*

I telephoned on 17 March. 'Oh! Hugo Vickers,' she said. 'Any time, anywhere, whatever you like,' she said. Later she changed it, ringing me back: 'Mr Vickers?'

'Yes.'

'Hugo. Diana Cooper.' She was going, she thought, to Michael Duff's memorial service.

* Alan Pryce-Jones (1908–2000), one-time editor of *The Times Literary Supplement*.

'It's Michael Astor tomorrow,' I said.
'Well, the same applies,' she said.

I started this diary because I was lunching with Lady Diana Cooper in May 1976. It has kept going for nearly four years now and today was the day of my visit to her . . .

I drove to Warwick Avenue and I found the house and planted myself outside it. At eleven o'clock I went in. The yellow door has a brass plaque on it announcing that it is the gift of Paul Getty. I rang. Wanda (Pissara), the Portuguese [housekeeper], opened the door for me. There was a huge sign saying: 'BEWARE OF THE DOG' – in case someone stepped on the little creature, I suppose. 'You've come to see Lady Diana?' asked Wanda. I climbed the stairs and followed the sound of barking and Lady Diana talking on the telephone. Doggie is a tiny little thing. She leapt towards me and we made friends. Diana was in bed, propped up on huge pillows. She wore a little yellow lace cap and a white shawl. Letters were all over the bed and to hand there were pencils, pens, postcards, everything imaginable. The bed had a huge canopy and there were lovely large windows. Diana smiled, and in due course the telephone conversation was over and we began ours. She introduced me to Doggie: 'I sometimes think that when I'm gone – and it can't be long now – she is the only one that would care.'

I showed her the piece Cecil wrote about her in 1929, the compliment about turning her upside down to judge her beauty. She was amused. I still had to convince her that there was something to be said about Cecil. I was quite confident about it. She seemed to accept it. She said Cecil was one of her dearest friends. 'I loved him dearly,' she said. 'Of course he could be very spiteful, but I never suffered from that. He did once write in his diaries that I never stopped talking. I was rather surprised. I just tried to keep the conversation going and think of things to talk about,' she said. 'He was kind but he could be nasty. Of course when he had the stroke, all that was forgotten, the slate was wiped clean and the neighbours were very kind to him.' She said she had been unable to go to St Martin-in-the-Fields 'right in the centre of Trafalgar Square. I told Eileen,' she said. She asked if anyone was interested in the house yet – 'I mean anyone *we* know.'

She recalled Cecil's early photographing of her. She said she went to Sussex Gardens where he took her with a small Brownie. 'It wasn't technique,' she said. 'He was a genius. When you think it's such an infinitesimal fraction of a second to get the picture. He knew it. And after the stroke he lost that.' She said she hoped it might be possible to create a camera which was attached to a helmet and that he could look through. Then he could get it right and press. She's no fool.

She said she once went to Stephen Tennant's house, Wilsford, but she didn't remember meeting him in 1970. She said Wilsford was the oddest place she'd ever seen. She told me she didn't know Cecil at the time of the ducking [at Wilton] but a lot of people were outraged on Cecil's behalf. And the Pembrokes threw the culprits out.*

At one point her son John Julius [Norwich] called. And she talked to him just as I imagined she would. She was worried about his cold, and they tried to think of someone pretty for Paul-Louis Weiller.† She said, 'Paul-Louis's blind so it doesn't matter – someone with a pretty voice.' [When he rang off] she said to me, 'That was John Julius. But you knew that. It's like someone saying to her husband, "That was Sam, darling," after saying "Goodbye, Sam."' She's a good mimic. I hadn't realised. She quoted Cecil calling out to the manservant: 'Manley, come here and help, Manley. Oh! Do help, Manley.'

Diana enjoyed Laura's book but with one thing. 'If you really want to know, I don't approve of things like *erection*. Does that shock you?' Then she said that what Laura‡ needs is a man.

'There is the colonel [Alex Young],§ of course,' I said.

* In August 1927 Cecil went to the coming-of-age ball of Lord Herbert, heir to the Earl of Pembroke, at Wilton. He was propelled into the river Nadder by some young bloods, because he was wearing make-up.

† Paul-Louis Weiller (1893–1993), millionaire industrialist with properties all over France, including 85 rue de la Faisanderie in Paris (where the Windsors lived after the war), and his villa, La Reine Jeanne, which had a mile of sea front, in the South of France, near Bormes-les-Mimosas. He was generous to Diana, giving her a mink coat, which she called 'the coat of shame'.

‡ Laura had been a widow since 1972.

§ Colonel Alexander Young (1903–89), bachelor chairman of Redland, who enjoyed taking duchesses out to lunch at the Ritz and elsewhere, and whose generosity with car and chauffeur was roundly taken advantage of.

'Oh! He's no good,' she said. I said we had been promised a meeting with the colonel. 'Oh! He's mixed up with Loelia,* is he?' she said, when I told her the connection. She was surprised that I had never met him. At one point she said: 'Do you smoke?' She'd have taken a cigarette off me if I had.

I greatly enjoyed the conversation and the experience. She said, 'I'm always here. Come again soon, very soon.' And there was a splendid moment when a little stir was noticed in the bed and she said, 'Wait.' She sat very still and then Doggie's head emerged at the top of the bed. She was enthralled. It was a great sight!

She had to dress and go out to lunch, 'Not with *the* old Queen, with an old queen,' she said, so off I went. The little brown Mini was parked outside, ready to set off into the hurly-burly of the London traffic.

I called her again on 10 April to give her the bequest of candlesticks from Cecil. When I asked her how she was, she said, 'Oh, pretty bad,' adding, 'Come any time, dear boy,' and so I taxied over there. Wanda said, 'Lady Diana asks that you don't look at her too closely.' She sat in bed once again with no lace cap this time, but her glasses on. And her hair is fair-dyed and she looked pretty good. She loved the candlesticks and said, 'I could use them.' She was pleased that we were to meet at the Baron's dinner for Laura's book Laughter From a Cloud. *'I call him Weidenpuss,' she said.*

London, Tuesday, 15 April 1980

I arrived to collect Diana at seven forty-five for the Baron's dinner party and found her in a grey-white pleated Yuki dress, on closer examination a little grubby and wine-stained. Wanda and her young daughter were at the door, the child holding a sinister mask. 'Show the gentleman,' said Diana. 'I think it's the worst I've seen.'

The Baron greeted Diana and Laura with a kiss. Gillon was early, Hugh [Massingberd] had gone into a grey suit. There was Tom Parr, the

* Loelia, Duchess of Westminster (1902–93), one of the many wives of 'Bendor', Duke of Westminster. By then she was Lady Lindsay of Dowhill. In her day she had been in the middle of the Bright Young Things. While working on Cecil's book, I helped her with her album, *Cocktails & Laughter* (1983).

boyfriend of Fulco Verdura,* to whom I spoke unhelpfully on the telephone once. There was an attractive girl until I remembered her as the wife of Peter Ward,† who was fat, but boyish-looking. There were the Mannerses‡ – Lady John: 'Where's the Duchess? Hallo, Duchess,' and to me, 'Hallo, Ghost.' Then, at a silent moment at dinner, she called over to Diana, 'Hallo, Auntie' – I don't think it went down very well.

'Do you know 'er?' asked Diana, very much in the style of Gladys. 'Oh, you do . . .'

The Duke of Devonshire (who once ushered someone into a room with the phrase 'Ability before privilege') shook hands. There were Sir John and Lady Margaret Colville, Flora Solomon,§ fresh back from Jerusalem, and others to make up to twenty-four.

I was on the top table:

<div align="center">

The Baron

Lady Diana Cooper	Lady John Manners
Me	Tom Parr
Flora Solomon	The Hon. Mrs Peter Ward
Sir John Colville	The Duke of Devonshire

Laura

</div>

Diana greeted my return to her side with great enthusiasm and squeezed my arm. Then there was Flora on the other side to whom I had a more serious talk. She worries about what will happen [to Laura] when the excitement of publication is over. When the flatness sets in. She was also upset that none of her family had come.

At one point I could hear the Baron telling Diana why he thought a life of Cecil was so marvellous – another point of view and so on. 'Haven't I convinced you yet?' I asked. Then we began a long and excellent conversation. At the lunch four years ago with Alan

* Fulco, Duc di Verdura (1899–1978), jewellery designer, and his partner, Tom Parr (1930–2011). Parr was an interior decorator with Colefax & Fowler.
† The Hon. Peter Ward (1926–2008), younger son of the 3rd Earl of Dudley, and one-time stepson of Laura Marlborough.
‡ Lord John (1922–2001) m. Mary Moore (1933–97) – he was a younger son of the 9th Duke of Rutland.
§ Flora Solomon (1895–1984), legendary figure at Marks & Spencer, who created their welfare department.

Pryce-Jones* I hadn't been up to talking to her – in fact I stayed silent most of the time and did my best to keep track of who they were talking about.

Now it was quite different. She talked for about an hour about Cecil. 'Very conscious of his own worth,' she said, and of Greta: that there was a time when Greta was around Pelham Place and Cecil was really more interested in his play. She said that Mrs Beaton [Cecil's mother] left Reddish whenever Greta appeared and referred to her as 'that woman'. She told me about Maud [Nelson], the friend of Oggie Lynn.† She said Maud assaulted a girl who lived in North Wales.

Of herself she said she used to lie to her mother and that it was wonderful when someone said to her, 'You must tell the truth.' We discussed Enid Bagnold and she is going to take me to see her. She says she lives in the past and she alerted me to a row she had with Cecil over *The Chalk Garden*.‡ She asked me, to my very great surprise, 'Did you always know you were going to do as well as now?' Me – well – heavens, no! I was heading downhill very fast – I often think I still am. I attributed the change to Gladys, and we had a long talk about her again – her definition of madness, her way of inspiring me. It ended with me on my 'all legends are lesbians' theory, which was dangerous ground perhaps.

After dinner Diana said, 'I'm so worried. You see I'm so old and I'm wilting.' I promised to drive her home in due course. Johnnie Manners came over and sat down and talked rubbish. Diana was unimpressed. There was talk of a cottage. 'Oh!' she said. 'I thought you had a cottage you were going to give me.' Presently she got bored with him, so we set off.

At Marble Arch, she said, 'Now we'll go along the park so we can go *really* fast.' This we did – policemen be damned – and then headed to Warwick Avenue. 'Oh, you good, good boy,' she exclaimed. 'I love you.' For Diana likes her friends to do her will.

* Alan Pryce-Jones (1908–2000), one time editor of the *Times Literary Supplement*, who moved to Newport, Rhode Island, partly to escape from Mollie, Duchess of Buccleuch.

† Olga Lynn (1882–1961), known as 'Oggie', operatic singer, and her girlfriend Maud Nelson (see footnote on page 14).

‡ Cecil was livid when the colour of his sets for Enid's highly successful play was changed in New York. He blamed Enid and the producer, Irene Selznick.

At the door we went in and, on the strength of the 'I love you', I kissed her on the cheek. Then back to the party. By this time the Manners and Ward contingent had got rather rowdy and out of hand. Gradually it died down to just the Baron, Laura, Hugh, Gillon, and Camilla Horne. Gillon got drinks. 'You have a civic sense, Gillon,' said the Baron.

London, Tuesday, 29 April 1980

(Sir) Roy Strong (b. 1935) had been the young and inspirational director of the National Portrait Gallery from 1967 to 1973. He had staged the important 1968 exhibition of Cecil's photographs, the first time that photography had been shown, the first time that a living artist had been portrayed there and the first time that non-British subjects had been exhibited. Arguably Cecil was as important in the life of Roy Strong as Strong was in the life of Cecil. He was now director of the Victoria and Albert Museum. I had a meeting with him to hand over some clothes and hats for the collection Cecil had made there in 1971.

He was pleased to get them but he didn't itch with enthusiasm. What a strange fellow he is. He has emaciated considerably since I last saw him – his hair is now grey, silky and close-fitting, his moustache Proustian, his glasses ridiculous. He is a cartoon, not a real figure at all, and his arms and legs are so thin – he looks startled, and I wondered what on earth he was doing in the director's office of the Victoria and Albert Museum.

He asked what sort of biography I'd be writing and began on the old theme – he's done so much himself. He was quick to seize on boyfriends: 'That hasn't been done. You can go into that.' And of the diaries he said, 'He could be a real bitch, Cecil. But wasn't that Garbo stuff all fantasy? Typical homosexual thing – the one unobtainable woman.' He went on to *Turandot* – Cecil had no idea of a scale model. 'No wonder the Oliviers were livid.' He said Cecil was awful to Eileen. 'Why can't she learn how to dress?' Later Eileen would look after him, then return to an eighty-five-year-old mother, then back to Cecil. He quoted her as saying, 'It's like a prison.'

Cecil hated the Hockney drawings and Roy S was there while they were being done. Quoted Cecil: 'I've got a green suit and a pink one

and there's another hat.' He invited him to dinner once: 'He'd never heard of Dame Veronica Wedgwood,' said Roy in horror. 'One of the greatest writers alive.' Cecil just lived in his smart world of the Wrightsmans* and so on and the theatre. They deserted him after the stroke. Alan Tagg,† he thought, did a lot of the designs – one was blown up to a large scale. [Cecil] was furious it wasn't ready. 'Well, you make a costume from that.'

'I'll be interested in your verdict,' said the diminutive director. 'Sad, I should think.'

'Isn't it always?' I said. For really one wonders how anyone gets anything done. Everyone seems an idiot – or drunk or sick or perverted. Everyone is driven on by a sense of their own ultimate failure – and probably all creative people go bitter to the grave.

Rottingdean, Tuesday, 6 May 1980

I rang Diana Cooper to plan the visit to Enid Bagnold (1889–1981), widow of Sir Roderick Jones, one-time chairman of Reuters. She was a successful novelist, famous for National Velvet, *and had written a memorable autobiography. She was a marvellous writer, quirky and unusual, and I came to love her books and later bought her letters to Antoine, Emanuel and Marthe Bibesco. I had wanted to meet her because of Cecil's work on* The Chalk Garden, *and the ensuing row. She had lately been in France with her daughter.*

'It takes under two hours,' Diana said. 'So we'll have a bite of lunch with her and then you will go for a walk for half an hour or so because there are things that Enid won't say if you're there.' Laura Marlborough had explained this mystery. Enid had become a morphine addict following a bad fall. Diana's motive for visiting Enid was largely to get morphine from her. This she kept in a cupboard in her bedroom, so that she could possibly make her 'Exit' one day. So, in a sense, my visit was a drug run. I collected Diana at ten thirty on the dot.

* Charles Wrightsman (1895-1986), President of Standard Oil of Kansas, and his wife, Jayne (1919-2019), noted collectors and philanthropists. Cecil was often a guest on their yacht.
† Alan Tagg (1928-2002), celebrated theatre designer.

I waited in the hall. Diana came down the stairs in trouser suit and the famous hat. 'I haven't eaten a thing, drunk a thing, or smoked for five days,' she said. 'I feel weak.' She said she'd spent the bank holiday in bed with Doggie. Doggie was now very nervous at the end of this little episode. Out we went and she headed to her car. I said, no, we'd take mine, and she was as relieved as I was.

It was a struggle getting out of London. Also it was a ghastly road – but the journey went smoothly. Only very occasionally did she say, 'Over the kerb – I always do,' or 'Past that,' or when the lights went red, 'Bugger!' Nor did she smoke at all on the journey and Doggie sat very peacefully.

One warning note: 'Does she travel well?' I asked.

'Oh! Frightfully well, except occasionally when she makes a ghastly mess.'

She knows the road well and exclaims at the blossom and points out the landmarks she likes and the buildings she doesn't. Rightly, in my view, she prefers skyscrapers with tops on to square blocks and she still believes what she said on *Desert Island Discs* some years ago – that London should have been built on the South Bank and that old London should have been left alone.

We headed towards Brighton. 'We'll take the coast. It's a little longer but it's fun.' And so we saw the sea and I opened the window for sea air. 'Dr Brighton,' she said. 'When one was young and had influenza, one was sent to Doctor Brighton.' She loved Brighton and her mother's cottage at Bognor. Down they came and there was no bathroom or indoor loo. Later she used to milk the cow by hand – 'No machines' – and she said, 'There's something marvellous about putting your face next to the cow's skin.' Now it's gone and the place is covered with flats and holiday homes.

North End House is wonderful. It was Burne-Jones's and it stands on the road overlooking the prettiest green and Rudyard Kipling's house opposite. We drove to the back door. We met the nurse who told us there is a plot [by Timothy Jones[*]] to get Enid Bagnold out. They say she is going to Hamilton Terrace to her son Richard's[†] flat but, as ever, it is a plot to get her into a nursing home. The nurse has

* Timothy Jones (1924–87), Enid's eldest son.
† Richard Bagnold Jones (1926–2009).

just bought Maurice Baring's house, or is about to, and she said she'd have her there.

Enid Bagnold

In we went – through a huge library with plastic covers over the books, and couches and heaps of books and old sculptures all around. And we came to a drawing room where Lady Jones was seated. 'I'm just addressing an envelope, Diana. Can I just do that?' She kept saying, 'I'm so happy to see you, Diana.' I gave her the Black Magics and they were a great success.

'Will you kiss me, Mr Vickers?' and later: 'I'm ninety, Mr Vickers. How old are you, Mr Vickers? Can I call you Hugo? And will you call me Enid?'

The nurse again: 'Oh! The Lady Diana, you're looking as beautiful as ever and so well.'

And Enid: 'You're so beautiful, Diana.'

'Nonsense, Enid.'

'And you've done your fingernails so prettily.'

'Your eyes are too sharp, Enid. Go a bit blinder.'

'Why are you wearing glasses, Diana?'

'I wear them to read.'

'But you're not reading now, Diana.'

And then again: 'Mr Vickers, can I call you Hugo? And will you call me Enid? Will you help me put my slippers on?' She was

barefoot, very arthritic (hands and feet), but she can write and said she spent her time reading and writing. She has bright eyes and white curly hair. Sometimes she was with us, joining fully in the conversation; at other times, under her breath, she talked, mumbled away, in a mixture of French and English. The putting on of the slippers was a prelude to heading out to the loo.

'She doesn't need to,' said the nurse. 'This is a new habit since France.'

Suddenly Enid lifted up her skirt and pulled out a catheter-thing – she called it 'my icon' – and put it on the table, and a cloth. Out she went.

'Did you see that sinister object?' Diana asked me. And: 'Is it funnier than you thought?'

We tried to talk about Cecil but only got: 'He was a very dear friend of mine. No, we never quarrelled. Oh! Yes, Irene [Selznick], and he had a terrible quarrel, but they patched it up.'

Diana got her gin and I had one too. The bottles that used to be at hand had been taken away by the nurses. To a request, 'Will you lift up the glass a moment, please, Lady Diana?' Diana said, 'Only if you fill it up for me.'

Lunch came on trays – very much hospital food and not much of it, but edible. Enid didn't want to eat hers. 'Oh! Diana, tell her I mustn't eat it. Don't make her force me. She's so terrible to me. I'm so frightened of her. She won't give me any pudding.' The nurse was all for her having a bit more so when she was out of the room I rearranged the plate and some went on to Diana's. Enid liked her apple pie and even asked for more. She got it. And I was sent to ask for more gin for Diana.

'One gin is quite enough for her,' said Mrs Scott, the new nurse.

'She's not driving,' I said, making it an excuse. 'I'm only the messenger.'

'Oh! I know Lady Diana – she has all her men running errands for her.'

Anyway, the gin came and Diana poured some of it into my glass.

Later there came the time for me to take my walk in the garden. I talked to Mrs Scott – in fact she talked non-stop and told me the story of her life, her money, her protecting of herself and so on. These confidences – which included how difficult Lady Jones was: 'I took

her to her brother. Within minutes she had the whole house revolving round her' – led to me being shown some of the thirty-five rooms. The house was *amazing*. It has three staircases, a rabbit warren of bedrooms, some of which have as many as three doors to open before entering – there were holes in the floor so that you could practically see down into the floor below, and one never knew for a moment whether one was on the first or second floor or on one between. Easy to get lost. And also one had to be very careful where one stood, lest one went right through. Wonderful books lay all about – discarded, forgotten, great hunks of fine old furniture, drawers full of 'stuff', curtains, old newspapers, pictures and so on. Sir Roderick's bedroom was as he had left it and there was *The Times* of 1956, which I think had his obituary in it. Her bedroom was a dream. It was not a grand house, but a fascinating one – the walls covered with prints, framed letters, etc. There was a letter from Dickens, several Sickert sketches, a Gaudier-Breszka bust and sketches by him, drawings by [her daughter] Laurian Jones for *National Velvet* – a treasure trove I could have spent hours in. And most of the house now unused, deserted, crumbling to bits, like the poor old lady who owns it and who, any day now, may find herself in the bleak horror of an institution.

There was much more to see but a shrill call came from the garden – Diana, 'Hugo! Hugo!' – so down I went and Enid was in the garden and Diana had disappeared. I found her in a maze of overgrown greenery like a Secret Garden. 'She's in a frenzy for us to go,' said Diana, and I took her hand and steered her back to the lawn. Then I was very lucky and they posed, and I do hope the pictures will come out.

Enid had said to me earlier, 'Are you happy, Hugo? You look happy.'

I said, 'Quite – I'm not unhappy. But I don't look for happiness. If I'm too happy, I curl up and purr and that doesn't get things done.'

'You look happy. I'm happy.'

Diana said: 'I'm always unhappy.'

Off we went – much goodbye kissing. 'That's my grandfather,' said Enid, pointing to a bust.

'He's good,' said Diana, 'by which I mean he's noble.'

In the car she said, 'It's so sad. If you'd known her as I did, when she was brilliant, and you see her now . . .' She was very against the nurses. 'She needs an amateur to care for her.' It's all too awful. Diana

said, 'When you were away, I said to Enid, "You mustn't take that thing out when people are here." It was the way she put it on the table. I asked her, "Are you incontinent, Enid?" and she said, "No, but I like it because it's warm and comfortable."' I, of course, did not blanch, from my days with Gladys at St Andrew's Hospital.

So we got back to Warwick Avenue rather swiftly. I gave her the pictures from Cecil – she wouldn't sign the books, though. 'Don't ask me now, darling. It'll be an excuse to lure you here again.' She was going out again that evening, naturally, to hear Ellen Terry and Bernard Shaw's letters read. Meanwhile a short respite. A proffered cheek and she disappeared behind the door.

I drove home. Stuart [Preston] was here, so instantly I was bombarded with questions. He was anxious to know if Diana remembered him. What she actually said was: 'The Sergeant? What was he doing here? Was he a spy? He never left England. A social figure.'

I said, 'He was the kind of person that if you introduced him to a duke you happened to know, he'd be staying there the next weekend.'

'Exactly.'

Stuart Preston (1915–2005) had invited himself to stay in my flat in Lexham Gardens, and was occupying the room upstairs. He was a legendary figure in a certain world, an art critic who had enjoyed luminary success in London during the war and inspired the character of Loot in Evelyn Waugh's Unconditional Surrender. *His nickname, 'The Sergeant', was not usually mentioned in his presence. He was knowledgeable about art and society, and having helped Consuelo Vanderbilt (first wife of the 9th Duke of Marlborough) with her memoirs, he had been a huge help to me with my book on Gladys. In 1976, he had moved to Paris, inspiring Harold Acton* to muse to me, 'What did Henry James say? All good Americans go to Paris to die?'*

Earlier in the year, the Sergeant had taken me to 44 rue du Bac, in Paris, where Peter Watson had once lived. 'Just think, Hugo, Cecil climbed these stairs, his heart beating with love for Peter.' On this visit he described Peter Watson as a masochist: 'He liked to find rough boys in bars who stole his gold cigarette case. Well, he was lucky. He found them.'

★ ★ ★ ★ ★

* Sir Harold Acton (1904-94), aesthete and writer, lived at La Pietra in Florence.

On 4 June I rang Diana to make a plan to deliver one of Cecil's hats to her.
She asked for it as her local pet priest, Father John Foster, wanted one.*

She said, 'Where are you on 12 June?'
 'France.'
 'Bath?'
 'No, France.'
 'Bother. Rather grandly I have the Queen Mother coming for lunch and I wondered if you'd like to come in for a drink.' I was to be 'a neighbour.' But, alas, I couldn't change it.
 I delivered the hat and waited in the drawing room but Wanda said, 'Lady Diana says she hasn't done her face and she's too ugly to see you.' Instead I saw the Martin Battersby panels in the drawing room – a lovely room.

London, Saturday, 21 June 1980

The legendary fashion editor Diana Vreeland (1903–89) came to London on
a visit, and was in touch with Eileen Hose. She agreed to see me and invited
me to lunch at the Dorchester. She had been editor of Harper's Bazaar, *and*
then of Vogue, *and an important catalyst in the lives of numerous fashion*
designers, models and photographers. She was known for sayings such as 'Pink
is the navy blue of India.' Something of a martinet to work for, she had been
a friend of Cecil for fifty years.

 By now she was seventy-seven and, after her dismissal from Vogue *in*
1971, had created a new role for herself as special consultant to the Costume
Institute at the Metropolitan Museum in New York.

Then I went to the Dorchester rather nervously but Mrs Vreeland was easy to get on with. She is tiny, with very red make-up and jet black hair, pulled straight back and into the ears. We went straight in and talked of *Gladys* – I gave her [a copy]. She said that she first met Cecil in 1929 and wanted a caricature for Christmas that year. He did one of an American with a huge sparkly ring. She said, 'I will never wear a ring like that.'

* Father John Foster, vicar of St Mary's, Paddington Green. He retired to Bath and died there aged eighty-nine in 2019.

'Oh! But all Americans do.'

'That's a very good reason for me not doing so.'

She told me she saw Garbo lately: 'The lower part of her face is not good, but remember, I'm talking of a famous beauty.' But she came to dinner and laughed and it was as wonderful as ever. Garbo is always home by six. She lives in the same block as Madame Schlee, but they must never meet. So Garbo is in by six, and Madame Schlee comes out after six.

She said that the other day they did meet. This was a big happening as nothing happens in Garbo's life. She thought that Cecil should never have published *The Happy Years** and she would not acknowledge receipt of the book. She believed rather melodramatically that the fact he had made his affair public knowledge brought on his stroke. She is a believer in the zodiac. Capricorn. 'Oh! Yes, that old goat keeps climbing up the hill and always gets there in the end.' She was full of praise for Grant – she said the way Cecil's things were laid out in New York was 'better than a woman travelling with two maids thirty years ago'.

She said I should come with her in the car – we went to the Hyde Park Hotel and I dropped her there. She was due later at the Michael of Kents for drinks at five fifty (baby goes to bed at six). I'm sure I made a new friend.

London, Sunday, 29 June 1980

Doggie had died so I drove Diana to the Wandsworth Dog Show in the quest for a new Chihuahua. She looked terrific in her sailor-suit outfit. Then she came to see my flat.

Of a postcard she said, 'Look, it's got an enormous erection.' It was true – the statue in the picture had a palm tree behind it, which looked most odd.

She liked the Bérards – she didn't like the Wishart. 'I must have looked at it in what I called my room and then quickly looked away.'

* Cecil had published details of his affair with Garbo in his third volume of diaries, *The Happy Years* (1972). Many of his friends took a dim view of this.

She loved the little figures* and recognised several of them. On Margaret Argyll:[†] 'It's the spit – she doesn't deserve better.' And to the bedroom – would I have believed on that (sad) Garter Day of 1972 that eight years later this would happen? She admired the view, then the kitchen and the upstairs studio. She signed her three volumes [of memoirs] for me.

Then we drove back to Warwick Avenue. She showed me the hollyhocks from her bedroom window and some unicorn books and we talked awhile to Wanda. While I recall: of June Osborn (Hutchinson),[‡] she said, 'June was very funny about that affair. She said that Cecil would never make up his mind whether he wanted her to be a man or a woman.'

So off I went. 'Give my love to David. Tell him I love him greatly,' she said. She presented a cheek for a kiss and clasped both my hands in hers. As ever my life was enhanced by the encounter.

Tangier, Tuesday, 1 July to Tuesday, 8 July 1980

David Herbert (1906–95) had invited me to stay in Tangier when I visited him at Ewelme in June, at the home of his sister, Patricia (Viscountess) Hambleden. He was the younger son of the Earl of Pembroke and had been brought up at Wilton. Later he had gone to live in Tangier to escape the conventionality of his parents' lives, set himself up in a house on the hill and lived the classic expatriate life of pantomimes at Christmas and relentless entertaining. There, too, he was able to indulge freely in 'vices only supported in the days of ancient civilisations' – as Cecil described it in his celebrated spoof, My Royal Past.[5]

At this lunch he was hobbling about on crutches due to a fall. He began by identifying all the characters in My Royal Past, *and he talked about Cecil.*

* I had spent much of my teenage years making models of living figures, about five hundred in all. Several popped up in my life when I was writing this book, which was in a way surreal.

† Margaret, Duchess of Argyll (1912–93), a celebrated beauty who had been involved in a sensational divorce case in 1963.

‡ June Osborn, later Lady Hutchinson of Lullington (1920–2006), an attractive widow. Diana had tried to promote a marriage between her and Cecil.

How his aunt Jessie was responsible for bringing out his interests – how his mother still got a thrill if the Duchess of Kent came to tea. He said all that Lady Mary Beaton stuff was nonsense, as I had suspected. Then he said the thing about Cecil was that he was a hard worker – good, solid, middle-class stuff.

After the stroke, David Herbert said to him, 'Stop blubbing. Go out and paint.' He did – results in *Vogue* – and Nancy [Cecil's elder sister] wrote to say he'd saved his life. New beginnings.

Aunt Cada:* 'He's a nice man is so-and-so.' Never lost the North Country accent. DH loved her. At the ninetieth birthday party at Pelham Place, Cecil took people over, many celebrities. 'And this is David. Now, David, you come and sit beside me and talk to me. I'm fed up with all those others.'

Edith Olivier's funeral – a pigeon flew from the grave. David and Cecil, tears flowing: 'Soaring through the tracks,' moaned Cecil. EO very important to him.

Stephen Tennant likely to be vitriolic about Cecil – exchange of roles – Lady Glenconner† famous Sargent painting like Mrs Adeane and Lady Wemyss – Cecil v. impressed.

June Hutchinson. David: 'No woman could ever have lived with him.'

The war the time that 'made a man of him'. Before that very made up. 'I'm just going to have my eyelashes dyed.' The thing to do on holiday.

The Queen Mother not represented at Cecil's memorial service. Difficult issue. Difficult for her to create a precedent. Royalty, though not Princess Marina, worried by his flamboyance. Though, as he aged, he became more of an 'Old Master'.

Mrs Beaton v. much worst sort of middle class. Played it *grande dame*. Nancy the same, but not Baba‡ and Cecil. Old Mr Beaton, little man, pinhead. Impossible to bring out like the mother and daughters. Mrs B. very good looking.

* Cecil's aunt Cada Chattock (1879–1970), his mother's sister, married to Richard Chattock. She went blind in later life.
† Pamela Wyndham (1871–1928), Stephen's mother, married to 1st Lord Glenconner, and later to 1st Viscount Grey of Fallodon.
‡ Baba Beaton (1912–73), Cecil's younger sister, married Alec Hambro (1910–43).

Ashcombe – all the furniture junk. Deal – painted by Cecil.
Elizabeth Ponsonby[*] gassed herself in a bookshop in King's Road.

Lady Hambleden came in. I liked the way David Herbert said, 'Isn't my sister beautiful?' and he called her 'darling'. Later still appeared Lady Nutting, who had come for lunch. David thought her very beautiful too, but I thought her somewhat cold, in fact more likely shy. She was the famous model Anne Gunning.[†]

When invited to Tangier, I thought that if ever I were to go there, surely the way to do it was to stay with him. But I would not have gone if Lady Nutting had not been going at the same time. He alarmed me before I arrived by announcing, 'I will be there to meet you – with open arms.'

I flew out on Tuesday, 1 July, and was met by David at the airport. We drove to the house, which was settled on the mountain, a mass of foliage, in fact a jungle. My bedroom had the Cecil Beaton sketch of the naked backside of a man – cited as Mick Jagger's. The small single bed had linen sheets. These were ancient and had been cut in two and stitched down the middle so that the less worn part was slept on (as was the mean custom in certain houses). On the first night my big toe inserted itself into a hole in the upper sheet, and the sheet ripped. By the end of the visit, it was rent in two. Nevertheless the bed was made daily by the Arab servant as if the sheet was intact. I was so fed up that I didn't care.

Of the bathroom, Clarissa Avon later recalled Mickey Renshaw[‡] saying, 'It wasn't the smell of gas that I minded, it was the troupe of ants circling the loo seat that I particularly objected to.'

The week's stay was a mixture of meals with the same people, often in different places. We went to beaches or we visited the town. At the Café de Paris, David spotted Ahmed, a local character who had married Diane de Beauvau,[§] an heiress from the Patiño family and their tin fortune. Now they were separated. This was to be his repeated story that week: which was the

[*] Elizabeth Ponsonby (1900–40), a 'Bright Young Thing'.
[†] Anne Gunning (1929–90), married to Sir Anthony Nutting Bt, the politician who resigned over Suez.
[‡] Mickey Renshaw (1908–78), bachelor friend of Cecil; he worked for *The Times*.
[§] Princesse Diane de Beauvau-Craon (b. 1955), daughter of Prince Marc de Beauvau-Craon, of the Château d'Haroué, in the Lorraine region of France; m. 1979, Ahmed Mohamadialal (b. 1952), moved on to Jacques de Bascher 1980; divorced Ahmed 1985.

more iniquitous of the two? It gave David the chance to relate in anglicised French: 'Vous savez que j'ai rencontré Marc à la soirée pour la Reine Mère. J'ai dit à lui . . . et il a dit à moi . . .' Of Cecil what did I glean? That he had an eye like a snake, and that if David Herbert had really been his 'best friend', he would have been in trouble.

I felt mildly threatened throughout my stay. Never more so than when, at a Thursfield dinner, I overheard one of the Tangerines asking David Herbert: 'Have you . . .?'

Herbert replied: 'No, but I long to.'

My blood ran cold.

Then I slightly overplayed my hand to the point at which one evening Anne Nutting suggested I leave my bedroom door open to get a breeze through. She came into my room and began to examine the clip on my suitcase. I just wished I could be left alone – which, to be fair to both of them, I was.

By Saturday I was distinctly unhappy. On the Sunday we lunched with the sinister Mark Gilbey in his strange house. He was a good mimic: Dudley Forwood†– 'a laugh like a shot rabbit – wingggggg . . .' One evening we saw Yves Vidal's‡ extraordinary York Castle. It was sumptuous, overly opulent, mosaic pool, rooms everywhere, a tower room, views over the sea, a huge tent on the roof for dinners. 'Of course this is only a holiday home. We use it two months in the year.' Yves Vidal: 'Paris has gone mad this season. Parties for four hundred sit down night after night. Mad, wonderful. And I'm not easy to please.'*

At the Palais Harem of Sultan Moulay Ismail, owned and adorned by the eccentric David Edge, and further embellished by his Spanish companion, Adolfo de Velasco, there were fur rugs on his bed, the new suite, scarlet heavy-pile carpet – blue chiffon-veil curtains and more beige carpets. My comment to Annie Lambton: 'The only thing to do here is commit suicide. A knife in the throat – blood on the beige – you'd fall and feel nothing. You'd be awfully

* Mark Gilbey (1923-92), bachelor member of the gin family.

† Sir Dudley Forwood Bt (1912-2001), equerry to the Duke of Windsor after the Abdication.

‡ Yves Vidal (1923–2001) worked for the Knoll furniture company and brought it into the world of luxurious French interiors. He became president of Knoll International in 1951. He and his partner, Charles Sévigny (1918-2019), acquired York Castle, in the ramparts of Tangier, in 1961. Here they entertained in style, but the exterior was eventually destroyed.

comfortable.' At dinner I met the only normal man there, or so I supposed. He was Peter Wildeblood, who had been the guiltiest in the Montagu of Beaulieu Boy Scout case.*

The next day I flew home. When I got back to my flat I did something I have never done before or since: I leapt into my bed and pulled the duvet over myself. Later I wrote,

Ugh! I can't bear to brush by it in thought at the moment, the uncomfortable house, the people, the dreary parties, the sultry climate, the no one to talk to, the loneliness, the ill-health (a grotty tummy and then a cold).

Diana and I now talked regularly on the telephone. On one such occasion, Ali Forbes was there. He seized the telephone. He said he would be happy to talk. 'If Lord Weidenfeld has given you a massive expense account, perhaps we might lunch together?' I took Diana to a dinner given by Lady Freyberg for her daughter, Annabel. Loelia Lindsay (a former Duchess of Westminster) appeared, complaining, 'It is rather galling to think that having once owned four hundred acres of Central London, I don't even have a flat over a garage now.'

London, Wednesday, 23 July 1980

Diana Cooper's call woke me at nine thirty or so. 'Hugo, do you know who this is? Oh! This poor old voice . . .' She has been thoroughly depressed and feels awful. And she still has no little dog. She finds it difficult. 'I do my best,' she says.

London, Wednesday, 23 July 1980

At the Beaton sale I had bought Michael Wishart's painting Arab with Djenoun, *the one from which Diana had averted her gaze when she came to*

* Peter Wildeblood (1923–99), journalist, who was arrested in 1954, charged along with Lord Montagu of Beaulieu and Michael Pitt-Rivers of misdeameanours with boy scouts – more specifically with 'conspiracy to incite certain male persons to commit serious offences with male persons (or "buggery")'. He was imprisoned for eighteen months. He published *Against the Law* (1955), which led to a more tolerant approach to homosexuality, and the Wolfenden Report.

Lexham Gardens. I wrote to him and he came to the flat to see it, and to talk about Cecil.

Michael Wishart (1928–96) was a talented artist who lived life to extremes. He could be nervous or wild in behaviour. He veered between a heterosexual and a homosexual life. He belonged to the world of Lucian Freud and Francis Bacon. He was pleased that his paintings appealed in particular to writers, having been collected by Cyril Connolly, Caroline Blackwood and others. He possessed many dramatic aunts, citing, 'one a lesbian with a moustache, the image of George Sand, who with or without the lash managed to seduce her idol, T. E. Lawrence ONCE ONLY, afterwards retiring to a Beverley Nichols cottage with a lady named Philip de Winton'.[6]

Michael wrote an outspoken memoir, High Diver. *I quoted from this in my* Times *obituary of him, a line about his love for Denham Fouts,* which somewhat shocked my late parents-in-law: 'Years later he visited Fouts's grave in Rome, musing: "What had become of the scorpion tattooed in his groin that I had kissed so many times?"[7] Ali Forbes was right to detect a 'poetic painter's eye and imagination'.[8]*

Michael Wishart arrived at four thirty-five, wearing a tweed jacket, black shirt, white scarf, grey trousers, green cord belt, bright yellow socks and black shoes. He looks Italian, with grey hair close-cropped. He was immensely shy to begin with but gradually blossomed into talk. We began by looking at the pictures – he loved the Bérards. He loved my little Cocteau. He was reunited with his own picture and liked it better than he recalled. He also saw the Christian Bérard exhibition poster, which was one he had brought over from Paris.

He told me stories about Cecil. When first he came to the studio, he said, 'Now put the picture on the easel. Right now the next, and the next.' MW was immensely surprised by this – he thought they were making no impression at all – but the following day Cecil sent him a drawing of exactly the one he wanted. Therefore he had the kind of eye that could take in the whole thing instantly and reproduce it. MW said he never much liked any of Cecil's stage-work – least of all *Turandot*: once there was a stage set with what looked like a fender above it – 'Oh! Well, I ran out of ideas so I reproduced fender in the

* Denham Fouts (1914–48), *homme fatale* and later an opium addict, who inspired the character Paul in Christopher Isherwood's *Down There on a Visit* (1962).

drawing room.' Lady Juliet Duff* used to say that Cecil had 'flair but absolutely no taste'. She taught him that every room must have a trowel by the grate to give the impression of gardening, etc. Her house was grand while his was smart. [Wishart] said Cecil was not generous – he would buy the pictures before an exhibition, pay cash and then lend them.

He spoke of Francis Rose and his wish to visit the National Gallery to see (I think) a Piero della Francesca. He went to a restaurant afterwards and fell down dead. He was drunk, of course, and with a weak heart he didn't have a hope. MW reckons Cecil should have been more generous – the odd £5 at Christmas not enough. But once he gave Francis £20 and he went out and drank £10 of it and then bought £10 of roses for Cecil, so Cecil had to put up with roses he didn't want and a drunk Francis Rose. In his earlier days it was through FR that Cecil met Gertrude Stein and Bérard. Francis used to wear Cecil's old suits, which fitted him well. When complimented on them, he would say, 'I have the same tailor as Sir Cecil Beaton.' He spent his evenings in the pub – he liked getting letters from Cecil and MW as often they contained a fiver. He died in the Middlesex Hospital and was given a pathetic funeral – cheapest possible coffin, etc. He had wanted a Roman funeral but all he got was a few hurried prayers from a sinister clergyman friend. In his youth he had millions, which he lost to a thug he was obsessed with.

Stephen Tennant, he said, was almost a hermaphrodite. He wore more make-up than a woman and would be to an ordinary person very bizarre. He was extremely intelligent. He was furious with Cecil for what he wrote in his last diaries about him – very unkind. He now sees nobody, but he is avaricious and might see someone who had bought one of his paintings and wanted another one: £30 small ones, £40 large ones – he does three a day. He wouldn't even see his niece, Pauline Rumbold. He sees Stephen occasionally but not lately – nobody stays overnight nowadays but some go to lunch.

* Lady Juliet Duff (1881–1965), patron of the Ballets Russes, and neighbour of Cecil at Bulbridge, Wilton.

London, Thursday, 24 July 1980

Through Eileen Hose, a suggestion had been formed that I would house-sit for Clarissa Avon at Alvediston, when she went away in August. This had amused Diana: 'Are you going to live in open sin with her?'

Clarissa Avon

The Countess of Avon (b. 1920) was then just sixty. Born as Clarissa Churchill, she was beautiful, well connected, well read and well educated. With Winston Churchill as her uncle, she met many of the great figures of the age when she was young. She also attracted numerous suitors, many of them immensely distinguished in their own right. She was taught philosophy by Isaiah Berlin and Lord David Cecil. James Pope-Hennessy and Lord Berners used her as heroines in books. As a girl, she was distant and did not feel the need to speak unless she had something to say, so very often she remained silent, acquiring a reputation, not entirely misplaced, for aloofness. She could have been described as an haute Bohemian.

After a life of independence, she married Anthony Eden in 1952. He was foreign secretary at the time, and served as prime minister from 1955 to 1957. She cared for him devotedly during the next twenty years, when his health was frail. Only after he died in 1977 did she resume her earlier life, going to the opera and theatre and travelling extensively. She was selective in her choice of friends, and I was immensely flattered when she admitted me into her world. She was a key witness to the life of Cecil, having known him well since the early 1940s.

I went out for lunch with Clarissa Avon. We met at Cheyne Walk, the home of Nuala Allason* – I went there as a child. A dreadful Chelsea woman came in after me and virtually accused me of loitering. Clarissa appeared at that moment, however, and we went out. We drove to Pimlico to the restaurant that used to be Avocado. The reason for the lunch was to discuss Alvediston. All is well. I am to provide my own food at the house, since I know what I want. She will provide me with wine and liquor.

We discussed Cecil. She reckons he had no more black moments than anyone else. He was always trying some new creative venture, so always struggling. She said that on 'those black, lonely Saturday nights' he was scribbling in his notebooks, all part of the thing.

We spoke of servants in general and Grant in particular. She said her last one just served them out of snobbery. 'He loved the continual flow of statesmen and politicians. Then he fell ill and his life was over.'

The next day came the second visit to Enid Bagnold, with Diana.

London and Rottingdean, Friday, 25 July 1980

Diana appeared in a summer dress with a headscarf under her hat . . . We talked of Clarissa Avon. Diana said, 'But will you be all right?'

'I shan't want anything.'

'But will she want something?'

We got to Brighton on a perfect day – and we drove past St Dunstan's [the home for the blind at Ovingdean]. 'What a waste!' she said. She thinks the blind should not be given such a view.

We reached North End House, where we were not expected. She went in and I went for 'a little walk' to the seafront and to a cider. When I came back, the nurse said, 'Lunch is twelve thirty in this house. Next time Lady Diana wants to come, please let me know. Anyway, there's a friend of yours there.' This turned out to be Tara

* Nuala Allason (1919–2008), former wife of James Allason MP (divorced in 1974). She lived at 15 Cheyne Walk, where a number of people took rooms, including, at one time, Johnny Churchill, Clarissa's estranged brother, and where she gave an annual summer party. She was born Nuala McAravey, and had appeared in films as Nuala McElveen or Nuala Barrie. She spent her last years at Meadbank Care Home.

[Heinemann] with John Randle, the publisher of Enid's letters to Frank Harris.* Quite a merry party was gathered. Enid was dressed to kill in patterned silk with her hair done and all made up. It was marvellous.

'Mr Vickers, how nice to see you. I'll talk to you after lunch.'

So we all chatted together about Cecil Beaton and the sale. Enid asked for water quite often, which I got for her, and we ate hospital food. Time for more drinks. Half a bottle of gin on the table. 'We'll finish it between us,' said Diana. 'That's right. Don't stint!' And I poured the biggest gin I've ever poured in my life. She drinks it with ice only.

After lunch Tara wanted to take the photos so I talked to Enid, and we looked at her book. 'That's Antoine Bibesco.† I loved him half my life. And Frank Harris. I loved him half my life.' We talked of Cecil. 'I never had a quarrel with him. He was very touchy. He's dead now, of course.'

'I'm sad. I'd hoped to talk to him.'

'You're glad?'

'No. Sad.'

'Oh! Sad. I thought you said glad.'

And later of the frontispiece of the verminous lady‡ – Diana: 'What's this?'

'It's by Lovat Fraser, Diana, you've often heard me talk of him.'

She signed my copy of her autobiography and later the letters [to Frank Harris]. 'For Hugo Vickers, with love 1980'. The nurse said, 'I can't imagine why she loved Frank Harris. He boasted he had his hand up more girls' skirts than anyone in London.'

Later we went on a tour of the house – I saw the same rooms as before and some new ones. The nurse must have been high on something. She started to poke fun at everyone. 'Oh! Those two old ladies. They're both quite batty, talking rubbish to each other.' Of the other nurse, Mrs Scott: 'Gramophone Grace?' Later she told Tara

* Frank Harris (1855-1931), Irish American editor, remembered for his wild memoirs, *My Life and Loves*.

† Prince Antoine Bibesco (1878-1951), Romanian diplomat and writer, a friend of Proust.

‡ A sketch of Enid in colour, entitled 'Alas! thou verminous lady'.

that Enid has 375 grams of morphine a day. A normal cancer patient has fifty.

I dropped Diana at Firle where Diana was to spend the weekend with Lord and Lady Gage. She showed me the Van Dycks and Knellers.

★ ★ ★ ★ ★

On Friday, 1 August I drove down to Alvediston to stay there until 16 August. As it turned out, Clarissa was there until the fourteenth. I had brought a lot of Cecil's papers with me to work on during my stay.

Alvediston, Friday, 1 August 1980

Clarissa opened the door and showed me round. I have a very comfortable room and a lovely view over the garden. I hadn't realised the garden was as beautiful or as grand. I saw the kitchen and the library where I will work. Later I settled to read and sort the family letters. These I find the least interesting on the whole. I think I got them in quite good order. Today I will actually read them.

I have often wondered how Clarissa spends her time. She listens to fine music and reads a lot. At dinner I saw the *Spectator* in which Ali Forbes has blown the story that Caroline Blackwood is at work on what he called 'a Windsor–Blum-side' book on the macabre drama. He is awful . . .

Later we watched *Starsky and Hutch* for light relief.

Alvediston, Saturday, 2 August 1980

I got up rather slowly . . . Just a moment ago the gardener came in. 'Good morning, sir. Her ladyship asked me to ask you if you like globe artichokes.' Clarissa is spending the day in the fruit garden picking . . .

Clarissa was in the winter garden when I came in. She is not going on holiday but will be away from time to time. We are having Anthony Hobson* for dinner one evening, and Eileen rang me and

* Anthony Hobson (1921–2014), bibliophile, who ran the book department at Sotheby's.

asked me for lunch tomorrow, to which I look forward hugely. Clarissa said, 'I'm thinking of having dinner in about an hour. Shall we have it at the same time? We might try out the dining room.' I was pleased that we were to have the chance to talk as at present we tend to avoid each other in a curious way. This meant that there was more point to me being here. The other thing I must do is to walk the dog, and also find out how to get out on long walks or, better still, bicycle rides.

At dinner Clarissa told me the story of Cecil having tea with the Pembrokes or, rather, Bee Pembroke. He took Garbo there. Society was a 'jungle' to him. And he said, 'You too could have tea with her if only you would make more of an effort to be polite and friendly.' He could not understand, she said, that she'd known Lady P all her life and didn't want to go more out of boredom than anything else. She was always being asked! She said that Garbo was very difficult – always playing a curious game. Sometimes odd flashes of insight emerged. Peter Watson – 'charm' – that affair was mucked up by Robert Heber Percy. Kin she thought little of. June Osborn 'gamine' and Doris Castlerosse* 'jumping off the deep end', also Lilia Ralli.[†] Clarissa thinks Garbo reads every word written about her.

Alvediston, Sunday, 3 August 1980

I went to lunch with Eileen.

Eileen looked well and has Billie Henderson's new picture of Cecil in the drawing room. Otherwise all is the same, and her little bedroom is quite a muddle of papers and so on. We had a good talk and a good lunch. She told me that the two aunts were more natural than Nancy and Baba, who, when they saw their cousins, Tecia and Tess, felt they were slumming it. Mrs Beaton was definitely an anti-enthusiast, 'obstructing' Cecil's career.

* Doris Delavigne, Viscountess Castlerosse (1901–42), one-time lover of Cecil, whose spirited attitude to sex was 'There is no such thing as an impotent man, only an incompetent woman.'
† Lilia Ralli (d. 1977), Greek-born friend of Princess Marina. She worked for Christian Dior.

Eileen said that Cecil was not good at giving love – always as a reflection to himself. That's why Peter was a disaster, Kin too. He gave Kin the little room at the back and a fold-up bed in London. Eileen thought it little wonder he did not stay.

When I came back I had a long talk to Clarissa. She told me that she first met Cecil when at Oxford with James Pope-Hennessy and Gerald Berners. They lunched at the Bear, and he photographed her at the Ashmolean Museum. Later they became friends. She hardly spoke at first. He described her as 'glum': 'I didn't speak in those days unless I knew somebody well.' Later she wrote that she hated the rose and chintz wallpaper in a hotel she was staying in. He replied that perhaps he was getting outdated. What was the new thing? From then on she saw him more. 'He always made it clear if he disapproved of some aspect of one's life.'

Alvediston, Friday, 8 August 1980

The important thing was writing to Stephen Tennant a long letter in the hope that I will see him while I'm down here. I have left my address as c/o Eileen and sent him a photograph of the picture I bought . . .

Clarissa and I coincided our dinners. She told me that she had got Cecil his CBE as also Freddie Ashton.*

Alvediston, Saturday, 9 August 1980

Letters were forwarded to me from London.

There was a charming letter from Diana Vreeland, offering me Cecil's letters to her, and having enjoyed *Gladys*, and it was signed 'Diane', and also another delightful one from 'Michael' Wishart . . .

[To write a letter], I've chosen the winter garden for its scent and its beauty – I don't think I had a clue about the meaning of the word 'beauty' until I saw Reddish House, and this and other things I have seen confirm a wonderful awakening that has been taking place within me.

* Sir Frederick Ashton (1904-88), distinguished ballet dancer and choreographer.

Alvediston, Thursday, 14 August 1980

Clarissa had been in London. I was due to leave soon for France and she for Italy. She returned and I said, as a joke,

'What a pity that our paths don't cross on this holiday.'
'Well, perhaps they do . . .'
Before I had spoken, she had worked out that it was possible for me to meet her in Siena. And presently she had telephoned Lord Lambton,* so I am to stay with him for a few days.

Later I recorded:

Eileen said: 'Heavens! That should be *more* sinister than Tangier. I mean doors open in the night, Tony lives on heroin.' Claire† adores him, and though she goes round to Laura to weep about his infidelities, 'if you say anything she defends him to the death'. Then there was Cecil's diary, which said something like 'The papers say that Bindie‡ will stick by him (this after the vice scandal). Of course she will. Who wouldn't after fifteen years of infidelity on both sides?'

Alvediston, Friday, 15 August 1980

Christine [the maid] knocks. Lady Avon had been in a good mood and said of the dogs, 'Look after my little honeypots for me.'
Eileen came to lunch and sat beforehand in the winter garden. I cooked most of the lunch – the liver a bit overdone but tasty.
Clarissa said yesterday that when she took Cecil to Ashkenazy he knew nothing about music but leant forward intently to watch every expression on the pianist's face. 'If he'd been well enough, he'd have

* Antony (Tony),Viscount Lambton (1922–2006), minister who resigned in 1973 over a sex scandal; thereafter he spent most of his time at Villa Cetinale, near Siena.
† Claire Ward (1936–2019), ex-wife of the Hon. Peter Ward, mistress of Viscount Lambton.
‡ 'Bindie' Lambton (1921–2003), Viscountess Lambton, the estranged wife of Viscount Lambton.

gone home and written about it,' she said. Eileen told us another expression of Cecil's: 'I could have hit him.'

Alvediston and London, Saturday, 16 August 1980

Eileen rang with a letter from Stephen Tennant. I would collect it on the way. I was sad at the thought of leaving . . . I called on Eileen. Stephen's letter was wonderful. He said that he used to know Gladys years ago and that he liked her – 'the wonderful Duchess'. Eileen thinks he will take the chance to have a real go at Cecil. He enclosed a drawing of roses for me. Of course it was significant that he waited until he thought I'd gone before sending his letter.

London, Sunday, 17 August 1980

Laura . . . had been rather surprised that I was going to the Lambtons with Clarissa. 'Have you grown fond of her?' she asked nervously.

On Monday, 18 August I drove to Dover, where there was some worry about strikes and delays, but arrived in Flayosc, beyond Draguignan on Wednesday, the twentieth. I stayed for several happy days with Lucinda [Airy] and her family.

I left on the evening of Tuesday, 26 August, driving past Nice, Monte Carlo and Menton and into Italy. I was past Genoa before I slept – between 3.30 a.m. and about 8 a.m. On the Wednesday, I drove past Florence and reached Siena.

Siena and Cetinale, Wednesday, 27 August 1980

I drove on towards and round Florence and past glorious Tuscan countryside, and by eleven or so I had reached Siena, located the Park Hotel and was sitting in the mellow magnificence of the hotel lounge. I nearly dropped off several times and I tried to read. There was no Clarissa and I wondered if the plans would fail.

I think it was about eleven thirty that she came in, saying, 'I can't believe this is true' – it was indeed rather remarkable that we were able to meet at an unknown spot and a fortnight or so after the plans were made.

Well, there I was at the Park Hotel. 'The others are outside,' said

Clarissa. So I did meet the Salisburys* – he is like Valentine [his son] to look at, large and grey, dressed as only an English peer could when abroad, scruffy and giving the impression of just a tie removed. Lady Salisbury, on the other hand, could have been at a country wedding, hat and low décolleté lace blouse under dress, kind eyes and a faded beauty. Evidently she is extremely tough but I didn't see it at all.

Clarissa said later that they were her oldest friends but she couldn't have stood another day of them. Mollie S moves very slowly looking in windows, difficult to hurry. He has such a bad leg that he can hardly walk. I rather liked them but wondered what they thought of me and my role.

Later Clarissa and I drove to the Villa Cetinale to stay with the Lambtons. I have to confess I had no idea it was to be such a house. I was expecting a low villa with a swimming-pool, not a mini Caprarola. The villa is famous in Italy, huge and splendid, set in the hills near Sovicille. The gardens spread out before and behind, and an avenue leads up to a wooded hill with a hermitage set high on the skyline. The view from it and of it is wonderful.

Claire Ward, whom I have not seen (and I mean 'seen') since Egerton Terrace days, appeared briefly, then disappeared as she was resting with flu. Tony Lambton met us and supervised our unloading. He showed me to the room where I am now writing and said, 'You'll find it's haunted, I'm afraid. Ghosts in the night. I hope you don't mind.' For several days after this he said, 'Any trouble with the ghost?' and once, 'Some people dream of clerics and one person had the sensation of someone walking round the bed.' It's all to scare me so that the imagination becomes susceptible to the idea of the ghost. The room is wonderful with a huge four-poster bed in the middle and a large picture opposite. A cast of a priest looks down from on top of a wardrobe. I love it.

I slept ages and then emerged at eight o'clock to find great crowds of people gathering for dinner. Lord and Lady Wilton, who have been staying for three weeks, Lulu (or Lucinda) Guinness,† a young girl evidently helping Tony with some typing, and later the O'Neills,

* Robert, 6th Marquess of Salisbury (1916-2003), and his wife Marjorie ('Mollie') Wyndham-Quin (1922-2016).
† Lucinda Guinness (b. 1959), daughter of Peter Guinness, managing director of Guinness Mahon & Co.

whom I've met – Raymond (whom Princess Alexandra wanted to marry) and Gina (who took a photograph of me at the Morrison wedding) also Fionn, Ann Fleming's daughter.*

Some of us talked all about Mountbatten, and Fionn asked me to lunch as she had Philip Ziegler. Diana Wilton said that Patrick Plunket used to say that he was always pushing himself forward at state occasions at the Palace. Tony Lambton didn't care for him and said, 'Edwina had an affair with Nehru. Some say this ended as she also had one with Jinnah.† He is immensely funny and entertaining.

Lord Lambton and me, August 1980

Cetinale, Thursday, 28 August 1980

I rather overslept and was not at breakfast until nine forty-five. The Wiltons, Lulu and Tony were gathered there. I was to lunch at Fionn's. Tony Lambton walked me down the hill and I found my way through a most unlikely path to their house.

* Ann Fleming (1913–81) Laura's sister. She had been married to Lord O'Neill, and had a son, Raymond, 4th Lord O'Neill (b. 1933), and daughter Fionn (b. 1936). She married Ian Fleming in 1952.

† Countess Mountbatten of Burma (1901–60); Jawaharlal Nehru (1889–1964), first Prime Minister of India after Independence; and Muhammad Ala Jinnah (1876–1948), founder of Pakistan.

Later we went to another part of Tuscany to drinks with Evangeline Bruce and Marietta Tree.* Mrs Bruce was fast asleep when we arrived – I reckon – but did her best. She has had 'Diana (the Coop)' to stay, and said, 'She was wonderful. She longed to have visitors day and night in her room and kept up a flow of conversation.' Later Tony said, 'I can't imagine anything worse than Diana showing off for a week.' Marietta Tree has a friend called Cyrus, an enormous thug of a Persian, who is in fact a great bibliophile, and has 80–85 folios of Shakespeare. He got four-fifths of his library out of Iran. He looks as though he's come to make a barrel but instead he sits down, courteous and gentle, a most unlikely figure – of course, with those two he didn't, couldn't speak, but he would have had much to say.

Marietta Tree, widow of Ronnie Tree, is a large and powerful American – she was with Adlai Stevenson when he collapsed and died. She's a director of CBS and Pan Am, and travels the world free. She talks the same way as Evangeline Bruce but is much less natural – she's contrived.

On the way out, Marietta Tree said, 'Oh dear! All of a sudden the *fall* has come,' and looked disconsolately at one red-brown leaf. There were many jokes on the way back. Marietta: 'That church. Oh! I think it's so charming – oh! No, I don't think I'm with you yet, but it is *so* charming.' They were having rather a grim time in my view.

Cetinale, Friday, 29 August 1980

At lunch they got me talking about Cecil and June Capel. I quoted: 'In her letter to him saying she wouldn't marry him she said that the queer side of him that she liked as a friend she'd find rather tiresome in a husband.' And then I quoted Diana: 'When in bed with Cecil she used to say he never knew whether he wanted her to be a man or a woman.'†

Tony Lambton commented, 'That can only mean one thing, can't it, really?' I'm afraid so.

* Evangeline Bruce (1914-95), widow of David K.E, Bruce, US ambassador to Britain; Marietta Tree (1917-91), widow of Ronald Tree (1897-1976), one time American-born MP, who owned Ditchley Park in Oxfordshire.
† My understanding is that they never did have a physical affair.

Of Cecil Tony told two stories. One concerned Grant.

'What is your man's name?'

'I really don't know.'

'But he's been with you for five and a half years.'

'Oh! I think he's called Gordon.' Grant corrected Tony when addressed as such. Also he said that when his aunt Violet Ellesmere chucked Nancy Smiley out,* years later in the war Tony was due to dine with Cecil but couldn't. He said, 'It's because your aunt once chucked my sister out of a party.' So it stuck with him.

Dinner was very funny too, and in the evening in bed I couldn't read. I just laughed and laughed as I lay there.

Cetinale, Saturday, 30 August 1980

We went to see a count who showed us his palominos, and they virtually stampeded. When Tony, in his shorts, stroked a dog and it licked his legs, I told him the count had used the word 'Rabido – I don't know what it means.' He almost leapt into the air. I said, 'Haunted room.'

A sort of joke has risen up, which is that I have an encyclopaedic knowledge of certain things. They all think I know much more than I do. As a joke they think I'm blackmailing Clarissa over her letters to Cecil, that I've become the custodian of all Laura's secrets and so on. It's really very funny. Clarissa thinks I don't miss a thing.

Cetinale (Siena) to Bologna, Monday, 1 September 1980

Today was departure day, which was sad. Tony had to go to the dentist. He said, 'Do come and see us again,' and after going downstairs he returned to say, 'We did enjoy having you,'

So just after 9 a.m. off we went. Clarissa said she always has a sinking feeling that she has said too much and that in one form or another it will be repeated. She says Tony is very kind and there are incidences of kindness that are not generally known. She said later that after he

* This was the major society scandal in which the Countess of Ellesmere threw some gate-crashers out of her ball at Bridgewater House in the summer of 1928. What made it all worse was that he talked to the press about it.

was young he had romances with beautiful women like Debo Devonshire but later he descended to people like [—] who looks awful. Clarissa said that if she was Claire she'd be miserable at his behaviour. 'And now she knows he's going off to Paris to some unspeakable orgy.' Yet Clarissa is very fond of Tony. She said I was the first person whom she had seen 'rattle' him a bit – he felt uneasy – all those remarks like '"He is the most sinister character." He doesn't forget a single thing you say. It's all filed away in recesses of his mind.'

Italy, Monday, 1 September 1980

I drove Clarissa to Florence and on to Bologna, Munich, visited Dachau, and stopped for the night at Lampartheim, beyond Strasbourg.

Lampartheim, Alsace, Wednesday, 3 September 1980

Clarissa told me that she had been very worried about Cecil's finances. 'Every time he made something, he made a new runway in the garden. The house was charming at one time, but he overdid it. *My Fair Lady* was a disaster' – same reason . . .

Mark Boxer* she doesn't wildly like. He is a mocker, as many are – especially that age group. He came over recently [to a Weidenfeld dinner]. After ten minutes she said, looking at her watch, 'Well, you've done your stint now.' He went off looking bemused. But he'll have made mischief out of it.

We drove on and stayed at Montreuil, crossing to Dover on Friday, 5 September, then driving all the way back to Alvediston. On Saturday, 6 September I returned to London.

London, Saturday, 13 September 1980

In between these exotic travels, I explored Cecil's early life. A good source on Cambridge was Stewart Perowne (1901–89), who invited me to lunch in the little house in Arminger Road he shared with his brother, Leslie. Stewart had

* Mark Boxer (1931–88), the cartoonist, who worked for some time at Weidenfeld.

been a diplomat, archaeologist and historian. He had even designed stamps for certain overseas territories. Despite being homosexual, he had married Freya Stark, which prompted an exchange at a lunch party I attended, at which Harold Acton mused, 'When they married she hoped to be taken out into the desert and ravished. Oh dear. She ordered a double bed, a double bath, double lavatory . . .'

Diana Cooper said: 'And I could have told her all she was getting was an old bugger!' adding, 'Now he lives in open sin with his brother.'

'Really open sin?' I asked.

'No.'

Somewhat later Nigel Ryan told me he was nicknamed 'the red rose cissy, half as old as time'.*

Stewart Perowne looks like a retired heavyweight fighter but is in fact very gentle and scholarly. His brother has a brash manner and uses unnecessary obscenity – 'A copy, please, for the al-*bum*', etc. They both worship Diana. Stewart Perowne said Cecil was very shy when he first came to Cambridge and should have been at Magdalen not at John's. Then he established a niche for himself as an actor and designer. He was immensely funny apparently. They met later at Bagdad during the war where he was to photograph Lady Cornwallis. 'What am I to do, Stewart?' he asked. 'I don't want to make Lady Cornwallis look a hag.' Then, too, they met afterwards and latterly were in touch. Both brothers spoke of Steven Runciman, who is very funny about royals evidently. He quotes Queen Alexandra[†] when a friend died: '*I vill send a wreath and I vill write a po-em.*' At the funeral he used to stand, head bowed, at the graveside until he had committed Queen Alexandra's poem to memory.

London, Tuesday, 16 September 1980

June Churchill, ex-wife of Randolph, had been suffering from incurable cancer, and had died by 'Exit', at her home in Cornwall Gardens on 17/18 June [1980]. This time Diana had her way and the memorial service took place at

[*] Nigel Ryan (1929-2014), editor and chief executive, ITN 1971-77, known as Diana's 'Last Attachment.'

[†] Queen Alexandra (1844-1925), widow of Edward VII.

her favourite church in Little Venice, which produced a number of sources on Cecil. I went to it with Laura. Peter Coats came in, prompting Laura to exclaim, 'Oh, God, there's Petty-coats – he'd go to anything.' I hadn't seen Diana since July. She came to sit beside me. Afterwards there was a reception at Diana's house in Warwick Avenue.*

A genial old boy wandered over and offered to swap names. He eventually confessed to be Adrian Daintrey,† the painter. He used to go to Ashcombe to stay with Cecil and, of course, he used to know Gladys. He remembered that she hated her husband. He also said that Michael Tree‡ thought Cecil's malice was the great thing about him.

Diana told me that she had had a funny letter from Enid. She said Enid had just been moved to London (the day before) – she showed me the letter . . . She had heard from Stewart Perowne: 'Well, you've had lunch with Mr Stewart Perowne. And he's fallen in love with you. You went to the house? And met the brother too?' (This last bit amused her most of all.)

Then I got hold of Patrick Procktor. He reminded me that Cecil had spoken on *Desert Island Discs* and asked as a luxury a very warm cashmere poncho. This he left to Patrick but too late for him to wear in China. Patrick Procktor says that Michael Duff§ was much funnier than David Herbert and any stories [Herbert] may have had would have been second-hand from [Duff]. I asked him about Stephen Tennant. He said that one has to keep knocking at the door. 'I just appear,' he added. He said that when Stephen's sister [Clare Beck] died he turned the funeral cortège away; the gates were locked and he stood laughing at the window like an ogre. Patrick Procktor was

* Peter Coats (1910-90) ran Viceroy's House in India for the viceroy, Lord Wavell, in the Second World War; he was a gardening expert, and social man, the boyfriend of 'Chips' Channon.

† Adrian Daintrey (1902-88), eccentric painter who sometimes stayed the weekend, sketched his hostess's house from the garden and then sold the drawing to her, before returning to London. He was fond of – and befriended – a number of ladies of the night.

‡ Michael Tree (1921-99), lived at Donhead, married Lady Anne Cavendish (1927-2010).

§ Sir Michael Duff Bt (1907-80), of Vaynol, an old friend of Cecil.

either doing a brilliant impersonation or he was laughing at his own story. I'm sure he has great depths but there is a sinister quality too. Michael Wishart was also at this party – very charming – and so was Hardy Amies. He complimented Laura. He had to – she was wearing one of his creations. No sign of June in the air – alas, alas, it was a party, fun, sparkling, funny, but no June.

The next day I called Diana and said: 'I shouldn't say so but I really enjoyed it yesterday.'

She said: 'Yes, I know. Cynthia Gladwyn, who invited herself, rang up and said, "Wasn't it fun?" which hardly seemed appropriate.' She had Stewart Perowne coming to see her the next day. 'He'll want to talk about you, I imagine.'*

London, Thursday, 18 September 1980

For a long time I had been trying to penetrate Wilsford Manor to see Stephen Tennant (1906–87). I had had nightmares that he might die before I saw him. Today proved to be a momentous one.

In the middle of the morning the telephone rang and a Wiltshire voice said 'The Honourable Stephen Tennant would like to speak to you. Can you hang on?' I waited, and he came to the telephone and spoke. He sounded like an actor with a rich, fruity voice, deep, intellectual. He began by talking about Gladys and asking how much social life I needed. He spoke of Willa Cather as a novelist he especially liked. He felt the same way about her as I did about Gladys. 'Some people,' he said, 'to do good writing, had to have no visitors at all for at least a month.' He told me of his love for Marseille and seaports in general. 'They are partly sinister, partly displeasing. Marseille had a rich, drowsy languor,' and of Mexico, he mentioned 'avenues of tuberoses'. 'All our roses grow in Mexico.' He said that the best roses grow in the north of England. 'The roses are very poor in the south.' He continued, 'I adore a black velvet rose.'

* Cynthia Noble (1898-1990), wife of Lord Gladwyn, former British Ambassador to Paris.

Stephen Tennant in his garden in the 1960s

Suddenly he broke off to say. 'I don't like the telephone. It's in a cold part of the house. I just want to go and get a wrap to put round me.' There then followed a delay of three or four minutes. Of Cecil Beaton he said, 'He's too complex. There are so many contradictions, though each may be right.' He suggested I should visit him, leaving London in my 'motor' at about nine thirty, passing through Virginia Water and Bagshot, and lunching at the Cricketer's Inn. I could be with him at four. The plan was for Saturday. He recommended two Willa Cather books, *A Lost Lady* and *The Professor's House*.

He spoke of his introduction to Willa Cather's *On Writing* – '*On Writing, with a foreword by Stephen Tennant.*' He said all his friends were writers, brilliant men. Someone thought Willa Cather 'just a copy of Turgenev, like a dull Jane Austen'. 'She plays down her material,' he said. 'Most writers do the opposite, trying to engage your attention. Most writers are addled with conceit and don't take their work seriously enough, unlike the French and Germans, though we have compensating qualities they haven't got.' Willa Cather had 'Gentian blue eyes, famous Irish red hair with dark eyelashes so that she looked made up, though she never had. She looked as made up as an actress. She had a liking for good manners and sophistication – thought a lot of questions in bad taste.' A curious thing she said to him: 'I hope you are not superior to the pleasure of taste.' She didn't like jewels. Her first novel was *Alexander's Bridge*, when she was twenty-six. He ended

by talking of the world in general, and mentioned recent bombings. He said, 'We're all in this together.' He thinks we are lazy-minded these days.

I was fascinated by the conversation and the chance that I might see him on Saturday. This raises my book into a new realm . . .

Caroline Lowell* came for a lunch . . . We talked generally and she was most interesting about Stephen Tennant, whom she used to see twenty years ago. She said he wore the most extraordinary clothes and had gold dust in his hair. He would place leaves in the house and you never knew whether to walk through them or round them. He was always saying, 'We'll have a bottle of champagne,' but it never appeared. She said that Cecil got all his ideas from Stephen. Stephen was the first person to put lights behind curtains, and to hang fishnets over the banisters. Now 'gay' bars like the Poulbot and the Matelot all have them. It originated with him. This all sounds most intriguing. She reckons that Cecil stole the ideas as he was out and about, and Stephen wasn't . . .

Of the Baron [Lord Weidenfeld], Caroline said that in moments of sexual frenzy, his eyes pop right out on stalks and he has to spoon them in with olive oil. I must say she has a taste for the macabre . . .

London and Wiltshire, Saturday, 20 September 1980

I rang Stephen Tennant's housekeeper and she said that he was expecting me. I was to arrive at four o'clock and drive into the yard. 'Don't drive on to the left or you'll end up in Lady Sykes's drive,' she said, with humour.

I drove into the courtyard and the man, who is John [Skull],† came out. 'Mr Vickers? Would you go round to the front door, please?' I did, walking on a mossy untrampled path to a huge oaken door. A bolt was drawn back, a chain clanked, but *no!* The door did not

* Lady Caroline Lowell (1931–96), born as Caroline Blackwood, under which name she wrote dark novels. She was married to Lucian Freud, Israel Citkowitz, and the poet Robert Lowell.
† John Owen Skull (1927–2010). He worked for Stephen for sixteen years. After the death of his wife, Mary, in 1983, he left Stephen's employ. He moved to Ordnance Hill, in St John's Wood, London, and remarried in 1985.

actually creak on its hinge. Apart from the faded, musty air, I could not take in the hall – no time – but through I went, following John, to the staircase and up. 'Mr Tennant is on the landing,' he said. We passed the first of the draped pieces of material, crossed numerous rugs, animal skins, etc., and turning the corner, there he was, the lone occupant of Wilsford Manor for over fifty years.

Stephen Tennant. How to describe him? I was disappointed. He was not as eccentric as I'd hoped. I wanted a figure with wisps of orange hair, a Father Christmas beard, bright rouge and false eyelashes, dressed, I suppose, in a kaftan or monk's robe – I got the wisps of henna-dyed hair, the back of the head bald, some hair hanging down the shoulders, some piled up on the brow. Then there was a big face with a strong nose and puffiness round the jowl – thick glasses with a round eyepiece in each prevented me from seeing the eyes. He wore a soft, whitish shirt, an ill-tied yellow tie, a blue jacket and grey trousers. He had a paunch, but did not appear unduly fat, and on his feet, he wore shoes tied with ribbons, like a ballerina. He looked younger than his seventy-four years due to a powdered face.

Stephen Tennant

His fingers were small and feminine and tapered. A huge turquoise ring was on the 'wrong' finger on the left hand (wrong, I say, for men who wear signets). And, of course, *awful* scent! But the overall impression, though odd, was not from another world. He could have been

an old actress, or a schoolmaster gone to seed; one has seen such figures before. If you saw him in the street, you'd say, 'Good God,' but the image would pass. Cecil B said 'a mad tramp'. Perhaps. I have a feeling that he wanted to look as normal as possible on this my first visit.

Little noises of greeting and delight emerged from him and he shook me by the hand. Cushions were brought for his 'guest to loll into' and in due season came a delicious tea – fine china, freshly homemade sandwiches, which melted in the mouth. He urged me to eat them to please Mary, John's wife. He praised them both highly: 'We've had some adventures in the last ten years and she's never lost her temper.'

He talked of *Gladys* and my prose. He liked it – his criticism was that it was too serious and needed a bit of frivolity here and there. Well, he could be right. He remembered his visit to Gladys and her mauve hat – he wished his mother could talk to me about her. She knew her well. We spoke a bit about Cecil Beaton, but not enough. He remembered his visit and what he wrote. He said he didn't think Cecil could have been happy – he tried to achieve so much – but he loved Eileen. He said that Cecil said to him once, 'She's so marvellous, but she shouldn't be with me. She should have a nice husband, children and dogs.'

He told me about Willa Cather, about his visits to the Sitwells with Siegfried Sassoon, how they missed *Façades* by some days, how Christabel Aberconway came into his room and told him what had happened – she with hair plaited in two tails – how the Sitwells said to him that there were scorpions in the passage, how he replied, 'You do offer kind hospitality.' He related the tale of the Brontë sisters and their visit to London to reveal that the authors of the poetry were women not men. Such things he told me. He also said that my eyes were tired and that I should not read at night for two months. How can I fulfil this?

Now and again he recited a poem. Now and again he sent me on a mission – to see the room with the zebra rug, to see his mother's room, and then the drawing room. These rooms looked untouched – he'd removed the oak panelling and Rex Whistler had been at work, but otherwise nothing. The beds were unmade – I feel sure his mother's clothes were still in the house. The drawing room had the

lighting behind the curtains, and the curtains, heavy, bright red velvet, were often swept up and placed on the window seat with a shell on top. Then there was the expedition to his bathroom. There was a small path, many mirrors, painted panels and again shells placed – one here, three there. His bedroom, into which I peeped, was the most squalid room I've ever seen. A bed had been crawled out of. On it were letters, drawings, scribblings, jars of cream, beads, shells, screwed-up bits of tissue, old press photographs, that kind of thing. It was extraordinary. I am not conscious of seeing any pictures on the walls, though there was much to make it look like a stage-set (the whole house) and there were indoor plants and outside there were palms. I wonder where the dining room was.

He was at his worst when he said things like 'I used to be beautiful like you. I'm a bit overweight, but I'm still rather beautiful, aren't I?' And 'Some people say I'm a genius.' And when I wandered off on one of my tours, he said, wheezing to himself, 'Oh! Such a beautiful boy!' Huh! He loaned me two Willa Cathers and he exhausted me by three and a half hours of solid talk.

Later

David Herbert doesn't use his brain enough – at all – though he has a good one. When he painted the bathroom at the School House [at Wilton] black, he said to Stephen, 'Don't tell my mother.' As Stephen said, 'It was rather silly. All she had to do was to walk round and look in through the window.'

He likes sailors – and he loves Bournemouth and Southsea – and he likes weekdays when people are working in the factories. He thinks we are 'lazy-minded'.

Stephen also said that Cecil's mother tried to prevent him from becoming a photographer: 'It was very difficult. If he had not been a strong and determined character, he might have given in. It was an awful thing to have done.'

I went to stay with my aunt at East Chisenbury, only a few miles away from Wilsford. The next day I visited Lady Harvey at the Priory.

East Chisenbury, Sunday, 21 September 1980

Estelle Harvey knew Stephen when he was young and showed me a picture of him 'looking like Shelley'. She didn't like Cecil Beaton. 'He was a *poseur* on the make.' He didn't bother with her as she wasn't of use to him. She kept saying to me, 'I don't want to say anything nasty about him – it's all so long ago.' But she gave the wonderful impression of herself clinging to Rosemary Olivier and saying, 'Oh! Isn't he *beastly*?' rather softly and quietly.

London, Tuesday, 23 September 1980

Another letter from Stephen T – this time in violet . . .

The great excitement was drinks with Diana. Wanda prepared a vodka Campari for Diana and I helped myself to a gin and bitter lemon. Diana was in bed in pale yellow with two little 'doggies' disporting themselves and engaging in what Diana called 'lesbianic activities' – though I'm sure one was a male dog so that seemed to make it all right. We had a long conversation only occasionally interrupted by the telephone and at one point by the appearance of Kitty Farrell,* the niece, who was much more imposing than I'd pictured her. She left the room when Diana started on a story about a Dalmatian, 'which as they say "had" a Chihuahua in the park the other day'.

Then we went through all the stories – Stewart Perowne, whose brief marriage to Freya Stark was a fiasco. They never met again after they parted. He kept saying, 'Freya won't see me,' and she said, 'Stewart won't see me.'

On departing I got two warm kisses and she held my face like you hold a child's. She really is an extraordinary and fascinating person. Her beauty astonishes even now, and when her gown slips on her right shoulder her skin is soft as chiffon. And her brain takes in so many varied things. She'll talk for hours on any subject, from dogs to sculpture, people to poetry, really anything. She enjoyed my description of my visit to Stephen.

* Lady Katherine Farrell (1922–2017), daughter of the 6th Marquess of Anglesey and his wife, Lady Marjorie Manners.

London, Friday, 26 September 1980

Eileen telephoned, back from her holiday in Cumberland. She was fascinated to hear that I'd seen Stephen. 'Did he talk about Willa Cather?'

'He talked about nothing else.'

During the next days letters flowed in from Stephen Tennant. One day he sent a poster. And he telephoned to ask me down again. He spoke of A. E. Housman's poems: 'There is no superfluity in them,' he said. 'A grief as big as his becomes a victory.' He particularly wanted me to visit 'while the gold-dusted footsteps of Autumn were hovering'. I drove down, arriving just after 3 p.m.

London and Wilsford, Saturday, 4 October 1980

John greeted me warmly and led me through the cushion-strewn hall and upstairs. Stephen was again on the landing, but standing. He moves, like Gladys did, with support. Evidently there's nothing wrong with him except that he takes no exercise. His hair was up, but the wisp later fell over the left ear. He had not done up his buttons this time, so his trousers were undone and he clasped a handkerchief, to which, from time to time, he applied lavender water from a bottle. He wore two shirts, one on top of another. He looked much scruffier than last week and had the same – or another – yellow tie ill-tied round the neck. His shoes were furry carpet slippers, again tied on like a ballet dancer's.

Royalty, he said, are 'splendid symbols. The Queen Mother still inspects prize pigs today.' He once stayed at Glamis when he was nine and remembered 'rotting tapestries' and 'hideous Danish furniture'. His room had 'spinachy green and sour yellow tapestries' hanging in it. Lady Strathmore told him that one wing of the house was never used, yet as they came down to dinner one evening, they saw a foot-man cross the hall, go under the rope and up the staircase and he was bearing 'an enormous tray of steaming food'. This was presumably for the monster, either 'a huge sheepdog' or 'half man, half baboon'. The Queen Mother would never refer to it. In early days Christopher Glenconner had wanted to marry her – he was one of six

disappointed suitors. Stephen used to watch her in London at parties and found her 'afraid of meeting the wrong people'. He concluded that she was 'snobbish but not conceited'.

He said that Violet Bonham Carter, on hearing him say she was a genius, replied, 'Is there anything so heavenly as undeserved praise?' He referred to the South of France as 'that ambush of the South'. How true! How I felt it in the summer.

He said that Cecil was thrown in the Nadder because he was wearing built-up eyelashes – too much for 'a hunt ball in Wiltshire'. In fact it was Lord Herbert's coming of age.

E. M. Forster said of the cinema, 'It's not life, it's not art, what is it?'

He said that Cecil's home life was not unhappy but that he had an inadequate mother. He said there was a strong vein of sensitivity in him. He was once in a yacht in the Mediterranean, hoping to be put up by Mona Bismarck.* She hated his hostess and said, ' "Darling Cecil, of course I would love to have you, but I'm afraid . . ." Mona B had eight fishermen's cottages – Cecil counted on an invitation.' Cecil described Mona Bismarck as having 'aquamarine eyes', as 'a rock crystal goddess'. Mrs Belloc Lowndes† evidently hated him. I wonder why.

Cyril Connolly said: 'There are people who like a social atmosphere around them, but who never like an individual for his individuality.' Stephen quoted Shelley: 'Virtue how frail it is. Friendship how rare.'

Rex Whistler used to say of Cecil at the fancy dress balls, 'Do you notice how Cecil always pretends he's taken no trouble? Then, dressed as a white peacock, he eclipses everyone.' Stephen said, 'The world's ways were in a way his.' Sarah Churchill annoyed him by writing: 'Cecil Beaton is before anything else a businessman.'

Stephen said that the pictures with gimmicks such as silver balls created a sensation at the time.

About 1926, Stephen wrote an article for *Vogue* about the cinema. Rex said, 'The reason why you praise Cecil Beaton so highly is

* Mona Bismarck (1897–1983), formerly Mrs Harrison Williams, married Count Bismarck in later life, and lived in Paris and on Capri.
† Marie Belloc Lowndes (1868–1947), novelist.

because it annoys everybody so much.' He 'alienated conservative London – one night he was a toreador in a Spanish tie – another night he was French . . .'

Cecil used to tell Stephen that the three *Vogue*s hated each other (London, Paris and New York). 'They were forever rending each other like panthers.'

If Cecil photographed the Duchess of Buccleuch or Lady St Just and they liked him and asked him to lunch, he always stayed.

This time I was able to speak much more easily to Stephen. It was a conversation, not a monologue. A delicious tea arrived and then we listened to *Oklahoma!*. We sat in quiet listening. When we reached the song, 'Poor John', Stephen put tissues in his ears, so that he couldn't hear it. 'The Pembrokes are always very much amused when I do this,' he said.

We looked at a lot of his pictures. His early ones are by far the best. He must have been a superb draughtsman. He wanted me to take masses of pictures. In the end I accepted one. And he wants me to help arrange an exhibition for him. (Later John advised me not to get involved in that.)

The pictures are quite extraordinary. So is the house – now that I have seen more of it. He said Greta Garbo loved the turquoise-blue blind in the corner of the room. He said Cecil was a very difficult man, that Michael Wishart rang him at 11.30 p.m. the first time they ever met, which he thought an uncivilised hour, that he found Simon Blow* rather dull. In other words we began to get a lot of vitriol this time.

London and Alvediston, Friday, 10 October 1980

Michael Wishart rang me. He said Stephen was 'a marshmallow in iron'. He said that Diana 'absolutely adores' me, that he's pleased I take her to things . . .

Late in the day I drove to Wiltshire to stay with Clarissa.

* Simon Blow (b. 1943), Stephen's great-nephew.

Wiltshire, Saturday, 11 October 1980

Clarissa read her letters [to Cecil], was amused by some, didn't mind about the political things, only thought she had been unwise to write about her private life. It was also very funny that she had written so much from Chequers [staying with her uncle, Winston Churchill] in the war, which had gone straight into the hands of the censor . . .

I went to see Stephen Tennant in the afternoon.

He told me about Georgia Sitwell.* 'She wanted to be the wife of a writer. She was un-maternal. Her children hate her.' . . . I met Mary, John's wife.† She was a round Wiltshire lady with hair the same colour as Stephen's, and a grey woolly.

The next day Clarissa and I collected V. S. Naipaul, who lived in the cottage at Wilsford, with his first wife, and drove them to lunch with Anthony Powell and his wife, Lady Violet.‡

V. S. Naipaul

* Georgia Doble (1905–80), Canadian, married Sir Sacheverell Sitwell.
† Mary Skull (1925–83), née Pennels.
‡ Anthony Powell (1905–2000) and his wife Lady Violet Pakenham (1912–2002).

Wiltshire, Sunday, 12 October 1980

I asked Clarissa what I should wear. 'I think you should wear everything you possess as it's the coldest house in England.'

The Naipauls were friendly, he West Indian with a firm, clear voice, amiable, willing to make small-talk, but of course I was intimidated by what I'd heard of brain power, the narrowly missed Nobel Prize, etc., so I kept rather quiet ... V. S. Naipaul has never met Stephen Tennant, though he has seen him and waved at him once, but he knows John and Mary Skull. He speaks of Stephen's *madness*, his illness. He says that he believes the servants don't answer the bell when he is alone. He said, 'You know, he has designed hundreds of book covers for a book he will never write.' *Lascar*, the greatest unwritten novel of the twentieth century.

We drove to Frome, and to the Chantry.

Lady Violet Powell, who reviewed my book so kindly, is a jolly-looking person. She told me that she had enjoyed the book particularly as she used to know of Gladys, having lived in the area. To look at her, you would never know she was Longford's sister or in any way a lady of distinction. She made no efforts of any sort to look other than a countrywoman. But that's by the by. She was very sweet to me. 'The great novelist', as Hugh Massingberd calls him, also said he enjoyed *Gladys, Duchess*. Otherwise I did not have a lot of conversation with him unfortunately.

Lady Violet told me that Cecil's father was an insignificant man, whose only joy was to ride in the park early in the morning. Baba* was difficult and at the time of Nancy's wedding to Hugh,† nobody quite knew if she was to be married to Alec Hambro or not. ('He'd been sent to dig a hole somewhere to prove himself.') Hugh Smiley nearly married Bridget Poulett‡ apparently. She said of the 'Bridgewater House' incident,§ Elizabeth Belloc Lowndes was involved, but never mentioned. She (Lady V) was a particular friend of Baba's for a while.

* Baba Beaton (1912–73), Cecil's younger sister, married Alec Hambro (1910–43).
† Nancy Beaton, the elder of the Beaton sisters, who married Sir Hugh Smiley Bt in 1933.
‡ Lady Bridget Poulett (1912–75), society beauty, and one of Nancy's bridesmaids.
§ When the Countess of Ellesmere threw some gate-crashers out of her ball.

I did think it was a good idea to have such a long dining-room table. It meant that husband and wife could both talk about their own things, undisturbed by each other. Recipe for a happy marriage.

Clarissa and I went to dinner with Michael and Anne Tree. They were in kaftans – which suited them. Michael Tree said he thought Cecil was essentially 'a man of fashion'. He made the best of his talents, they said in unison. 'He was the best of friends to us. We miss him dreadfully.' She said the later diaries never hit it on the head. They just said: 'Dinner with the Trees. Pity Anne has got so fat.'

After dinner Michael Tree showed me the famous series of Anne Rosse caricatures.* They are wonderful and full of venom. From early *Tatler* ones of her with baby Tony to the later ones of the wedding – one mother meets another, Lady R curtsying to the Queen Mother (very rouged) – the process of getting ready for a ball at Windsor and later appearing in gold sequins. Decorating a room – a spoof of flower decorations, of course the most awful things: tulips and gladioli. In one she sees the news that the Queen consents to a divorce between Margaret and Tony . . . And later Lady R is blown to bits [by the IRA] – and there is a wonderful finale with the Cenotaph marked 'TUGGERS' and the Queen laying a pink wreath.

There is cruelty in them and in the series – *Portrait of a Marriage* (Princess Margaret and Tony Snowdon) – yet I wonder if they are as full of hatred as Michael Tree thinks. I go along with Eileen: 'She was such an easy target for Cecil.'

Wiltshire, Rottingdean and London, Monday, 13 October 1980

I spent a hectic morning, copying out Clarissa's letters from Cecil. This took really ages. It was lunchtime before I left. Clarissa has left my bed made up in the hope that I come again . . .

Now that Enid Bagnold was living permanently in London, a sale had been arranged at North End House. I slogged across country to view it, only just

* Cecil purportedly hated the Countess of Rosse (1902-92), sister of Oliver Messel and mother of 1st Earl of Snowdon, and he drew a series of scurrilous caricatures of her, which he sold to Michael Tree before Kin Hoitsma came to live with him.

arriving before the doors closed. The nurse said that Enid had had three heart attacks since our visit in the summer. Later in the week I went to the sale in quest of copies of her books. It was a wet day and freezing cold. I bought two lots of Enid's books for £28 and £18, then a miscellaneous box of 'French' books for £50, so about 400 books for £100. When I got home a copy of the first edition of Proust's Du Côté de Chez Swann, popped out, given to Enid by Antoine Bibesco. 'Holding it at home was like holding an unexploded bomb.' Later Enid signed many of her books for me.

London, Wednesday, 15 October 1980

I took Diana to Hugh Montgomery-Massingberd's launch at the Ritz – his book on the hotel.

I rang Diana. 'I'm having tea with you this afternoon, aren't I?' she said.

Diana appeared dripping in ostrich plumes and black. Picking up Doggie, we set off . . . We arrived and, leaving an 'Infirm Passenger' notice on the windscreen, we parked on a yellow line outside the Ritz, Arlington Street. In we went. Eileen was waiting – Margaret Argyll sitting at a table in the Palm Court, sipping tea. We went into the party, greeted by flashlights and, in due course, by Hugh . . .

Margaret Argyll came over to Diana. 'Diana, dear, and what is its name?' A meeting with Doggie. She was rather sweet, I thought. Also very charming to Hugh. There was only one bad sign. She went over to the waiter, took a book, saying, 'I'm the Duchess of Argyll. I will be in to pay for it tomorrow.' But Hugh likes her and Diana says, 'Isn't she beautiful?' Quite amused by her.

When we arrived we met Alastair Forbes (1918-2005). Geoffrey Wheatcroft described Ali as 'one of the last of a line, a curious product of Anglo-American culture, who became a journalist in London and enjoyed two brief seasons of fame, but who was, in the end, better known as a boulevardier and courtier'.[9] Originally a Bostonian, and a cousin of President Franklin D. Roosevelt, he had been a regular at Chequers during the war. At this time he was reviewing regularly for the Spectator, *writing long and convoluted sentences (Eileen Hose said his writing was 'constipated – he just could not get it out'), inspiring outrage and writs in equal number. He was the repository of an enormous*

amount of gossip about a wide acquaintanceship, royalty, society figures, writ-
ers and Hollywood stars. A noted ladies' man, he was wont to point out that,
thanks to his ministrations, one of the Queen's maids of honour at the 1953
Coronation was not a maid in the accepted sense. I had first met him with
Laura Marlborough in the summer of 1979.

Ali Forbes was there. He made the first allegation: 'Not just house-
sitting, but also the Grand Tour . . .' Then he greeted Diana. 'I call her
the White Cliffs of Dover,' I overheard him say. I also heard part of the
conversation with Margaret Argyll – she went over to him and said,
'You're Alastair Forbes. You dined with me ten years ago.' He flew at
her and said, 'You don't think that just because I dined with you I'm
going to give a good review to your disgraceful memoirs, do you?'* . . .
Later he could be heard saying, 'Of course, I was quite a friend of His
late Grace . . .' (line for a novel – indeed Ali would make a splendid
figure in a book).

I loved the atmosphere – the tables spread with smoked salmon and
cucumber sandwiches, adorned with garlands, the tea of all descrip-
tions. Diana took my arm and we went and sat down and talked to
Eileen . . .

On the way out I seized Ali for Diana. He came over. He asked
about Laura, 'Or have you given her up in favour of Clarissa? Everyone
is talking about it.' Diana nodded. I was horrified. In the end, though,
I said to him, 'I did enjoy your review of Evelyn Waugh'. As it was
not published, this was meant to be a dig – but it set him off for half
an hour on the subject.

London, Saturday, 18 October 1980

I awoke in a rage, the full implications of Ali Forbes's gossip having
sunk in. I hated people to think I was having an affair with Clarissa. I
began to dread that it might appear in Hickey or elsewhere.†

* Ali's review: 'Her father may have been able to give her some beautiful diamond
earrings, but nothing to put between them.'
† This tiresome rumour persisted and went round in circles. Presently Andrew
Barrow told Ali Forbes that I was getting married. Ali told Clarissa and in November
she rang to ask if it was true. She sounded relieved to hear it wasn't.

As if to make it worse, Clarissa rang. 'Were you talking to Stephen Tennant? . . . Any chance of lunch?' I invited her here. She told me that the dinner with Princess Margaret for the Soames party was rather grand.

Princess Margaret said, 'Snowdon rang me up the other day and asked me to hum a tune from —' (I forget). It was for his *Desert Island Discs.* 'Then he rang again and please hum the one from —. I said, "Which one? There are forty."' Evidently she might appear on the programme. She was annoyed they had Snowdon before her. The guests all asked which book she'd take – *War and Peace.* Later the Soames party at Claridge's was 'a late night cocktail party'. Sarah was carried out by Mary Soames* single-handedly, 'her legs dangling like a puppet'. Clarissa also said Robert Armstrong [the Cabinet Secretary] had stopped a terrible Mountbatten programme on Suez. 'Bastard,' she said.

We had our meal and talked of Ali Forbes. She believes he's a Boston puritan who, having been thrown into society, can't react normally. He goes berserk. Especially now he's cooped up in Switzerland all the while. She read his letters and that of Patrick O'Higgins.[†] 'Very boring.' I did like her comment: 'Oh dear, I suppose Cecil did bring the worst out of everybody.'

London, Monday, 20 October 1980

Dennis Arundell (1898–1988) had been at St John's College, Cambridge with Cecil and had starred in Pirandello's Henry IV *at the university. He became an actor and librettist, a scholar in opera as well as translating, directing, composing, producing and conducting. Before the Second World War he was mainly an actor, but afterwards turned more to opera. He lived in Lloyd Square, Islington.*

Dennis Arundell was a great help, didn't care for Cecil much – thought he was more interested in getting his sister's pictures in the *Tatler* than he was in the university. It was a massive social climb.

* Sarah Churchill (Lady Audley) and Mary Soames were sisters, both daughters of Sir Winston Churchill.
† Patrick O'Higgins (1922–80), personal assistant to Helena Rubinstein.

He also told me that he had a friend, Oriel Ross.* 'She could tell a few stories. She left Lord Poulett for two reasons. First, he used to go downstairs at night and rave. Second, he liked to break her fingers.'

It was a wonderful moment when Dennis Arundell played his burlesque, 'I'm Just a Little Piece of Seaweed', for me on the grand piano.

London, Tuesday, 21 October 1980

I accompanied Diana Cooper to a lecture given by Joe Alsop[†] at the Victoria and Albert Museum, attended by Prince and Princess Michael of Kent.

Roy Strong (who had greeted me at the door, 'It's Sir Cecil Beaton's biographer!' and had said, when I asked, 'May I park?', 'If you're with Lady Diana Cooper, you can do what you like') made a willowy speech. Then Joe Alsop gave his lecture, a splendid and erudite speech, way above my head . . .

Afterwards there was dinner . . . There was a wonderful moment when a man bearing a plate tried to go through a mirror and fell on the floor in a crash of crockery. 'Blood?' asked Diana.

Someone said to Diana: 'Is this your grandson?'

'No – boyfriend.'

London, Wednesday, 29 October 1980

Diana gave a lunch for Joe Alsop.

I had a long talk to Ali. He asked, 'What's the news of Wiltshire?' . . . He told the story of how Cecil met Freddie Ashton at a lunch for the Queen Mother. 'Diana doesn't much worry who is talking to whom. Freddie was on the black list for not going to visit Cecil. But the

* Oriel Ross (1907–94), muse and favourite sitter to the sculptor Jacob Epstein, married the 8th Lord Poulett (1909–73), divorced 1941. She was variously an actress and amateur artist. Sorry I missed her.
† Joseph W. Alsop (1910–89), influential Washington journalist and writer from 1945 and beyond the Kennedy years.

Queen Mother's presence helped and they embraced. Before Nicky Haslam's* dance, Ali said, at Hackwood, "I'm so pleased that you and Freddie have made it up."

'"Well, I haven't *really* forgiven him," came the reply.'

London, Friday, 14 November 1980

Margaret, Duchess of Argyll (1912–93) had been a society figure at exactly the time that Cecil was making his name in London. She had been Nancy Beaton's bridesmaid when she married Sir Hugh Smiley. Later she had become a somewhat controversial figure due to the elaborate details of the many lovers cited in her divorce from the 11th Duke of Argyll, though there is emerging evidence that he was the true villain of the piece.

In due course I went out to a drink with Margaret, Duchess of Argyll, who had telephoned on Wednesday after my letter. She knew Cecil, his sisters and his mother. She told me on the telephone that she had enjoyed *my* book on the Ritz. She got it all wrong. Then she said how much she liked 'Mr Massingham [*sic*].'

Margaret, Duchess of Argyll

* Nicky Haslam (b. 1939), interior decorator and writer. He had given a ball in Hampshire for his fortieth birthday in 1979.

I arrived at Grosvenor House in good time. The lift was grim – an eternal wait – and the corridors rather awful. But Margaret Argyll's flat was plush and spacious, and beautifully decorated. She was there in black velvet, pearls and diamonds, looking the same as ever, beautiful, cold, but really rather wonderful at sixty-six, as she said, or sixty-seven perhaps – even sixty-eight!

She gave me a drink – and said she had known Cecil and all that crowd for years. The interesting thing was that she said, 'We never knew they were homosexual. We never thought about it, we were all too busy with our beaux.' She said she used to go to Oxford to see friends and step over the figures horizontal on the floor but it was only later she realised they were all plastered with drink. She adored Peter Watson – didn't realise he was queer – said she disbelieved the Garbo stuff. She said she would never have asked Cecil to a dinner party – 'Did he ever go to dinner parties?' She reckoned he wouldn't have been able to cope with the Carringtons of this world: 'They were Bohemians.' She said that people like Cecil were not wanted in the normal world. Charles Sweeny [her first husband] would have hated him, for example. She disputed many of the points in Cecil's diaries, *The Restless Years*: 'I simply never said that. I would never say something like that.'

It occurred to me while we were talking that though she may be rather silly, and I'm sure is potentially a dangerous woman, there is something pathetic about her. Society makes its own code and you have to know the rules. Therefore Diana C is really wonderful, and must be praised at all times while Margaret Argyll can be knocked at any time – she's fair game. Ditto Laura's book – 'Unreadable, though I couldn't put it down.' Mark Amory's *Letters* are really wonderful, one loves Ali Forbes despite anything he ever does – and so on. Gradually you pick up all these nuances.

She described Mrs Beaton as 'middle class' ('Please don't quote me on that') and Hugh Smiley as an intolerable bore. He had an affair with someone whose name, alas, escapes me but in the middle of her story, the bell rang and Peter Eden arrived. He owns the [Brompton Road] Brasserie. He asked me about various things, including my previous book. I told him about Gladys and the way the Duke of Marlborough treated her. 'Oh! These dukes!' said Margaret Argyll. 'I'll tell you the way these dukes behave any time you like.' We

discussed settlements. She said that they were so mean over here. Peter Eden, on the other hand, said that the wife can have an affair and the husband has to leave the flat. She said English men have no idea how to treat a woman, while Americans are much better. 'If an American sees me across the room, he comes straight over. They know how to treat a pretty woman.'

London, Tuesday, 25 November 1980

Sir Harold Acton was in London for some days, and I went to two lunches for him. At the first, all he said was 'What a task to write about Cecil. What will you tell us?' I said there was much new material. For instance few knew that CYK drama, in which Cecil unwisely introduced some anti-Semitic words into a drawing for Vogue, *and was promptly dismissed. 'Oh, yes' – he knew about that. The second lunch was given by Lady Freyberg.*

The guests today were Harold Acton once more. 'Ah! Here's this genius, who is going to write Cecil's life.' I talked to him – he thought Harold Nicolson rather second-rate and a bore. He said that the Evelyn Waugh letters were well edited by 'nice Mr Amory, who gave me the chance to take out references to me. I'm old now so I don't mind being called B-U- double G-E-R, but it doesn't look good in print. We have to think of the provinces.' He said that Diana Mosley loves publicity and that there is a girl who wants to write a book about Nancy Mitford.* Debo doesn't want her, Diana does.

There was Paul Wallraf, [the art dealer] to whom I hardly spoke – he looks old and tired . . . Then there was Sonia Cubitt,† who is really rather good-looking – wonderful eyes under a large hat – not as good as Diana but impressive. She was very nice to me this time. 'We've corresponded, haven't we?' was her greeting – she wouldn't help over *Gladys.* Now she said how much she liked her. Mrs Cubitt is Mrs Keppel's daughter and there's some reason why she is connected with Prince Charles. She's a friend of his.

* Selina Hastings, whose biography was published in 1985.
† Sonia Cubitt (1900–86), daughter of Alice Keppel, mistress of Edward VII and the grandmother of Camilla Parker Bowles (now Duchess of Cornwall).

There was good talk about Stephen Tennant. Sonia Cubitt said a carriage (a barouche) with horses drew up in Wilsford once. In the back was a lady with a huge hat (Edwardian) and parasol. It was Stephen.

London, Saturday, 29 November 1980

There were several visits to Enid Bagnold at her new home in Hamilton Terrace, sometimes alone, sometimes with Diana.

We arrived at Enid's without flowers 'because you were too late, you beast' – and met Miss Hughes, the very nice nurse. Enid herself was in a bad way. All one could see was her head on the pillows, her mouth open and she asleep.

Diana sat stroking her head – 'Poor darling.' Then later, to the nurse: 'It's an enviable state. She's perfectly happy. I envy her.' And to me later: 'I wish she'd die – like that, knowing nothing.' I left the books, which Miss Hughes promised she would sign for me when she awoke. We declined a drink. 'I'm on my way to one,' said Diana. And we left the sleeping Enid lying there like a child . . .

I went to Paris on Wednesday, 3 December to attend the memorial service for John Utter (the Duke of Windsor's private secretary) the following day. I was to have lunched with Sir Oswald and Lady Mosley that day, but he died the night before. It was on this trip that I met Maître Suzanne Blum, the Duchess of Windsor's sinister lawyer, in her office. And I had dinner with Stuart Preston.

Paris, Wednesday, 3 December 1980

I made my way to the Sergeant's rue de Rivoli apartment. I was punctual and he was waiting at the lift. Practically his first words to me destroyed my tomorrow: 'You've heard the news? Sir Oswald *is* dead.' Evidently he died peacefully in his sleep. He simply did not wake up . . . Once again I was the angel of death. Scarcely do I elect to visit someone than they drop dead.

Sir Oswald Mosley was a fascinating man, but I only met him twice. The first time I was so impressed by the power of his personality that I read his entire heavy political memoirs. His son seemed to sum it up best in an obituary in which he said that, while his father grasped high

ideals with the right hand, he let the rats out of the bag with the left. The first time I met him (March 1974) he was still on grapefruit juice, waiting for the call. Last time, in September 1979, he was much friend-lier and took a liqueur. Diana, of course, has become a friend only lately through correspondence and over the death of John Utter. My visit to them would have cemented this. Ironically, I had brought a copy of a book by each of them to sign for me.

The Sergeant was not on good form. He gave me a drink, told me he was taking me out to dinner and that we would be at the café he loves. As the evening went on – snails, meat, plenty of red wine – he sank into a kind of stupor. He became repetitive, boring and from time to time blathered like an idiot, his face gazing like a mesmerised owl's, his mouth open. When the waiters addressed him and asked him a question he just replied, '*Oui*' – which was not the answer. '*Côtes du Rhône ou Beaujolais, Monsieur?*'

'*Oui, oui.*'

Then a friend saw him and said, which was telling, '*La dernière fois que je t'ai vu, tu étais très fatigué. Ça va mieux maintenant?*'

Stuart looked perplexed: '*Oui, oui, ça arrive.*'*

He expressed a longing to see Diana. 'I'll do anything. I must see her.' He confessed he was a little scared by her. He actually said: 'Oh! She'll probably say something like the Sergeant . . .' (the first time I've heard him use that word).

He told me that after coming out of prison 'Sir Os' began an affair with Lady Jeanne Campbell,† which must have been rather humiliat-ing for Diana, who went to prison for him for four years.

I was most grateful to escape into the civilised world outside.

London, Sunday, 7 December 1980

Back in London I paid another visit to Enid.

When I got there, Enid was asleep . . . I succeeded in getting her to talk about Cecil Beaton and *The Chalk Garden*. She said that there

* 'Last time I saw you you were very tired. Better now?' 'Yes, these things happen!'.
† Lady Jeanne (1928–2007), daughter of 11th Duke of Argyll, married at one time to Norman Mailer (1923-2007), the American novelist.

had been a row and that he thought it was her fault. Irene Selznick she described as 'dictatorial' and very rich. She also said, 'I wonder if he had heart. He seemed to, but I wonder if he did.' She told me he was very fond of his mother. 'That's all I can remember,' she said, with a smile.

Enid doesn't like to be in bed as she is frightened she will die.

At the end of the year I went to Egypt with my father and my aunt. During the trip I mused on the duality of my life — a year of many changes, confusion as to where I stood, sometimes swept up into this new world, and sometimes left behind.

It is difficult and I am forever caught between loneliness and selfishness and the possibility of ending up as a miserable old bachelor, unattractive, overweight and finally unwanted (because at the moment I am wanted and as Diana says, 'You're young. You don't have to be alone if you don't want to be').

One of my New Year resolutions was 'to work hard on Cecil Beaton, do it and do it well'.

1981

The interviews continued throughout 1981 while I worked my way through Cecil's albums, diaries and correspondence.

London, Thursday, 8 January 1981

I had dinner with Diana in her bedroom at Warwick Avenue.

I asked her who Serena Blandish was.* She told me it was Paula Gellibrand, Cecil Beaton's heroine. She is still alive. I would dearly love to know if that's right. Diana says Enid is worse and worse. She had lunch with Enid. 'I keep longing to kill these people,' Diana said. She also said, 'Well, it's a long time since I had a stranger in my bedroom . . . I don't mean a stranger . . .' Laura telephoned. 'Guess who I have sitting on the end of my bed?' There is funny rivalry between them though Laura never shows it.

Diana said Cecil couldn't get on with his sisters. 'Really, I have tried,' he would say. She also qualified the statement about June Hutchinson. She said that June worried whether or not *if* they were in bed he wouldn't be wanting her to be a boy, so I must be cautious of that one.

London, Sunday, 11 January 1981

I went to see Enid and got her to talk about The Chalk Garden.

'Oh, yes − *The Chalk Garden*. So brilliantly done by Cecil Beaton. But he didn't do them in London for some reason. Those were done

* Enid had written *Serena Blandish − Or the Difficulty in Getting Married* in 1923.

by Byam Shaw* – not nearly so good. I made an enemy of him on account of it.'

'But you made it up eventually.'

'No, not really. Only a chilly sort of friendship.'

London, Tuesday, 20 January 1981

A few days later I went again with Diana.

Enid admitted that Paula was Serena, as Diana had told me. 'She was the loveliest girl I ever saw.' Enid said, 'The d'Erlangers† lived next door to us. My father said, "You'll never get to know them", but I did and I used to go to parties there and meet lots of men.'

Roehampton, Saturday, 24 January 1981

Paula Gellibrand (1897–1986), was an important figure in Cecil's early life. In 1925 he spotted her, for the first time, in a Rolls-Royce in Bond Street, she had been the unwitting heroine of Enid's novel Serena Blandish, though there are conflicting theories as to who Serena was based on. Paula fits as she married the Marquis de Casa Maury, but another candidate was Gwynaeth Cooper Willis (d. 1945).

Born on 1 December 1897, Paula was the daughter of a timber broker and agent (born in Russia in 1864), then living in Wales, she was sent to school in Kensington and taken up by Baroness d'Erlanger, who launched her into society. She married several times, first to the Marquis de Casa Maury, sometimes described as 'The Cuban Heel', then to the phrenologist Bill Allen, during which time she may have had an affair with Prince George, Duke of Kent, and finally to 'Boy' Long, a cattle rancher in Kenya, which landed her in the middle of the Happy Valley set at the time when Lord Erroll was murdered.

Returning from Kenya with no money after the war, she had been lent a bungalow near Nettlebed by Commander Colin Buist and his wife, Gladdie.

* *The Chalk Garden* was directed in Lonon by Glen Byam Shaw (1904-86), the sets were designed by Reece Pemberton (1912-77)

† Baroness (Catherine) d'Erlanger (1874-1959), noted hostess and patron of the Ballets Russes, lived in Byron's house, 139 Piccadilly.

She lived there for thirty-five years, but was eventually moved, in about 1980, to the Priory, Roehampton, suffering from Alzheimer's, and remained there until her death.

Cecil Beaton thought Paula one of the loveliest women in the world. Latterly he was horrified that the looks had gone. Laura was in blue, and we made our way to the Priory, a typically Richmond fortress. Inside we wended our way along the many corridors to her room – No. 8 Lower Ward South or some such. Did she know who Laura was? I couldn't tell, but it didn't matter.

I could recognise her – very thin, the high forehead, the enormous eyes, the angular quality, the beautiful hands. She was quite well dressed – a blouse covered in Ps means, I think, Pierre Cardin. She was also in green slacks and her hair was well done. There was dignity there. Worse, there was no television in her room, no radio, no books, nothing. The large room was like a schoolroom and there was a private cubicle at the side of the room with bath, etc.

She was very talkative and we stayed with her for about an hour and a half – it seemed longer. She said she had seen Cecil not long before he died, thought Grant splendid and the house lovely. She recalled being photographed by him [1920s], nanny holding up the light, the mauve-green curtain behind him. How did she know him? 'Oh! I suppose he just came up to me at a party.' He would say to her, 'You're not taking it seriously enough.' He hated her to smile. 'Of course I had no idea he was a pansy. I loved him.'

'I was the first person he ever photographed of course.' (So many have said that.) His painting of her in bed with flu was above her bed now. 'I had fun at the time.' She loved it for the details, the books, the orchids on the bed, the quaint telephone.

So here she was – and now I had seen three of Cecil's five great beauties: Paula, Diana, and Princess Marina.

She talked of the Priory: 'There's a restaurant here. I go . . . They're quite funny, the people here . . . The nurses are kind . . . but that one, the head one – oh! One day I walked down to the village to buy sweets. You'd have thought I had committed a crime. They sent a search party for me. Now, of course, they always look at me as

if I'm about to do something . . . The head one is very bossy, but I don't like being bossed, so I've made that clear now.' She told us that Freda [Casa Maury]* had been to see her and was walking much better.

She told us that Colin Buist† had been taken to a hospital. He no longer speaks. He just says, 'Biscuit,' if he wants some. She said she had a nurse at home and the nurses at his house called for help. Old Colin was in his bath and would not budge. As Laura put it, 'You mean he was slipping about like soap and no one could get hold of him?'

'Well, I wouldn't know which end to take hold of,' said Paula. 'None of the nurses could do a thing. And he refused to budge. Every now and then he shouted out, "NO!" and brought both hands down into the water. My nurse said she was soaked by the time they got him out. Finally she took control and slapped him on the face. Then he behaved. Evidently after that it was no good. He had to go to a hospital nearby. It costs the earth. Meanwhile, Celia Johnston, the actress, has taken all the pictures to her house.'

You could see that Paula had been a very amusing, very chic woman – no great brain or reader, not much left for her in life either, alas. But very friendly, no malice in her. She had no idea who we were, called me Laura's husband and spoke of her own having been to see her.

On the way out she led us to the door and past rooms where 'They have dances or some other nightmare,' she said. Then she waved us goodbye. In her room she had kissed both Laura and me. Sweet.

Though well seasoned in such places, I must say the horror leaves behind some grim thoughts. Enid and Stephen are both lucky not to be in such a place.

* Freda Dudley Ward (1894-1983), another wife of the Marquis de Casa Maury, long-time girlfriend of the Prince of Wales (later Duke of Windsor).
† Commander Colin Buist (1896-1981), of Highmoor Farm, Henley-on-Thames. His wife, Gladys ('Gladdie'), had died in 1972. They were great friends of the Duke of Windsor.

London, Sunday, 1 February 1981

Eileen rang me and we had a long talk. Nancy Smiley put plastic Christmas roses on Cecil's grave. She wants them back.

London, Wednesday, 4 February 1981

I was invited to lunch at the Travellers' Club by Stewart Perowne, to meet Sir Steven Runciman (1903–2000). He had also been at Cambridge with Cecil, where he was described by 'Dadie' Rylands as one of the 'Tea Party Cats'. Grandson of a shipping magnate, he was independently rich. He became known as a historian of the Crusades and Byzantium, an expert on the Middle East. Later he led the British Council in Athens. Now he divided his time between London and the Hebrides.

Stewart was in the hall dressed in a country suit. He introduced me to Sir Dennis White, a former secretary to the club. He then gave me the first of three sherries of the day and prepared to await Sir Steven Runciman. Sir Steven is seventy-seven going on seventy-eight, but in an Oliver Millar–James Lees-Milne kind of way he has the appearance of a man of fifty-five. Tall, thin, and with the wizened scholarly look, he had also a self-assured arrogance, which was not unpleasant. He is an 'erudite' scholar, a Byzantine historian, but Hugh [Massingberd] who knows about those things, says that his works are unreadable.

We descended to the bar. Stewart and Sir Steven talked a lot about mutual friends. They are both burdened with writing little essays of appreciation about friends who have died or friends who are celebrating seventieth birthdays. That I enjoyed – also Stewart's line: 'One of the only Raphaels still in captivity.'

Sir Steven had many stories.

A cigarette that Cecil threw out of his window in Bridge Street landed on a lady's straw hat and there was an altercation about a hole burnt in it. Steven thought him most entertaining. He was the Queen in *The Rose and the Ring*, Cecil the Princess. Those weekends, at Wilsford, for example, were 'very exhausting'. He didn't like seeing

Stephen Tennant – 'rose-red cheeked Stephen' – rather as one doesn't like to return to a place where one has been happy as a child. He said that he saw Cecil a lot at Cambridge and found him most entertaining but then Cecil became very grand, while he turned to the world of Trinity College.

When he was knighted, Cecil apologised for not having written. 'I was furious,' he said, confessing that jealousy was one of his great failings. Cecil was also very difficult when he was ill. He could only be visited if one happened to be in the area. Sir Freddie Ashton suffered particularly from this. Cecil used to say, 'You're just coming to see me out of pity.'

Queen Mary didn't like *My Royal Past* – the Queen Mum did 'because she hadn't had one'. So did Princess Marina. He said that Cecil wrote it out of fury at all those memoirs about dinners . . . 'I had the great fortune to dine with . . .'

Steven Runciman told Princess Marina that, when knighted, he felt 'middle-aged and middle class'. Princess Marina told this to the Queen. She was *furious* and he will receive no further honours. Of the Queen: 'She's perfectly civil to me when she sees me,' he said, implying nothing more than that. He said that Princess Alice* wrote to him inviting him to lunch: 'It will be, if I may say so, a select party, you, me and the Swedens.' Princess Alice refused to have *any* man in her bedroom when she was bedridden.

Stewart said that when Cecil Beaton saw the Regent of Iraq, he described him as 'very Marie Laurençin'. Sir Steven invited me to stay when I liked in Dumfriesshire. That might be interesting, especially as I have never seen Scotland.

London, Thursday, 5 February 1981

I had first met Diana Mosley (1910–2003) in France in 1974, when she and Sir Oswald came to lunch with John Utter, the Duke of Windsor's private secretary, at his house in the country. She had reviewed my book generously when it came out, and I met her again with Jane Abdy. We had been in close touch during 1980 over various issues connected with the Duchess of Windsor,

* HRH Princess Alice, Countess of Athlone (1883-1981), the last surviving grand-daughter of Queen Victoria,

and then over the illness and death of John Utter. Now she had come to London and had borrowed Durham Cottage for some days.

Diana Mosley was, of course, a controversial figure. Born as the beautiful Diana Mitford, she had left her first husband, Bryan Guinness (Lord Moyne), for the leader of the Black Shirts, Sir Oswald Mosley. She and her sister Unity had seen much of Hitler between 1933 and 1939. Both Mosleys had been imprisoned during the war under Section 18B as dangers to the state. Latterly they had lived in France in the Temple de la Gloire, at Osmoi, not far from Paris.

I went to dinner with Diana Mosley at Durham Cottage in Christchurch Street. I was mystified by the address as I had found a letter written from there by Rex Harrison to Cecil Beaton. It transpired that the house used once to belong to Laurence Olivier when married to Vivien Leigh, and is now owned by Nicholas Mosley (Lord Ravensdale).

Diana Mosley, a widow since December, was in black velvet and white collar. She looked pale and rather drawn – in fact, very like her Snowdon photograph in the *Sunday Times* colour supplement last year. She also looked rather nervous and is probably very sad and at a loss. After all it was quite a devastating marriage, involving her going to prison for several years during the war.

Then there was Jane Abdy: 'Diana – how delightful.'

The other guests were Derek Hart and Lady Selina Hastings.[*] Derek Hart never stopped talking, mainly about Mrs Runcie [wife of the Archbishop of Canterbury] being unable to stop talking. I found him arrogant in a self-assured way. He told me that Cecil was very difficult over *Don't Count the Candles* – he co-operated enormously, then tried to pretend he had been tricked into appearing in it, assumed editorial control, etc. 'He bitched.' Derek Hart said he had written a number of apologetic letters. He wants to redo the film putting in the expurgated bits.

Lady Selina Hastings, whose sister I met by chance with the Nuttings, was rather fun. She said that she thought Cecil depended very much on whether or not one liked *him*. Jane thought him 'a

[*] Derek Hart (1925–86), current affairs journalist and documentary maker; Lady Selina Hastings (b. 1945), biographer and reviewer.

good judge of character'. Jane also said, 'He liked to think of himself as a Renaissance man, able to draw, paint, write and so on.'

Diana told me she was a friend of Paula Gellibrand, that Paula came from a family in Cardiff and was adopted by Baroness d'Erlanger, the mother of Baba d'Erlanger (later Baba de Lucinge). Paula and Baba were both painted beautifully by Augustus John. She said that Cecil promoted his sisters, though they were a bit of a dead loss. He did his best for them.

Diana said that old Mrs Beaton used to knock the gin back and Cecil used to keep the cupboard locked because he was frightened that she would fall downstairs. And Juliet Duff said, 'Oh! I'd give the key and let her.'

'You know, I can't think of Juliet in quite the same way again after that,' said Cecil.

It was when Jane and I were left alone that Diana's sadness came to life. 'Oh, my dear, I'm always awake.'

I then retreated to Nether Westcote in Gloucestershire to house-sit for Sir Anthony and Lady Nutting, she having become a friend after the ill-fated visit to Tangier. In the autumn Stephen Tennant had written to me saying it was too cold: 'No bath till May.' He had fallen silent but on 14 February I realised he had come to life after the long winter when four letters arrived from him. I was in London for a few days when more came: 'Wonderful letters from Stephen Tennant – so funny . . . I like the "Guard your talents, Hugo. I sense genius in you" – this on the back of an envelope. How funny it all is. And how sad that Cecil is not around to share it all. He would have been amused, I think . . .'.

There was another Diana Mosley dinner.

Lady Emma Tennant,[*] Diana's niece, mentioned 'Uncle Stephen' immediately and we were off on that subject. In fact, I found myself addressing the group on the subject of Cecil Beaton for some minutes after my arrival. Emma told me her stories about Stephen. She had only met him once and that at Lord Pembroke's. He'd been invited to

[*] Lady Emma Cavendish (b. 1943), daughter of 11th Duke of Devonshire and Deborah Mitford. She married Toby Tennant (b. 1941), Stephen's nephew, and was the mother of the model, Stella Tennant.

the wedding but hadn't gone. A flowery telegram excused him the day before. So they did not think they'd meet him. But when at Wilton, Henry Pembroke said, 'Oh! We must get him over to tea,' telephoned him and he came. And told stories which directly involved them and then in due course left. She said Henry doesn't produce him 'as a comic turn' but really likes him and is kind to him. She said that she thought Cecil got a lot of his ideas from Stephen – for example, the cracked mirror photograph. Stephen does, of course, have a very vivid imagination.

Diana and Emma both said that Cecil was a crashing snob and Diana went on to say, 'He did, of course, always have some very loyal friends like Rex Whistler so somehow it was all right.' They took the line that it was because of his social climbing that he was given a swift soaking.

Diana said of herself, 'There aren't many people who have known both Goebbels and Cecil Beaton.' And her face creased with laughter when this was repeated back to her.

Diana also said again how grim the Bridgewater House affair was. And she said that her sister Nancy once asked Cecil, 'Have you seen *My Fair Lady*?' And he replied, 'Ye-es,' in a downward-dropping voice. Diana: 'Wasn't it *marvellous*?' She made the important point about the Bridgewater House affair that 'In those days there were a few people who knew everything about everybody but the papers knew nothing. It was rather *ghastly* for her [Nancy Beaton] to find herself on the front page of the *Daily Express*.'

She has asked if I would like to come over and visit Mona Bismarck – she'd sent her *Serena Blandish*: 'My dear, it was rather awful making Casa Maury a *mulatto*!' . . . Of Paula herself she said, 'She had no idea that we couldn't come and visit her, that we were in France. An endless stream of postcards came asking us to come.'

There were wonderful farewell scenes between Emma and Diana. 'Oh, Aunt Diana. It has been *marvellous* . . . But I've hardly seen you . . . Just a *glimpse* . . . How long are you . . .? Oh! Lovely to have had a *glimpse* anyway.' Clearly, they were not to meet again this time.

I was back at Nether Westcote when, on Tuesday, 24 February 1981, the engagement of the Prince of Wales to Lady Diana Spencer was announced. This was of considerable concern to me as I had written a royal wedding book

for Debrett and my revised contract stated that I had to produce 6000 words on the bride within twenty-four hours of the announcement. Luckily there had been strong enough evidence that Lady Diana was the one – so most of it was written but I needed to return to London at speed to tie up the missing few paragraphs and, as it were, bring the bride to the lawn of Buckingham Palace. It did not help that my car battery had gone flat and it was in a local garage.

Nether Westcote, Gloucestershire, Tuesday, 24 February 1981

Evidently the peace of the moment is likely to be shattered. *The Times* (a Murdoch scheme, perhaps) has said that THE ENGAGEMENT is to be announced today. Oh! Hell! It could not be more inconvenient – I'm cut off and only two days more to get through. It's too grim . . .

An hour later the news came. Shock. 'Buckingham Palace has just announced the engagement of the Prince of Wales to Lady Diana Spencer.' I didn't even wait to hear the rest.

I retrieved my car and drove to London to put finishing touches to my royal wedding book.

I heard *The World at One*, which had a good interview. The prince calls her 'Da-ana' and she squeals with laughter. Her sense of humour is one of her strongest points. They were asked dreadful questions, of course, but did very well – much better than Anne and Mark. There were good slips. On the age question, Prince Charles: 'I shall be exhausted.'

There was also the moment later when Lady Diana said, 'It's what I wanted. What I want.' There is firmness there.

More touchingly her, 'With Prince Charles beside me I cannot go wrong,' got through to me. Also their hand-holding, though her nails need attention and his cuticles are terrible. Would Cecil like such observations?

London, Thursday, 26 February 1981

I took Diana [Cooper] to the Heath place, which she had liked so much before. We discussed the wedding and she told me how it had

been her mother's fervent hope that she would marry the Prince of Wales [later Duke of Windsor], but *she* said that she couldn't have stood the formality of it all. She was well out of it. But it's funny to think that they thought of another Prince of Wales and a Lady Diana. It's very curious. She has the Queen Mother for lunch on 26 March and I am to come in for a drink to meet her. What fun that will be.

Diana said that when the royal couple were asked, 'Are you in love?' instead of replying, 'Of course,'* they should have said, 'Yes, madly.' Diana said to me, 'I think you were born under a lucky star.' Yes, I believe so.

London, Friday, 27 February 1981

I rang Mary Skull at Wilsford to invite myself to tea with Stephen, following his invitation. 'The letters come down in batches – three at breakfast, two at lunch-time,' she said.

Wiltshire, Sunday, 1 March 1981

I arrived promptly at three. John Skull let me in through his door. So I walked along a long corridor and then up the side stairs and thus into the main part of the house. I have a fascination for the house lying asleep in all its faded glory. And then, enclosed in his room, with the curtain drawn and the lights pinkish so that he is ageless and unreal [is Stephen himself]. Anyway, there we were and we talked for nearly four hours, non-stop. There was a great deal about Willa Cather – her mysterious past, her dislike of talking about that – and so on.

He told me about *Lascar*, his great unwritten novel. He related that it starts in Marseille at sundown. A lorry sets off – someone had forgotten to do up the back and a pile of boxes tumbles out, containing oranges or pineapples, which spill out over the quayside. This is heard by Madame Seraphim Neffus and her *dame de compagnie*, Madame Hortense. They have had a visit from a sinister figure

* This was the interview in which the Prince added, 'Whatever "in love" means.' Interestingly not one newspaper reported those ominous words at the time. The phrase has been much aired since.

searching for the nephew. He is Manuele das Cubas and the nephew muffed their escape from gaol. And Madame Neffus has given him money and the address. Stephen describes it so well. I wish he'd write it or hand over the drafts.[*]

At the very end came the bit about Cecil. He said, 'I once told a friend of mine, "You might think Cecil is listening to what you were saying but in fact he's counting the hairs in your nostrils."' He said that Cyril Connolly said, 'Some men like a social atmosphere round them rather than individuals.' The diversity of Cecil's life is most fascinating.

After tea John was summoned and a glass of sherry served. Then I went on my way, leaving Stephen slouched on his bed but happy.

London, Tuesday, 3 March 1981

I went to have lunch with Juliet Nicolson[†] and her PR assistant, Ann Grove . . . Truman Capote was due here to promote his book. He is now in a mental home in California. He went off with his lover, a rough, of course (but one he'd loved for years), and his young secretary (female). The lover seduced the secretary and Capote flipped. He left with nothing and came back to his flat. Later, I think, he was carted off. Foyles and everything had to be cancelled . . .

In the evening Clarissa came to dinner. She told me that at lunch V. S. Naipaul said, 'Hugo Vickers. Oh! Yes. An unhappy man. He must have had a very unhappy childhood. This is why he works so hard.' Interesting! He gets very drunk, evidently.

I asked Clarissa how much I should say in my book.

She thought I should spill all the beans. Of Peter Watson she said. 'If he had been other than he was, I could easily have fallen in love with him.'

[*] After Stephen died, I bought the drafts at the Wilsford sale. Eventually I sold them to the Beinecke Library at Yale.
[†] Juliet Nicolson (b. 1954), author of *Frostquake* (2021) and other works. Daughter of Nigel Nicolson, of Sissinghurst.

Diana and I visited Enid on 5 March. On the sixteenth Diana rang to say, 'Enid's on the die.' She had taken to her bed. At least it meant she would not go to a nursing home. Diana had seen Lady Diana Spencer at the opera evening with Princess Grace of Monaco. She was very funny about her 'provocative plunger' black dress: 'Wasn't that a mighty feast to set before a king?'

London, Saturday, 21 March 1981

Then I went out to get Gloria Swanson's[*] book. I queued up. Miss Swanson looks fantastic at eighty-one. She seemed very pleased that there were so many young people there. I told her I was writing Cecil's life. 'Oh! You're a writer. What a nice man he was. Or is. Wherever he is now.' This was her comment. She arrived in a huge limo and wore a neat little hat (grey) and grey eye make-up to match her hair.

Lady Diana Cooper gave only two luncheon parties each year, one for Harold Macmillan and one for the Queen Mother. She told me that these were 'very nice for me – and very nice for her'. She invited some guests to the table and her neighbours in Warwick Avenue to come in for drinks before lunch. On this occasion she appointed me an honorary neighbour.

London, Thursday, 26 March 1981

I was rather nervous as I drove to Warwick Avenue. I waited until the hour was right: twelve thirty-five. In I went. Charles Farrell[†] was hovering outside to greet the Queen Mother. Diana was in the hall looking absolutely marvellous – in a black dress with a little veil. She was talking to a very bronzed Nicky Haslam. She gave me the lethal house cocktail.

Lady Kitty [Farrell] is strange and brash and lacks Diana's subtlety. She chides. Her greeting, 'I wasn't told that you were coming' implied, I suppose, that I was unwelcome. Probably she didn't mean it, but

[*] Gloria Swanson (1899-1983), originally a silent-film star from the Cecil B. de Mille era, best remembered as Norma Desmond in the film *Sunset Boulevard* (1950).
[†] Charles Farrell (1919-2015), former Foreign Office man, married to Lady Diana Cooper's niece, Lady Katherine Paget (see footnote on p. 72).

that was what she said, thinking aloud. There was Adrian Daintrey, who is vaguer and vaguer.

There was general chatter until the arrival of the Queen Mother and Lady Kitty did the presentations – me first, Nicky next, then the others. The Queen Mother wore that green-turquoise coat of velvet and matching hat. Later she took it off to reveal the dress in the frontispiece of Godfrey Talbot's[*] book on her. After the presentations, she gravitated to the other side of the room to dreadful John Drummond.[†] He was due to sit next to her at lunch – of course, that always happens. I got even more fed up with him when I heard his booming voice crying out, 'Sir Lennox and Lady Berkeley, ma'am.'

Various people talked to her. In due course Diana (who spent most of her time mixing and pouring an immensely strong brew of gin and grapefruit – what a wonderful photograph she would have made, silhouetted against the light, pouring an entire bottle of gin into the jug) came over and decided that it was my turn to talk to the Queen Mother. She led me by the arm and presented me as 'This is my great friend Hugo Vickers, who's writing the life of Cecil.' So we began on this subject – the diaries. 'How fortunate that he kept them all . . . Do you think it's a help to know your subject?' Then Diana: 'Tell Her Majesty about your latest project.'

'Ma'am, I'm afraid it's a royal wedding book.'

'You must have worked very hard . . . Does it have lots of pictures? That's what people seem to like.'

Later she asked me: 'Do you know Charles?'[‡]

'I've met him once or twice, ma'am.'

'You young people pack so much into your lives – you at sixteen, eighteen . . .'[§]

I have felt very light of foot ever since – blessed with eternal youth.

We spoke again of Cecil. 'What fun he was,' she said, and she told

[*] Godfrey Talbot (1908-2000), veteran BBC commentator. The book was to celebrate the Queen Mother's eightieth birthday.
[†] Sir John Drummond (1934-2006), arts administrator with the BBC.
[‡] HRH The Prince of Wales (b. 1948). He was then engaged to Lady Diana Spencer.
[§] I was then twenty-nine!

me about the photographs he had taken of Buckingham Palace. 'The funny baths – people today have no idea how we lived.' She asked where the collection was now. In due course we turned to Stephen Tennant. She said, 'Oh, Stephen. I'd love to see him again. It brings back so many memories of when I was young – Christopher . . .'* (Lord Glenconner wanted to marry her – so, incidentally, did Laura's father.) She knew Wilsford of old.

'Ma'am, you'd find it hasn't changed.'

She said, 'Stephen used to ride over the downs in a carriage thinking lovely thoughts or whatever one did in those days.'

I said that to be at Wilsford, it was hard to remember that one was in the twentieth century at all.

Of Cecil again, she said, 'Of course, there was another side to him. Pins going in . . . here . . . there.' She gestured to the right and left.

Then it was Adrian Daintrey's turn. He paid her some compliment and in a vague way went on, 'I always notice women's clothes.' The Queen Mother was very kind to him and said, 'That's rather marvellous . . . To be encouraged.' I heard no more as, having had more than a fair deal, I thought I should clear the way for others.

Adrian Daintrey

* Christopher, 2nd Lord Glenconner (1899–1983), elder brother of Stephen.

Loelia Lindsay (ex-Duchess of Westminster) had arrived. She told me that she was at work on another book. She has about twenty albums, and will do a Louisa* effort, then sell them.[†] It's all for money. She asked, 'And how is your patron, Laura Duchess?'

As I was but a drinker, I felt I should now run away. I left as the Carringtons[‡] were coming in. 'We had the most frightful traffic jam,' he said.

London, Monday, 30 March 1981

I rang Diana. She had seen Enid, taken her flowers but the end was near. Enid was lying there, did not speak, could take nothing in. Diana said, 'It was awful – the gaping mouth.' The doctor was there and he said she was unlikely to last the night. Very sad.

London, Tuesday, 31 March 1981

I took Diana Cooper to an early-morning Yuki show.

We drove back to Warwick Avenue. I was coming in to read the Queen Mother's letter. Wanda came downstairs, saying in a most casual way. 'Lady Jones died at a quarter to eight this morning. The son rang you – the one who's funny. I don't know his name.' Diana's attitude at the loss of her old friend was extraordinary. She almost said, 'Good.' The blind blue stare, so well described by Enid, gazed ahead of her. Thank God. That's over. Well, the suffering has continued for a long time and the threat of the nursing home was a grim one. But Diana is strange. She sees it in the present, not the past. I thought of the vital spirit of Enid that had been in this world for ninety-one years and is now no more. She did not want to die.

I went up and we looked at the Queen Mother's letter – very formal, 'Dearest Lady Diana . . . Ever yours affectionately . . .' She

* *Louisa, Lady-in-Waiting* (1979), the diaries of Louisa, Countess of Antrim, edited by Elizabeth Longford.

† I ended up editing these and they were published as *Cocktails & Laughter* (1983).

‡ Peter, 6th Lord Carrington, KG (1919-2018), and his wife, Iona McClean (1920-2009). He was Foreign Secretary 1979-82.

made reference to the 'HOUSE POISON' in capitals and how the neighbours and friends spoke more freely, their voices rising as the cocktails took effect. She had clearly hugely enjoyed it.

London, Wednesday, 1 April 1981

Enid's obituary in *The Times* bears no photograph – how aggravating! She went to the trouble to get one specially from Cecil Beaton. Otherwise it was a concise enough account, I suppose. There is more to be said.

Faringdon, Friday, 10 April 1981

I was seeing a lot of Cecil's friends. It was time I saw one of his enemies. I got in touch with Robert Heber Percy (1911–87) and he invited me to Faringdon for a night. I had been taken to stay with him at Faringdon for Easter 1979. This was the famously eccentric house of Lord Berners, who had bequeathed it to Robert on his death in 1950. They had been together for many years and stayed so, even when Robert married Jennifer Fry and she produced a daughter. Known as the 'Mad Boy', he had kept on the traditions of the house, dyeing the doves various bright colours (which made them vulnerable to predators), summoning guests to dinner by the playing of a music box. He had run the estate well and embellished it with further eccentricities.

When I got there, it was very late. Robert was asleep in the chair in front of a *Carry On* film – his daughter, Victoria Zinovieff, was sitting on the floor. He looked much older than when I previously saw him, two years ago. I felt more relaxed, though, even when I discovered I had forgotten to pack casual trousers.

At dinner we had a long talk about Cecil Beaton. He said that the trouble was over Peter Watson. 'Unfortunately he liked me, not Cecil.' His best story was that he thought Cecil was going to make a pass at him, so Lord Berners and he swapped beds – Lord B arranged that no lights could be switched on at the door. When Cecil entered the bed, Lord Berners called out, 'Cecil, what a delightful surprise!'

'He never forgave me for that,' said Robert.

Robert was at great pains to point out that he didn't hate him *until* the cruel diary bit was written. He recalled Gerald [Berners] and

Cecil both staying with Clarissa, and Cecil telling him that Robert didn't love Gerald. 'That was very unkind and Gerald came back most upset.' Robert thought Cecil had great guts and courage. He said it was ridiculous of him to go to the Wilton ball with gold-dust in his hair, though – asking for trouble.

Robert said, 'He had success. He worked terribly hard with the minimum of talent . . . [Of *The Gainsborough Girls*] Oh! That awful play! How poor John Sutro and I suffered. He rewrote it twenty times, each time duller and sillier than the last . . . I put him out of my mind as much as possible.'

Robert had an affair with Doris Castlerosse. 'Doris was wonderful,' he said. For his birthday in Paris, she took him to a brothel and said she had paid for him to be able to whip a naked whore to death. He gave a couple of disconsolate taps. Doris then said, 'I haven't wasted my money just for this,' and delivered a welt-raising cut. Robert said, 'Doris, any more of that and I'll be sick.'

Faringdon, Saturday, 11 April 1981

I had the chance of seeing the [editing] Lord Berners did [on] *The Book of Beauty*.* He blacked in faces, added teeth, and in the case of Mrs Vernon Castle added a bottle. But they could have been much worse. There is a book somewhere in which images of King George V and Queen Mary are drawn. When Prince George came to stay, he wanted Robert to show it to him, but Robert refused. Lord Berners locked it in the safe on the grounds that he would have said it was funny but not thought so truly.

There were guests for lunch. I talked mainly to Tanis [Phillips][†] – a lot about Cecil, Stephen and so on – but nothing quotable. She did say that her husband, Howard Dietz, was the man who created the 'I want to be alone' legend of Garbo. She liked him a lot, I rather think.

The tourists were wandering around as before. Robert was tired, still unshaven and collapsed asleep in a chair in the study, so I left him

* Lord Berners defaced a copy of Cecil's *Book of Beauty* (1930). I had longed to see it, but concluded that the results were not that funny.
† Tanis Phillips (1908–93), one of the many Guinness cousins.

sleeping. Meanwhile the tourists asked about the coloured doves –
were they bred like that?

Wilsford and Wilton, Wiltshire, Friday, 8 May 1981

I belted down to Broadchalke to have lunch with Eileen and to collect
the 'Rose'* for New York. I am a 'twentieth-century Rosenkavalier',
hoping to take it to Greta. Eileen gave me a note for Customs and for
her to sign. But will I succeed? God knows.

Eileen and I had an enjoyable lunch together and chatted in a
general way. Having arrived late, though, I was late again and had a
dash to Wilsford for my tea with Stephen Tennant.

Stephen was still in his room. He was in bed in his pyjamas and the
curtains were drawn so that a lovely afternoon disappeared. I have not
seen Wilsford in the spring. It was joyous to see the trees laden with
blossom and to enjoy the sunlight pouring in. Yet Stephen's own
room was as dark as ever. He'd never been in bed before – on, yes, but
not in.

Stephen talked of Pavlova – 'I used to know Pavlova' - and of
Virginia Woolf: 'I wish you could have known Virginia.' He spoke
much of Cecil's time in Hollywood and described Kin as 'a great
white buffalo of a man' ('Good description,' Nicky Haslam said later.
Kin was the only person who made Cecil feel that he was a little girl
– he used to throw him up in his arms in the swimming-pool and
catch him).

At one point Stephen gave me a silver box to hold – I opened
it and it was full of powder. He said, laughing, 'I showed it once
to Diana Cooper. She thought it was a cigarette box and opened
it and the powder went all over her dress.' He thought it very
funny.

I asked permission to see the downstairs rooms of the house and
John was summoned. He took me. Upstairs the rooms have books
signed by Virginia Woolf; the drawing room stands unused and asleep;
the bathroom is filled with shells and I am not the first to doubt that
Stephen ever goes into the bath. Downstairs the rooms are equally

* A watercolour of a rose, bequeathed to Garbo, not the framed rose sold in the
Beaton sale.

extraordinary. There is a library filled with fine books, and from it you can go into the passageway that leads to the dining room with shells on the ceiling – Stephen re-decorated after the war: he converted it to his own style after it had been a hospital. (I wonder how much Syrie Maugham* is left therefore.) There is the hall and a morning room. This has wall panellings and paintings but is draped with curtains. There are special locks on all the windows for fear of burglary.

John told me that Stephen, or rather 'Mr Tennant', was seventy-five and living on borrowed time. To hear John talk, he was in a bad way. He'd gone to Bournemouth and eaten rich food, as a result of which he became terribly constipated and had to go to hospital. 'He never told me,' said John, referring to a previous occasion when there had been a terrible mess to clear up in his room. John came to work for him because he used to drive him in earlier times and when 'the bad couple' left, he took over. He keeps Stephen informed of happenings in the outside world, especially to do with the Royal Family – he doesn't tell him the gory details of Ireland, for example. The Skulls had seen me on television the other day and wondered if it was me. They asked me to sign their visitors' book, which included the name of Hermione Baddeley.[†] The Skulls also said how upset Stephen was about the Pembroke separation.[‡]

Bearing my pictures, my book and reeking of the awful scent that pervades the atmosphere, I drove in a summery haze from Wilsford to Wilton. I was able to get in and I found the right door but needless to say that is as far as it went. There was nobody to be seen. I could have picked a Holbein off the wall, driven away and lived in great comfort (and perpetual shame and anxiety) for the rest of my life. A few years younger, I'd have been petrified. This time I decided to sit it out.

I settled down to read and presently Nicky Haslam appeared. Soon after came Claire Pembroke, with wistful smiling eyes and her

* Syrie Maugham (1879-1955), estranged wife of Somerset Maugham, and well-known in her own right as an interior decorator.
† Hermione Baddeley (1906-86), actress, married to Hon David Tennant (1902-68), Stephen's brother, between 1928 and 1937.
‡ The Earl of Pembroke and his wife Claire were separating.

children. Sophia is fourteen, Emma twelve. Emma was my favourite. Flora we saw on Sunday and William, the heir to it all, a curly-haired little fellow of two.

A great sadness hung over the house – packing cases and bridles in the hall, and the billiard room full of odd bits of junk. (Later I was to see one of the north rooms stacked high with furniture, old beds and cupboards, etc.)

Mr Allen, the butler, and his stooge, entered. 'Whose is the grey Honda outside?'

'It's mine. Do you want me to move it?'

'No, sir. If I could have the keys I'd like to unpack it for you.'

'Oh! Thank you.' (Trying to regain badly lost ground.) 'I only need the two cases in the boot.'

Later Claire showed me to my room, called 'Maiden Lane' – I saw a dressing-gown hanging over a chair she showed me, but nothing else was explained. Yes, the bathroom, but not times or clothes or where and when breakfast was. It was delightfully informal, one might say.

The room was large and comfortable, the view over the park green and tranquil and rather grand. My first taste of life in a stately home. Cecil Beaton danced here at the age of twenty-four – I stayed at twenty-nine – but he hadn't gone round the world by then.

Later, downstairs, Claire asked about Stephen. She said he came to tea once, arriving at two thirty and not leaving till six thirty. 'We all did a stint of conversation, but it was exhausting. In the end we had to ring Mr Skull to get him to come and take him away.' She said he came bearing cushions and all kinds of things.

Wilton House, Wiltshire, Saturday, 9 May 1981

I didn't know what time to rise. I'd been told I'd be called. A head looked round at nine forty-five so I got up. I'd been awake ages. I went down, but where to go? I found my way to last night's dining room, which was deserted but for a dog. I retreated. Then down I went again. Finally I saw Mr Allen and said, 'I'm lost.' He directed me to the morning room where breakfast was served.

It is strange and sad here, because it is the last day of the reign of Claire Pembroke. She leaves for a new cottage, a new home and a

new life. And yet she shows no signs of the horror of what she is going through.

Claire said that Emma got on so well with Cecil that she said (as a little girl), 'I do hope your mummy will let you come to tea again tomorrow.' As Claire said: 'Emma saw no difference in their ages at all.'

Wilton, Sunday, 10 May 1981

As others left, so the house became empty. I took my camera out into the park – I inspected the spot where Cecil was dipped into the Nadder. I wandered in the peacefulness of the empty estate. Later the tourists would flock in and it would become a beano – not my spot, though: that's the private bit . . .

I called on Clarissa, whose acerbic verdict on the separation was 'I suppose she couldn't stick him.' Then back to London.

In the evening I watched *On a Clear Day* with sets and costumes by Cecil and with Barbra Streisand and Yves Montand. It was splendidly Cecil – flowers everywhere, the huge Chinese-style chairs in the Winter Garden, the reds of her dress and hat and so on.

London, Monday, 18 May 1981

It was getting late and I was due at Diana's for a drink. I dashed off. I found her in bed but very worried as there was an old man coming to see her. It turned out to be Count Friedrich Ledebur,* whom I had long sought. John Pálffy† described him as 'a wild gypsy of a man'. He is tall with a high forehead and white hair. He was a rake; he could almost have been a philosopher. He was married to Iris

* Count Friedrich Ledebur (1900–86), Austrian cavalry officer, who worked in gold mining and deep-sea diving, and took part in rodeos. Later a character actor in Hollywood. One-time husband of Iris Tree (1897–1968).
† Count John Pálffy (1922–85), son of Count Pali Pálffy and Dorothy Deacon, sister of Gladys, Duchess of Marlborough.

Tree* and adores Diana. We got on like a house on fire immediately. He had met Gladys but it was Dorothy† he knew best. 'God, I could tell you stories about Dorothy,' he said. She was lovely, he thought. He had had a love affair with Dorothy. 'Now I am old I can say it.' And that she used to have love affairs with many rich men. She had one with Prince Kinsky, and after leaving Pali Pálffy, she went back to get the money off her first husband, Aba Radziwill.

This was to be his last visit to London, he said. He was eighty-one, and he had come to say goodbye to Diana. It was interesting to see them together. She adored Iris and, of course, Raimund von Hofmannsthal‡ and so did he.

'When Iris and Raimund died, my life was over,' he said.

'I'm going to cry,' said Diana. (One does not often see her moved.)

He told us that he had had a love affair with Alice Hoyos,§ and when he discovered she was going to have a child, he asked Iris what he should do. 'She said, "You *must* marry her." Really I had such agonies over marrying this woman. But Iris was right.'

They both spoke of their lives: 'I am old now but I have had many adventures, many love affairs. I've had a good life. And so have you, Diana. You've had a very glamorous life.'

'I know that,' she said. 'But I hate it now.' Once again she was complimentary in listing me as one of the compensations of her old age.

We talked about Cecil, and the count said he thought his best work was his line-drawings. He said that the photographs were too glamorous, too poised. His work suffered from his being the royal photographer too often. Diana said at one point, 'Cecil wasn't sweet. He was a beast.' She showed us the photographs he gave her on her eightieth birthday.

* Iris Tree (1897-1968), daughter of the actor-manager, Sir Herbert Beerbohm Tree. A poet, who performed in *The Miracle* with Diana.
† Dorothy Deacon (1891-1960), married first, Prince 'Aba' Radziwill, and secondly, Count 'Pali' Pálffy.
‡ Raimund von Hofmannsthal (1906-74), son of the librettist. He later married Lady Elizabeth Paget. Diana loved him.
§ Countess Alice Hoyos (1918-2007). They married in 1955.

The count said that Garbo goes often to Cécile de Rothschild* for dinner or to stay. If they go out, she never has any clothes so she has to have some. Dior or Cardin is called up and this is arranged. Garbo doesn't like to pay. She's very mean. Once in the desert, the riders and grooms took them on a jaunt for several days. At the end of it, FL said that they wanted her to sign photographs for them. She refused. So he said, 'Greta, these men have worked hard for you. They have made your journey possible. If you don't sign these pictures, then you can walk back across the desert.' She signed.

In Greece they were walking and Greta likes to walk naked. FL was told he must not look and he must warn her whenever anyone appeared. So FL called out, 'Greta, there is a peasant coming,' and she put something on. Another time he warned her and then: 'Greta, don't worry it's only a jackass.' He said, 'I thought you wouldn't want the jackass to see you.'

The New York Visit: 19 May to 12 June 1981

The main purpose of this trip was to meet as many sources for Cecil Beaton as possible. I was also promoting my royal-wedding book, Debrett's Book of the Royal Wedding, *a biography of Prince Charles, who was marrying Lady Diana Spencer in July. Just before I left London, I had sat next to Larry Collins,[†] author of* Is Paris Burning?. *He advised, 'Remember, you're not there to answer their silly questions. You're there to promote your book. So tell them a story that'll make people want to go out and buy it. Otherwise you're wasting your time.' The trip included many radio and television appearances, including an interview with Jane Pauley on NBC's* Today *show. I also made a quick publicity visit to Toronto.*

* Cécile de Rothschild (1913–95), who entertained Garbo in Paris and on her yacht. She had a gruff voice, once inspiring Alastair Forbes, at a nearby table, to turn and ask, 'Who's that man who sounds like Cécile de Rothschild?' He saw a photo of them striding out together, looking, as he put it 'like two Guards officers'.
† Larry Collins (1929–2005), American writer, who also co-wrote *Or I'll Dress you in Mourning* (1967) and *Freedom at Midnight* (1975), with Dominique Lapierre.

New York, Tuesday, 26 May 1981

I called Diana Vreeland and we had a long, helpful talk as a result of which I found myself visiting her beautiful secretary, Elaine,* at the Metropolitan Museum. She Xeroxed my list of contacts and later called back to tell me new numbers for some of them. Incredible help and efficiency. I stayed at the costume exhibition to look at the Chinese show, which was wonderful, and which Diana was working on last summer when we met, and then I took a snack at the museum, a good place to feed . . .

Then I took my diary out to Central Park for an hour or so. It was bliss to sit there in the steamy heat, writing a little, basking a little and generally enjoying the scenery.

Irene Selznick (1907–90) was the daughter of Louis B. Mayer, the great Hollywood producer and co-founder of MGM. She had been married to David O. Selznick, producer of Gone With the Wind. *In her own right she had produced many successful stage plays, notably* A Streetcar Named Desire, Bell, Book and Candle *and, relevantly to Cecil, Enid Bagnold's* The Chalk Garden. *Laura knew her and talked about her and she was a fascinating figure in Enid's autobiography.*

Back at the hotel I decided to ring Mrs Selznick. I got straight through. We began to talk – she thanked me for my nice letter. I explained what I was up to and asked if I could see her. 'I think that would be a great disservice to both of us.' I was horrified. She hated Cecil and didn't want to talk about him. She didn't want to do him down. Yet she went on talking. (It was later suggested by Leo Lerman and John Richardson† that this was out of loneliness and meanness – if she saw me, she'd have had to give me a drink.) She still has the 1938 magazine with the 'Cyk' drawing. There was a corsage, a box of roses, and a place card – the names of Mrs Selznick and Mrs Goldwyn appeared on them: 'He [Cecil] hated show-business people invading Long Island.' But Mrs Goldwyn hardly qualified as she did not mix in

* Elaine Schaub, who left to get married soon after this time.
† Leo Lerman (1914–94), and (Sir) John Richardson (1924–2019): see notes on page 120.

those circles. I said he disguised it in later life. 'No, he didn't. He paid heavily, very heavily. He was punished. I wouldn't use him, I couldn't use him . . .'

Then Enid asked her to use him. 'It meant so much to her to have him do the clothes. He did a very nice job. He was no trouble, behaved beautifully. But in Boston he was foul to Enid.' Later he would speak to neither of them. She [Enid] wrote to him when his mother died, but when Irene met him at a party at the Bruces',* she asked him: 'Have you written to Enid?' (This after Roderick died.)

'No, I couldn't.'

'Oh! Have a heart.'

'He was so awful to her – terrible – hateful to her in Philadelphia, hateful to her in New York. It was dreadful. He was disregarding whatever she had done for him.'

She used to say, 'You mustn't mind Cecil. He's amusing and he's such a darling.' She said, 'It wasn't in the best interests of the play, but Enid practically promised it to him.' She explained, 'I did tell Cecil about the set. It was Enid's decision. Binkie† was only too pleased not to use him . . .'

Irene said, 'Cecil was always civilised to me, but the things he was saying behind my back!'

After the first night in Boston, he didn't speak to Enid for four and a half weeks, and he still expected to be used in London. She still thought she'd get him back. She grieved over him but she didn't want him in London.

We then discussed Enid. She said that the letters were very, very legible. She longed for her (Irene's) book. 'It meant attention again, which she adored.' Irene wrote to her: 'You are in my thoughts in the forthcoming weeks.' She said she had been up in the attics and seen all the papers. She was one of the prime forces for Enid's books. 'There were all these gems coming out. I told her, "Don't spill them to people. Keep paper everywhere. Write it out. *You*'ll have a book."' She was worried about Frank Harris. 'It's so shaming.' She asked the

* David K. E. Bruce (1898–1977), US ambassador to the UK, and his wife, Evangeline (1914–95).

† Hugh 'Binkie' Beaumont (1908–73), theatre manager, for many years the *eminence grise* of London's West End Theatres.

children. They said, 'Oh, Mamma, we couldn't care less.' So she did
it.

Then back to Cecil . . . and her best statement: 'He was not the
White Knight.' She said that to the things he did the best he attached
the least value. He despised his photography because it came easily to
him. He wanted to be a designer and a playwright. He was bitterly
jealous of Enid – forced her to get Harold Freedman* to read *The
Gainsborough Girls*. 'I had to read it.'

I said that he [Cecil] and Enid used to consult each other over
plays.

'Once I took over with Enid that was the end of it. Before that he
was giving her lots of advice. He couldn't believe he wasn't the
playwright.'

She said he was very good at photographing the sets. 'A lot of
photographers are very *chi-chi* about it, but in a few minutes he got
wonderful results. And he wouldn't accept extra payment. It would
have lowered him . . . Photography was a means to an end to people.'

'On the whole he had a very good time of it,' she concluded. Yet
she did not conclude. She always went on. 'He had no end of rows.
He had great flair, great eye. He was not that inventive. He resented
Oliver Messel. Oliver was a giant, a great friend of Capote – Cecil
thought he was going to do *House of Flowers* but Peter Brook† wouldn't
have taken him on if he had. Of Truman Capote she said, 'The truth
isn't in him. Take everything with a pound of salt.'

Then came George Cukor:‡ 'George went white speaking about
him. Cecil did the costumes for *My Fair Lady*. However, the costumes
became more important than the direction of the piece . . . The tail
wagged the dog,' as she put it.

She also said: 'I'll tell you one person you won't be seeing and that's
Garbo . . . I know . . . you wrote to her and you didn't get a reply.' I
said I would approach it another way.

* Harold Freedman (1894–1966), Broadway theatrical agent.
† Peter Brook (b. 1925), theatre and film director. He directed *House of Flowers* in the
USA in 1954. Capote's biographer wrote: 'Rarely has a show wasted as much talent
as *House of Flowers*.'
‡ George Cukor (1899–1983), film director. He and Cecil fell out spectacularly in
Hollywood in 1963.

Fifty minutes after we began talking, she said, 'Mr Vickers, I wasn't going to talk to you at all. I seem to have helped you rather a lot.'

I was absolutely thrilled. It could not have been better.

New York, Thursday, 28 May 1981

A quick bath and then off to Diana Vreeland's apartment just behind the Regency. There are two efficient porters at the door and one is soon up in the lift. A portrait of Diana hangs outside her door. A maid answers. Urged to accept a drink, I was left to savour the atmosphere of the apartment. I soon came to the conclusion that there was nothing in it that I did not *want*. (I don't go in for little porcelain heads much.) But the so-called 'Garden in Hell' was wonderful – a rich, red with flowers painted on it, a sofa stacked high with cushions, minute chairs beside it, one table which was relatively free of clutter, but the others covered to the last inch. Then there were bookcases filled with enviable treasures – walls covered with Bérards and the picture by Cecil Beaton which Diana had had the glister removed from. I had time to look before Diana emerged and we talked before the other guest, John Bowes Lyon,[*] arrived.

It was a good evening from the Cecil Beaton point of view. Diana used to call him 'Cecilia'. She said he entered with gusto into anything he did. John said that the Garbo thing was made idiotic by friends and was something that meant a lot to both of them. Diana was a great relief when she said anything I found [about Garbo] was OK to publish. It was different me doing it than him. She believes it killed him – the knowledge that it was in the open. She said, 'Don't feel bad about Garbo. She's tough. She can take it.'

Garbo would come to New Year's Eve parties and jump up on the side-bench and call out, 'Here's a toast to President Roosevelt!' Diana said she was the liveliest and most entertaining guest you could ever hope to meet. She said that Sam Green[†] was the only human creature she ever saw. (I had spoken to him in the morning: 'So you're writing

[*] John Bowes Lyon (b. 1942), a distant cousin of the Queen Mother, then living in New York.

[†] Sam Green; see note on page 127.

about the late Sir Cecil . . .' We meet for lunch on 12 June.) Evidently Sam owns various houses on Fire Island and Garbo goes there from time to time. She remains in seclusion.

The dinner was delicious – smoked salmon to start with, a chicken (made as for old people). Afterwards we drank masses of framboise. It became later and later, and we went on talking. Diana said she hadn't seen John talk like this before.

Later, when it was time to go, he and I went down together. He said he was meeting someone at Xenon and would I like to come? I accepted and we set off (Diana having kissed both of us goodbye). There was a small group outside and we went in through them. Inside it was huge – an old Henry Miller theatre. There were many wild characters dancing happily around. Huge mirrored globes hung from the ceiling and laser beams hit them as they turned, sending dazzling sparkles in all directions. Girls dressed in all colours and in garments that varied from chiffon ball gowns to hot pants were busy working off the calories. I was introduced to several people but caught no names.

I did recognise Andy Warhol, however, and was surprised by his strong handshake. No words passed, though, and this strange emaciated figure then turned to a young boy who was sitting beside him and began to osculate with him. Meanwhile louche figures began to expose their derrières dancing high up by the loudspeakers. Otherwise it was all normal and a great deal more impressive than anything one would see in London. At times balloons fell from the ceiling as did multi-coloured feathers from on high.

As these bright creatures danced, John showed me a private upper room with a shower off it. I bet there have been some happenings up there in the past – nude frolics, copulations and worse! It was nice to be away from the noise. He told me more about Sam Green. He doesn't think that Garbo does entirely trust him. Sam's main claim to fame is that he got a lot of money out of Yoko Ono. She was very rich in her own right – sort of Miss Mitsubishi. She used to send Sam and John Lennon round the world to terrible places.* He used to

* Evidently Yoko Ono had a habit of sending people on these global circumnavigations for reasons that are unclear but certainly as a kind of test.

pretend he had gone, then get people to send postcards from each place. Meanwhile he stayed in New York. But he conned Yoko good and proper. John didn't think I should trust Sam and certainly I should not hand over the picture of the rose.*

New York, Friday, 29 May 1981

I went to Diana Vreeland's office in the Costume Institute to copy out her Cecil letters.

Elaine put me into a red office where I was able to copy bits out. Stephen Jamail arrived and talked. He's Diana's amanuensis, a private secretary always on call. He said Diana would never *ever* ring him at six in the morning, though she might well call him up at 1 a.m. He spoke also of travel. Elaine said, 'Some people we know travel with fifteen pieces of luggage.'

There was a good moment when Stephen called out, 'Do you want me, Elaine?'

'I *always* want you, Stephen.'

The humour in it was not lost on me.

Roslyn, Long Island, Sunday, 31 May 1981

I went to stay with Sonny and Milo Gray, she being a niece of Gladys. Nicholas Lawford (1911–91) came to lunch. He was the stablemate of the photographer Horst, about whom he wrote a comprehensive biography in 1984. He had been private secretary to Lord Halifax, Anthony Eden and Ernest Bevin, had been at the wartime conferences such as Yalta, and later wrote articles on American society to accompany Horst's photographs in Vogue, House and Garden *and* Architectural Digest. *He published his autobiography,* Bound for Diplomacy, *in 1963.*

Nicholas Lawford kindly suggested that I might like to come over and meet Horst. He told me he was rather bitter about Cecil, who had kept doing terrible things.

* Cecil's bequest to Garbo. This was hopefully a way of getting to see her.

Horst (1906–99) was in some ways a rival photographer to Cecil. Coming from a middle-class German family, he had studied art in Hamburg. By meeting the eccentric photographer Baron George Hoyningen-Huene (1900–68), he was propelled into the artistic beau monde of Paris. He photographed society figures, models, and the interiors of palaces and houses, working with Vogue *and other magazines. When I told Diana Vreeland that I was going to see Horst, she said, 'Hmm, that'll be interesting. One photographer talking about another photographer. He did some interesting things, but fundamentally . . .'*

On arrival at Horst's house we went on a long tour of the property, past avenues, trees called 'Mona' and 'Eddie' after the Bismarcks (the tree that flourishes is the one known as 'Mona'). It was very pretty.

Later Horst arrived and he was a small Austrian [in fact German] with prominent teeth and white hair. He grinned. Presently I went over and talked to him. He had been the boyfriend of Hoyningen-Huene years ago, whom Cecil admired. When he and Nicholas got together, Cecil said, 'But I simply don't understand the chemistry of it.' Cecil clearly rather disliked Horst – some say because Cecil thought he had the fashion world buttoned up and then Horst appeared on the scene. Cecil used to change his emphasis if ever it got rough in one area. When the photography was in hot competition he went off and became a stage designer. Horst said that Cecil never once mentioned him in any of his books and in the one with Gail Buckland[*] he was most dismissive. He said that Cecil reviewed a book of Horst's in the most vicious way. For this he was not forgiven. Horst said that Cecil once made him play out a charade in Austria – a difficult word – and laughed at his discomfort. 'At that time,' said Horst, 'Cecil was having an affair with David Herbert, so I had a little affair with David.' Both Horst and Nicholas laughed at the idea that Cecil and Garbo had had anything to do with one another. 'He made it up. He mistook her for Patrick O'Higgins.' Even Nicholas said, 'Well, I went to the theatre with them and I can tell you he wanted something wholly different. In fact it was me that he wanted at the time.'

[*] Gail Buckland (b. 1948), produced *The Magic Image* with Cecil in 1975.

New York, Monday, 1 June 1981

Diana Vreeland directed me to Leo Lerman (1914–94), who worked for Condé Nast for fifty years, invited me to lunch with (Sir) John Richardson (1924–2019), an urbane Englishman, now integrated into New York life, a well-known art historian, who had lived for some years with the rather difficult (and dodgy) dealer, Douglas Cooper. He would go on to write a multi-volume magisterial biography of Picasso.

Leo Lerman is a large, bearded man who could well be a *New Yorker* figure. He is the books editor of *Vogue* but some say art director. His guest was John Richardson. He is Caroline [Lowell]'s friend – he writes reviews for the *New York Review of Books* – and an art dealer. He's smooth, English, a big man with a bland look. He could be a senator. Yet underneath he is a sadist . . . The combination of Lerman and JR meant that we got a lot of talk about Cecil vis-à-vis sex.

Lerman said he'd seen Cecil emerge from the Dakota one New Year's Eve and have a clinch with Laurence Harvey.* JR said that Peter Watson had been murdered. They spoke of Ruth Ford, who has agreed to see me. 'She was an expert at making gay men feel *butch*.' Also she was 'said to be an expert cock-sucker'. Really! Her mother was a Mississippi bar hostess and she and her brother, Charles-Henri [Ford] had come to New York and had a great success.

On the doorstep they discussed Diana V and quoted her wonderful expression: 'My *voo-doo* is better *chan* your *voo-doo!*' (I like it.)

John Richardson helped Leo L into a car – he's old, has been ill (Oh! That awful story about the doctor looking up his rectum and saying: 'Aha! I see you like ze Richard Strauss.') He told me that the last time he saw Cecil, he helped him into a car. Cecil's leg wouldn't go in. 'Oh! Give it a kick,' he said. 'It's just like a debutante's train.'

* Laurence Harvey (1928–73), film actor, particularly remembered for *Room at the Top* (1959).

Reddish House in the spring of 1980.

The Winter Garden.

Cecil's empty chair in the library.

Cecil's hats.

A selfie of the author in
the drawing room.

The door to the garden.

Eileen and Brian Blick making plans.

Grant in the Winter Garden.

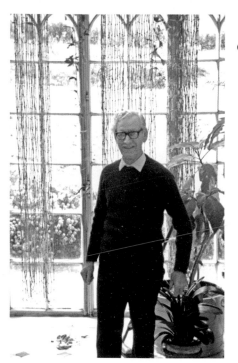

John Herbert, of Christie's,
showing a picture to the press
before the sale, June 1980.

Enid Bagnold at Rottingdean,
July 1980.

Diana Cooper at Rottingdean,
May 1980.

David Herbert's house in
Tangier, July 1980.

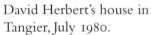

David Herbert in his house.

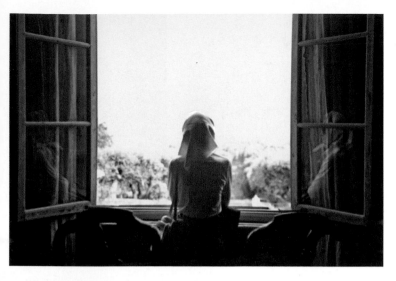

Villa Cetinale,
Italy, August 1980 –
Clarissa Avon.

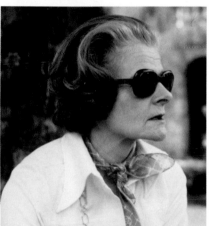

Villa Cetinale, Italy, August 1980
– Clarissa at lunch.

Villa Cetinale, Italy, August 1980 –
The villa, seen from the garden.

Villa Cetinale, Italy, August 1980
– Tony Lambton at lunch.

Horst in his garden,
May 1981.

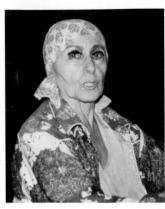

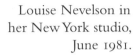

Louise Nevelson in
her New York studio,
June 1981.

John Bowes Lyon with two friends and Mary Richardson in a VIP room at Xenon,
November 1981.

The landing of Stephen Tennant's
house, Wilsford Manor.

The rose that Cecil bequeathed to Garbo.

Cathleen Nesbitt, about to go on stage as Mrs Higgins. New York, November 1981.

Ginette Spanier at Laura Marlborough's country house, June 1982.

Anita Loos, author of *Gentlemen Prefer Blondes*, in 1927.

Clarissa with V. S. Naipaul at Alvediston, summer 1982.

The author with Sir Sacheverell Sitwell at Peggy Willis's house, March 1983.

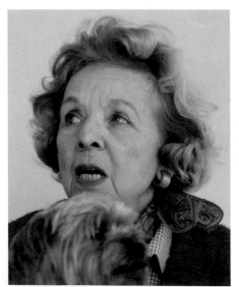

Tanis Phillips, February 1983.

New York, Tuesday, 9 June 1981

I had my mission to deliver the rose picture to Garbo, so I had contacted her lawyer, Mrs Lilian Poses. She called me.*

'I've been hearing some awfully nice things about you,' she said. I agreed to drop the rose into her office later in the day . . . They were expecting me, and the lady at the reception desk asked to see the picture. Mrs Poses is a tough lawyer with a blue rinse and a kind, friendly face. I'd rather have her on my side than against me, I swiftly concluded.

She told me that Garbo was now in California but may be back soon, possibly before my departure. She told me how it was that she got the job of lawyer. Garbo was looking for a new lawyer and she was recommended. Then she left the party or gathering where she was, met someone else in the lift and asked, 'Who's the best lawyer in New York?'

'Lilian Poses.'

Then she met another friend in the hall: 'Who's the best lawyer in New York?'

'Lilian Poses.'

As Mrs P said, 'The way her mind works, she became so suspicious that she never called me.' But later Garbo arrived at her home one day and asked, 'Who advised you to buy these?' pointing at Utrillos. 'No one. My husband and I like them.' On the strength of that she hired her.

She said that on one occasion she told Garbo, 'Now you get out of town. I'm about to make the most enormous row ever.' Mrs Poses said that, whatever happened, I should contact her when I got back to New York. She'd like me to come to dinner. I left her a copy of the royal wedding book . . .

New York, Sunday, 7 June 1981

Ruth Ford (1911–2009) was an actress and model, and the sister of the Surrealist collector and author, Charles-Henri Ford. Brother and sister came

* Lilian Poses (1908–94), famous New York lawyer.

from Mississippi, arriving in New York at the time of the depression. By 1937 she was modelling for Carl van Vechten, Man Ray and Cecil. She acted in Orson Welles's Shoemaker's Holiday. *Stephen Sondheim said that in another century she would have been one of the great courtesans and salonnières. She was also a muse.* West Side Story *emerged from a meeting between Sondheim and his librettist in her drawing room in Manhattan. She was married to Peter Van Eyck and later to Zachary Scott, both actors. She was at one time involved with William Faulkner (though not his mistress), adapting his novel,* Requiem for a Nun, *for the stage. In the 1970s she was involved with Dotson Rader, a former male hustler who became a part of the campus revolution in the 1960s. She was twice his age. By the time I met her, he had departed and she was estranged from her daughter.*

She lived in the Dakota, later inheriting her brother's apartment there, so that when she died her estate was said to be worth $8.4 million.

The Dakota is a huge dark edifice and famous. Recently it became more famous as on the pavement outside it John Lennon was shot dead by a mad assassin (some kind of frustrated fan). *Rosemary's Baby* was filmed there too. I went to the main desk. There are guards and porters, and an entrance like that of a prison. The lift inside, all enclosed in wood, has a seat in it, which one needs as it is interminably slow on its progress. Of course I hoped to see the dark-glassed figure of Yoko Ono or some other star but nobody appeared.

Ruth Ford is a charming woman with fair hair and a long kaftan. She is extremely friendly and welcoming and lives in rather a nice apartment. The walls are hung with Tchelitchews – her brother Charles-Henri had a long affair with him. (Leo Lerman: 'He took one long look at Charles-Henri and that was that.')

Ruth Ford, having promised to tell me lots about Cecil, didn't have much to say. She loved him; she used to stay with him. She had often been photographed by him. These she showed me. She seems to buy anything concerned with herself, and she tells one things about her life – a play she produced, with photographs by Tony Snowdon.

She had an extraordinary romance with Edward James,[*] and he gave her a lot of Schiaparelli dresses, which are now in the V and A. 'Cecil

[*] Edward James (1907–84), eccentric Surrealist collector, who lived at West Dean, near Chichester and later in Mexico.

told me I helped put Schiaparelli back on the map.' She still sees Edward James, and again she showed me photographs of them, in Ireland – she was hugging him warmly. There was a lot of the actress about her. I find myself in a muddle about her. Part of her I liked enormously and part of her I found very silly. I think she is a nice, silly, misused woman, who doesn't really understand the world. She was furious with Stephen Tennant because he wouldn't see her when she was in London last summer. She asked me to send him her love and also to rebuke him. 'I want him to feel bad,' she said – a vain hope.

That was, as they say, about the size of it.

After our discussion she took me to meet Dale Keller,* an extraordinary figure. He owns an apartment overlooking Central Park from six or eight huge French windows. It really was quite a sight – green treetops and the famous New York skyline in the distance. He told us that there had been a crisis during the weekend. Rudolf Nureyev's shower had overflowed into Lauren Bacall's bathroom on the floor below. About this there had been a fierce row . . .

Ruth Ford and I left. As we reached her door, she suddenly said to me, 'Now there's something I must tell you which embarrasses me very much.' I waited. This was the classic situation. You wait for hours and then on departure comes the *real* story.

'Cecil,' she said, 'once described me as one of the ten most beautiful women in the world.'

Having said that, she slipped into her apartment and disappeared behind the huge door.

New York, Wednesday, 10 June 1981

I went to see John Richardson. Marianne Hinton, Patrick O'Higgins's niece, urged me to look out for brackets on the wall of his apartment where he would tie up willing accomplices to whip them. I found none, though there was some

* Dale Keller (1929–2016), architect and interior designer. With his wife, Patricia (b. 1926), he was president and she chief designer of Dale Keller & Associates Inc. Together they created the largest firm in the world, specialising in interior design for the hospitality industry, operating to considerable effect in Asia and the Middle East. Their achievements were formidable. They rescued and restored the Taj Mahal Hotel, in Bombay (Mumbai), and the Manila Hotel, in the Philippines. They won the Lifetime Achievement Award in 1999 for their contribution to hospitality design.

Japanese pornography in the bathroom. Such was his reputation that on my
return to London, my literary agent, Gillon Aitken, amused himself by asking
me, 'You didn't submit, I hope, Hugo, to any of his . . .'
 'No, Gillon, indeed I did not.'

John Richardson had two stories about Stephen Tennant. One was in
the war, when James Bailey's moustached father* leased some kind of
land from Stephen. He went over to Wilsford and came back fuming.
The lease reeked of scent.

 Then he said Stephen once went to a shop in Salisbury to order a
cushion. The shop was in the Close, I think. He said, 'I want an
enormous one.' So they made him one about eight feet by six. 'Oh,
no!' he said. 'I meant something bigger. I want it to fill a whole room.'
John Richardson said, 'It was about that time the family thought they
should do something about Stephen.'

That evening John Bowes Lyon took me to a dinner hosted by Pepé Viviani.
Carolina Herrera, a ballerina called Alison Woodard and Maura Moynihan
(daughter of the senator) were at the table. We went on to Xenon once more:
'I was dazzled by the falling feathers and balloons, by the New York skyline
which lit up in neon, and by the models of marvellous kissing couples that lit
up and approached each other, finally their lips meeting.' There I met Kerry
Kennedy,[†] daughter of Senator Bobby Kennedy who was assassinated in
1968. She said she was a friend of Sam Green. 'I wish I was having lunch
with Sam Green on Friday,' she said.

New York, Thursday, 11 June 1981

Sleepy and what a day ahead of me . . .

James Berry, who had met Cecil with Robert LaVine,[‡] and had worn a long
cloak at Cecil's funeral, had invited me to the writer, Anita Loos, and the

* Lieutenant-Colonel Frederick Bailey (1880-1951), married Lady Janet Mackay.
Their son was James Bailey (1909-44). They lived near Wilsford, at Lake House.
† Kerry Kennedy (b. 1959), later an international human-rights activist. She was
married to Andrew Cuomo (now Governor of New York) between 1990 and 2005.
‡ W. Robert LaVine (1919-79), 'Bob' or 'Ace', costume designer who worked as

sculptor, Louise Nevelson, on the same afternoon. He was a photographer and had evidently made a lot of money, designing and selling T-shirts. He had strong views about how I should approach writing the biography. I had talked to him about Cecil publishing The Happy Years, *in which he revealed details of his affair with Garbo.*

He said that Cecil had made many parts of his life public, so there was no reason to hide this. He did think there was a large element of fantasy in it. 'It was a process of his fantasy, not a strong reality, like a tree. He had the need to express himself as a full man. That woman offered a possibility of achieving what he wanted.' He thought that Garbo was more 'subtle in her sexuality'.

We arrived at West 57th Street, and went up to the bright and sunny apartment where Anita Loos lived with her maid, Gladys. She was clearly high on something and rushed about the apartment on various missions during our visit.*

Anita Loos (1888–1981) was the author of Gentlemen Prefer Blondes, *and the first Hollywood caption writer to make the captions in silent films funny: 'Fate keeps on happening' was one of her lines. In later life she was asked what a girl's best friend was, these days, and she replied, 'Her job.' She was also asked what gentlemen prefer, these days, and answered, 'These days gentlemen prefer gentlemen.'*

special consultant with Diana Vreeland, and for Travis Banton; he assisted Cecil in designing Raffles in New York; in 1976 he designed the costumes for a revival of *My Fair Lady* (1976); nominated for a Tony Award (1970) for the Broadway play *Jimmy*; designed costumes for the landmark gay film *The Boys in the Band* (1970); and author of *In a Glamorous Fashion – The Fabulous Years of Hollywood Costume Design* (1981). His stablemate was Robert Prairie (d. 1989). At some point he walked off with a dozen of Garbo's letters to Cecil, on a visit to Reddish House. These were sold after Prairie's death.

* Gladys Tipton (1904-?), who became Anita's maid and very much one of the family since about 1944; she was twice married in early life. Gary Carey, Anita Loos's biographer, wrote, 'Gladys has always been vague about her past.' She accompanied Anita on all her travels. Carey also revealed that since November 1980, Gladys had suffered from a sex urge, that Anita was now scared of her, that it was somewhat apparent that she had taken to the bottle. Anita's family were naturally suspicious of her.

Anita Loos was almost the tiniest person I ever saw. She was minute, a huge head and a tiny little body, big goggle glasses and a smart bright blue and white patterned trouser suit. She came and sat down on a tiny little chair while I sat on the sofa and James took photographs discreetly, and Gladys yelled and screamed and generally made conversation impossible. 'Oh! What a pity he hasn't got a tape recorder. Maybe I've got one. Let's see now,' and so on.

Unlike a lot of the New York people who are very bitchy and vicious, I found Anita Loos absolutely charming, very friendly, intelligent, and generous-hearted. She said she knew Cecil so well that it was almost impossible to remember specific things. She said, 'When I met Cecil we clicked immediately. I took him to Hollywood. Yes, he met people through me but he was popular and he soon didn't need that. My husband was much older than me at the time, and he was jealous of Cecil. I had to put him right on that one.'

She said that she thought Garbo was 'a monster'. She said, 'Any attempt at a relationship with that woman was bound to be a disaster.' I asked whether she thought Cecil was a happy man or not. 'No, he was not happy,' she told me.

That I'm afraid is the gist of it. But it was fun looking at old photos and seeing her bedroom where even now she writes each day, lying on a little chaise-longue. She was tremendously friendly.

Gladys, meanwhile, made a great pretence of not wanting to be in any of the photos. Yet she knew exactly when they were being done. She was just playing an extraordinary game.

Anita Loos said I could always write and ask anything more that occurred to me. And Gladys rang up Lillian Gish on my behalf.

Sadly, Anita Loos died soon after this, on 18 August 1981. There was to be an exhibition in the Grand Central Art Galleries at the Biltmore Hotel: 'Anita Loos and Her Friends'. Anita had agreed to attend the opening on 20 August, somewhat reluctantly as it embarrassed her. A few days before, most of the Biltmore (one of New York's iconic landmarks) was demolished despite its protected status. The show went on. Helen Hayes, opening the exhibition, said, 'Anita always knew when to leave a party . . .'*

* Helen Hayes (1900–93), first lady of American Theatre.

From there James and I took the subway downtown to visit Louise Nevelson (1899–1988), the exotic American sculptress, known for her giant works, and for wearing striking clothes and false eyelashes made of mink.

The door was opened by an extraordinary woman (it was a day of extraordinary women). The sculptress herself was more conventionally eccentric. She is over eighty, but still powerful and strong. Her head was covered with a scarf, and she wore a floor-length kaftan. The room in which she received us had massive sculptures by her as panels, in her very distinctive style.

She only met Cecil Beaton on that one last visit and he came to the house and photographed her. They also dined. She liked him, but had some reservations. 'I didn't want to get too involved,' she said. 'There was something about him . . . I think it was the pity that his illness caused.' But she would have liked to see his house.

New York, Friday, 12 June 1981

I had heard a lot about Sam Green (1940–2011), as far back as the warnings issued by Grant at Reddish House. 'Slippery Sam' was one nickname applied to him, and the New York Times *would produce a telling description in his obituary: 'a fabulist, an unabashed poseur blessed with good looks, a natural flair for storytelling, a knack for self-promotion and a markedly elastic relationship to the truth'.[10] Nothing about Sam was straightforward. The note I wrote on him, guided by him, on pages 41–42 of* The Unexpurgated Beaton *requires re-examination. He was not a descendant of the Adams family; he was not a relation of Henry McIlhenny.[*] He was an early promoter of Andy Warhol when director of the Institute of Contemporary Art in Philadelphia. He did have a facility for making friends with famous figures such as Cecil, Greta Garbo, John Lennon and Yoko Ono. He had an affair with Barbara Baekeland, who was said to have seduced her son in an attempt to convert him to heterosexuality, as a result of which he stabbed her to death. (When the police arrived, he was telephoning for a Chinese takeaway.) Sam was good company and could be very funny. He lived on the edge.*

[*] Henry McIlhenny (1910–86), extremely rich Philadelphia-based collector and connoisseur.

My last day in New York and a very hot and hectic one . . . I had a bit of time before my lunch with Sam Green. At the chosen moment I rang his bell. He also has a youth dwelling there. He was not as described but he was as I imagined, slightly bearded, very wiry, very agile, very, very smooth. 'Let's go to Mortimer's, like everyone else,' he had said.

In his apartment, which he was busy decorating, he was making elaborate plans involving the arrival or non-arrival of a huge cheque from Boston. He was clearly exceedingly worried about this. The youth was left in charge. He showed me a marvellous room, which I suppose he had created. It looked like something out of Versailles. We had a quick drink.

He had heard of me already from several sources – John Richardson and Kerry Kennedy. He looked at the copy of *Madame*. He said it was the only good thing Patrick O'Higgins had ever done. He said the way [O'Higgins] behaved over the *Town & Country* article* was appalling. 'I'm surprised Cecil stayed friends with him.'

We went to Mortimer's, which is sometimes known as Mortheimers because the owner is Jewish and doesn't like to be thought so. There was much vying for where we would sit and there came the first subtle joke about me paying. Slippery Sam likes to unnerve one. That is his art. I can see how people would fall for his gambits. He is ultra-smooth.

'There's one thing I am reticent about and that is my friendship with – shall we call her Miss Brown? Everybody else does.'

Yet he told me lots about her, some of it very good stuff. 'So – you want to know did they sleep together?' he launched off. He doubted it.

'First of all, he was a poof. Second, he got crushes on people, but how good he was at doing things about it, I don't know. And let's face it – *tears in the pillow do not lead to stains in the sheet*. Third, he was always pursuing stars, but he was *too star-struck to star-fuck*.' It was coming thick and fast. Sam thought it was a fantasy in the mind. He said that Garbo was to this day a very warm and friendly person. If

* Cecil was furious with O'Higgins for concocting an article in *Town & Country* about a made-up weekend, which involved the Queen Mother and others. This was adorned with a Hirschfeld cartoon.

one accompanied her to a museum, she might easily press her knee into the back of your leg and put a hand on your shoulder. Cecil probably exaggerated the physical side of things.

He said that Cecil claimed to have had an affair with Gary Cooper out in Hollywood. He said that he had never heard of Cecil Beaton until it was suggested that he, Sam, might take him on an expedition to an art gallery. They got on well together. Sam said he was a nice person to travel with – he didn't mind any discomfort in the cause of seeing things. He said that he had been responsible for taking Garbo to Broadchalke. She was paranoid about seeing him. They spent ages at Salisbury station with her saying, 'But he'll use it in some way' – as though he'd have photographers perched in the trees. But, as in Friedrich Ledebur's story, she had no choice. Sam said, 'I figured it would do him good. And she wouldn't suffer from the experience either.'

He said that on departure, Cecil threw his arms round her and said, '"Greta" – she hates being called Greta – "the love of my life."' Garbo winced and Sam caught her eye. He reckons that to sign the visitors' book was her way of escaping from his arms. Sam said: 'I was horrified that he would use his illness that way. It was revolting.' He went on to say: 'It was an experience that she had no desire to repeat.' Therefore, when Cecil visited Cartagena and fell ill, Sam was in a quandary. Cecil could not leave and Garbo was due to arrive at any moment. In the end by the skin of his teeth, the situation was saved. Sam conducted Cecil to New York, picked up Miss G and took her down there.

So all Grant's made-up tales were not as clever as poor Grant thought. (Grant had said, 'Sam, I've been talking to friends of yours. You've been seen in nightclubs.' Sam must have loved that, though he referred to Grant most deprecatingly: 'Only just tolerable.')

Sam also told me that the Sotheby's deal was a lousy one. He said he offered Cecil double the money but Eileen wouldn't have it.*

A curious character, Sam Green. At the end he paid, 'You English have certain problems.'

I returned to England after a fascinating trip.

* From my later knowledge of Sam, Cecil's chances of Sam paying him were slight.

Send, near Guildford, Friday, 10 July 1981

Lady Lindsay of Dowhill (1902–93) had been born as the Hon. Loelia Ponsonby, daughter of Sir Frederick Ponsonby, treasurer to King George V. She had been part of the Bright Young Things and had then become the third wife of 'Bendor', Duke of Westminster. He had hoped for a male heir, but this did not happen, and the marriage ended badly. She had written a popular book of memoirs, Grace and Favour. *In later life she married Sir Martin Lindsay, a one-time polar explorer. He had died on 5 May that year. She was not overly generous. Alastair Forbes had once popped into a kitchen to say how much the duchess had appreciated the service. 'Ah, oui, Madame la Duchesse. Toujours les compliments, jamais les pourboires!'*[*]

I drove Diana down to lunch with her at her house in Send.

The house was lovely, a vicarage once, covered to the roof with roses. A butler greeted us.

'Good morning, m'lady.'

'You've never seen me before.'

'No, m'lady, but I recognise you.'

A curious exchange.

Loelia Lindsay is a large woman with a rather nice deep voice. (I have met her twice before.) She gave us strong drinks and we talked about Laura. She is quite heated on the topic of Laura. Loelia would have no nonsense. She was anti. Diana came up with good defences, for example that the nurse was found for Ann [Fleming – her sister] on Laura's sole initiative. 'Come on, Hugo. Back me up,' said Diana. I did, to a point.

We lunched in a charming dining room and drank from glasses encrusted with ducal coronets and LW.

We discussed the *bride* [Lady Diana Spencer] and the wedding in general, and I said that the groom was in a black depression. Loelia had heard that.

Cecil was not much discussed except that the Nadder incident was brought up. Loelia was staying with Stephen at Wilsford at the time and he left to get dressed at about 4 p.m. He emerged, looking like a gilded butterfly, long lashes and gold-dust in his hair. She was obliged

[*] 'Ah, yes, the duchess! Always compliments, never a tip.'

to dance with him and he swooned about the floor. She noticed the heavies moving in – Laycock, Feversham, etc. – and feared they would be propelled into the river too, but as the storm rose, so it dissolved. 'Stephen was very beautiful,' she said. 'Now he looks like an old toad.'

London, Monday, 20 July 1981

Clarissa took me to a David Jones exhibition at the Tate Gallery, and then to a party given by Lord Weidenfeld, which was said to be for Barbara Walters, the well-known American television journalist, but turned out to be for the author Anthony Holden, who had produced his own royal wedding book.

The Baron said both of the things I knew he would say: 'Hugo, I'm so pleased to see you. This is the most delightful surprise of the evening.'

Later: 'Now, we must talk presently. There are lots of ideas for the future.'

It was a grand party – the American ambassador and Mrs Louis* (she introduced herself and I didn't know who she was), then the French ambassador and Madame de Margerie.† I had a long talk to him about whether or not Cecil had had an affair with Garbo. John Curtis then appeared and I met Tony Holden again. We had a long talk about the wedding, only interrupted by a Baronial summons to meet Princess Michael again. 'Well, I have been reading both of you,' she said . . .

Wiltshire, Tuesday, 21 July 1981

I set off for Wiltshire to see Eileen and Hal [Burton]. After lunch we took Hal to the station and then to visit Stephen Tennant. In Salisbury I began to feel distinctly unwell. But we went on and arrived at

* John J. Louis Jr (1925–95), US ambassador to the UK 1981–83, and his wife Josephine (b. 1930).
† Emmanuel de Margerie (1924–91), French ambassador to the UK 1981–84, and his wife, Hélène.

Wilsford. Stephen was in bed, surrounded by his usual paraphernalia of objects. He greeted us with delight.

Stephen said, 'My doctor says I'm too fat but I'm a logical person. I'm nice, so the more of me there is the better. But my doctor says, "One day I'll tell you what I really think about you and it will be a day that you won't forget in a hurry . . ."'

He also said to Eileen, 'Of course, Eileen, you only knew a small part of Cecil. I knew him since 1925.'

He made Eileen close her eyes, then handed her various bits of jewellery, first to hold, then to see. And he squirted Max Factor on our hands. That's what did it, I think. I had to go out and be sick. Not once, but twice.

I asked John if I could lie down for ten minutes.* When I did so, I shivered. I couldn't get up and finally stayed the night in that haunted house. One time I nearly got up to go to the loo – but I heard footsteps. I thought, *No.* I had a restless time.

Wilsford and London, Wednesday, 22 July 1981

After some tea from John, I got up. I wandered around the strange house with Mary and saw the new dining room. This was partly to convince her I was well enough to go home (which I wasn't really). She told me about a 'secretary' who stole a nice table and other things from Stephen once.

I called on Stephen briefly to say goodbye to him. He was full of offers of John driving me to London and so on. Then he said, 'Well, come again soon. We'll sit in deck chairs for ten days and do nothing.'

Meanwhile he has written a marvellous piece about Cecil for Eileen to show me. And he's full of lines such as 'Groom your mind.' He's right. I set off back to London in the rain. Back here I found that I had a temperature of 101. I collapsed.

The next days were taken up with the royal wedding on Wednesday, 29 July. Re-reading my diaries I seem to have assessed it privately more succinctly than

* When Philip Hoare interviewed John Skull for his biography of Stephen, *Serious Pleasures* (1990), he told him that my face went 'as white as that marble fireplace!' (p. 396).

I would have been prepared to state in public. By 5 August, I was back plod-
ding through Cecil's diaries. Once again I looked after Alvediston for Clarissa,
my main duty being to walk the dogs.

Alvediston, Sunday, 30 August 1981

I was to dine with Dicky Buckle at Semley in his funny cottage. Another
car was parked outside. Billie Henderson and Frank Tait were there.
They stayed for dinner. I must say 'The Tisbury Pansies', as Clarissa calls
them, showed a different face in all-male company. Frank said that Cecil
told him Enid had an affair with Irene Selznick in New York at *Chalk
Garden* time. That fits. Also he said that Coral Browne[*] had sex with
Cecil. 'He was just like a stoat,' she said. 'It was all over in two minutes.'
Geoffrey Toone[†] had been given drawings – as an object of Cecil's atten-
tion. 'I should have held out and got the drawings,' said Coral Browne.

Dicky Buckle

Billie said he once drove Cecil past Ashcombe. 'Shall we go down?'
he suggested.

'I'd love to, but I daren't,' was the reply.

There was a lot of talk about Stephen Tennant and new stories

[*] Coral Browne (1913-91), Australian actress and film star.
[†] Geoffrey Toone (1910-2005); see note on page 312.

emerged. Stephen and Dicky went to Paris at the same time. Dicky hadn't much money but Stephen said they would stay at some exotic hotel. He had a suite and Dicky had a room under the stairs 'to which I brought various Arabs and so on' – cognisant nodding of Messrs Henderson and Tait. Stephen had been left money by Willa Cather and went along to the bank where it was. He said to Dicky, 'I want to take you out to lunch. Begin thinking of all the delicious things you want to eat. We'll go to Le Grand Véfour.' At the bank, the manager practically bowed. They descended to the vaults where there was a *coffre d'or*. The manager produced one key and looked to Stephen. 'Oh dear,' said Stephen. 'I've left my key in Wiltshire.' So Le Grand Véfour was forgotten and Dicky took Stephen to some lesser place instead.

In the late summer I went to the South of France with my father. It occurred to me that I might be able to scoop in meetings with John Sutro, Lesley Blanch, Princess Grace and Alan Searle.

Monte Carlo, Friday, 18 September 1981

John Sutro (1903–85) had been a friend of Cecil since the 1930s. He had always been independently rich and had been a director of London Film Productions. In his early life he had founded the Railway Club and been a friend of Harold Acton and Evelyn Waugh. He was a superb mimic, and when filming at Ashcombe, he had been dressed as a yokel. So convincing was he that he passed the time with a real-life 'yokel' who thought he was the genuine article. He had married his wife, Gillian (1917–99), in 1940.

I returned from watching the Ruritanian changing of the guard at the palace to find my father already with the Sutros.

Mrs Sutro looked very young at first glance – fortyish. But she must be nearer seventy. She had had her face lifted, her eyebrows removed and wore her hair *à la jeune fille*. She had an excellent figure and was extremely likeable. He looked slightly like Picasso – much older than I had expected and dressed rather splendidly as a Frenchman. He leant on a heavy stick. We went straight into lunch.

John Sutro said of the *Vogue* incident that Rudolph Kommer* was very

* Rudolph Kommer (1886-1943), right-hand man to Max Reinhardt.

influential in helping Cecil out of trouble. I think he was quoting Cecil about Louis B. Mayer when he said, 'He's not as good as you think he is now, or as terrible as you will think him in five years' time.' He told the story of Robert and Lord Berners swapping beds and of dining one night with Lord Castlerosse. 'Doris came in with Cecil and Lord Castlerosse said, "I never knew Doris was a lesbian."' He remembered going down to Hyères with Merle Oberon for Korda in the late thirties and meeting Bérard, Oliver Messel and Cecil. There was always rivalry between Messel and Cecil. When the Princess Margaret–Snowdon match was taking place, JS was staying with Cecil. Cecil was woken up in the night. His comment was 'Not even a good photographer!' He thought Cecil was happiest at Ashcombe. The war changed things and though he had fame and success in many fields it was a harder life. JS thought that homosexual relationships were very difficult to maintain. He said they all went through it – 'I did for ten years, then luckily came out of it' – at Oxford. He said that Peter Watson never reciprocated Cecil's love. And David Herbert stirred it up by saying that Oliver Messel had been given a car.

[Bérard said to Cecil, 'You'll never be a good painter,' and he gave it up – for years – like Henry James, who always wanted to write a play but was told he couldn't. In fact he wrote many plays.]

Then Cecil's own play, which meant so much to him, started well in Dublin, but was killed at Wolverhampton by Sir Donald Wolfit.* He believed that the row between Cecil and Irene Selznick had its origins in a flower shop. When the Sutros went to Monte Carlo, Cecil said, 'You'll end up like Alan Searle.'†

Somerset Maugham told JS that he was very surprised at Cecil's success in New York. English society was easy to get into, but not New York, he thought. Maugham liked Cecil.

When I told John Sutro it was Bob Laycock‡ who chucked Cecil into the Nadder, he recalled a time when someone made up a

* Sir Donald Wolfit (1902–68), actor who starred in and ruined Cecil's play, *Landscape with Figures* (1959), the rewrite of *The Gainsborough Girls*.
† Alan Searle (1905–85), secretary, companion and principal heir to Somerset Maugham from 1944 until the writer's death in 1965. Not entirely uncontroversial. Lady Hartwell, in particular, hated him: 'He should be whipped in the streets of Monte Carlo for what he did.'
‡ Major General Sir Robert Laycock (1907–68), distinguished commando, and later governor of Malta.

lampoon about Pempy Dudley Ward,* based on 'Don't Put Your Daughter on the Stage Mrs Worthington'. Laycock and others were outside his house waiting for him one evening. He was glad to be able to say that he had just signed her up for a five-year contract, so it was unlikely to be him. 'It shows he had a menacing side to him.'

When I mentioned Maud Nelson, he recalled that Lady Howard de Walden cut Oggie Lynn's allowance by two thirds when she found out about Oggie and Tallulah [Bankhead]. Friends were asked to help out. Lady Cunard said, 'I don't mind helping someone when they're on their last crust, but not their last *croûte*.'

It was John Sutro who wrote *Heil Cinderella* and a mock Shakespeare one he dictated in an afternoon to Cecil and David Herbert. Rex Harrison didn't get on with Cecil.

Gillian Sutro said that Cecil could spot a Balenciaga at a stroke. 'His eyes looked through you. If there was a safety-pin somewhere, he'd find it. He had eyes like a woman. If Cecil complimented you on the way you looked, you knew you were all right.' She didn't like the way he'd ask them to stay just before an exhibition. 'It was because he knew I was a buyer.'

The house was always 'very busy', though London was more monastic. The times she liked best were when they were rung up at short notice and asked to dine. Then they would gossip about their friends. 'I had to be very careful what I said about Graham Greene, because Cecil had total recall and after we'd gone, out would come that diary.' Graham Greene is a great litigator apparently. 'Once,' she said, 'they stayed there – Diana was in one room, Roy Strong in another. And they had to share a bed. She took Mogadons and so on, but couldn't sleep. The next day she broke a *cachepot* in the drawing room. She offered to replace it – it was one of a pair – but a letter came from Cecil saying, 'There's just *no* point. You *simply* won't find the one that I like.' Irene Worth† used to take gumboots with her because Cecil made her garden. She said that when Cecil went to stay on the Wrightsmans' yacht, one of the guests was meant to pick up the bill when they came ashore. Cecil's turn came round at Antibes.

* Penelope Dudley Ward (1914-82), actress, daughter of Freda Dudley Ward, married to the film director, Sir Carol Reed (1906-76).
† Irene Worth (1916-2002), actress.

He took them to the Bonne Auberge and got a good rate through Alan Searle.

Mrs Sutro met Garbo once and thought her perfect. 'She mixed her drinks, though,' she said, referring to Salka Viertel* in Klosters.

John Sutro's remark about melons – a Chinese proverb: 'Girls for copulation, boys for pleasure, melons for satisfaction.'

I told them I was going to see Lesley Blanch.

Mrs Sutro told me they are friends though they hadn't seen each other for ages as neither drives. She said that the death of Romain Gary had been a terrible blow to Lesley Blanch. That there was a drama over a man winning the Prix Goncourt with a book that Romain Gary really wrote.

Back to my room and I spied a message. It was from Monsieur de Choisy. He turned out to be Princess Grace's chargé d'affaires. He was very friendly on the telephone. He said that Princess Grace was in Paris, that she didn't have much on Cecil, but that I could ring her. He gave me the number, urging me that it was a number *privé* and that I should not give it to anyone else. There was not time at this moment as I had to catch my train for Menton [to see Lesley Blanch] but he said I could ring from Paris.†

Lesley Blanch (1904–2007) was well-known as the author of The Wilder Shores of Love, *and other books. She had been married to the novelist and diplomat Romain Gary (1914–80), but he had left her for the actress Jean Seberg (1938–79) and they divorced in 1962. That had ended tragically with Jean's suicide, followed by his a year later. Lesley Blanch now lived in the South of France.*

Then I ran. Oh, why in my life does this so often happen? Why is it that in four days at Monte Carlo all my work has to be on one afternoon? Anyway, that's life's joke. I caught the train; it rattled along with the door open through tunnels and then past wonderful views. It stopped at every station and finally at Garavan, the last town in

* Salka Viertel (1889-1978), actress and screen-writer, close friend of Garbo.
† A year later, this was the day of her funeral.

France, I got out and I found Lesley Blanch's house easily. I rang the bell once, twice, but nothing happened. Then she appeared above the jungle of a garden in a pink and white *galabeya* and let me in. Up I went through the mighty tangle and arrived at length at her front door.

I can't describe the house. It was wonderful – Arabic with pictures all over the wall, a carpet on one wall with an icon in the middle, a view over the rooftops one way and the great rocks behind that put Menton into a dip, avoiding the mistral. The outer world faded away – as at Wilsford. A jungle of plants. Delicious tea was served and we had a long talk. I knew we would get on before I saw her. She said later that she knew as soon as she saw me at the gate. We were on the same wavelength.

She was devoted to Cecil. She first met him in the days of *Vogue* and was rather frightened of him. She said that, had she had the confidence, they could have been friends then, but it had to wait. She said there was much more to him than people realised. 'They saw the tinsel image and they looked no further.' Underneath was this great understanding. I remember how he hit the nail on the head when he asked me about Gladys. He knew I cared for her and he very soon had me with a lump in my throat. I remember being pleased that he understood and feeling on the same wavelength.

Hollywood provided the key to her best reminiscences. Cecil hated it. But I think he was grateful for her presence. He used to ring up before a dinner.

'Are you getting dressed?'

'Yes.'

'Isn't it awful?'

'There'll be good grub.'

'It's not enough.'

'The women will wear Balenciaga dresses.'

'They've no idea how to put them on.'

Once they held a picnic. Blinding rain at each end and at their destination. They ended up at the docks. 'Now what? I'd better go and find a sailor.'

He loved the technical side of filming, the expertise of the camera crew, the wonders of the design department, the way the men painted

stained glass on windows. 'Do you realise they've got a whole room full of buttons and buttonholes?'

But he was too dispirited to accept Lesley Blanch's invitation to see a cowboy being filmed. 'I'm not tempted. Not even by the cowboy.'

Cukor would have been exceedingly rude to him. 'Fucking Audrey Hepburn isn't going to have any more fucking photos taken. So get the fucking hell out of here' – that sort of thing.

Cecil also told Lesley Blanch once: 'I have to think carefully of menus. I'm not as grand as Diana Cooper. She can get away with serving stew.'

Lesley Blanch is a great admirer of Diana's. She said she thought her three books were beautifully written. She said that she once told her that the account of Duff's death written to Cecil should be in every anthology. She burst into tears. She greatly admires Enid Bagnold's books too.

She said that since Romain Gary's death, her life was over. Which did not mean that there weren't things she enjoyed but effectively it was without purpose. So there was another subject for thought. The cut-off point. When does it occur? Usually with widowhood, I would say. For Aristotle Onassis, perhaps, the death of his son.

Our talk made me think of the fate of the gigolo husbands, the one who wed Judy Garland and others. The biographer who passes through the pearly gates and has to face up to his subjects – it would have to be Shakespeare meeting Richard III – something like that. (I couldn't cope with it.) And then the moment when *real* life means nothing. The time to leave the party – the time to die.

She spoke of Romain Gary. He could not understand Cecil's love of a house. She, like Cecil, liked things. He had moved round too much. She referred to Jean Seberg as that dreadful actress (he met her in Hollywood where he was consul). She was an alcoholic and a nymphomaniac. 'He should never have married her. He should simply have gone to bed with her. She ruined his life. He once came here and said there were so many problems that the only solution was for one of them to die. In the end, of course, they both died.' She said suicide was an act of courage and of vanity. One could not face the humiliation of the future.

Apparently Romain Gary and she made friends later in life and he often came to see her. They were in touch just before the suicide, but he

said nothing about it. The French government gave him a state funeral. This was never reported in the British press. Many people are writing about him. Douglas Cooper* advises her to but she can't, not yet anyway.

Lesley Blanch gets many visitors, but turns most away. Usually they say things like 'all those Arabs as lovers'. But Shirley Conran† she allowed in. She came with flowers. Now they see each other and recently Shirley Conran wrote asking for details about Arab lovers for a novel: 'She should have gone out there and tried one for herself.'

We spoke of buildings. She said there was too much corruption. But that that would stop under Mitterrand (she hoped). She said that Princess Grace was very ambitious and was behind all the building in Monaco. She said that now they had overdone it – some of it goes on under the window of the palace (as I saw). She said that the Shahbanu‡ was a wonderful woman, well read and intelligent. She said the Queen thought the Princess of Wales's wedding dress 'very Shaftesbury Avenue'.

It got dark. It was late when I left by taxi. She came down to see me out and we moved the dustbin into the street. She quoted a mock diary entry: 'Went to see Lesley Blanch. Had to move dustbins . . .'

Back via the coast and all the little lights were marvellous.

Monte Carlo, Saturday, 19 September 1981

I rang Mrs Sutro, whose husband was in the lobby . . . John Sutro said that his wife had adored meeting me. 'How rarely can one say that?' That she didn't want me to see the flat as it was rather untidy, that she didn't like people to know how long they had been married. She was married in time to stay at Ashcombe in the war, and had they not done so, a bomb would have killed her. It landed just where she would have been sleeping. It was at their cottage, Wood Cottage, Ham Green, that Cecil and Noël [Coward] made it up and became friends, he said. He also told me that Samantha Eggar§ was once a '*protégée* of mine whom Gillian didn't like much'.

* Douglas Cooper (1911–84), controversial art dealer, living near Avignon.
† Shirley Conran (b. 1932), author of *Superwoman*, and steamy fiction such as *Lace*.
‡ Empress Farah Diba (b. 1938), widow of the last Shah of Iran.
§ Samantha Eggar (b. 1939), actress, starred in *The Collector* (1965), took part in Cecil's play, *Landscape with Figures* (1959).

I came back to my room and bravely telephoned Alan Searle. He was there and I told him quickly what I was up to. He said, 'I'm going into hospital for a month but after that I'd be glad to see you.' It won't work. It is funny – all these people I talk to on the telephone.

After Monte Carlo, my father and I drove to Paris. He left me there. I found myself a hotel in the rue de Richelieu.

Paris, Monday, 21 September 1981

I began by ringing Princess Grace. I got through easily. A man answered, who could not get my name right but he put me through. 'Oh, hallo,' she said. 'How are you?'

'I'm fine.'

'And you're in Paris now, I understand,' she said. 'I was sorry to miss you in Monaco. Well, tell me what sort of a book you're doing. Is it a picture book or a biography?'

I explained.

'Well, you've certainly got your hands full. I don't know how I can help. Perhaps you could come and see me one day. How long are you here? . . . Wait a moment while I get my book.'

We fixed Wednesday at eleven. She told me to come to 80 Avenue Foch: 'Eighty, mind, not eighteen. Come to eighty, then go into the square and I'm at eighteen.' I got that. Then she won me by saying: 'All rightee. I'll see you then.'

I was really thrilled and my mood lifted. I had a purpose again.

Paris, Wednesday, 23 September 1981

It was a great excitement to be meeting Princess Grace of Monaco (1928–82): I had been following her since my earliest days. She had been famous before her marriage as Grace Kelly and I had watched many of her films when growing up, notably High Society. *As a teenager I had visited Monte Carlo several times. One evening I was alone at dinner with some friends of my father, who lived there. They had told me how frustrating she had often found life in the principality.*

I took an RER and a Métro and arrived at Avenue Foch. I was a bit early so I decided to wait. I sat down – the bench was soaked in rain-drops. I became wet, uncomfortable and cross at a stroke. But that is the joke life plays. As one wants to look well, so one must be humiliated.

80 Avenue Foch is the entrance to a small private square with little houses quite unlike anything I've yet seen in Paris. There's an embassy or consulate or whatever, and number 18, the private residence of the Prince and Princess of Monaco, has an iron gate, a high fence and then a rather pretty garden.

The butler answered my ring. '*C'est pour la princesse?*' he enquired. He was not a particularly friendly or smart person. He showed me into a morning room. I had time to examine it at some length. There was wood-panelling and a mirror with a divide in it. Lots of fine old books at the back and a few on Impressionists here and there. Otherwise the décor included a lot of Chinese porcelain, two silk-covered sofas opposite each other, with white cushions criss-crossed in silver lines, and on the far side near the desk in front of the large window, a brown-covered sofa with carefully arranged cushions. To sum up, it was very conservative and quite French, very understated. The blue curtains were unlined, there were photos of Princess Caroline, and of Prince Rainier with Princess Caroline.

After about five minutes, long enough to wonder if I should sit down or not (I decided not to), there were brisk footsteps on the stairs, the doors opened and in came Princess Grace.

At first I wasn't sure I recognised her. She is much fairer – do I mean faded almost? – and has a flattish face, a little wider than I'd expected, and her fair hair severely drawn back. She was smart in skirt and pullover, beiges, light blues and greys. She is very nice, very friendly, simple, easy to talk to, open, eager to help.

She motioned me to sit down and we sat opposite each other. She said she had known Cecil for a long time but hardly ever saw him. He had first come into her life in about 1955 in California, when he came to photograph her. 'At that time everything in California went in fashions. Everyone had a car of one particular colour. I had just moved into a new apartment. It was awful, mustard yellow, with paper-thin walls, a swimming-pool that meant every sound was heard. It was clean because it was new. In those days we worked six days a week.

He was determined to come. He kept writing to me and asking through friends of mine.' Finally she agreed. 'He came on a Sunday and I remember this elegant Victorian-Edwardian figure coming in so stylishly dressed and what a contrast he made to this mustard yellow flat.'

He came with his Rolleiflex and there wasn't enough light. She sat on the floor under a lamp and he took his pictures. Then, she said, he designed a poster for the centennial celebrations of Monte Carlo as a resort in 1966 (she was president of the committee). 'I wanted him because his name was synonymous with style and elegance.' Cecil came to Monaco and lunched with them. Then he asked her for a photograph for Raffles in the Sherry-Netherland Hotel in New York and she sent one. (He decorated it.) He photographed her with her daughter Stephanie in 1966.

'Then two years ago he photographed my daughter [Princess Caroline] for *Vogue*. It was a great experience for her – he took all the young French beauties in Paris – but they wanted him to take them in the style he photographed the Duchess of Windsor and Princess Marina and it wasn't entirely successful. They found the style a bit stiff.'

We talked about Garbo. 'She's a very selfish woman. I haven't seen her for ages but I used to see her when she came to the South of France with Georges Schlee. She is a sad person. She waits for people to come to her. My uncle, George Kelly,* the playwright, created a character just right for Garbo, who says, 'He who lives for himself is left to himself.' She said, after having heard about Gladys, 'Your Duchess of Marlborough was probably like that.' It's true.

We talked about shyness and she said, 'Most people are shy especially when they're young.' She said it had to be conquered. She cited 'Prince Charles of England' as an example. I said that horsemanship proved this. She said, 'Now he won't get off.' She said the wedding was marvellous, especially the crowds. 'I was there from Sunday, I suppose. On the night of the fireworks we all went in buses to Hyde Park from Buckingham Palace and the crowds were *so thick*. There were millions of them there, so close to each other. That never happens in Europe.' She said the French were very impressed by the way the crowds followed the police up the route, almost as though

* George Kelly (1887-1974), American playwright, known for satirical comedies.

they were part of the procession. 'Of course I didn't see that,' she said. 'How Lord Mountbatten would have loved it. He adored ceremony.'

Returning to the Cecil generation, she said they all took offence very easily and cut each other dead on the strength of something someone repeated to them. They took it second hand. 'My father-in-law was a bit like that. So was my grandmother.' She said she never took offence from what she heard people had said.

I was very interested in all she said and felt that we'd covered much more ground than I had dared to hope. She was keen to see what he said about her flat and offered to let me have a photo of the Monte Carlo poster if I couldn't find it. As the conversation came to an end after three-quarters of an hour we both smiled at each other and sort of said, 'Well . . .'

On the way out she asked me if I was seeing anybody else. I said I'd seen John Sutro – the name meant nothing – and Lesley Blanch. 'I haven't seen her for ages either. She can be sharp-tongued too,' she said. Yes, I can see that. I told her about the wonderful jungle she lives in and the Arab house. She took me to the door and let in one of two little tabby cats as I went out.

All in all, my trip has been most fruitful. I'm very glad I came to Paris for seeing her.

Send, Saturday, 10 October 1981

I stayed a weekend with Loelia.

I spent the morning buried in albums. Jim Lees-Milne* joined me. He said that Cecil was 'a man who wore a mask' and that it was my job to remove the mask. He liked him better alone than in company. How true of most of us. Perhaps it's not true of married people, however. He looked with me at the Cap Ferrat photograph. I pointed out that Stephen Tennant was immaculate – that Cecil was in an identical pose but that he didn't then carry it off. He failed. His jacket was crumpled and he looked anxious.

* James Lees-Milne (1908–97), National Trust consultant, author and diarist.

London, Tuesday, 13 October 1981

I had known Anne Wall (1928–2016) since 1972, when I was working on Burke's Guide to the Royal Family. She was assistant press secretary to the Queen. My early teenage study of the Royal Family paid off and she found me well-informed, and we stayed great friends until the end. She came to see me, not in connection with Cecil, but to look at the albums I had kept about the Royal Family. So this was not an interview as such.

Anne Wall would have been in good time but, alas, came out of Lexham Gardens and then had to drive right round Kensington High Street. Over the course of a light and sensible lunch we discussed many royal matters . . .

We discussed Cecil's fear of the Queen. She said she thought that Cecil Beaton might have frightened the Queen because she would be modest as a woman. 'She would think he was always photographing very beautiful women and that it would bore him to photograph her.' She said that Prince Philip was very good at sharing people's interests. She was surprised they [he and Cecil] hit it off so badly.

A rather different lunch took place the following day.

London, Wednesday, 14 October 1981

This was special because Ali Forbes came to lunch and we made friends with one another. He is quite different when alone with one. He talks easily and doesn't have to do this shouting and showing off.

We had a lot of royal talk. He seems to know them all. Of Cecil himself he spoke with great friendship. 'There are so few people in the world,' he said, 'that one both likes and admires. I really loved Cecil.' He met him in the war. He was at Broadchalke when Garbo nervously asked, 'Shall I hang up my hat with Mr Beaton?' Cecil did not know a great deal about the ways of woman. He would ask Ali: 'Can a woman have a period that lasts a whole month?' He didn't like that sort of rebuff. Ali said that Garbo took vodka 'in order to be able to speak at dinner'.

Then he told me of Tangier. He said that Cecil was more reticent than David [Herbert] and the others. They were disappointed in him.

He said Cecil behaved as a heterosexual would if a crowd of hearties from White's took him to a brothel. He said, 'Much of Cecil's sexual libido went into photographing Truman [Capote] and in the end the world was better served.'

He said Cecil was very much the victim of being a member of his family. The heavy hand of Nancy, his mother and so on weighed on him and he therefore didn't always let himself go as much as he might. Everyone is, of course, very much part of their background. Similarly, Ali said nobody could imagine what it must have been like to be a homosexual and to fear conviction for the crime. For Cecil it would be worse still: 'Court photographer.' He said Cecil was a photographer with a painter's eye, just as Freddie Ashton was a choreographer with a poet's eye. He said that Loelia was on the black list for not having been to see Cecil in old age. But she had had a dying husband at the time.

London, Wednesday, 21 October 1981

In the evening I went to George Plumptre's party for his book, Royal Gardens.

Peter Quennell[*] had two good stories about Cecil. One concerned Peter Watson. In a tiff, Cecil sought to make amends. He bought hundreds of butterflies in the hope that Peter would see them flying round the room. He woke up with the slimy butterflies crawling over his face.

Doris Castlerosse and Cecil were said to have retired upstairs at Faringdon. The rest of the house party gathered to listen outside the door. Finally Cecil cried out, 'Goody, goody, goody.'

London, Monday, 2 November 1981

I collected Diana and we drove to St Paul's, Covent Garden for Enid's memorial service, where a bevy of press photographers turned their cameras on Diana like marksmen.

[*] Sir Peter Quennell (1905–93), much-married literary editor and writer.

Sir John Gielgud* was in the seat behind and he leant over to greet Diana with a kiss. He tapped me on the shoulder, not sure if he knew me or not. The service was all right – good lesson from Sir John and good address from Nigel Nicolson. (He said he thought *The Squire* her best novel.) A pianist played 'Jesu, Joy of Man's Desiring'. I fear that 'keeping up with the Joneses' will lose its impact. They didn't even stretch to a choir for poor Enid.

Afterwards we talked to John Gielgud, and then Edward Fox came along in a whitish raincoat. He asked us to lunch at the Garrick. He said he'd based his character in *Quartermaine's Terms* on Adrian Daintrey. Sometimes AD slumps along the street like a wounded animal. At other times he's very vital. It's because he sold a picture for £200.

Edward Fox† said that Cecil once asked: 'Which of you two, you or Tracy,‡ will become a success first?'

'Oh! Tracy, I'm sure.'

'Yes, so am I.'

When Cecil wanted to go to the theatre, he wanted six theatres a night for five minutes each. 'You can judge a play in that time,' he told Alan Tagg.

'I must say I rather agree,' said Edward Fox.

London, Thursday, 5 November 1981

Diana Cooper came to dinner at Lexham Gardens with some of my young friends.

Diana was funny quoting Max Beerbohm. She said that he was there when an enquiry was made about Lady Cunard. How was she?

'Neither aged nor ill nor unhappy. In fact she was perfectly all right, well and happy.'

'Oh! I'm sorry to hear that,' said Max Beerbohm.

* Sir John Gielgud (1904-2000), one of the most distinguished actors of the twentieth century.
† Edward Fox (b. 1937), actor on stage and in films, neighbour of Diana in Little Venice.
‡ Tracy Reed (1942-2012), actress, and 1st wife of Edward Fox.

Diana and I talked a lot about depression. I asked if she'd go through the last year all over again. She was emphatically against the idea. I suppose she is depressed and unhappy unless brought out of it. But so too are Laura, Loelia, Clarissa, and Sir Arthur [Bryant].* So was Cecil. Who is not depressed and unhappy? Diana Vreeland perhaps, Charlotte Bonham Carter? I have seen too much of all this. Yet Gladys wasn't always unhappy. Nor was Enid.

I returned to New York to pursue more interviews.

New York, Sunday, 8 November 1981

I sometimes work hard but I haven't worked hard enough of late. I have come to the USA to simplify my existence and escape from my telephone. Yet it's fascinating to read that even George Painter† lay slumped in his bed for some weeks before finishing his book on Proust.

New York, Saturday, 14 November 1981

At last I met Irene Selznick face to face. When we had talked in the summer, I had told her that Laura (whom she knew) had written her memoirs. She expressed interest in receiving a copy so I sent her one. While in Wiltshire, I had received a letter from her, which began, 'Dear Hugo Vickers, And well may I say dear! I should have known you wouldn't forget. I hereby say to hell with Cecil. When next you visit here, come and see me . . .'[11] She lived in her own apartment in the Pierre Hotel.

The apartment has one of those oak rooms at the end of the corridor 1007-11 (I think). She came to the door in a kaftan-type thing, of brown-orange. She wore thick glasses and a fringe, almost like the

* Sir Arthur Bryant (1899-1985), prolific and somewhat priapic historian, who had become engaged to Laura, Duchess of Marlborough, following the publication of her memoirs, *Laughter from a Cloud*. The full story of his romance with Laura is told in *Historic Affairs: The Muses of Sir Arthur Bryant* by W. Sydney Robinson (Zuleika, 2021).
† George Painter (1914-2005), author of the great two-volume biography of Marcel Proust.

Beatles. She was a bit stockier than I had expected but otherwise very much what I thought. The drawing room was wonderful, hung with a Matisse, a Degas, a Vuillard (Enid's favourite) and others. It was very large and grand. We talked there for a little while, with Mrs S in a high chair with her feet on a stool and myself on the sofa. She was astonished by my age. She said, 'I expected someone of fifty. Your attitude is of someone of fifty. It's a compliment.' She then said, 'You could pass for twenty-four.'

Irene Selznick

We talked about Enid's service and how bad it was ... *The Chalk Garden* was another matter. This they worked on for years. 'I don't know if I could go through it again,' she said. Apparently Enid would write, then she'd read it to Roderick and he'd say it was splendid, ('How could *he* know? He knew nothing!') or to [her daughter] Laurian. Enid would present her writing and say, 'This is what Roderick says.' Mrs S would sit there in silence. And Enid would go through a whole saga finally, wailing and weeping and wanting to chuck the whole thing in. Then Mrs S would say to her, 'Enid, when you're finished and when you're ready, let's start all over again shall we?' And they did. When the whole thing was done, Enid felt she'd like to kill Mrs S to take all the credit. 'Do you want to kill me, Enid?' I can see it.

Most interesting was the beginning of their work, Enid because

more interested in Irene Selznick than in the play. She'd study her as they worked.

Mrs S said, 'Now, Enid, let's get one thing quite clear. I don't want to be between bed covers or book covers. You did it to Carol Brandt.* She loved it. You did it to Diana [Cooper]† and she loved it. You're not going to do it to me.'

'But you're a—'

'I know what I am. You're not going to do it to me.'

This scene followed a quick telephone call in which a heated few lines took place. 'Did you see Cathy? Good. I want to talk to you. Kennedy on the agenda . . . on the agenda . . . on the agenda. We'll talk later.' And she came back and said, 'You learnt more about me in those few seconds than anything so far. I didn't mean to give myself away like that.' She was laughing. But what did I learn? Was it lesbianic gossip being eaten up 'twixt friends? All interesting.

She did the usual trick on me. Re the memorial-service cutting: 'I'll give this to Kate. I'm writing about Kate at the moment.' I guessed Kate [Katharine] Hepburn correctly. Then she said I should see Truman. He was 'a genuine friend' and it 'would be a kindness if you went to see him. I'm sure he'd love it. But I advise you to see him more than once and don't trust a word he says.'

She said of *The Chalk Garden* that she employed Laura Harding, a rich socialite who'd never worked before but who had a good eye, to help with the costumes and Johnnie Johnson to do the sets with him [Cecil]. They were spies in a way. They were the ones on whom she put pressure and both knew things like where to go to shop around, where you could buy off the peg and so on. Cecil took a nap after lunch and this, I believe, is when she talked to them.

Enid's book resulted from Irene Selznick trying to save her from future disasters. She said that she would never work with her again despite much pleading. She wanted Enid to rest on her laurels after *The Chalk Garden*. The autobiography was unique and wonderful, but Mrs S said she needed a better editor to work on it, 'to draw her

* Carol Brandt (1904–84), literary agent.
† Enid based her play, *Gertie*, on Carol Brandt, and *The Loved and Envied* on Diana Cooper.

out here, to say less there'. She said the tragedy of Enid's life was Antoine [Bibesco]. 'He loved me for three days.' All her life led to that point and was retrospective to it. 'The poor thing,' Irene Selznick kept saying. She said that Cecil 'poisoned her paradise' over *The Chalk Garden*. Two amateurs, they had plotted and planned together for years. He couldn't bear it when Enid was suddenly taken up on Broadway. She was the success and he was the failure. 'He was not a photographer. That was too humble for him. To be a playwright,' she said, 'would get rid of much of the rot inside him.' Enid had an awful life at Rottingdean and drew Cecil into her orbit, lending him Kipling [or Dale?] Cottage because he represented the theatre world. She believes Enid got Diana through Cecil. I must find out.

Cecil didn't dare insult Mrs S again in public. 'If ever he did at least I never heard about it.' I got the impression that she quite enjoyed her battle with him. She said she once went to lunch at Babe Paley's* and Cecil opened the door. She thought, I can cope with this. Meanwhile Cecil was very flustered. It was a lunch for Isak Dinesen and she had got the wrong Wednesday. Babe Paley, of course, said, 'That's wonderful. So we have you for both Wednesdays.' She didn't know about the flower-shop drama. Some of those *Vogue* things were blacked out, which may explain why I couldn't read it in the Metropolitan Museum *Vogue*s. Truman Capote says that someone else did the drawings and Cecil took the blame. But I don't believe this. Nor does she.

The apartment was huge – a dining room, drawing room, green study, with lots of photos of Kate Hepburn, and my eyes glimpsed the bedroom with a huge bed in it. When she said of Diana [Vreeland], 'She's short of money,' I concluded that it was all relative.

New York, Sunday, 15 November 1981

There was only a short time in which to get ready for Diana Vreeland's dinner. Diana opened the door herself, dressed as usual in a black trouser suit. She is extraordinary to look at – her black lacquered hair,

* Barbara ('Babe') Cushing (1915–78), wife of William S. Paley. She was one of Truman Capote's 'Swans'.

her thin, tiny figure, her very modern red boots. She is so friendly and unspoilt by all that that world must have brought her. She complains now that her legs give way below the knees, says she wishes she had a sedan chair to carry her through the Metropolitan and yet she has no intention of giving up. Even this day she had been on television to accept money for the museum. She says that she keeps the evenings free because she works late at the museum and never knows how tired she'll be. She cut out of going to the Stones concert the other day (Friday) because she doesn't like people *en masse* (I do not blame her). There are stories of her not attending things but at her age she is still quite remarkable. It was my second visit to the apartment that she describes as 'a Garden in Hell' – I love its blood-red carpet and red walls with trees on them, the huge sofa with the needlepoint cushions, some of which are like packs of cards (five of hearts or clubs).

The other guests were David Bailey and Marie Helvin.* He is *the* photographer and wore boots, blue jeans, a black open shirt and leather jacket. He looked so like the character in *Blow-Up*. They call him 'Bailey' and he calls Diana 'Vreeland'. He was friendly up to a point but his 1960s style meant that he had to down-put very often. He was longing to jump on one if a chance arose. He thinks a lot of himself and there is a cruel streak in him.

(On Monday Diana said, 'Isn't Bailey sweet? He first came to my office with Shrimpton. There he was, this Cockney boy – he looked just like a Shetland pony. They arrived soaked to the skin and I said, "You must be English."')

Marie Helvin was pretty and is a top model. She was also very sweet and friendly. She knew about me from having read my *Tatler* pieces. She thought we'd met before. She wore a black dress, which was boned she later revealed, therefore quite uncomfortable. What women do for vanity's sake!

'The queer side of Bailey is that he likes women,' said Diana, memorably. I love the little knowing chuckles she gives as she leads one openly along a path one has begun to explore tentatively. 'Hu-hum,' she mutters, her eyes twinkling as she looks around her. There was a lot of talk about films. Bailey hated *The French Lieutenant's*

* David Bailey (b. 1938), and his then wife Marie Helvin (b. 1952), a fashion model.

Woman – 'So middle-class, John Fowles' – but raved about *Chariots of Fire*. Last night they were at a party with Tony Curtis, who is hating growing old. 'And he's not that old, let me tell you,' said Diana. Then there was Stones talk – the Stones are making £70 million over their present tour of thirty-two cities. Mick Jagger is scared stiff of being gunned down and has a bodyguard. After John Lennon, he fears that he is the next.

There was a lot of Stephen Tennant talk, because Bailey had been down to photograph him. There were the usual problems. They lunched with Cecil. 'I liked old Cecil,' said Bailey. Then they went on to Wilsford, but couldn't say (I think to either) where they had been or were going. Stephen put on some Bermuda shorts and made up his legs. The photos were published in *Ritz*. I'd love to see them. Stephen discussed make-up with Marie Helvin: 'He likes girl talk. He was really happy discussing eye shadow and so on.' He gave her a scarf drenched in something dreadful. She left it on her dressing-table at home and a friend said, 'Where did you get that Fortuny scarf?' It was all tattered, alas, and had probably lain on his bed for years. Bailey: 'He loved all his jewellery and it was all rubbish. He was quite happy playing with it.'

Bailey got Cecil the job of photographing Jean Shrimpton for English *Vogue*. He said that Bea Miller* and Cecil did not get on and she was reluctant to use him. The point about him, they both agreed, was 'the people he photographed'. Bailey said he thought he'd be remembered more for his photography than anything else. He said that in the early days he did some dreadful things – 'All those silver balls and tinsel – awful.' He also said, 'A lot of those photographers were indulging their homosexual delight in photographing beautiful women and naked young boys. They went round, draped in pink chiffon.'

'Yes,' said Diana. 'And they were very well paid for doing it.'

Neither thought Cecil as good as Baron de Meyer† or 'Hoinike-Hoinike', as Bailey called Hueningen-Huene.‡

* Beatrix Miller (1923–2014), editor of UK *Vogue*, 1964–85.
† Baron de Meyer (1868–1946), elegant portrait photographer of the Edwardian era.
‡ George Hueningen-Huene (1900–68), fashion photographer of the 1920s and 1930s.

Diana said that Valentina had rung her and invited her to dinner on Tuesday. She had been very flattering and friendly: 'And I always fall for that.' I wonder if I should try to see Madame Schlee one day. It might be a slant on the Garbo thing. Bailey said that Anne Tree had good Cecil stories. She'd paid fortunes for a special wallpaper. Cecil saw it and his comment was: 'It could do with a good splash of white-wash.' So much for that.

Bailey said he tried to get Garbo for the film. She wouldn't do it. He said Cecil wanted to be Leonardo da Vinci and Marco Polo wrapped into one: 'I said I only had time for his photography and perhaps a few designs.' After dinner Bailey sat first on the sofa and then on the floor. He sat cross-legged and put a toothpick into his mouth. Very posed. He'd ask, 'Where do I pee, Vreeland?' and this would be accepted. Marie he calls 'Toots'. Of Marietta Tree, whom he clearly loathed, he said, giggling, 'I used to like to make her cry on Christmas Day or her birthday. She's such a snob.' He didn't know – yes, he did – about the recently dead lover, Lord Llewellyn-Davies.[*] He said, 'So typical. I can just see her with her legs up, having a boogie on the beach.'

At the beginning he said to me, 'How old are you? You're older than you look, aren't you?'

A few days later Diana reported on her evening with Valentina. She said it had been perfectly pleasant but that 'it was hard to see how the twenty-four hours go by.' She said that she was keen to refer to Monsieur Schlee as her husband only and therefore nothing to do with Garbo. I told Diana that I contemplated taking a pram up and down 52nd Street in the hope that Garbo would talk to the baby. She thought that would be such great fun. Realising, however, that Garbo was likely to elude me, I dropped in a letter to Madame Schlee (thus the door of 450 East 52nd Street was opened to me) and I also dropped one in for Truman Capote at the UN Building. Neither replied.

[*] Lord Llewellyn-Davies (1912–81), architect who designed Milton Keynes.

New York, Monday, 16 November 1981

I went to have lunch with John Richardson. His apartment is coming on a bit and the upstairs room is now hung with paintings and drapes, but he was distressed that Anne Tree had described it as very 'Steptoe & Son'. The dog, Rosie, was in full voice as ever, leaping about. I noticed royal photos framed, and in the cane stand a sinister spiky one. For what purpose, I wonder. There are different levels to him. He's always been very nice to me but I gather he's a sadist and likes whipping people. His obsession this morning was with Arianna Stassinopoulos,[*] just commissioned by Simon & Schuster for money beyond dreams to write the official life of Picasso. He knew Picasso, had done a lot of work on it and deeply resented 'a girl who knows no more about art than she did about opera' taking this on. He'd talked to the Baron, who said that there was still time to squash it but he'd have to act fast. He said that it was not his commission but S & S. It sounds to me that the Baron was being less than loyal to Miss Stass.

He said he'd seen Truman Capote a year or so ago. Truman had come for tea, but soon it was 'I think I'll have a whisky,' and he became stewed. He said Peter Watson was most fastidious and craved cleanliness. 'He'd have hated the butterflies.' He said that Boy Le Bas[†] ended up with 'rough trade' lurking in the background, living 'openly as a queen'. He said that I had met Jones Harris,[‡] Ruth Gordon's illegitimate son with him. (I love Mia Farrow saying to Ruth Gordon, 'Ruthie, let's take out a pram and wheel it up Main Street' – this after *Rosemary's Baby*.) He said Cee Zee Guest[§] was the best way to see Truman. He told me that Cee Zee had 'only fluff in her brain. She might be able to tell you a few things about the gardening book, but nothing more. Use her to get to Truman, who's crucial.'

[*] Arianna Stassinopoulos (b. 1950), author, who later founded the *Huffington Post*.
[†] Edward Le Bas (1904-66), schoolfriend of Cecil, and later a painter.
[‡] Jones Harris (1929-2019), son of the actress Ruth Gordon (1896-1985), and Jed Harris (1900-79), theatrical director.
[§] C. Z. Guest (1920-2003), a noted socialite, married to Winston Guest. Cecil drew her some flower pictures for her book, *First Garden* (1976), after his serious stroke.

Back at the apartment, James Fraser rang.

'I'm Lillian Gish's manager. You wrote such a nice letter to Miss Gish. Miss Gish is leaving for Florida today but would like to speak to you personally on the telephone.' So this famous star came on.

'When Cecil first came to America, I was one of the first people he photographed. It was in front of a mirror in the hotel. Every memory I have of him is pleasant. He was interested in everything and everybody. And, like all photographers, he had that blessing which is curiosity.' She apologised for not having more. She wished me well with my work and ended, 'God bless you and thank you for calling.' What a sweet person she is.

New York, Thursday, 19 November 1981

I lunched with James Berry at the Metropolitan Museum.

He told me that he used to work in the restaurant there, then five years later by his initiative he found himself attending a party there as a guest along with Diana Vreeland. He had completed a cycle. He took a turn round the restaurant and walked off. Then he heard that John Lennon had been shot, so he went to the Dakota. Now he wants to do things for young people. One of his breaks was to become a friend of Bob LaVine, whom I think he met at the restaurant. Recently he has had a hard time with the Mafia. It concerned the destruction of the Biltmore.* He was photographing it illegally. The Mafia were involved because of a solid gold brick built into the foundations. 'Where is it now?' I asked.

'In my closet,' he replied.

'I wouldn't tell too many people that story,' I said.

* The Biltmore Hotel at 335 Madison Avenue, belonged to two brothers, Paul and Seymour Milstein. They gutted it in August 1981, despite the protests of preservationists. In an article in the *New York Times* of 18 October 1981, Paul Milstein was described thus: 'Mr. Milstein is a portly man who smokes cigars, dresses in a pinstripe suit and wears a jeweled ring on each pinkie. His shirts have long pointed collars and he wears a Timex automatic watch. He speaks in a deep, froggy voice with a Bronx accent.'

'If it was in my closet, I wouldn't be sitting here, believe you me.' He was keen to point out that I should try to make my book on Cecil of relevance to twenty-year-olds. 'Give them something.'

No one seems to have heard of James Berry since the 1980s.
*In the evening I went to the theatre with my New York friend, Dorothy Safian.**

Katharine Hepburn, in the first week of *The West Side Waltz*,[†] couldn't have been much better. I suppose they applauded for about a minute when she came on. She is magnificent. She had such power and that famous tough line she takes on everything is most enjoyable. She was far and away the best thing in it and duly received a standing ovation at the end . . . The point has been achieved. I've seen Katharine Hepburn on stage.

Afterwards Dorothy and I had dinner at the Madison Pub.

She envies me my freedom. 'You work surrounded by beautiful things. You meet people who are a part of history. It's wonderful.' Yes, it is, but I have my low moments.

New York, Friday, 20 November 1981

Cathleen Nesbitt (1888–1982) was a celebrated actress, additionally famous as having been the love of Rupert Brooke. She had gone down to Oxford to play Cleopatra and had married her Antony, Cecil Ramage (1895–1988), the leading undergraduate of his day. He became a barrister, briefly a Liberal MP and appeared in a number of films. Arguably Oxford was the zenith of his career. He sank into alcoholism, he and Cathleen separated, but she went on acting, partly to support him. She had been the first Mrs Higgins in My Fair Lady *in 1956, and continued to appear in plays and films well into her nineties. She was now*

[*] Dorothy Safian, a successful financial head-hunter. I met her in New York the night before I appeared on the *Today* show with Jane Pauley in 1981, talking about the royal wedding. We have been friends ever since.
[†] The play opened on 19 November at the Ethel Barrymore Theatre but ran for only 126 performances.

back as Mrs Higgins, the only actress old enough to play Rex Harrison's mother convincingly.

I had been to see the play twice since arriving in New York, noting how she looked 'so pretty, so old-world, so tiny and elegant and brave at ninety-three'. She made a spectacular entrance, draped in grey ostrich feathers. Her voice was clear and it did not matter if she missed the odd line. In the ballroom scene, she sat smiling and swinging her legs, like a child. She delivered a great 'Bravo, Eliza!' line, and for the curtain call, was led in on the arm of an extra — possibly for effect. Now was my chance to meet her.

I was very excited about my visit to the dressing room of the Uris Theatre. I found the stage door and watched people going in. Cathleen Nesbitt arrived with [her minder] Joanna Malley. She was wearing a pink hat and coat and walked briskly in without a stick. I waited a while and then followed. Joanna Malley came down. She took me up and along the back of the stage to the dismal stone steps and lime green municipal walls that surround the dressing rooms. I spotted Mrs Eynsford-Hill* in her room.

Cathleen Nesbitt

* Harriet White Medin (1914-2005), who had appeared in the film, *La Dolce Vita* (1960).

Cathleen Nesbitt was sitting in a chair in her day clothes. She is very pretty with fine bone structure and an enchanting smile. She is quite small, but not really frail – inasmuch as she gets up easily and walks well. Her arms are very thin, though. And she is deaf so one has to project the voice. It never occurred to me to do the writing trick. That was by no means needed. Her hands are very arthritic.

She told me how much she missed Cecil. She said that one of the first things she would always do, on returning home, was to contact him. Later she recalled the first time she went [to Reddish House]: 'When I woke up and looked out of the window at the garden, I felt I had been crowned. Here I was staying with Cecil Beaton.' The great charm of that was he used to wait outside stage doors to see her, so he must have felt as good. She said she seemed to have known him for ever, but apologised that she couldn't remember exactly when they'd met. 'I have my ninety-third birthday next week and one of the things that happens to you is that your memory begins to go. Everything becomes hazy. You seem half-witted and if your memory goes, then you are half-witted.'

We talked about the costumes he designed and she has written in her book of the effect she felt when wearing them. She said she thought he was quite happy. 'He was not an effusive man. But he achieved a lot of what he wanted and that makes for happiness. Yes, I think he was happy by and large.'

We talked about the show. 'I have been away for over a year. I was in Los Angeles, Boston and other places,' she said. 'I don't want to carp but Rex is very difficult to hear.' I can see how hard it must be. 'He's been married five or six times but this wife is the nicest, I think.' She goes back to London next week. 'I shall go back and goodness knows what I'll find. Things I'll have to do, bills to pay, tax I'm liable for. I'll have to start thinking about it all tomorrow.'

She didn't know that Enid was dead. I told her that Irene Selznick sent her love and we talked of Diana [Cooper]. I told her how much I enjoyed her book. 'Well, I don't think it sold very well but Faber & Faber paid me very well to do it.' She signed it for me. Then I asked if I could take her photograph. She said yes, and added, 'Why is it that the first thing a woman thinks when someone asks to take her photograph is Where is my lipstick?' She liked the little camera.

Joanna Malley then came back. She was horrified that I had photo-graphed her before the make-up was put on. So I went out for quite a long time. The show had already begun. Thus I saw all sorts of characters rushing in and out, men changed from tails to rags, Eliza skipped by, then the chorus girls *en masse*. And each one smiled at me and some said things, presumably on the principle that I might be a producer spotting talent. 'You're still here,' said one. 'What *are* you doing?' I didn't say. I had a good exchange with Alfred P. Doolittle,* who comes from California – or lives there. And Pickering† went by. Rex Harrison did not. He comes in the other side. I enjoyed the scene of Mrs Pearce yawning behind the set, waiting to go on. And I could watch some of the play again.

Then I returned to photograph Cathleen Nesbitt, who was now dressed for Ascot but without the hat. She'd been given a B12 injec-tion, which I gather she has every night before going on stage. My admiration for her increases. She was in some pain this evening. Anyway, I took two more photographs. Then I waited to see her come out.

I talked to Joanna Malley who told me a terrible story. Cathleen has earned $90,000 this year – about £50,000. Her son says it's only £20,000. He has rented out her flat – and says she can come and stay with him. It did not take long for me to conclude they wanted to put her into a home. The son‡ is rich – he's an advertising man and seems to treat his mother very badly. When he came to New York he didn't even take her to dinner. In fact, she hasn't seen many people – though she must know lots.

I saw Cathleen come past, fully dressed, and take her place behind the stage. I was taken round the back to the other side. Rex Harrison walked past and I saw him talk to Cathleen. She missed a line and he had to say: 'Yes, well, Mother, that flower-girl we were telling you about . . .' And I saw the Ascot scene line up. All those chorus girls came in, tripping over each other, muttering and exclaiming. Joanna

* Ben Wrigley (1903-94), a British actor, who had been in the films of *My Fair Lady* and *Oliver!*.

† Colonel Pickering was played by Jack Gwillim (1909-2001), who had played Poseidon in *The Clash of the Titans*.

‡ Mark Ramage (1924-2013), successful in advertising.

told me that one girl had been changed and the new one was wearing a dress the wrong size (that's why she tripped a bit). They were soon lined up and ready for that marvellous scene. Unfortunately I had to go before it ended.

New York, Saturday, 21 November 1981

Daphne Fielding (1904–97) was born as the Hon Daphne Vivian and had married Viscount Weymouth, later the 6th Marquess of Bath. After their divorce she married Xan Fielding. A popular society figure, with a not unracy past, she had written light memoirs of friends such as Iris Tree.

When I began my research on Gladys in 1975, I discovered to my horror that she was also preparing a book on Gladys. This made my work difficult as a number of her friends, such as Diana Mosley, Robert Heber Percy and Sonia Cubitt, closed ranks and refused to help me – though they all later helped me with Cecil. It was now time to put differences aside.

I rang up Daphne Fielding and she asked me to lunch that very day. So I had to pull myself together in a big way . . . I arrived at one. Daphne was in her drawing room in a dark red trouser suit. She's quite a big woman, dramatically made-up – one might have thought her an actress. She has a kind face, though, and is, of course, in all respects perfectly charming. She gave me a vodka on ice and we just talked and talked.

Ben Kittredge* died a few weeks ago, having been in the torture of intensive care, where, she says, they never leave you alone for a minute. Finally she agreed that they should let him go.

She said that now she is very sad, not sleeping, and falling victim to the windmills of depression, which hit one in the small hours. She is rightly wary of pills, which dull the emotions, as they always have nasty side-effects. (Daphne sent Diana [Cooper] a card the other day, saying, 'This is the saddest news I've ever had to write. Ben died . . .').

She knew Cecil for ages and ages. Said the father meant nothing to her, but Reggie Beaton was round and fat and not at all as dapper a figure as Cecil. She said the sisters were always beastly to Eileen, because they were jealous. When he came back from trips abroad

* Daphne had taken up with Ben Kittredge (1900–81) in the 1970s.

they always got to the presents first, before Eileen, so that they made sure theirs were the best. Cecil, of course, created the mother and sisters.

We talked a lot about Diana. Daphne worries about her. She says she's bad with servants, either too friendly or she gets impatient. There was a Dr Woodcock* they called 'Dr Timber-doodle' who once became Diana's doctor. He came back, dancing and saying, 'I'm Lady Diana's doctor. I'm Lady Diana's doctor.'

Later he said: 'I'm going to call you Diana. It sounds so nice.'

'I think Lady Diana sounds much nicer,' she said.

We had a nice lunch with white wine. 'We've killed a bottle. Ben would be pleased. At the end of it, she said, 'So you're not my enemy,' and we embraced warmly and powerfully. It was a most dramatic gesture, but a good one. I came out with a lighter heart.

New York, Sunday, 22 November 1981

Daphne Fielding rang up. She had got my long letter just after our meeting. She asked me to lunch again to talk about Cecil. She asked if I knew Paddy Leigh Fermor† or not. I said I didn't. 'He's marvellous,' she said. 'He's such a tonic. He should be turned into pills so that he could be taken regularly.'

New York, Tuesday, 24 November 1981

Daphne told me Garbo stories. Evidently Garbo used to come to visit a tiny little lady on the other landing of this block (fifteenth floor – she is 15B), called Miss Jessica Dragonette.‡ Miss Dragonette had been the angel voice in *The Miracle* when Diana was in it. Garbo used to bring a rather sinister German troll, and it was put on the landing. She used to

* Dr Patrick Woodcock (1920–2002), fashionable London doctor with many famous clients.
† Sir Patrick Leigh Fermor (1915–2011), who walked across Europe in 1934, kidnapped the commander of the German garrison in Crete, and published two memorable accounts of his adventures – *A Time of Gifts* (1977), and *Between the Woods and the Water* (1986).
‡ Jessica Dragonette (1900–80), American radio singer, married to Nicholas Turner (1915–2010).

come each year and see it. Miss Dragonette is now dead but has a mad sister (who used to be her press agent and is now in a home). This sister's husband might be a good source on Garbo.

Cecil once took Garbo to Sturford Mead (I think) to meet Henry Bath [Daphne's first husband]. He, alas, missed the point and didn't realise who she was. When she was out of the room, he enquired and was told. He was furious with himself for this missed opportunity. 'It's Greta Garbo, you clot,' said Cecil. And Caroline Somerset* can tell me about Grant bringing Cecil to stay after the stroke. There were some steps down to the dining room, which he just couldn't manage. David Somerset, an expert horse-trainer, was able to tap him on the back of the legs with a riding crop and down he went with no further problem.

It was Doris Castlerosse who seduced Cecil in a room filled with tuberoses. The intoxication of the smell was powerful. And then Doris helped him considerably. 'He wouldn't have had to do a thing,' she said.

Back at the apartment Irene Worth telephoned from Washington.

She sounds so nice. She told me how much she adored Cecil. She said that it was she who had brought John Gielgud and Cecil together after a quarrel they had over, she thought, *The Second Mrs Tanqueray*. Cecil and he had tea, but later Cecil said, 'I may forgive, but I never forget.' She said he was 'an incredibly sensitive man' and a perfection-ist. Before he went to Hollywood he was so scared that he would have rows and make enemies. They had a long talk. It reminds me of David Bailey's question: 'Why don't you go into films, Cecil?'

'I can't afford a new set of enemies,' was his reply.

New York, Sunday, 29 November 1981

C. Z. Guest (1920–2003), formerly Lucy Douglas Cochrane, was a beautiful blonde socialite, married to Winston Guest. She lived on Long Island. She was a superb rider, an expert on gardening and a fashion icon. Cecil illustrated

* Lady Caroline Thynne (1928-95), Daphne's daughter. She married David Somerset, later 11th Duke of Beaufort (1928-2011).

her book, First Garden *in 1976, after his bad stroke. Her great friend Truman Capote (to whom she remained loyal even after his disgrace) described her as one of 'the enduring swans gliding upon waters of liquefied lucre'.*[12] *He commended her on serving exquisite vegetables – 'That's what you can do when you have acres of greenhouses.'*[13]

Cee Zee Guest rang me first thing. 'What do you drink? A bull shot? Some wine?' I caught the train from Penn and she was waiting for me at the station. She had a station wagon with CZG on it. We drove to her house at Old Westbury, which is enormous with paddocks and avenues, greenhouses and many dogs. Inside she showed me her books and articles on gardening. Later she gave me copies of the books.

She gave me a delicious lunch in a small room at the end of the house and we were joined by her stable manager, Kirk someone. He seemed an intimate of the house. He claimed to have heard me on the radio at one point. Later we walked outside, saw the stables and horses, saw the wondrous greenhouses with rare and special plants (many orchids) lined up to await burgeoning ready for Christmas. I was amazed. Then she and I sat and talked for the rest of the afternoon. Some of my time was occupied on Gladys, who seemed to fascinate her. She said that she thought G foolish to have lost the Marlboroughs. It was because she didn't play the game. We talked of the Duchess of Windsor whom she knew well. 'What's the point of worrying about her? No one can do anything. So why worry about it?' (Awful attitude.) [Caroline Lowell later raged against her: 'Her awful leopardskin carpet. Her gardening articles. "Oh! The Duchess was charming. She was dee-vine."' And so on. Caroline said, 'I have done horrible things but I wouldn't let an old friend die in that way.' And the conversation with Winston Guest in Palm Beach about the weather and how she envied him, which she spelt out in initials: 'I–N–V–U'.]

Cee Zee knew Cecil for a long time socially and was a great help to him when he was ill by flying over specially to get him to do the flower-drawings with his left hand – that in January 1975, just after the stroke. She believes that Cecil and Truman Capote were lovers. She said that she once saw them walking along the street hand in hand. They didn't see her. Cecil and Truman had a row about

something and never made it up. (Eileen said that Cecil was furious that Truman was wasting his talent and ruining himself. He took against him rather after *In Cold Blood*.) Her main point was that he rowed with those he worked with. She is a believer that we should all be athletes. In some ways I see it – a healthy spirit of competition, the fitness of the body and so on. She showed me the original drawings for the book and some Cecil photos in her room.

Later Sonny Gray came to collect me to take me back for dinner. Cee Zee kissed me goodbye.

New York, Monday, 30 November 1981

I tried to ring Ruth Gordon.* Her husband, Garson Kanin, answered. 'She's being interviewed,' he said. 'It's rather a bad day. Natalie Wood was her closest friend.† Please call her tomorrow.' This was real Hollywood talk. Natalie Wood got one line in her book.

Lincoln Kirstein (1907–96) has been described as 'the Maecenas and the conscience of the arts of twentieth-century America'.[14] *He brought George Balanchine to the United States and was the creator of the New York City Ballet and the School of American Ballet. I went to see him in the afternoon.*

The door of Lincoln Kirstein's house is sandwiched between small houses and giant warehouses. The house gave the impression of being in darkness. But the door opened and a large figure asked if I was Mr Vickers. He let me in and I found myself confronted by a huge man who could well have been an Austrian. He wore a black jacket of Germanic cut – nothing like a suit – and black trousers of which the zip was somewhat disconcertingly undone. (Later he realised this and did it up surreptitiously.)

The first part of the interview was conducted in a situation of undone flies. The house was amazing. A huge hall was hung with

* Ruth Gordon (1896–1985), American actress, remembered for films such as *Rosemary's Baby* and *Harold and Maud*; Garson Kanin (1912–99), writer and director.
† Natalie Wood (1938–81), the film star. She had drowned off Catalina Island on 29 November.

golden yellow drapes, with marble heads set in each niche. At the end of it was a small dining room with places set. One imagined the Spectre de la Rose appearing at any minute. We went into a brighter room at the end of the house, where a large drink-laden table dominated the centre of the room.

Tchelitchews adorned the walls and more marble heads and portraits of the owner. He gave me a gin and we went to sit down in the middle facing the door. I found Lincoln Kirstein very helpful on the atmosphere of the ballet world, and also encouraging in that I felt I was on the right track.

He said it would be hard to write about Cecil objectively and sympathetically. He first met him in about 1927 in London and in those days he had a very distinct pose, rather like Brian Howard* – an exaggerated way of speaking: 'He never came to terms with his homosexuality,' said Lincoln Kirstein. He didn't think him 'inventive'. You had to give him ideas. As far as the ballet was concerned, he had no problems with him. He thought this was because Cecil greatly enjoyed doing the work, and there was not much money involved. Things like *My Fair Lady* and Irene Selznick's productions were fated due to too much money. He said Cecil followed in the pattern of people like Oscar Wilde. He was a good reflection of his times.

He said that Cecil was basically homosexual nevertheless and yet tried to hide it.

[Eileen told me later that Lincoln Kirstein used to send Cecil photos of nude boys: 'They went straight into the wagger as far as I know. I never saw them again.']

I arrived back in London early on 2 December.

London, Monday, 7 December 1981

Maureen, Marchioness of Dufferin and Ava (1907–98) had been born a Guinness, another of the set to which Cecil aspired in the 1920s. She was the mother of Lady Caroline Lowell.

* Brian Howard (1905-58), English poet.

Caroline introduced me to her and said, 'He's writing a life of Cecil Beaton. You could tell him your experiences perhaps?'

'Oh! We were close acquaintances,' she said. I thought that would be all she had to say but we went on talking. I told her that I was busy reading old diaries and that I was amazed by the things I found. Suddenly she decided to tell me her version of the story and she was very funny about it.

She said, 'Well, shall I tell you my Cecil Beaton story?' Evidently she was in America staying with Nin Ryan.* A huge party was given and Americans, as is their wont, were busy introducing her to other English. It was a ghastly evening. She heard a man next to her saying, 'Would you care to dance?' She half rose to her feet and then saw the girl on his other side getting up. Cecil was a godsend. He said to her, 'Any time you want to go home, I'll be happy to escort you.' So they walked to the guest cottage. 'I must see the drawing room.' He inspected it. 'I must see the bedroom.' Before she knew where she was, she was pinned to the bed and surprised by how strong he was. She reacted to the situation in fright and in astonishment — how unlikely that Cecil should do such a thing. Then she just laughed and laughed. He was enraged and left.

The next night Mrs Ryan put her in a small dinner and, of course, Cecil was there. He said to the assembled guests, 'In Maureen Dufferin you have the bloodiest bitch in England.' It was such an awful thing to say that people assumed it was funny and laughed.

She said, 'After that he went back to men.' She explained that as far as women were concerned he was a very bad lover. He had had a spell of Doris just before. He was trying to get it together with women.

London, Monday, 14 December 1981

Finally Diana met Laura's friend, the colonel [Alex Young], at lunch at the Ritz.

* Mrs John Barry Ryan (1901–95), philanthropist and supporter of the Metropolitan Opera; daughter of the financier Otto Kahn; mother of the Countess of Airlie.

Diana regaled the colonel with stories, which led to Venice: 'There was an American called Laura Corrigan* . . .'

Me: 'Diana, she had a husband.'

Diana: 'Can I do it?'

Nod.

Diana: 'They never had any children because Mr Corrigan's penis was not a virile one.'

Roars of laughter from the colonel.

* Laura Corrigan (1879-1948), American socialite, famed for her malapropisms – following a trip to India: 'To see the Aga Khan by moonlight.'

1982

The work continued. The plot thickened.

Nairobi, Tuesday, 12 January 1982

In Kenya with my aunt and my father, we had lunch with the high commissioner. Sir Michael Blundell (1907–93) was also at lunch. He was a distinguished farmer and politician in Kenya, who had served as minister of agriculture. He was an old friend of my aunt.

After lunch I asked Sir Michael about Karen Blixen.[*] He said he had indeed met her years ago. He couldn't understand her great popularity in the West. She had no idea about farming. She tried to grow coffee of the Jamaican blue-gold variety but her land got precious little rain and therefore there was no hope. He said that when he went there the leaves were all yellow.

He said that Denys Finch-Hatton[†] was 'a typical younger son of an aristocratic family. He came over her, balls-aching about, shooting at everything. When he died, he was made into a kind of hero.' Sir Michael said that Raymond Asquith was a much more impressive figure.

London, Sunday, 31 January 1982

The only event of the day was drinks with Maureen Dufferin. I didn't know why she asked me. Yet she kissed me warmly and gave me good champagne . . .

[*] Karen Blixen (1885–1962), Danish writer, as Isak Dinesen, author of *Out of Africa*.
[†] The Hon. Denys Finch-Hatton (1887–1931), second son of the 13th Earl of Winchelsea. He settled in East Africa in 1910. He moved in with Karen Blixen in 1925. He died when his Gypsy Moth plunged to the ground, flying from Voi airport. He was portrayed by Robert Redford in the film, *Out of Africa* (1985).

Maureen Dufferin suddenly produced a letter from Cecil to someone with the aim of making my 'mouth water'.* It was a very bitchy letter. The contents were about some pictures that had been returned. It implied that the recipient was a woman who was grabbing all that she could from everyone and the world had increasingly little place for such a revolting creature. It was signed 'Yours never, Cecil Beaton'. But it was the most extraordinary thing to do. She covered up the name at the top . . .

London, Tuesday, 23 February 1982

Diana gave a lunch party at Warwick Avenue for the former prime minister, Harold Macmillan.

Diana: 'Harold . . . This is Hugo Vickers. He's a very good writer.'
 Harold Macmillan: 'Oh . . . er. If you say so.'

London, Wednesday, 31 March 1982

The Baron gave a dinner to celebrate John Curtis's twenty years with Weidenfeld & Nicolson.

The Baron's mighty form was present to greet his guests . . . He made a speech. Hugh had joked about this a lot beforehand. He said the Baron will say, 'This is in fact a double celebration because it marks John's retirement from the firm.' Apoplexy of John. Instead, he greeted John, who replied, in familiar nasal tones, 'This is the first time that George has ever made a speech. I am quite unprepared. I enjoy working with George. He's an optimist. I'm a pessimist. I enjoy working with my editors, and the authors . . .'

* Typical Maureen. The letter was to her sister Aileen Plunket. It had in fact appeared in an article in Town Talk in the *Sunday Express* on 12 November 1972. It involved Aileen having sued Felix Harbord for selling eight pictures without her permission. The matter went to court, costing Harbord £2,400. Cecil wrote Aileen a vitriolic letter along the lines that he was glad she was sitting at home getting older and uglier. He signed it 'Yours never'. It was too much hassle to play Maureen's game and I found an even worse letter, addressed to Louise Dahl-Wolfe, in which he castigated an American editor: 'Meanwhile, if you see Willa Cushman, please spit in her eye.' I used that instead.

'Zee agents,' cried the Baron. 'Don't forget zee agents!'
A roar of laughter. There were no agents in the room.

London, Thursday, 1 April 1982

I was alone until going out after dinner to Diana's to meet the Queen
Mother . . .

I was terrified I'd fall asleep and miss the Queen Mother. I set off
in good time and waited until I saw the Berkeleys go in (Sir Lennox
in a suit), then Edward Fox and Joanna David* go past. John Julius
[Norwich] was greeting everyone at the door. Inside I found Kitty
Farrell, who has now become my great friend. 'Don't be so nervous,
Hugo,' she said, as I spotted the Queen Mother in pink by the fire-
place and began to retreat to the dining-room part by the screen.
Diana was there in a long dress given her by the Aga Khan's sister-in-
law. The others in the room were Artemis Cooper,[†] Charles Farrell,
Anne Norwich,[‡] Lord Head,[§] Paul-Louis Weiller, Nicky Haslam and
boyfriend, Cavan O'Brien, Father John Foster, the 'Last Attachment',[¶]
Virginia Ashcombe,[**] Charles Ritchie[††] and his wife – a select group,
most of whom I know.

I stayed by the dining-room table. Kitty sat me down with her and
we had a long talk. She is very insistent on how kind I am to 'Auntie'.
She wanted to know how I knew her. She said Wanda approves of
me, presumably because I look after Diana. Then she said it was time
to take me over to the Queen Mother. In the meantime everyone
who'd been with the Queen Mother came rushing back to relay their

* Joanna David (b. 1947), actress.
† Artemis Cooper (b. 1953), Diana's granddaughter, later biographer of Sir Patrick
Leigh Fermor and others.
‡ Anne, Viscountess Norwich (1929-2020), first wife of John Julius.
§ 1st Viscount Head (1906-83), one-time minister of defence.
¶ Nigel Ryan.
** The Hon. Virginia Carington (b. 1946) married Lord Ashcombe. She later
worked for the Prince of Wales.
†† Charles Ritchie (1906-95), Canadian high commissioner to the UK 1967-71, and
published diarist. When he was in Paris in the 1940s and knew few people, Diana
arranged 'Ritchie week' to put him on the map. He had been the lover of the writer
Elizabeth Bowen.

story. Virginia Ashcombe had said to her something about a friend and the Queen Mother had described the person as 'a good egg'.

'Talking about good eggs, ma'am,' said Virginia. 'I do like your necklace.' The Queen Mother was wearing beautiful rubies in clusters of diamonds. They were vast and real (obviously) – the gift of a maharajah to Queen Victoria.

So over I went. Kitty would have to say, 'He also writes books about the royal family,' which received a slight frown, but was saved quickly by Diana: 'Ma'am, you know Hugo, you met here before.' So the Queen Mother beckoned me to sit beside her, patting the little stool.

She looked wonderful in a long pink dress with jewels sewn into it. It was tight-fitting and then very full. I suppose the Queen Mother looked about seventy, not nearly eighty-two. We started on Cecil and she asked, 'Was he more of a giver or a taker in life, do you think? . . . I think more of a giver, probably, really.'

There was a long discussion about the artist Edward Seago.* The Queen Mother said that she had been asked by the Tate to lend a picture and had offered one of his. They didn't want it. 'So I said, "Well, then, I might not lend anything." Finally they took an English landscape, a large one. Really! . . . Horrid snobs!'

I told her that I'd been to Osborne. 'Oh! I love Osborne.' (Pronounced Osb'n.) 'I can so understand how Queen Victoria spent so much time there. Those lovely blue skies.'

Normally one does about five minutes with the Queen Mother. But John Julius chose this moment to sing his French ballads. So I stayed nearly forty minutes. At the end of each song, the Queen Mother would say, 'Enchanting,' or 'Wasn't that marvellous?' to which one struggled to find something other than 'Absolutely, ma'am.' I think she was having a good time, though. Occasionally she sipped a whisky, but not often. Nearer the end of the evening she tried a surreptitious look at the clock as any of us might have done.

Finally at eleven thirty the Queen Mother thought she should go so I swapped places with Kitty who could better mastermind the situation. They are great friends and they kiss on parting. So, too, Diana,

* Edward Seago (1910–74), artist. Prince Philip took him on his Antarctic voyage in *Britannia* in 1956. The Queen Mother was one of his major patrons.

who then sank in agonised curtsy, which she later imitated to me to express the pain of the act.

The room groaned as Paul-Louis sidled forward. Earlier he had monopolised the Queen Mother and by his blindness approached so close that gradually she had been pushed almost into the grate. Kitty had frog-marched him away and the Queen Mother had said, 'Thank you.' Now he moved in for the kill. '*Majesté*,' he said, kissing her hand. '*Voulez-vous* [Artemis said he actually said: '*Veux-tu*'] *diner avec moi quand vous venez à Paris*?' I then witnessed a famous Queen Mother gesture. Up went the forefinger of the right hand, and with an angelic smile she said, 'Ah! Now I shall have to look in my book.' To me that meant: 'NO.'

Smiling to all, she stopped particularly at Charles Ritchie. Earlier in the evening he had said how much he wished she would visit Nova Scotia again. 'Dear Nova Scotia,' she said, and John Julius relayed this widely: 'Just as Charlotte Bonham Carter might say "Dear Wales . . ."'

After the departure, there was general relaxation. Diana hugged Paul-Louis, who is eighty-eight, and thanked him. He had produced champagne, whispered wine, *foie gras* for twenty, flowers of great price from Fortnum's and so on. '*C'est un homme riche et c'est le seul homme riche que je connais qui est généreux*,' said Diana, planting a big kiss on him.

I had a long talk to Lord Head, who was perched behind the screen. The Queen Mother had just told me that he had marvellous stories about Winston, 'which he must write down'. We had bemoaned the fact that nobody learnt by heart any more.

He was excellent on Cecil: 'I was one of those who threw him in the river at Wilton,' he said. 'Not something that I review with pride.' Cecil was primarily a homosexual, and much encouraged by people like Stephen Tennant. He was terribly ambitious when young, always putting people down, and he hated squares. But in the war he met a lot of squares, generals and so on, and saw the solid work they did. Although he never stopped being homosexual, he almost became a square himself. Latterly he'd say, 'How right you are!' or 'How delightful to lunch and meet Mr Macmillan.'

'Of course he wasn't that brilliant a photographer. In Nigeria he came with us to photograph some tribes. Kisty Hesketh* and Diana were there, acting as loaders. Philip Royston, my ADC, got much

* Christian, Lady Hesketh (1929–2006), of Easton Neston, Northamptonshire.

better photographs, but Cecil sent his off to be specially printed. That's where he won. His came out better in the end. I remember once asking him to photograph a duck in Wiltshire and he had a terrible time. He was not at all professional.'

I think Lord Head liked Cecil in the end and his assessment is a valuable one. I feel I am on the right lines as far as the general atmosphere of my book goes.

London, Maundy Thursday, 8 April 1982

Artemis [Cooper] told me that she once went to the theatre with Enid and Enid failed to recognise a man in the audience. 'I wish I could remember his name. I know so well the quality of his soul.'

She remembers going to Les Avants with her grandmother when Cecil was there. She was relegated to the children's end with Coley [Cole Lesley] and Graham [Payn]* while Cecil, Sir Noël and Diana were together. Cecil told her that photography had nothing to do with the camera. It was a question of the eye. You could get wonderful results on a Box Brownie.

Send, Good Friday, 9 April 1982

Lunch with Loelia – to which I drove Diana.

Loelia is in a rage with Laura whereas she is equally guilty or as much a victim. All this concerns a silly newspaper article in the *Sunday People*. While on this topic . . . Loelia wrote Laura a rude card. Laura replied that she was blameless. Now Diana wants Laura to drive her to Sutton on Sunday the eighteenth – but Laura is terrified of Loelia. Laura said, 'The last thing I want to do is to confront that stony bulk when it's angry.'

London, Easter Sunday, 11 April 1982

Ginette Spanier (1904–88) had been directrice of Balmain, and had become a close friend of Marlene Dietrich, Noël Coward, Laurence Olivier and others. She was also a friend of Laura. She had recently come to live in London.

* Cole Lesley (1909–80), secretary and biographer to Noël Coward; Graham Payn (1918–2005), actor and partner to Sir Noël. He later ran the Coward estate.

Ginette came down in a fur coat, with immaculate hair, fair-brown with two white streaks. Until later I had no idea that she was seventy-eight. I would have said sixty-five. It was fun for me to meet her as I had so often heard her on *Woman's Hour*. She told me that she had been to a tea party in Hampstead at the home of a marchioness. There she had met Cecil. Otherwise she did not know him. She said how much she likes Laura with her husky aristocratic voice and her way of relating stories. 'Of course I read her book,' she said. 'There was much she did not say.' And Diana – the perfect example of old age.

We reached Laura's and talked to her for a while. Then Sir Arthur Bryant, who was there for the weekend, came in and joined us. There was amazing talk about the Princess of Wales. I have had these dreams about her, quite innocent ones, in which she comes round for consolation, sits and watches videos on the floor, and goes back to the Palace much happier. Sir Arthur said, 'You had better be careful. This is dangerous talk. One day you will find yourself on Tower Hill watched by a cheering mob!'

We talked about Ruth Gordon and Garson Kanin. Ruth Gordon was foul to him and made him give up spirits out of spite. (He tippled a lot.) Ginette said that the Kanins are great ones for microphones in the flowers. Noël Coward said he did not dare die for fear of the folder marked 'C' coming down from above the bed and the biography being written. When Spencer Tracy died, Katharine Hepburn said she had *not* yet read Garson Kanin's book. 'I need the Kanins at the moment. When I've read it, I know I'll never be able to speak to them again,' and it was so. Garson Kanin used to have a great love affair with KH.

Irene Selznick: 'God, I must say you are not mentioning my favourite characters . . .' said Ginette. Well, she seduced Binkie Beaumont* in the Ritz, Paris. She was very possessive of him – she put him off women for life. And Marlene is now drunk from noon on and a total recluse living in Paris.'

* Hugh ('Binkie') Beaumont (1908–73), one of the most influential theatre managers of his day; chairman of H. M. Tennent.

London, Sunday, 2 May 1982

I went to lunch with the Sutros at the Garrick. Gillian is extraordinary – I wonder what age she is. She looks like a teenager, rather like Pandora Astor.* 'Gillian has a certain charm as you see,' says John. He spoke of 'Let's call it Greek love – a pleasure that gives only pain.' He said Cecil was unlucky in love. John was staying with Robert when the Lord Berners things came out:† 'It would have been better if he had sued really.' David Herbert learnt from Bridget Parsons‡ about the car [that Peter Watson gave Oliver Messel] and passed the news on to Cecil. Gillian said that Cecil had 'panache'. Rex Harrison moves into Monte Carlo any day now. They will help me meet him. They said his present wife§ has really 'hit the jackpot'. She has got him off the booze and he has massages regularly and bicycles on one of those bicycles that doesn't go anywhere. A few years ago he was going to pieces. Even when she was away, he kept up his routine. She protects him. That's how he got through his recent stint as Higgins.

Later John and I sat upstairs for a while. I noticed that from time to time John threw his head back and laughed and his mouth came wide open and he looked like a child. It was both engaging and sinister. In a way he is joke-ugly. He is also a superb mimic. Putting the name card in his pocket, he mimicked a policeman: 'This card from the Garrick was all we found on 'im.'

Tuesday, 4 May 1982

Diana and I set off with Doggie to visit Eileen in the Close at Salisbury, where she has settled. We talked about Stephen Tennant, who had written to me that he suffered from *neurosis* – 'the price I pay for being a genius'. Diana was all for going in [to Wilsford], but was

* Pandora Astor (1930–88), formerly married to Enid Bagnold's son, Timothy Jones.
† In 1972 Cecil upset Robert Heber Percy when he published *The Happy Years*, in which he told the story that Robert had refused to allow Gerald Berners to have his breakfast in bed, and that he had turned his face to the wall (p. 113). When the book was serialised, Robert was livid. It provoked him to knock Cecil down outside Peter Quennell's house in March 1974. Cecil had his serious stroke soon afterwards.
‡ Lady Bridget Parsons (1907–72), one of the Bright Young Things.
§ Mercia Tinker, who married Rex Harrison as his sixth wife in 1978.

easily deterred. We found the Close and Eileen's apartment. It had a splendid view of the west door of the cathedral. It was warm and convenient, and bright. My only criticism was that it could have done with one more window in the main room.

Diana is funny. She said she didn't approve of the great head in the hall or of the Ashcombe urn on top of the wardrobe. She said, 'That old brute – he could go there.' The urn had to be 'outside'. She loved the Bérard of Cecil, and thought Billie Henderson's portrait of Cecil in the drawing room 'not good but charming'.

There was one terrible moment when Diana choked. She coped well but it was potentially dangerous. Eileen said that if her heart hadn't been good, she might have died. Yet Diana being Diana she was soon fine again and, when recovered, went on eating and talking as though nothing had happened.

Eileen said that when Cecil was upset it was like in a novel: 'His innards turned to water.' (The diaries are full of that.) Talk turned to Cecil and Garbo. Diana said she lunched with them both and asked him, 'What does she do all day?' This at Pelham in 1951. Cecil concluded she did nothing. She said it was a dismal lunch, whereas at Chantilly, once Garbo had had a little too much to drink, she was wonderful. Diana asked Eileen, 'Could you be fond of her?'

Eileen clearly wasn't. 'I could *see* how you could be,' she said.

Diana and Eileen both thought the portrait of Lotte Lenya (Mrs Kurt Weill),* done by Cecil, very good.† Diana was sad when she looked through Eileen's album and saw a picture of Cecil's grave. She suddenly cried for a second. I think she feels things more than people realise.

The nicest thing from my point of view was the reconfirmation of confidence in my work. Diana said how 'lucky' they were that I was doing the book. Eileen clearly agreed whole-heartedly, which was marvellous as I feel I have taken so long that I'll be letting them down. I hope the shade of Cecil will not feel ill served at the end of it all.

Presently (four-ish) we set off again and I related Hollywood tales. Diana said that Kin Hoitsma was perfectly accepted by the friends: 'If

* Lotte Lenya (1898–1981), American-Austrian singer, known for her Brecht-Weill associations, *The Beggar's Opera*, and later as Rosa Klebb in *From Russia with Love* (1963).
† I bought it in the sale after Eileen died.

Cecil came round he came too. He was very amenable and aimed to please.' She said, 'He must talk to you.'

London, Sunday, 9 May 1982

Dudley Scholte (1905-90) was a school friend of Cecil from Heath Mount days. Son of the well-known tailor, he still lived in Hampstead.

Dudley Scholte lives in a nice flat at the back of a house with a lovely garden. He said he thought Mrs Beaton one of the most beautiful women he'd ever seen. Cecil too was 'lovely' and 'beautiful' – 'I use the term in relation to him as a human being.' There was a photo of the school group. Cecil was the only one with a thick fringe. He was bright-eyed. His tie was not well tied, but he looked a cheerful little soul.

Dudley Scholte loves what I'll loosely call music-hall stars. He talked to Zena Dare the afternoon she died. He sees Eva Turner[*] and knew Fritzi Masary and Ethel Levey.[†]

This is his world and in a way it is Cecil's world, but he escaped from Hampstead into a brighter but tougher one. Dudley Scholte said, at dinner in the Villa Bianca, 'It's terrible to realise that one's on the last lap and that there's so little time left. I've so enjoyed my life, thanks first to my parents, second to my friends.' He loves Hampstead and after a brief spell in the West End, he has returned here. He is a friendly man, who dislikes things like promiscuity, who has simple tastes and who enjoys them.

After dinner I walked down Langland Gardens, Cecil's first home, indeed his birth-place. Then I drove to Templewood Avenue and the corner of the house where he lived later on (Reddington Road). It was a nice break and an escape into my real work.

May 1982

Laura said that Robert Heber Percy loves living alone: 'The thing about living alone is that you can gurk and fart whenever you like.'

[*] Dame Eva Turner (1892–1990), international soprano.
[†] Fritzi Massary (1882–1969), soprano and actress; Ethel Levey (1880–1955), American actress.

Send, Tuesday, 18 May 1982

A visit to Loelia. She had asked me to edit her albums. This proved a grim exercise, as I ended up doing all the work, and even ghosting an article for her for which she was paid a thousand pounds and I was paid nothing. It led to a bitter row, but eventually the book came out as Cocktails & Laughter. *The plus side was that she arranged meetings with the Jungman sisters, Sir Sacheverell Sitwell and a talk on the telephone with Audrey Hepburn.*

I found her in the garden, enjoying the peace of a lovely summer day . . .

My conclusion about the marriage of the Duke [of Westminster] to Loelia is that he chose her as a good young girl, strapping and likely to give him an heir. His only son had died. When she failed to produce a child, he became exasperated.

Loelia told me more about Cecil. She said that the play was awful, but she remembered that Diana went round saying, '"Now we must all raise a loud cheer when he comes in." He got a drenching from the critics the next day.' The setting was pretty and the costumes, but the dialogue had nothing in it. 'You kept waiting for something to happen.'

Cecil evidently used to ask for dialogue. 'How could he know what a man said to a woman in a love scene? It was like Noël Coward. His love scenes were all awful too.' Loelia once incurred Cecil's displeasure because Charlie James made her a dress in a very dark room and she couldn't see it properly, so she refused (I rather think) to pay for it . . .

The Falklands War was raging, the Pope visited Britain and a host of rich Americans arrived in London to attend various events, including a ball at Broadlands (at £250 a ticket) in aid of the United World Colleges at which I had my first meeting with the Princess of Wales; forty-one pages of diary on the Pope's visit, sixteen on the ball and ten on the next day's polo match.

Broadlands, Saturday, 29 May 1982

I was the guest of Suzanne Rothschild, a friend from teenage holidays, whose grandmother had been a friend of Lord Mountbatten. Somewhat reluctantly, I

give myself away with this over-the-top account of effectively a non-encounter.
That I consigned to my diary my sparklingly original words shows the pulver-
ising effect that royalty has on so many mortals.

We squeezed into the library where I was able to point out the signed
photos and royal wedding telephone. Then we prepared to enter the
Wedgwood Room. Nothing was as surprising as the line-up, for
there were the Romseys and . . .

then . . .

the Prince of Wales and then . . .

THE PRINCESS OF WALES

It was too exciting. So through we went, announced at the door as
the previous evening and by the same man. Lady Romsey* was in
white with a different hairstyle – Suzanne said to the Prince of Wales,
'You went fishing with my sister.'

He paused and hesitated. 'Oh! Yes . . . er . . . with the Soameses?'
But she'd gone.

I said, 'Good evening, sir,' with my bow, then approached my
heroine.

The princess was in pink – almost Barbara Cartland pink. She
looked radiant – she is a real star – with her mop of fair hair and flash-
ing eyes, a firm handshake from quite a podgy little hand, a smile for
everyone. 'Good evening, ma'am,' I said, and passed on quickly,
swooning out onto the terrace and down onto the lawn.

I have made fun of myself and my feelings for the Princess of
Wales, but I was most surprised by the effect that she had on me. It
was as though one had met the girl of one's dreams, never believing
such a thing possible.

London, Thursday, 3 June 1982

I went to see the Baron (Lord Weidenfeld) to talk about Cecil.

Lord W was seated in a huge chair with his feet up. He makes a terri-
fying sight – slumped back, cigar in hand, with his huge stomach in

* Penelope Eastwood (b. 1953), wife of Lord Romsey, Mountbatten's grandson;
now Countess Mountbatten of Burma.

front of him. He had another man with him, who promptly disappeared – he was dismissed. He then sat back and the man offered me a drink. I sat in a low and comfortable sofa some distance away with an enormous iced orange squash. I asked George how he got on, as his publisher, with Cecil and what he might hope to find in my book. I was surprised how much he remembered. He is a fluent speaker and he dazzles with talk of high politics.

'There must have been Cecil Beatons, *mutatis mutandis*, at the time of the collapse of the Holy Roman Empire, recording the decline. He recorded the aristocracy – he sharpened their awareness of themselves. He flattered them, romanticised them, but he was a conspirator. He showed that in his diaries and in his speech.' He said that Cecil found the aristocracy easy to be with. He enjoyed their comforts and way of life, but he was not like Mrs Kenward.* 'She really believes that they are important.' He also said that he thought so long as Cecil was given a good enough seat, he would not mind seeing the entire aristocracy being executed in front of him.

The Baron said, 'Beaton was part of the new Churchillian renaissance. If Evelyn Waugh was opera, then Cecil Beaton was operetta.'

'In some ways he sold himself to the devil.' The Baron thought that the *Vogue* anti-Semitic thing was a kind of hitting back, a revenge for what he had to do [in his life]. 'The life of the twenties and thirties never really left him . . . He was like the character in *The Tales of Hoffmann* who, when he is wearing his glasses, sees everything as beautiful, but when he takes his glasses off, it is all very tawdry.'

The Baron first met Cecil in 1951 through Clarissa when she was working on *Contact* magazine, the origin of Weidenfeld & Nicolson. Cecil had been given an advance of a thousand pounds to do his book, *Photobiography*, by Odhams. He was fed up with Batsford. Thereafter George and he had a good relationship. 'I published all his books after that.' Waldemar Hansen† helped him with his books. The Baron thought that *The Glass of Fashion* was his best.

I asked what he thought of the Garbo incident. He said that she might well have taken a fancy to him. 'The physical side may not have

* Betty Kenward (1906–2001), social journalist who wrote 'Jennifer's Diary', in *Tatler*, *Queen*, then *Harper's & Queen* for many years.
† Waldemar Hansen (1915–2004); see note on page 214.

been as important as it usually is when a beautiful woman is involved.'
(Speaking of himself, probably.)

Gellibrands, Sunday, 6 June 1982

*I went to stay with Laura, Ginette Spanier and Hugh Massingberd being the
other guests.*

I was at work on this diary when Laura came down and announced
that Ali was due for lunch. Hardly had she spoken when the tones of
Forbes could be heard in the next room. When Hugh and I came out,
he said: 'Ah! . . . Gilbert and Sullivan, as it were.' From that moment
until ten o'clock that night, Ali did not draw breath. At times it became
exhausting, so much so that I had to leave the room, but he was also
terribly funny and we all laughed a great deal. He is an excellent mimic
and has a way of getting all the minor details correct. His story of the
Queen of Spain and her wedding:* 'Oh! There was blood all over my
wedding dress. It was terrible. And the head of the man right there by
the carriage . . .' 'Yes, ma'am, and last week the head was on the other
side of the carriage.' Ali said he got Cecil his knighthood ('non-swanks')
with the help of Anthony Head. Also that the reason that Noël didn't
get his for ages was due to a currency fraud, albeit the fault of account-
ants, in the 1940s. Roy Jenkins had to say as chancellor of the excheq-
uer, that 'The Treasury would have no objection.'

Lord Mountbatten, of course, took the credit for the business: 'I
shall take it up with Lilibet.'

There was a lot of talk about Randolph Churchill. Ali was at
Chequers when Averell Harriman, President Roosevelt's special
envoy, tripped along to Pam Churchill's room. Randolph, 'slum-
ming it in the Mohammed Ali Club, in Cairo' resented this – but to
WSC the 'special envoy' bit went down rather heavy. Ginette, Laura
and Ali thought that Pam was the last of the great courtesans – 'ten
pounds under the clock' – yet the view was also expressed that there

* King Alfonso married Princess Victoria Eugenie (Ena) of Battenberg in 1906. In
later life the Queen often related the story of how a bomb was thrown at their
carriage as they returned to the Royal Palace after the wedding ceremony. The royal
couple were unharmed, but twenty-three people died.

was hardly a mantelpiece built that would hold the sum of money she needed. There were jokes about Gaston Palewski,* who could have anyone he wanted once he was minister of the interior. 'Hmm,' said Hugh, finally getting a word in. 'Minister of the interior . . .'

Ali said, 'Inside every bully, there's a coward trying to stay in.' At the end of the evening he disappeared into smoke, while we three set off on our journey to London.

London, Wednesday, 23 June 1982

I hoped for a quiet day but ended by having a stream of Cecil Beaton visitors. Thus it was a day for talking, rather than study. The first to come was Ali Forbes. Noted for his reluctance to pay for anything, I can record with pleasure that he invited me out to lunch at a bistro. But I said how much nicer it would be to see him here. Ali arrived at twelve thirty or so and was very funny as usual.

Ali's best bit was his description of my awful photograph of the hand of Mrs Stass Reed† as 'wax poured loosely into a contraceptive'. He took some photos and I began to fuel my thoughts that he might be a spy. Possibly he has to send back some snaps of people here and there in order to earn his trip. Later I heard that he took photos of Eileen and her flat.

Hardly had he gone than Michael Wishart appeared. We talked of Stephen Tennant. Michael said he'd often gone down there as an invited person and been turned away. He also told me about Sir Anton Dolin, whom I was shortly to see. He said that Dolin hated Cecil. He had torn up some photos that Cecil took because he didn't like them. He was a friend of the Queen Mother. He had been upset not to have a knighthood because it was difficult for a homosexual to get one. But finally the Queen Mother fixed it for him. Several attempts by others had failed.

Michael Wishart liked the portrait of Elsa Maxwell.‡ He thought it

* Gaston Palewski (1901-84), French politician and ambassador, a noted ladies' man, known as L'Embrassadeur; Nancy Mitford loved him for years.

† Martha Cuneo (1921-2003), wife of Stass Reed (1913-89), Russian-born businessman in New York. I had taken a photograph of Mrs Reed's aged hand coming over a seat in the bus in which we had travelled to Cowdray Park.

‡ Elsa Maxwell (1883-1963), rotund gossip columnist, who arranged parties and exploits for society figures.

one of Cecil's best. I gave him a copy of *The Glass of Fashion* and in exchange he is to give me a Cecil portrait of Joe Louis.

London, Sunday, 4 July 1982

Sir Anton Dolin (1904–83) was a ballet dancer and choreographer. He had joined Diaghilev's Ballets Russes in 1921, becoming a principal in 1924. Later he was a principal with the Vic-Wells Ballet and went on to found the Markova-Dolin Ballet and the London Festival Ballet. He was a choreographer with the Ballet Theatre until 1946.

I spent the morning studying Sir Anton Dolin . . . At four thirty I went to see him. He lives in Orme Court, near Jeremy Thorpe, and in the same block as Spike Milligan. He shares a dwelling with the dancer John Gilpin.* It is a sturdy Victorian block with a good enough view over Hyde Park. Sir Anton was at the television, a Dick Emery-type man, with white socks and black slippers. He was deep into the Wimbledon men's finals. In the end I got no interview but a lesson in tennis. He described Cecil as 'a horror'. He said it was quite disgraceful that he published those 'fantasies' about Garbo – 'all made up'. 'I suppose he made a fortune from the serialisation?' he said.

He told me that he had so hated photos Cecil took of him in *Nijinsky* (the film) that he tore them up. 'Unwise I now think. They're probably worth something. I love money.' He said that when Cecil designed *Camille* he made no bed for her to die on. 'She'll have to die on the window seat,' said Cecil. He did like the earlier ones – the earlier costume he did for him in the Cambridge revue, *Le Charlot de Masquerade*, or some such.

This conversation took place as Connors and McEnroe† fought out the men's final. It was a never-ending match, it seemed. I could not get out my question: 'Did he make a good contribution to ballet?' But later I got the answer I had expected: 'Nothing like as good as Oliver Messel.'

Sir Anton told me he was once in a car with Garbo and a very drunk Schlee after a party. Schlee was weaving around the roads of

* John Gilpin (1930-83), who married Princess Antoinette of Monaco shortly before his death.

† Jimmy Connors (b. 1952), and John McEnroe (b. 1959). Connors won.

the South of France. Dolin v. scared but then thought of the public-
ity: 'Garbo and Dolin in hospital.' Really! After Schlee died, Valentina
got the Cap d'Ail property and said, 'I'll exorcise that woman from
the house.' Valentina speaks in a thick Russian accent, I gather.

His flat is full of signed *Vogue* photos – even the Duke of Connaught
and Princess Marie Louise.* I gave him a copy of *The Crown & the
People*, and he signed his book for me.

Wilton, Friday, 9 July 1982

*The Earl of Pembroke (1939–2003) had known Cecil all his life, since his parents
and his uncle, David Herbert, were all close friends. He was a friend of a younger
generation and I had found him to be a sympathetic visitor to Reddish House just
before the 1980 sale. He inherited Wilton in 1969, and was a film-maker.*

I drove up to the gates just on time and was escorted to the right-hand
side by a very friendly gateman. 'I'll just tell Lord Pembroke,' he said.
Henry Pembroke emerged from an estate office or whatever at the side
in blue jeans, belt and open shirt. He is very tall, gentle and friendly. I
drove my car up to the door that looks like a window and we went in.

Henry Pembroke gave me a drink and then told me of his visit last
Saturday to Stephen. The old devil was not in bed. He was up and
about somewhere. The first they knew his arms were outstretched in
exaggerated greeting: 'Henry, dear.' He brought with him 'Liz-Jug' as
they call Princess Elizabeth of Yugoslavia,† and her current American
boyfriend. They were fascinated by Stephen and had wanted to see him
again. So Lord P wrote him what he called 'an oily postcard'. The
worst of this visit was that Stephen decided he would show them his
legs as they were so beautiful. Therefore he raised himself up, began
fumbling with something that held his trousers up and gradually
succeeded in getting the trousers down to his thighs. Then he sank
back dramatically and announced, 'You'll have to help me.' The

* HRH The Duke of Connaught (1850–1942), son of Queen Victoria; HH Princess
Marie Louise (1872–1956), granddaughter of Queen Victoria, memorably
photographed by Cecil.
† HRH Princess Elizabeth of Yugoslavia (b. 1936), daughter of Prince Paul and
Princess Olga.

assembled company was by now in fits of laughter. They could hardly control themselves. But Princess Elizabeth took the initiative and grabbed the ends of the trousers and pulled them down. She revealed Stephen in his bloomers, again tied around the knees. Stephen held out his legs and said, 'Aren't they beautiful?' They weren't. They were fat. He said, 'I've always longed to be photographed with a Pekinese on my ankles – like an actress.' Mr Skull came in and didn't bat an eyelid.

He went on to play them *Oklahoma!* with his 'signature tune': 'People Will Say We're In Love'. As it was played, he struck various attitudes, stretching his arms out to left and right. Lord P said, 'But it's all very well. We come away with these funny stories. But he must be very lonely sometimes.'

Lord P is an expert on Willa Cather now. He's delighted when Stephen talks about other things. Once he tried very hard to get him to change the subject without success and finally shouted. 'There's no need to shout, Henry dear. I'm not deaf, you know.'

We had one drink and then that butler, Mr Allen,* came up to announce lunch. We went down to the charming dining room, and there was a small table in the middle of the room – not the extended one. Mr Allen served lunch and I, of course, took the salad and put it straight onto my plate, not noticing the salad plate. I looked up and observed his downturned mouth – awful man. He was so beastly the last time I was there.

I went to Salisbury and Shaftesbury, and when the time was right, I went to Clarissa's.

I was so happy to be back there. I was shown into the dark blue room with the Sir William Eden pictures in them.

On Thursday, 5 August I set off for a three-week trip through Europe. This was a holiday, but I took the chance to look up Count Friedrich Ledebur, met

* The Pembroke family remember Mr Allen as a more humorous figure. When Twiggy came to lunch, and being virtually vegan, enquired about the red meat, his reply was: 'Bambi.' Lord Pembroke was not known for being tidy. Mr Allen ventured: 'A poltergeist appears to have got into your room, my lord.' It is conceded that he could look forbidding when he arrived at the house in a black cloak.

with Diana Cooper, the previous summer. On 21 August my hostess at Nöchling, Peggy Neumann (met when I was studying at Strasbourg), rang the Ledebur house, and Countess Ledebur promptly invited me to lunch the next day – on the strength of the introduction from Diana.

Schwertberg, Austria, Sunday, 22 August 1982

The house is called Villa Friedegg, which is funny as the name sounds like Fried Egg. Fortunately I spotted the figure of Friedrich Ledebur coming towards the gate. He really is rather like Count Frankenstein, hugely tall and dressed in old suedes and light browns. He'd been out riding his ponies – not bad for eighty-two. I think he remembered me but he didn't remember my name. His countess [Alice Hoyos] was better informed. She got all the names right first time round. She said, 'When you said you were a friend of Lady Diana's, we expected a tottering old gentleman.'

She was a curious-looking person, twinkling eyes in a pale regular face with grey hair pulled back. She was quite a big, strong woman, dully dressed in skirt, green pullover and those awful stockings that only come to the knees. But she wore expensive scent and had a kind face. There was one other strange thing about her. She had two marks on her forehead, two scars. They looked as though they'd been there a long time. What could they have been? It occurred to me that they must have been tooth marks and that the count really did live up to his name of Frankenstein and had bitten her. It would not have been impossible. The count is, of course, very kind and he, too, has twinkling eyes. He is amusing and lives on his anecdotes. But he was more discreet in his own home, or rather his wife's home, than he had been in London with Diana when he said that after Iris Tree's death and Raimund's, his life 'was over'.

The house was large and set out in grand style with tapestries, chaises, screens by doors, and so on, but not a lot inside it, it seemed. Later, the dining room had every kind of drink on the table and we were served a rather school-like lunch, cooked by the countess. 'It's so hard to get people to work on Sundays any more,' said the old count.

He was much interested in the subject of Edward James and his book. He was amused by the references to himself and liked Edward

James, but he said he was a complete homosexual. 'It was nonsense him saying that he made love to Tilly [Losch] four times in an afternoon.'

He liked Cecil but not the side that always went after famous people. 'He used to come a lot to Lake Kammer to stay with Eleonora Mendelssohn,* daughter of the banker. I saw him with David Herbert and Peter Watson. He was completely homosexual.'

He said he didn't think Cecil's photos particularly good. Too much society and court, not enough heart. 'In England if you are with the court you are everything. He was always with the Queen.' He thought some of Cecil's other work excellent, like *My Fair Lady*.

There was much talk of Diana a week before her ninetieth birthday. He said, 'Diana doesn't mind who you are. King or peasant. She judges you on what you are.' He told the story of Tilly and the itching powder, adding that Kommer said to her, 'Never were you better, Diana, than tonight. How did you do it?' She just stuck it out, tears streaming.

Temple Sowerby, Saturday, 4 September 1982

On my way up to Scotland I realised I could visit Temple Sowerby where Cecil's mother had lived as a child. It proved something of a revelation. While I was looking at Sisson family graves, the churchwarden suggested I should seek out Katie Pearson (now Mrs Kate Hindle),[†] aged eighty-five and the village's oldest inhabitant.

I knocked on her door and, though she was in the midst of cooking a huge but revolting lunch for herself, she was happy to let me come in and talk to her. She certainly knew a lot.

She said the three younger sisters were 'outstandingly beautiful'. They caused 'quite a sensation' in the village. The one called Clara (known as Cada)[‡] was 'very, very friendly' and they all had

* Eleonora von Mendelssohn (1900–51), actress who died in New York in questionable circumstances.
† Kate Elizabeth Hindle (1897–1989).
‡ Cada Sisson (1879–1970), married Richard Chattock; Cecil's aunt.

'bags of confidence'. Their father, Jossie,* was the village black-smith. And the girls were on the roll of the Methodist Sunday school. 'Jossie you'd know by his hat.' The house was the one next door, supposed to be Queen Anne and now owned by a Mrs Moberly. Joseph, the brother, was older than Etty; the older girls were much plainer.

The grandmother† was austere and in a way aristocratic. She might well have married beneath her. These were cousins, Annie and Minnie ('too distant and homely' – Cecil Beaton didn't go and see them when he came up). There was Albert, the auctioneer, John William, also an auctioneer, and Tom Park, who was a miller, sold flour at Acorn Bank. He was basically a poultry man. At one time he took the King's Arms and was very successful.

Then Mrs Hindle told me that Elizabeth had been inclined to go down to the King's Arms – they reckoned the three younger daughters were not Jossie's girls, but the daughters of young gentlemen who came up to fish and put up at the King's Arms. Likewise, when her daughters were growing up, she would look through binoculars and when she saw young gentlemen there she'd send her daughters down to the King's Arms. That's how they met men and escaped from the tiny hamlet.

Mertoun, Sunday, 6 September 1982

The 6th Duke of Sutherland (1915–2000), was the son of Violet, Countess of Ellesmere, the central figure in the Bridgewater House gatecrashing affair in 1928 – the time when Stephen Tennant took Cecil's sister Nancy and other girls to the ball, and Lady Ellesmere threw them all out. The duke had the album his mother had made about the affair, which contained all the press cuttings and the letters she had received.

Mertoun is a large and grand house without actually being a castle or a traditionally ducal home. It was one of the seats of the Earls of Ellesmere. This duke was Lord Ellesmere before succeeding. I walked

* Joseph Sisson (1830–1907), Cecil's grandfather.
† Elizabeth Oldcorn (1835–98).

up the many quite steep steps and the duchess opened the door. She was rather attractive and very smart.

I was telling the duchess about my work when the duke came in. He is immensely tall, thin, and thus rather a handsome man. I'd been told he was a bit shy and that gave him added dignity. I liked him, and he was as anxious as possible for me to have a good look at the book. He took me to another room where I wallowed in its contents for the next two and a half hours. He came in once to see that all was well and the duchess twice to give me delicious tea and cakes to sustain me as I saw 'the other side of the coin'. The duke said the whole episode sounded so ridiculous now, but at the time everyone was having trouble with gatecrashers and was furious. It was clear from the book that Lady Ellesmere's friends reckoned she had taken a gallant stand. I believe her to have being lying in wait for potential gatecrashers as she'd had trouble with them the year before. The duke thought this 'very possible'.

London, Monday, 6 September 1982

I took Diana to the launch of the Noël Coward diaries at the Baron's.

It was quite a crush. Coming up the stairs were people like the Wiltons, Evangeline Bruce and Drue Heinz[*] – then inside, amid a large number of Middle European figures of sinister appearance, were the mighty figure of Robert Morley,[†] his almost equally mighty son, Sheridan, and, looming large, the Baron himself.

I saw John Curtis approach and instead of jumping on me and saying, 'How are you getting on?' he rushed at me and said, 'I'm going to *pounce* on you for that book.' It was so overdone and unnecessary and particularly ill timed after my recent discoveries. It is clear that he has been sat upon for the book or some big book for next year and has decided to get mine from me. 'It will be a next-year book, won't it?' he urged.

[*] Mrs H. J. Heinz (1915-2018), philanthropist.
[†] Robert Morley (1908-92), actor; Sheridan Morley (1941-2007), author of numerous Hollywood biographies.

'Ye-es,' I replied, and hid in the corner for the rest of the evening, with Diana and Loelia. For me the evening was completely ruined.

John Curtis had hoped to bring the book out before now. He might have thought it would all be done by the end of 1981 at the latest, and here we were, well into 1982. He became increasingly aggressive as time went on, and I became equally annoyed.

I wanted to do a thorough job and, since the advance had long run out, I was financing the research myself by the profits from my royal wedding book. I was taking it all seriously, realising that this book was an enormous opportunity for me (to make my name as a biographer) and a challenge (to get it right). The nature of the project had magnified considerably since Cecil died. This was going to be the book on him. There were still people I needed to see, and I still had not finished deciphering the diaries. While I could see where Curtis was coming from, and appreciated his frustration, I still resented this, the first of many onslaughts from him, which darkened the remaining years of work on the biography.

Cambridge, Tuesday, 14 September 1982

I went up to Cambridge to explore Cecil's time there. Mr Buck at St John's College produced the report on Cecil sent from Harrow before he came up in 1922. And I was able to meet his old Gyp [college servant], W. G. (Bill) Butler (1896–1984), in his home.

Bill Butler

He was a dear old boy and had become eighty-six the day before. He had only nice things to say about Cecil.

He said that Armitage* travelled a lot in Spain. He used to get a lot of notable men as undergraduates. One day he called him in and said, 'Butler, I want you to valet one of my young men.' Bill Butler was then the under-porter at the college. He went on to be head porter. His job for Cecil was to clean his shoes, see what clothes he wanted, take away for pressing the ones he didn't want. He said Cecil's rooms were the top ones and he had a sitting room downstairs. He could leave his bedroom as untidy as he liked. He loved his studio in Ram Yard. The Gyp would ask him, 'Now, who are you having to lunch today?' and there would usually be one or two. Boy le Bas he remembered – as a member of Footlights: he gave Mr Butler a seat right up at the front.

Mr Butler never saw him after Cambridge, though he was nearly on *This Is Your Life* for Cecil.

He said Cecil was 'a very nice gentleman, a very refined man'. He didn't wear those famous hats at Cambridge. He was very fond of flowers, and beautiful flowers would be sent up for a lunch or a dinner. He spent his time 'drawing women's dresses and hats', He would be sent to do errands. 'He came to depend on me.' Mr Butler was forty-five years at the college and retired in 1960.

Mr Armitage was 'rather a queer man. No one could catch him in.' He had a secretary who would be left to deal with anyone who came. Armitage became very poor in his later days, dishevelled, baggy trousers. He grew a beard. He disappeared to South Africa and was never heard of again. Wife quite wealthy and she was thought to have come from there. Mr Armitage used to be visited by antiques dealers, who lent him pieces. Then he overstepped the mark and got into debt . . . The college staff called him 'Biff' after his initials.

Mr Bullivant† he thought to be a businessman in Cambridge. A smart man came up occasionally. He thought he was a friend from London. It was Cecil's tailor! Cecil didn't go to Hall much. He didn't

* B. W. F. Armitage (1890–1976), Cecil's tutor at St John's College, Cambridge. He left suddenly.
† William (Billie) Bullivant (1891–1958), a sinister former tutor to Cecil, who used to come up to Cambridge to entertain undergraduates.

mix with the undergrads. Only his close friends. He used the expression 'Alas . . .' a lot.

From Mr Butler I was able to escape from Cambridge, feeling I'd done well in material and in time. I got to a callbox and rang Diana. She was not going to the Duchess of Portland's party, but I reckoned I could get there . . .

I drove back to London and finally caught up with Sir Frederick Ashton at the duchess's party.

The Duchess of Portland's* party

I dashed off to Carlyle Square. It was a grand party and not too many people there. Loelia, who grows more and more friendly, introduced me to Freddie Ashton – I'd wanted to meet him for ages. He's an important source on Cecil . . . I went into the corner presently and had a long talk with him . . . He's very small, very red in the face, white of hair and lined, but friendly. He's also very camp in his movements and gestures: 'Yes, I'll talk about him . . . after a few drinks.' He said he loved Cecil but never felt entirely at ease with him. He didn't want to get too close and yet they had some good times together.

He told me he thought the Garbo stuff awful. He met her once. Cecil rang and asked him to come over. 'There's someone here who wants to meet you.'

'But I'm very dirty.'

'Perhaps she's dirty too.'

That gave him a clue. He brought a huge bunch of red roses. When she was given them, she shrank from them with no dignity at all – as though they were contaminated.

'Fonteyn would never have done that.'

* Kathleen (Kay) Barry (1911–2004), Canadian-born second wife of the 9th and last Duke of Portland (1897–1990). He succeeded to the dukedom in 1980. He and his elder brother were distant cousins of the 7th Duke, who had died in 1977, leaving only daughters. Welbeck Abbey and the other estates stayed with his descendants. The next two dukes were distant cousins, descending from the 3rd Duke. The two families remained distant.

He said that the mother was 'common. I dreaded her.' The aunt was a bit easier as they had South America in common. Cecil was easy to work with in the ballet (as Lincoln Kirstein had said), 'but occasionally he'd kick up a fuss about a rose or something'. He said he wished he could have worked for the film *My Fair Lady*: 'I'd have made a lot of money – but I had just taken on the job at Covent Garden.'

We talked of the Garbo thing and he said, 'Cecil could fuck women' (these words from the distinguished holder of the OM and CH). 'After all, he fucked Coral Browne,' he said.

Freddie Ashton wanted a lift so I took him. He leant on my arm.

Princess Grace of Monaco

It was on the Edgware Road that I heard on a crackly radio the report that Princess Grace had been badly injured in a car crash, driving with Princess Stephanie. My heart leapt as I thought they were going to say *killed*. I kept saying, 'Thank God. Thank God', when I realised it was but a case of broken ribs.

But, alas, so sadly, when I was watching television there came two newsflashes. The first said that the Lebanese president elect had been assassinated and I believe while on air (11 p.m.) Alastair Burnet reached for another piece of paper and the picture of Princess Grace came onto the screen. She had died this evening. Later they said her family, Prince Rainier, Prince Albert, Princess Caroline and Princess Stephanie were with her. She was only fifty-two. Less than a year ago I visited her and she was so kind to me. I went completely numb and knew, if I needed reminding, that I *could still feel*. I felt it acutely. It must have been a grim and terrible accident. I know those Corniche roads.

Gerald Clarke had been in touch with Eileen about the authorised biography he was preparing on Truman Capote, so we agreed to meet.*

* Gerald (Gary) Clarke (b. 1937), then at *Time* magazine as their show-business reporter and writer. In 1988 he published his superb and rightly acclaimed biography of Truman – *Capote* (Hamish Hamilton).

I made my way to the Savoy to meet Gerald Clarke who is over here to do a profile of Lord Olivier. We had dinner in his room at the Savoy, which was much nicer than going out. We talked solidly for hours from soon after eight, eight thirty until about one in the morning. Nearly all of it was about Cecil and Truman. He sees Truman quite a lot and indeed at times he has a problem with him: Truman comes round to see him and talk to him when he'd much rather be spending his time with the imaginary Truman writing about him.

He said that Truman believed Cecil and Garbo to have been lovers. He was in the next room once, not that he heard anything. He said that in Honolulu Cecil picked up two sailors who proceeded to beat him up and steal his cameras. Cecil was rescued by Truman who, though but five foot two 'is capable of courage at times'. Truman got his idea of a Black and White Ball from Cecil's *My Fair Lady* (as I guessed).

Truman now denies the story of the murderers trying to put his eyes out. But I have details of the story in my files. Gerald Clarke got nowhere much with Cee Zee Guest evidently. 'Truman's a faggot,' was her line. 'You never know what faggots do.' Evidently Truman speaks nicely about Cecil, and Gerald Clarke thought he'd talk to me. He doesn't think they were lovers at any time. Jack Dunphy* was always around, resenting Cecil rather. He said Cecil used to turn up and hang about. Gerald Clarke said that Truman's idea of an ideal man was a middle-class man with a wife and family. Once he fell for an air-conditioning mechanic and took him round the wall (as he put it) and sat him next to the Queen of Denmark at lunch. He soon got fed up and realised he was out of his depth. I recalled that Kin Hoitsma was the same but he left because he said that everything was 'trivial'. There was a man in San Francisco who wanted him back. He came over and he could do both – intellectual or light and fun. He could recognise any piece of music by the first two notes. So could Kin, but they never knew it till then. Truman was all for Cecil going to San Francisco to live with Kin. He said it need make little difference to

* Jack Dunphy (1914–92), Truman's long-term lover. Author of *Dear Genius* (1987). Originally a dancer who appeared in *Oklahoma!* (1943), he was married briefly to a fellow dancer, divorced and moved in with Truman. Also a novelist and playwright, as reclusive as Truman was outgoing.

his way of life. But no! Cecil would never have done that. You would have to revolve around him. He loved his garden too much, his English friends and life, and his knighthood was on the way. Truman said, 'This boy is the most important thing in your life.' But I think Cecil was the most important thing in his life.

Send, Saturday 2 October 1982

I took Diana down to Loelia's and we arrived just before Alastair Forbes.

Ali was very good with Loelia. Gérald Van der Kemp* was mentioned.
 'Your lover.'
 'Well. That's rather indelicate.'
 But he got away with it.
 Ali is so funny but he has a way of brainwashing one so that one forgets his stories. Basically all we did was to lunch. Then, to escape Loelia's appalling idea of us picking up conkers, Ali and I went to Guildford. Then back for tea, champagne at drinks time, then dinner and bed. Ali left after breakfast the next day.
 I loved Ali's description of Lucian Freud's pictures. He can't wait to get his sitters into 'the gynaecologists' stirrups'. It is certainly how he looks at them.
 Ali loves to make direct remarks and sometimes he offends. The best side of him is his love of his son and his urging of everyone to enjoy their sons while they can. He said he'd given up sex now because he had seen in friends' bathrooms the treatment they give for herpes.

Alvediston and Lake, Wiltshire, Saturday 9 October 1982

Clarissa read some of the diaries and despaired of what I had to decipher. She has been a great help over Cecil.
 She asked herself as we walked in the garden on Saturday, 'Did I consciously tidy up the house when Cecil came? Yes, I suppose so, because one wanted the reaction. When he saw the Winter Garden he'd say, "Oh! Ten out of ten."'

* Gérald Van der Kemp (1912–2001), curator of Versailles for thirty-five years; his wife, Florence (1913–2008).

London, Wednesday, 13 October 1982

Cathleen Nesbitt had died on 2 August at the age of ninety-three. I had heard news of her quite lately from Laura's friend Frank Wigram. James Berry had been right. As soon as she got home, within two weeks her marbles scattered in all directions. Her son did his stuff and got her two nurses. She was able to go down with him to see Frank and his mother. Unfortunately the two old ladies spent their whole time misidentifying each other. Cathleen would continually say, 'You know, I'm sure I've met you before. You look just like Winnie Wigram.' The end, when it came, was, thank God, at home. Frank also added some other pertinent information – that Rex Harrison hated her because she went to stay with him at a difficult time when Kay Kendall was dying. 'She tends to stay too long,' he said.

I collected Diana C and we went to St Paul's, Covent Garden to attend Cathleen Nesbitt's memorial service. There was only one pressman lurking by the door. We went in and I didn't give my name – Cecil would have disapproved. We were ushered up to the front by a side aisle. There was a lot of hand kissing. Sir John Gielgud kissed Diana's hand from the front row . . .

Behind us was Roland Culver,* 'the Duke of Omnium' in *The Pallisers* some years ago, and I knew a face and from the list it was Fabia Drake,† also in *The Pallisers* and *The Forsyte Saga*.

Diana introduced me to John Gielgud and we fell to talking about Cecil. He agreed to see me about him. 'I knew Cecil terribly well.' Then I told him I was reading all Cecil's old diaries. He said, 'I'm so sorry they published Noël Coward's diaries. So vulgar. I refused to take part in a documentary about it.' Then he asked, 'Did you know Cathleen?'

I said, 'Yes.'

'I adored her. I played with her so often. She played my mother, wife, everything.' And I noticed later that during the service he wept at one point. He read a piece, and the vicar was friendly and told us he had lately read Cathleen's autobiography. It's a good book. I enjoyed it and was proud to have it signed.

Otherwise I thought it was a sad little service . . . The son and

* Roland Culver (1900–84), well-known actor in films and on television.
† Fabia Drake (1904–90), formidable actress.

daughter at the door were rather slow at coming forward and we hovered nervously in front of them and moved on in silence. Embarrassing.

London, Monday, 18 October 1982

Paul Tanqueray (1905–91) was a photographer who had known Cecil since his early days. He looked a bit like Wilfrid Brambell in the TV series Steptoe & Son. *He had been a pupil of Hugh Cecil, then set up his studio in Mayfair, his portraits appearing in magazines such as the* Sketch *and* Tatler. *He had photographed every kind of star and society figure. He was much respected by the National Portrait Gallery, and Terence Pepper* was horrified when, one day, Paul Tanqueray told him he had had a constructive morning throwing away a mass of old glass negatives.*

I went to visit Paul Tanqueray at Brecon Road in Fulham. This proved to be one of the most enjoyable interviews I've done. He has a nice house, discreetly decorated, dark green carpet, pale pink walls, various friezes from his collection of props and pictures that have appeared as backdrops in various portraits.

He first saw Cecil at one of those theatrical garden parties. Then they both found themselves alone at the Russian Ballet. Cecil used a folding camera, not a box one, he said. The process in those days was called 'orthochromatic – so blue eyes came out better, hair darker, pink as very black'. Thus both he and Cecil had to retouch heavily. They were both exponents of glamour.

PT had a lot of shimmering scarves from the East and he used to photograph his own sisters. One committed suicide, like Reggie,† and he himself had a spell in St Andrew's [Hospital]. He thought Cecil's father was pleased in the end by his success. But it was good that Cecil had had a spell of office life. Perhaps we all need that.

Paul Tanqueray began life by wanting to go on the stage. He won a photo prize in his last term at Tonbridge. His housemaster said he

* Terence Pepper (b. 1949), brilliant curator of photographs at the National Portrait Gallery 1978-2014, who greatly enriched their collection.
† Reginald Beaton (1905-33), Cecil's younger brother. He threw himself under an underground train when he was in a state of depression.

should meet Hugh Cecil.* He spent a year there and learnt a lot. In the end he had to go because Tom Douglas asked for him specifically: 'He's cheaper and better than Hugh Cecil.' He had been allowed to do friends and used to gather up young actors and actresses.

He and Cecil worked in the darkroom at the studio he had in Kensington High Street. Every night there would be telephone calls from both mothers demanding to know when they would come home for dinner.

He took the famous photo of Noël Coward and the Lunts.† Cecil said, 'Bring along your biggest camera.'

As it swayed around, Noël Coward said, 'Harry Tate.'

Cecil asked, 'Would you develop mine?' but that was too much of a responsibility.

PT had said, 'I can't do these pictures.'

Cecil said, 'You can do it.'

In his youth, he was one of about thirty Mayfair photographers of whom only Madam Harlip remains. Now, he said, he has been outdated by the new fashionable figures. But money keeps coming in from the old photographs.

He remembered Cecil at the time of the Ellesmere drama saying, 'Those bloody duchesses.' He remembered the headline: 'Beaton apologises.' Cecil was brave. He was also brave over Maud Nelson. He went to court to support her. I must find that bit. He once photographed Stephen Tennant in clouds of tulle. He remembers Stephen's arrival at the studio. 'Stephen.'

'Cecil, my dear.'

They went to Burnet's for their backdrops. He and Cecil were for twenty-five years on surname terms and then, in 1952, it was suddenly Christian names. Cecil never came to a party that he gave but would have the night Reggie had died.

Paul Tanqueray said that it was bad luck Cecil died when he did. The memorial service was so drab as a result. He made a good point: 'No one wears mourning anywhere but the women didn't have to

* Hugh Cecil (1892–1974), society photographer.
† Alfred Lunt (1892–1977) and his wife Lynn Fontanne (1887–1983), legendary figures of the American stage.

wear their drabbest clothes.' John Fowler's service at St George's, Hanover Square was crowded in the summer.

I really enjoyed my meeting and at the end he said, 'Next time we must start on Christian names.'

Somerset and Dorset, Friday, 22 October 1982

The Trees had invited Diana for the weekend and me to drive her. On the way I tried to find Beaton graves at Tintinhull, but failed. We reached Donhead at about 6 p.m.

I had a long talk to Michael Tree all about Cecil and told him some things that surprised him. It is my plan to make my discoveries about Cecil's blacksmith grandfather quite well-known as a further reason for putting it in the book. By telling Michael Tree, I was on to a sure bet. He's known as 'Radio Belgravia', according to Laura. Later in the evening I heard it being repeated, a little inaccurately to Lord Glendevon.

Anne Tree said that Cecil went to bed with Adele [Astaire]* – she loved to 'talk sex' and said, 'He covered his parts with a towel.' Michael Tree said later that David Herbert once told him, 'Cecil had more physical success with women than with men.' He was such a stirrer. Anne said that June Hutchinson used to go through agonies, polishing nails and so on, before Cecil came to take her out. I said that Clarissa had admitted 'reluctantly' that she tidied the place up before he came. Anne said, 'Reluctantly . . . Yes, I have to admit that too.'

London, Tuesday, 2 November 1982

My aunt Joan was involved in the Falklands Ball to which a party of us went, including Diana Head.

Princess Alexandra† looks more and more beautiful as she grows older. When you think of her at sixteen and see what she has grown

* Adele Astaire (1896–1981), dancer with her brother Fred. She married the drunk Lord Charles Cavendish, uncle of Lady Anne Tree.
† HRH Princess Alexandra, The Hon. Lady Ogilvy (b. 1936), first cousin of the Queen.

into. She was very sweet and told me, 'It was always great fun being photographed by him [Cecil].' She said, 'I shall look forward to reading your book when it comes out.' She asked after Eileen, 'his charming secretary, who always lets me have photographs of my parents very cheap'.

London, Friday, 12 November 1982

My thirty-first birthday. I got thoroughly depressed and down and decided, in due course, that to cap the proceedings I would attend Princess Grace's memorial service at Farm Street.

I arrived just as a Rolls-Royce drew up and out stepped Princess Michael of Kent in a huge mink coat and hat. She did a sort of Hollywood swoop left and right to the photographers. I hung back to let her and the bearded Prince Michael enter and be greeted by Johnny Johnston.*

Inside, Princess Alexandra and Angus Ogilvy were already waiting. I crept round to the left and took up a place on the left-hand side. The Royal Family and the royal representatives then processed in and the mass began. It was very fine, with beautiful singing. There came the moment when everyone shook hands. Otherwise I was left alone and saw nobody I knew. Except at the end that silly woman Betty Kenward took off a ridiculous black veil, revealing her horrid black velvet bow. She pressed forward to get out quickly.

I slunk off on foot, passing Princess Alexandra whose car was stuck in the traffic heading to Berkeley Square.

London, Saturday, 13 November 1982

Sir John Gielgud (1904–2000) was one of Britain's most distinguished actors and directors. He had been famous since the 1920s, acting in plays by Shakespeare, Chekhov and Oscar Wilde. He had directed Lady Windermere's Fan *in 1945, for which Cecil had done the sets. He had been caught 'cottaging' in 1953, at a time when homosexuality was still illegal.*

* Lieutenant Colonel Sir John Johnston (1922–2006), Comptroller of the Lord Chamberlain's Office 1981–7.

Sir John came down into the foyer, then went up again for his coat. Like me, he had done some homework. I found him much easier than I expected, friendly and easy to talk to, not at all grand or forbidding. He smoked a cigarette almost in the style of one who expected his headmaster to catch him. And, of course, I had read that description of him by Cecil, 'looking like an oyster squirted by lemon'. I was therefore delighted when at lunch he ordered a plate of oysters. He is staying at the Savoy while he films. Today happened to be a free day. It had been a great help meeting him with Diana as that gave me a good introduction. He is fond of her. She had warned me to look out for his particular trait of always putting his foot in it. He didn't really do this today, but he did say on the way to the restaurant, 'I am thinking of writing some more myself. I've had such a time of talking about other people and I get fed up with it – Ralph Richardson's eightieth birthday, Larry's book. People really do get so garrulous in their old age.'

One of the things he said was on the subject of homosexuality. He asked about Cecil and women. 'Do stress that,' he said. 'I mean I'm totally queer myself, but the British public simply don't understand the business.' He said that an actress he knew had described Cecil as 'the best lay she ever had'. That was Coral Browne, of course.

On Tuesday, 30 November I flew to New York. Alistair Cooke was on the flight. I stayed with Joan Lazar, at her amazing rooftop apartment on 5th Avenue, kindly sent there by her daughter, Darcie du Pont.*

New York, Wednesday, 1 December 1982

By chance I strayed across Clarissa walking up Madison Avenue.

We went to the Metropolitan for a very light snack – I had wine, she an apple and coffee. She told me she had had an extraordinary time in Virginia staying with the Harrimans. She went to a meet and said that when they hunt there each horse jumps over the same gate in line. She was horrified to see that two immaculate black men were riding some distance behind the field. She thought, How awful, but

* Alistair Cooke (1908-2004), presenter of *Letter from America* for 58 years.

it turned out that they were Paul Mellon's[*] henchmen and that they follow the hunt to see that everyone behaves themselves. Pamela Harriman[†] (well-known courtesan of the age) is 'Democrat of the Year' and rides to several different sets of hounds. 'Every morning she came down dressed in another immaculate jacket with badges on it.'

Clarissa said she found the rudeness of the people here extraordinary. They say, 'Excuse me,' as they back into you. She had to make a speech last night: she'd been given four glasses of Chablis and nothing to eat. Then they suddenly said, 'Countess,' and she had to address them on an empty stomach.

We went to the front to meet Mrs Nin Ryan. I'd seen her the night before the Broadlands Ball. She took us to the Michael Rockefeller wing with its fabulous collection of African artefacts and heads, etc. They were so well set out and there were some wonderful things. Then we went up to the Impressionists. Mrs Ryan explained that the director, Sir John Pope-Hennessy,[‡] hated closed rooms and thus had these sections. If you went up close you could see the pictures as though in a room.

We went down to the Chinese Garden. Mrs Ryan said that twenty-five Chinamen came over to see it opened, and Brooke Astor[§] asked them what they'd like to see most. She thought they'd say Niagara Falls or the Grand Canyon. And that she'd arrange a bus for them. Instead they asked for Dr Kissinger. He was duly wheeled out.

Mrs Ryan told me that Cecil had photographed her quite a lot but said, 'You're just not photogenic.' He also took a lot of her daughter, Ginnie Airlie. She told us that Garbo never really talked to her[¶] – they said, 'Good morning' or 'Good afternoon' as they came past. But three years ago was a burst pipe in the building. 'This brought us all together and Garbo came into the apartment.' She said she couldn't ask Mrs Ryan to hers as it was not finished yet. (After all

[*] Paul Mellon (1907-99), American philanthropist, collector, racehorse owner and breeder.
[†] Pamela Harriman (1920-97), one-time wife of Randolph Churchill, later US ambassador to Paris.
[‡] Sir John Pope-Hennessy (1913-94), then head of European Paintings at the Metropolitan Museum.
[§] Brooke Astor (1902-2007), philanthropist, widow of Vincent Astor.
[¶] They both lived at 450 East 52nd Street.

these years.) Recently a very great Swedish friend of hers visited Mrs Ryan. She said that she wanted to go up to see Garbo or get the doorman to give her a note. The doorman said he couldn't ring. She wouldn't answer. In the end he was prepared to push it under the door. 'But,' he said, 'she won't read it.' Nothing happened. Mrs Ryan said that Valentina hated Garbo. She thought I should leave her a note.

Mrs Ryan had been lunching with Mrs Reagan in connection with an appeal for the Salvation Army. Mrs Reagan 'looked very pretty in white'. She said that every day Mrs Reagan rings up Jerome Zipkin* and says, 'Tell me, what should I wear today? My blue outfit or my beige one?' He advises her and that's all they say to each other. When Mrs Ryan gives a cocktail party in London she gets anyone she wants. Last time, Ali said she had three prime ministers. Certainly Macmillan and Heath, and I suppose either Home or Wilson. Heath is quite a good friend of hers – he was here lately and came down to tea in blue bathing trunks and with a huge tummy over the top. 'He didn't look aesthetic,' she said. June Hutchinson was there, saying it was the first time they'd met since their romance. Funny that Heath and Cecil have that in common.

New York, Friday, 3 December 1982

I dropped the book in to Madame Schlee, actually crossing the portals of the famous Garbo block. There was a Chinese doorman, who took it.

New York, Sunday, 5 December 1982

Herman Levin (1907–90) had been the producer of My Fair Lady.

Herman Levin was awaiting me at the top of the lift shaft. He is a small slightly round man, very much the cast of American theatrical producer. He was informally clad. He smoked a cigar though it was early in the morning. He lived in a small apartment – I wonder if he has fallen on hard times. He spoke sadly of 'my then wife' implying that in the end she had probably walked out on him. Yet on the walls

* Jerome Zipkin (1915–95), American socialite.

hung works by Degas and Segonzac, valuable and beautiful pictures. He invited me to sit down and he offered me no refreshment.

He is a *New Yorker* character: 'I like to think I'm quite funny and others consider me to be so.'

He said that a producer should have business acumen and art appreciation. If he is only knowledgeable about finance, it will fail. He said, 'I've directed hits and I've directed flops and you know it's extraordinary how when you've got a hit on your hands it works from the word go. You get your first choices. You want Rex Harrison, you get Rex Harrison. You want Julie Andrews, you get Julie Andrews.'

He had an initial reluctance to use Cecil because of the anti-Semitic thing, but meeting him he got the impression that he was not anti-Jewish. It was Helene Pons[*] who recommended Cecil to work on the costumes. He had seen some costumes for an Oscar Wilde play – he thought it was *An Ideal Husband*, and thought he would be good. It was too late to have him do the sets, too, as Oliver Smith[†] was already engaged. He was not under contract, but there was a verbal contract. The two men were friends and so it worked out.

Once again Cecil had put across the idea that he was a *grand seigneur.* HL was very surprised one day when they both wanted something to eat and the only place available was a hot dog stand. HL had a hot dog and Cecil a pizza. He pronounced it 'pizzer', rather than peetsah. The people standing around were very surprised at this elegant figure, standing there.

It was Herman Levin who chose Cathleen Nesbitt, though she was only in the part for three months. She was in it for the opening night and that is what was wanted. Then she had to leave for a Rattigan production. He paid her $1000 a week for the part. The production, which would now cost over a million, only cost just over $400,000 in those days. When they rehearsed, the chorus dresses were bed covers. Cecil had the idea to have footmen draw back the curtains before the ball scene.

Had he seen the revival? 'When I want to see *My Fair Lady* again, I'll produce it again.'

I liked him very much.

[*] Helene Pons (1898–1990), fled from Georgia and eventually came to America, where she became a highly respected costume designer on Broadway from 1926 to 1965.

[†] Oliver Smith (1918–93): *see* note on page 254.

New York, Tuesday, 7 December 1982

Today I was intending to go Garbo-spotting with my camera. But instead Irving Penn had rung me up, and when I called him, he invited me to come and see him immediately. So off I dashed. He had a studio right down by 26th Street. I went up in the sort of lift that almost crushed one in its doors. Clearly there was a dance studio halfway up because familiar dancing sounds came out.

Irving Penn (1917–2009) was a photographer known for portraiture and fashion, who worked for Vogue *for many years.*

Upstairs a fierce door concealed Irving Penn. He was not at all as I had imagined him. He was much thicker set and he was younger. He was casually dressed. He spoke of having been a 'New York street boy'. I liked him very much, and as the interview went on it was strange how much in tune we became. I felt that if I could present Cecil as he spoke of him, then I would be doing a good job.

He spoke of Cecil as a fellow worker on *Vogue*: 'He created the Cecil Beaton woman. She was rather distant, the sort of woman to whom roses would fall at her feet. He could take a girl from Texas or New York and transform her. Photography is projection. He projected them. Cecil will be remembered for his picture of an age that is passing.'

Cecil and he sometimes shared a studio: 'Cecil would come in. He'd give the impression that he hadn't thought about it much. He'd tear a bit of paper on one side. He'd talk to the model. He'd go behind the camera. Out would come the Cecil Beaton woman.'

Cecil once asked Irving Penn to a party on a Sunday evening at a room he'd designed in a hotel – the St Regis. It was all dark green, dark green shades, etc. The women were hard – not the sort of women he liked to see. Cecil liked them. He particularly liked his war photos, having served in the 8th Army – the brothel in North Africa particularly appealed. He thought that Cecil never got anywhere with Garbo – 'a troubled brother and sister relationship'. His photos of her were bad.

The one he took in the cloak was a present to Cecil: 'I didn't want to hurt him. I tried to think what he would like. When he came into the studio, he took a black ballpoint pen and began to draw his hair back on at the front. That was Cecil. He didn't do it before. He didn't

mind who knew.' He said that Cecil was a 'very willing subject'. He also posed for the one with the nude in the background.

Irving Penn suspected that Cecil was much softer inside: 'I often wondered what happened after the last guest had left.' It's true. He loved to be tucked up in bed – a cup of hot chocolate, that sort of thing.

He hits on the head a nail that I must hit – the inner spirit, the loneliness of the man. I said, 'He could have been much happier if he relaxed a bit.'

Irving Penn said, 'Yes, but he wouldn't have been Cecil then. I wished I'd known him better, but I showed a professional face too.'

Of Diana Vreeland he said, 'She's very theatrical. It's hard to know what she's really thinking.' And of Truman Capote: 'His books – there's quality within, if you take off the first layer of skin. He has a moral obligation to see you.'

At the end of the meeting he said, 'Well you've been very patient with me and I thank you.'

I went silently out into the bright New York noontide. I walked to Barnes & Noble, which was nearby. I felt very silent after the extraordinary talk, which had almost brought me to tears. I felt the terrific sensitivity of Irving Penn. He was intensely moving. He was shy in a way, kind and fair. I was glad to hear later that he had a really beautiful model wife and he told me his brother had a play opening presently on Broadway.

Then I made my way by taxi to East 52nd Street and First Avenue. I walked down the Garbo street and then I walked up and down for a while. I ate a snack in a nearby vantage-point restaurant. But no Garbo came out into this bright if suddenly slightly colder day. I left disappointed.

New York, Thursday, 9 December 1982

Alexander Liberman (1912–99) was editorial director of Vogue.

I had to dash for my meeting with Alexander Liberman. I therefore made my first ever visit to the Condé Nast building. Eventually he came in and was quite unlike what I expected – a neat, rather dapper Americanised Russian with white hair and moustache, hardly the great editorial power behind the Condé Nast throne. I found him very hard to talk to – he didn't want to tell me anything about Cecil

except that he thought he was a wonderful photographer in every way. He admired the way Cecil didn't wait to be commissioned. He'd go off on assignments on his own and offer them the work later on. He said he thought Cecil was 'as happy as society allowed'. He thought that the homosexuality was a problem for him in the times and background in which he lived.

He did not bother to stay long, but left me with the useful letters. He was annoyed that I had not brought a tape recorder with me.

Long Island and New York, Wednesday, 8 December 1982

I went out to Long Island to a lunch party given by Milo Gray. Nicholas Lawford was one of the guests and gave me a lift back to Manhattan.

Nicholas Lawford

Nicholas had been to see Valentina about Horst. He said she is dressed very strangely and talks only about herself. She remembered a dress she was wearing when she entered a restaurant and how its long hanging sleeves swept all the glasses on one side of the room to the floor. But she didn't like her table and on the way out accidentally did the same to all the other tables on the left side. Nicholas said I should ring her and would certainly find her in.

Betsy Bloomingdale (1922–2016), a well-known socialite and in particular a friend of Nancy Reagan, was married to Alfred S. Bloomingdale (1916–82), whose fortune derived from the New York store. He had died of cancer as recently as 23 August. Scandal ensued when his mistress of twelve years, Vicki Morgan (1952–83), sued the estate for $10 million. The mistress was murdered by her homosexual lover on 7 July 1983. Dominick Dunne turned the saga into his novel An Inconvenient Woman.

I was due to see Mrs Bloomingdale at four forty-five at the Mayfair. She wasn't there as it happened, but presently she came in, very tall and fair, and dressed in Cecil Beaton colours – black and white. She took me into the tea lounge for some tea – so many varieties were offered. We had a very pleasant talk, in which she gave me her line on Cecil. Basically she was one of his rich friends and patrons. She thought him wickedly amusing, a great friend, very talented and so on. He used to come and paint in her garden in California where he found Hollywood life unsympathetic. 'Well, Beverly Hills is awful now,' she said. 'You know, wall-to-wall Rolls-Royces.'

She had picked up a few hints as to the other side of Cecil's character from her 'walker' friend, Jerry Zipkin, who evidently loathed Cecil. He once rented Cecil's house and nearly walked off with the butler. So often did the unseen Mr Zipkin slip into our conversation that I began to suspect he had primed her with what to say. She also told me that her husband used to go in search of hats for Cecil in Hawaii. 'Alfred loved a mission,' she said. Only now as I write do I see the possibility of a joke in that: 'Alfred loved emission.' Poor Betsy Bloomingdale has been through the mill of late with Alfred, who died and who had been involved in terrible legal wranglings over the mistress he kept all these years. 'Palimony' is the word for it. She looks very like a thicker-set Mrs Reagan and her favourite designer is the Cuban Adolfo, to whom she introduced Mrs Reagan. She talked as often of Adolfo as of Jerry. It is said that following the scandal the Reagans had dropped poor Mrs Bloomingdale from their circle, though Mrs Reagan and she had lunched quietly recently – a kind of sop, perhaps. I found her gentle and friendly and kind. She said, 'Cecil was known not to be open-handed. He made you feel that you were special if you could get him.' A good point, that.

Back at the apartment, with a sudden surge of confidence, I decided to ring Madame Schlee.

Valentina Schlee

Valentina Schlee (1889 or 1899–1989) was a Russian with a dramatic past, who had come to New York in the 1920s and, after a false start or two, become an immensely successful dress designer for society ladies, and dressing actresses, like Katharine Hepburn in Philip Barry's The Philadelphia Story *(1940). By this time Valentina was somewhat forgotten by the world, but in 2009 there was an important exhibition of her work at the Museum of the City of New York. Irene Worth said that if you had a Valentina dress you had it copied over and over. I enjoyed Irene Selznick's description of her clothes: 'Later Valentina made all my clothes. They'd be in fashion today. You could move in them, you could run, you could stretch, you could reach, you could embrace someone without having your dress ride up.'*[15]

Valentina was the missing link in the Cecil-Garbo business, the other corner in the relationship, her husband, Georges Schlee, having been Garbo's close companion. She and Garbo had been close but they now hated each other, Valentina having vented her spleen when Schlee died in 1964 and Garbo deserted the body. Yet the two women continued to live in different apartments in the same building (each one more or less identical), the lift man ensuring that they never met. It was increasingly unlikely that I would meet Garbo, but I could perhaps meet Valentina.

She answered the telephone at the same time as the maid and I said, 'It's Hugo Vickers. I wondered if I could talk to you about Cecil Beaton.' She suddenly began to talk in French to me and I realised that she thought I had said the name 'Décazes' – indeed, I realised later that she thought I was the *'fils de Solange'*. So we talked in French and I was so fascinated by hearing her voice that I fell in with the strange situation. We had a long talk in which she explained to me that she was very sorry she couldn't ask me to dinner, but she had sacked the maid, who had taken from her a diamond necklace that she liked to wear with a simple black dress (*'Pas décolleté, vous comprenez'*). And so it went on, and at times she burst into laughter, which made me think she was either drunk or perhaps losing her marbles. It was left that I would call her on Friday and, if possible, we would meet. The strangeness of the conversation only dawned on me after I had put down the receiver.

I rang Madame Schlee again the next day. She put me off.

I rang Waldemar Hansen. He had returned from somewhere and was resting in darkness. At one point he said, 'I'm in the dark in more ways than one.' He told me that he was Cecil's 'amanuensis' and that he probably knew Cecil better than anyone. He'd like to talk to me but he would need six hours! So Sunday was set aside for this.

New Jersey and New York, Saturday 11 December 1982

Louise Dahl-Wolfe (1895–1989) was an American photographer who had worked closely with Diana Vreeland.

Up early and off in snow and cold to see Louise Dahl-Wolfe in Flemington, New Jersey. I took a bus and arrived there in grim weather a little on the late side. Her husband Meyer (Mike) Wolfe was waiting for me. Very brave at eighty-five. Along we went and found their rather pretty house in the snow in Broad Street. I liked them both enormously. She was Buddha-like and eighty-seven, very gentle, though looking strong. She was very fond of Cecil and saw him when he was over here. She let me look at letters – one of which is much better than the famous 'yours never' letter – all about 'Willa' Cushman,* an editor they all despised. They also knew Diana Vreeland well and had worked with her. Louise Dahl-Wolfe's message about photography was 'If you want to learn about photography, don't go to photography school, go to art school.'

That evening I went to dinner with Diana Vreeland. She had lately been to dinner with Valentina.

I couldn't get a taxi so I had to walk. All along Park Avenue there were would be taxi-ers waiting like prostitutes. I arrived at ten past eight and Diana was waiting for me, dressed in a black and white striped galabeya over trousers and little red boots. With her black lacquered hair, she looked marvellous. We were soon seated, happily drinking neat vodka.

Diana is magnificent even if she is a little older and quieter. The press have had their knives into her but I think her style will see her

* Wilhela Cushman (1898–1996), fashion editor of the *Ladies' Home Journal*.

through. We talked about Valentina Schleé. Diana said that there was a lot of laughing that night to humour Valentina and a maid who rather pushed her around but in a friendly way. She said that Valentina spends the summer in Venice. She takes out her own private gondola and gondolier and a bottle of champagne and just drifts around the canals for the afternoon.

'After Schlee died, Valentina invited me to the house in the South of France. She said, "I've had the house *exorcised* of that woman [Garbo]. There'll be no sign of her." Well . . . When I got to the house it was so full of *spooks* you couldn't move!' She thought it fun that I might go and see Valentina.

She didn't know about the blacksmith [Cecil's grandfather] but remembers that the mother had been disparaging about some models that came to the house. Cecil had to say, 'Mummie, these are my guests and my friends.' The mother became grander than grand. Diana: 'Isn't it always the way?'

Diana said that robberies and mugging were getting much worse and that drugs were behind it. She said a man had been found dead on the pavement of Park Avenue recently 'and this is meant to be a smart area'. She said people will have to stay in and watch television from now on. It's heading that way. And with Christmas approaching she said, 'It's time you went back home.'

Diana said she couldn't remember names any more. 'I must be able to call you in London or someone else in Paris. It's how I get things done. The other night at the opening people kept coming up to me. I didn't know who they were . . . I couldn't get out of that damned opening quick enough. I went to have a brain scan, which is kind of a relaxing process, you know. But they said there's nothing wrong . . . People of the age of thirty can't remember names.'

She also said that her assistant, 'a young man who works with me in the museum',* had 'this awful homosexual cancer'. Diana said, 'It's as though God is in his Heaven and he's telling everyone how to behave now.'

I thoroughly enjoyed the evening – a great privilege to see Diana alone and talk to her. She did seem a little weaker, but there was yet

* Stephen Jamail died of AIDS.

life in her. I found that I minded. She's better than all the up-and-comings put together.

As I left she said, 'You're a good and *consistent* friend.'

New York, Sunday, 12 December 1982

Waldemar Hansen (1915–2004) was an intellectual of Danish and Welsh origin. Raised in Buffalo, New York, he had made his way into the literary world of the authors Parker Tyler and Charles Henri Ford, and the painter Tchelitchew. Through Norman Fowler, Waldemar met Peter Watson and from 1947 to 1949 he lived with him in London until Watson replaced him with Fowler. Then John Myers introduced him to Cecil and he served as Cecil's amanuensis between 1950 and 1958.*

Hansen impressed Cecil with his encyclopaedic knowledge of science, philosophy, literature, music and most countries of the world. As Cecil's 'ghost' on various projects, The Glass of Fashion *was more Waldemar than Cecil.*

Waldemar Hansen lives in an area called Chelsea – rather pretty houses. I went up the stairs and into his small apartment. He said it is rather small, but if you think of it as being on board ship then it becomes quite luxurious. He gave me some lunch and we chatted. I was not too alarmed by his questions such as 'What is your prose style?'

In due course we settled down for our six-hour talk about all aspects of Cecil. He referred to himself as Cecil's 'amanuensis'. He had ghosted a number of Cecil's books, helped edit his diaries. He is 'a New York intellectual' and fairly intense on some topics. He knew people like Truman Capote, whom he described as 'the literary Joan Crawford'. He'd met Garbo and, being part-Danish, was able to make friends with her. He believed that Cecil's affection for her was genuine and that it was not something to mock, although he admitted that there was a case for saying that Cecil saw her 'publicity potential'.

* Norman Fowler (1927-71), from Kansas, originally met Peter Watson in New York in 1946 and became his lover. Said to have been responsible for Watson's death. He bought the Bath Hotel in Nevis in 1968, and drowned in the hot bath-house there on 23 March 1971.

They met in 1945 or so through John Myers,* the discoverer of the artist Larry Rivers. Cecil was revising his *New York* book in the spring of 1946, adding new material. They worked on the thirty-seventh floor of the Sherry-Netherland Hotel. Then Waldemar got involved with Peter Watson, in what he called the hiatus of January 1947. They were together for two years. He spoke of how Watson bought Picassos early and bought *Horizon*,† how he was a masochist, involved with the sinister Denham Fouts.

He said that 1950 to 1958 was the exciting period of working with Cecil. He would go over to England for several months in the winter and spring. He spoke of Cecil's 'absolutely true blue quality of loyalty'. He said how *The Gainsborough Girls*‡ had needed revision, that Roger Livesey was to be the original Gainsborough, but they ended up with Donald Wolfit, 'an old ham of the most despicable school'. The play *The Dresser* was based on Wolfit. '*The Dresser* was kind to him.'

They worked on *The Glass of Fashion*§ together. That went smoothly. He did not care for Cecil's mother, who was very selfish. Cecil got his nasty side from her, he thought. 'She always got what she wanted. She spoke in an up-country accent.' Cecil treated her well. She was stuck in the country for a long time, would preside at high tea at five. Cecil had a lateish dinner. 'He wanted to work fifteen hours a day. He was a real workhorse.'

They worked on *Photobiography*. 'Cecil had an unerring instinct for what was chic and fashionable. He knew who to cultivate. He was the right kind of snob. Not for nothing did he get to the young Edith Sitwell.' Only later did he sketch theatre designs and sets. 'He knew how to extract the marrow.' Just after the war he re-established opulence with *Lady Windermere's Fan*. But that world would never be the same again. He needed that world of style to feed off.

When Joan Crawford was coming to be photographed for *The Face of the World*, Cecil said, 'What the hell do I want her for?' She

* John Bernard Myers (1920-87), art dealer to the American avant-garde.
† Cyril Connolly's literary magazine, published between 1939 and 1950. Peter Watson was its financial backer.
‡ *The Gainsborough Girls*, the play Cecil wrote and rewrote over thirty years, staging it twice with scant success; later called *Landscape with Figures*.
§ Cecil's 1954 book about fashion and those who inspired it, much translated and frequently reissued.

was a movie actress with carrot-top red hair, only about five feet tall. Joan Crawford came in and sat down on the floor. He asked her to show some expression, show fear, show anger, show love. She became Joan Crawford. He asked her, 'Joan, could you hold that pose?'

'I can hold it for two minutes if necessary!'

When Marilyn Monroe came flouncing in two hours late, he immediately knew she had that quality – he followed her round.

'He didn't give a rap for the technology of the camera. His breed has died out. He saw the camera as "an instrument of art".'

Waldemar told me about the louche side of Cecil's life. Cecil used to have young men sent up to his hotel often via Lincoln Kirstein. Waldemar would let them in and the boy and Cecil would retire into the bedroom. Twenty minutes or so later they would emerge and Cecil would hurry the person to the door, bidding him a swift farewell. Waldemar said, 'Some of these boys were very good-looking. I'd have thought he might like to entertain them a bit.' Once they went to Holland together and they went to a Turkish bath. 'We tactfully went in different directions in the steam, but by mistake I came upon Cecil being fellated by the old Turkish bath attendant.' Cecil's fame made it hard for him to go out into the normal areas for such things. Usually sex was something he arranged as a release. Waldemar knew the story about the sailors in Hawaii, and had heard it from Cecil. So Truman was telling the truth. He said, 'Who knows? If Truman hadn't appeared, then perhaps things would have got rough, and Cecil might have been murdered.' He said that Cecil had to go out to find sex in Paris when he heard that his mother died. He felt guilty about that.

One of the things I particularly liked was when he said: 'He had his stethoscope on the heart of society and when there was a change in the beat he wanted to know about it.'

Our talk, which was meant to last for six hours, ended by taking nine and ran into supper and a reviving gin. He gave me confidence – he thought I had a kind of understanding of Cecil and that I was sympathetic. There were things that I understood at the age of thirty-one that he said he didn't think he would have done at the same age. He spoke freely and gave so much of his time.

He told me the story of the murder of Peter Watson, how Norman

Diana Cooper at Laura's country home, summer 1983.

Kin Hoitsma in his garden in San Francisco, June 1983.

Hotel Cipriani in Venice, August 1983.

Hotel Cipriani in Venice,
August 1983 – the Baron,
George Weidenfeld.

Valentina Schlee, friend and foe of Garbo, with her nurse, as seen from afar.

Serge Lifar at the Cipriani,
August 1983.

Valentina at the Cipriani,
August 1983.

Loelia Lindsay (former Duchess of
Westminster) in Paris, May 1984.

Ali Forbes in Switzerland,
October 1983.

Anne, Countess of Rosse
in her garden at Nymans,
July 1983.

The author with the Queen Mother at a Maureen Dufferin dinner party.

Diana Cooper in Paris, May 1984.

The book launch in July 1985, photographed by the late Desmond O'Neill.
The author with June Hutchinson.

The book launch – Maxine Audley and Geoffrey Toone.

The Earl and Countess of Longford with Maureen,
Marchioness of Dufferin & Ava.

Margaret, Duchess of Argyll inspecting the book – with Tim O'Donovan (left) and
Derek Williams-Freeman (right).

Copies of the biography in the window of Waterstones, July 1985.

The author relaxing with a copy of the book at the Cipriani in Venice, August 1985.

Fowler, the lover who replaced him had been in the house, how Peter Watson was in the bathroom with the door locked and was found drowning in the bath. The possibility was that this man, who was considered very evil, had held his head under. Evidently Peter Watson liked to be tortured in some ways and had been quite alarmed by this man who the year before had attracted an Italian count. When the count was leading him along a windy mountain road in his car and the car swerved and went over the edge, the man drove on and did not even bother to report the accident. Waldemar and he had been lovers. A while after Peter Watson's death they had had a 'rip' together (Waldemar hoping thus to learn the truth). Then Fowler had gone to Jamaica somewhere [Tortola, and later Nevis] and set up a hotel. Not that long afterwards, he too had died, drowned in the hotel swimming-pool.

It was all very strange. Out I went after this long session. Waldemar accompanied me and we soon found a taxi. As I got in and glanced round, he looked a sad figure, walking slowly back to his apartment.

New York, Monday, 13 December 1982

I was due to meet my former editor at Holt Rinehart, Tom Wallace, and then see Frederick Brisson, who had produced Coco *in 1969. I had no idea what an extraordinary twist the day was going to take.*

When I rang Madame Schlee, as agreed, the maid and she answered at the same time. '*Ah, mon cher, vous ne pouvez pas imaginer ce qui est arrivé . . .*'* It was a curious story about how *they* had stolen her diamonds, a thin string that she used to wear with a simple black dress – it was a weird story, similar to the one she had told a few days before. In due course, the maid, who had been listening in, spoke: '*Madame, pourquoi vous ne constatez ce monsieur de venir voir ce qui est arrivé?*'†

Madame Schlee asked me if I would come '*juste pour un moment*'. I agreed forthwith. I dashed off at great speed, expecting to find that there had been a burglary of some sort. It was a great joy to be able

* 'Ah, my dear, you can't imagine what's happened.'
† 'Madame, why don't you ask the gentleman to come and see what's happened'.

to ask the taxi for 450 East 52nd Street. Today the door was locked but the porter opened it for me and I entered the domain of Valentina, of Nin Ryan and, of course, of Garbo.

I went up in the elevator that I had read so much about. I don't know which floor I went to – about the fifteenth, I think. I came into a small landing and was admitted to a door on the left by the maid, who spoke to me in French. She regaled me with the story of the day, taking me into her confidence.

When she had arrived that morning the maid thought that Madame Schlee was dead. She could get no answer from her. She called the porter, begging him to let her in. Finally Madame Schlee had let her in – she'd found her as white as a sheet, lying on the bed. (Yes, it's a muddled story.) She was convinced that Madame Schlee had not eaten for two days, so she gave her some breakfast and now she was a little better. '*Voilà, Monsieur, vous trouverez Madame Schlee dans le salon.*'*

I went through a study where papers were strewn all over the floor and into an enormous and fabulous drawing room. It's the finest room I have seen in New York, spacious, grand, with windows over-looking the East River and downtown too – so about eight large windows in all.

One wall was covered with finely bound books, one or two of which had been turned into the shelf to display the motif on the front. There were fine pictures, a lovely antique clock and some flow-ers. There was a small Christmas tree beside the sofa.

Valentina Schlee sat on the sofa, a tiny little woman, who did indeed look like a French peasant. She wore a skirt and blouse of grey-beige, grey-green colours, a pale green scarf on her head, rather fashionable dark glasses. From this tiny figure emerged a powerful voice. Seated beside her was a rather un-together American friend, who was trying to get to the truth of the story. I was introduced as '*le fils de Solange* [the son of Solange].' (Since I've got back, I've found that Solange is the Duchesse Décazes – and lives in the Palazzo Polignac in Venice.)

Valentina's story concerned the theft of this thin string of diamonds that she liked to wear on a simple décolleté black dress for Arturo

* 'You will find Madame Schlee in the drawing room.'

López's* balls in Paris. The people had come up to her outside the River Club and seized her. She had pleaded with them: 'Leave me something of my family . . . a souvenir of the olden days before these *vile times* we now live in.' She had come in and found Gloria [Vanderbilt] giving a party in her drawing room. 'Yes . . . Over there in the corner.'

'No, dear, it couldn't be. I talked to Gloria,' said the friend.

The maid then came in, and the other woman and she went out for a gossip. I remained a little while only – I was getting very late for lunch and conscious of this. Finally I said to her, 'I must unfortunately go.' Madame Schlee then led me to the door through the little study where I noticed photographs of Prince Rainier and Princess Grace (her neighbours at Cap d'Ail) and at the door she thanked me profusely for having come, said it was a great help to be able to tell the story and kissed me goodbye.

As she opened the door to let me out, the elevator was there and a woman who did not know Madame Schlee came rushing in, looking rather flustered. I think she may have been the doctor.

The elevator man said to me, 'Are you a relation?'

I said, 'No, I've never met Madame Schlee. She didn't seem very well.'

'She hasn't been very well since she came back from Venice,' he said.

Alas, no Garbo – in the lift or in the hall – but a taxi came and I seized it.

Later in the day I rang Valentina, who told me she was feeling much better. The doctor had given her something. 'I will not be defeated easily. C'est moi, Valentina!' she said. She sounded more cheerful and hoped that we might be able to go to a film together the next day, or to a nearby Chinese restaurant. But she always cancelled. As I was leaving New York (on 15 December), I rang her again.

She said she might be coming to London. When I said, 'Ritz?' she said, '*Ach, non*! The Connaught.' She asked me to write my number

* Arturo López-Willshaw (1900-62), rich Chilean collector and connoisseur, who entertained lavishly in Paris after the war.

on a card for her and send it to her. She thanked me again for coming to call on her in the emergency.

I flew back to London, expecting never to see Valentina again.

London, Wednesday, 22 December 1982

In the evening I went to dine with Clarissa. She was full of relief at being back from New York. At dinner she said that it was a sad thing of homosexuals that they had to live such sordid lives. They found sex messy – it was all mixed up with their mothers and mother love. Therefore they did these awful things. Horst and Nicholas, having been lovers, now lead a sordid life – they hunt in pairs in the most seedy places. Cecil had to have his sex for relief. I feel it's sad that people like Cecil, whose life was dedicated to beauty, had to descend into such revolting areas.

London, Thursday, 23 December 1982

I took Diana to dinner with Laura.

Laura said Robert [Heber Percy] was very worried about my recent discoveries about Cecil. Laura said to him, 'You have no need to worry, have you?'

Robert said, 'Well, I don't know.'

1983

I was quietly working away on the book at home, though the interviews and meetings continued.

London, Tuesday, 4 January 1983

Ali Forbes rang up from Switzerland. 'I hope you'll leave poor Cecil with at least a fig leaf.'

Inkpen, Saturday, 29 January 1983

The Jungman sisters, Zita James (1903–2006) and Teresa Cuthbertson (1907–2010), were the daughters of an Anglo-Dutch artist and his wife 'Gloomy Beatrice', who later married Richard Guinness. When they were young they lived in style at Great Cumberland Place, where their mother entertained society figures and actresses. The sisters were leading Bright Young Things, arranging treasure hunts, bottle parties and charades. They had both married briefly, but had disappeared from public view around 1930. They were now living together modestly and in perfect harmony as, arguably, they had done all their lives.

Loelia took me to stay with Tanis Phillips, formerly a Guinness, so there were four former Bright Young Things reunited for this occasion.

Tanis was very friendly this time and Laura was right when she said, 'Well, you know how it is – once they're sure you're accepted, everything changes.' I am grown-up enough to understand that. Tanis lives an American-style life. She has a lovely glass room, which soaks up any daylight going and is warm and fresh. Here we sat and had our Bloody Marys (I hadn't the courage to protest my spirit ban). I had brought my tape recorder to use later on.

The Jungman sisters came in together. They looked like two of the sort of sisters you see very often in Cheltenham or Burford. You'd never have known they were once two of the brightest of the Bright Young Things. They wore funny old coats, which were rather ill-fitting, and they were both thin. Zita looked, as Cecil would say 'bedraggled', her hair in the same style as earlier on, but now white. Teresa was very neat and rather beautiful. I can see why people fell for her – Evelyn Waugh used to say that you had to rub her hand and then a tiny bit of warmth appeared. As soon as you stopped, it went. The 9th Duke of Marlborough was also rather in love with her. Both of them had met Gladys in their time. At lunch they told me about her and about Cecil.

Before lunch Loelia sat with them and they gossiped about old times. There was talk about Sachie Sitwell and his fierce maid, known in the family as 'Gertrude, Lady Sitwell'.* The Jungman sisters had seen him lately.

I sat at lunch between Zita and Teresa. Zita remembered the Duke of Marlborough. Teresa was worried that her sister had told the story. She said, 'The duke loved dancing and nothing more than that. Once he asked me to Blenheim with Michael Duff. He didn't tell Gladys, and when we went into the library, she was standing there like a statue refusing to move or speak, just staring at us.'

I asked Zita a bit about the twenties, and said, 'It was all good fun, wasn't it?'

'Well, more or less, such surprising things about people are coming out now.' (She must have been referring to the Mosley book.†) She thought that Cecil was 'very nice'. That's why they liked him.

After lunch we went into the garden room and I put on the tapes. Mainly I read to them from Cecil's diaries and often they roared with laughter. It sounds enormous fun when listened to on the tape. Zita thought they met Cecil through Stephen. Their message was that he was so extremely nice. He must have had that over his talent because

* Gertrude Stevenson (1908-93), maid to Georgia Sitwell since 1928, and later cook-housekeeper.
† Nicholas Mosley wrote a two-volume biography of his father, *Rules of the Game* (1982), followed by *Beyond the Pale* (1983). Zita let the author use her 1930 diary in the first.

he did have such a great success. His problem was to be a photographer and social figure at the same time.

Inkpen, Sunday, 30 January 1983

The Lees-Milnes came for lunch. Jim, of course, I've met many times but this is the first time I've met his (lesbian?) wife, Alvilde.* Jim was his usual self, friendly, remote, always a little pained – at lunch there was quite a talk about a married man with a lively private life. There was a good moment when Jim said, 'He was interested in boys too, wasn't he?'

Alvilde said, 'Some people seem to manage to be interested in both.'

The reference did not escape me.

London, Thursday, 3 February 1983

Diana said she was signing her will and that Lady Berkeley† and Lady Hutchinson would be witnessing it. Would I like to come for a drink? I dashed along as I wanted to meet Lady Hutchinson, who was once nearly married to Cecil. We didn't talk of Cecil *and her*, but she asked me how it was getting along. She is nervous and I wouldn't have thought Cecil would have been very good at handling her. Maybe, later on, she will see me properly and we can talk. I wouldn't have thought she would have appealed to Cecil's idea of beauty.

Inkpen, Friday, 11 February 1983

I went to stay with Tanis Phillips again, to make a recording of her maid Celina. Her daughter Liza Shaw was there, with her son, Benjy.

Tanis, Liza and I talked. Liza said she once came home and saw this strange woman sitting in her father's house. It was Garbo. She was wearing a curious pointed hat. Liza was asked by her father if she

* Alvilde Lees-Milne (1909–94), garden designer.
† Freda Berkeley (1923–2016), wife of the composer, Sir Lennox Berkeley (1903–89). They lived next door to Diana in Warwick Avenue.

liked the woman or not. She didn't, naturally. Howard Dietz said to Garbo, 'Will you have dinner with me on Wednesday?'

To which she replied: 'How do I know if I'll be hungry on Wednesday?'

[When relating this story, I have received various reactions. Ginette Spanier said, 'Isn't that a *wonderful* reply?' and Prince George Vassiltchikov* said, 'He should have lifted up her skirt and spanked her bottom.']

Tanis spoke of Diana Vreeland. She said the Vreelands 'were *nothing* in London' when they were here in the late 1920s. She said Diana had made a cult of ugliness. Only by persevering, like an old goat, had she reached her present heights.

London, Wednesday, 16 February 1983

I took Diana to see the exhibition of Cecil Beaton's drawings at the Michael Parkin Gallery in Motcomb Street.

Diana told me that when Cecil was knighted, he said to her, 'It's practically posthumous.' She told me that the unsold Wallis was rather good – 'a very good likeness, and that is exactly how she used to stand – not that anyone would be interested'. And so I decided to buy it. It only cost me £270.

We went on to Evangeline Bruce's cocktail party, which proved very grand – full of Knights of the Garter. I spotted many famous faces, Lord Longford, Lord De L'Isle, Edward Heath, Roy Jenkins and so on. I hid in the corner with Diana.

One of the first people I saw was the Baron [who was not prepared to publish Loelia's album]. He immediately rushed over, seized me by the hand and swung me into the corner, saying, 'You don't bear a grudge? Certain key colleagues had let him down.' He went on to say: 'When you have finished Cecil Beaton, I have something so important for you – I am not at liberty to discuss it with you at the moment.' (Which meant that he hadn't thought it up yet.) 'You will make a fortune – a million, a million,' and with that he slid off into the crowd.

* Prince George Vassiltchikov (1919-2008), editor of *Missy,* the diaries of his sister, Marie Vassiltchikov (1917-78).

It was a lovely flat – the central one overlooking the front court-yard. I hardly met anyone, although some I knew . . . Clarissa, who said, 'With great respect, what are you doing here? I mean neither of these ladies are exactly *your* scene.' I was a bit put out by this, I must say, and I did say. The other hostess was Marietta Tree. Then Clarissa was kissed by Heath and disappeared.

London, Saturday, 19 February 1983

I had heard from Andrew Yates[*] that he hoped I would come for a drink to meet 'someone whose daughter is in America at the moment and who lives nearby'. I guessed rightly that it was the Queen Mother.

Old Windsor, Sunday, 20 February 1983

I dashed to Old Windsor. Sally and Antonia Yates and others were there. We stood around – in a way quite nervously – awaiting the royal car . . .

In due course the Queen Mother's car arrived and she got out. The car was almost as large as her first official one. It had no flag or crest but it had the blue police light on the top and a cipher, and there was black glass. She wore a mauve-ish blue dress and coat with quite an old similarly coloured hat. She wears combs in her hair under the veil, one of which had slipped slightly and a three-string pearl neck-lace. She looked as fit and well and bright as a woman twenty years younger, her marvellous pale complexion and bright shining eyes. There's an aura of severity about her. Queen Elizabeth was accompa-nied by Ruth Fermoy,[†] which was marvellous for me as I know her.

Andrew presented us all in turn and was very good at bringing us each over to meet the Queen Mother in turn. Mine was a later turn, so to begin with I talked to Sally and Lady Fermoy. I'd had a great drama in the morning as I'd gone to quite considerable trouble to wash my nice Balmain shirt and iron it. I put it on and then went to

[*] Captain Andrew Yates (1900–91), a fellow lay steward at St George's Chapel, Windsor. He lived in Old Windsor.
[†] Ruth, Lady Fermoy (1908–93), musician, and grandmother of Diana, Princess of Wales.

shave. I found the finest speck of blood on the collar. Is there no justice in this world? I went through torture until I suddenly thought of Tippex and applied a quick dab. It worked. Sally loved the story and so we told it to Lady Fermoy. I'm sure she will relay it to Queen Elizabeth, who might well be amused.

Queen Elizabeth was talking to Antonia about Paul Getty and the Getty Foundation. She was commenting on how much money they had and how they could flood the art market. Andrew then told a story about meanness at Sutton Place and how they got nothing at a wedding reception. The Queen Mother had heard about the latest developments there: 'I hear rumours of cascades,' she said disapprovingly. Aware that I was brought over to be injected into the conversation, she looked in my direction several times. Then she asked me what I did. We talked of Cecil Beaton. 'He was so well chronicled,' she said, 'and he had so many friends . . . and enemies. I don't mean enemies, but he had a sharp side. He could be *so* amusing. And he loved his house at Broadchalke . . . with the conservatory built on . . . It should have been kept as a museum . . . so much more interesting as than all these Victorian houses . . . It was *his* creation.' We talked of Wilsford, another house that should be preserved. She hadn't heard from Stephen lately: 'I used to get a lot of letters at one time.'

'Ma'am, he communicates with the outside world as and when he wants.'

'Pink letters,' said the Queen Mother. She said that he used to take her on drives in carriages in the hills and 'it was as though you'd gone back two thousand years'. She adored the river there and spoke again of Sir Oliver Lodge,* under whose spell Lady Grey was. 'I think I told you,' she said. Sir Oliver used to communicate with the dead. 'They had a lot of fun, those boys, I think. And they were so individual.' She threw disapproving looks at my suit. 'It's so *easy*.' Help! Next time I come I must clearly arrive in Regency dress. Could it be that the Queen Mother is in fact a lot more Bohemian in outlook than we all think?

* Sir Oliver Lodge (1851–1940), remembered among other achievements for his psychical research and spiritualism. He lived at Normanton House, Lake, near Stephen Tennant in the Woodford Valley.

The Queen Mother had finished her drink and was anxious to depart – 'I *must* go' – when Andrew rang a bell and read an extract from a letter to his mother?/first wife? from himself about Princess Elizabeth and Antonia. Ruth Fermoy hadn't stopped talking when the bell rang, so the Queen Mother tapped her on the shoulder. Then Andrew took her into his little library. I felt so sorry for her as she clearly wanted to go, but could not disappoint.

In due course the Queen Mother was on her way, pausing to say goodbye to everyone. To me she said, 'I *shall* look forward to your book.'

Radway, Warwickshire, Tuesday, 1 March 1983

I drove Loelia to Althorp for tea with Lord Spencer, and then on to Radway to stay with Peggy Willis, in order to meet Sir Sacheverell Sitwell.*

Peggy Willis lives at Radway, Warwickshire, in a house right next to Edgehill, site of the famous battle. The story goes that sounds of the battle can occasionally be heard, the cries of wounded soldiers, the clash of breastplates. Peggy said that the sounds were in the air, and surely if one knew how to trap them, we could re-enact all sorts of extraordinary things – like television.

Radway, Warwickshire, Wednesday, 2 March 1983

Sir Sacheverell Sitwell (1897–1988) was the last surviving sibling, younger than Osbert or Edith. Many thought him the most gifted of the three. He was an inveterate traveller with an eye for the beautiful, the macabre and the odd, and he was a poet. His wife, the former Georgia Doble, had died in 1980.

Old Sir Sacheverell, the last of the brothers, came in on a stick. He has lovely sparkly eyes and great pouches beneath them. He is very gangly with long legs, huge feet and a profile identical to his sister's (as seen by me in photos only, of course).

* Peggy Willis (1908-2000), formerly married to Philip Dunne, of Gatley Park, mother of two lord lieutenants.

Sir Sacheverell Sitwell

He was partly all there, and partly repetitive. He told Loelia he had seen Zita the other day. 'I used to be rather in love with her and when I saw her, I began to weep. It was terribly embarrassing. I had to pretend I had a cold.' He talked of his godmother, Eve Fairfax,* who died aged 107. He said she had a son by a Belgian born in 1914 or so. (Suddenly I like to wonder whether she and his old father, Sir George [Sitwell], did not produce Sir William Walton, who died the next week, but that's too much to hope for. Lawrence Mynott† says that he is convinced that Walton was a Sitwell because he had drawn Sir Sachie and Walton and every line of their foreheads was identical. Lawrence also said that the Sitwells were not noted for taking in strangers and being generous to them without a very good reason.) Sir Sachie had a good story about Lord Berners. A churchwarden said to a visitor at the Faringdon church, 'My daughter has on two occasions obliged his lordship.' To which the visitor said, 'If she's obliged his lordship, then, she's really in velvet.'

He was interested in my work. 'It's a very good literary assignment,'

* Eve Fairfax (1871–1978), a famous Yorkshire figure, and model for Rodin. I went to see her twice in the Retreat, York, in 1977.
† Lawrence Mynott (b. 1954), illustrator, designer and portrait painter; I met him through my friend Diana Head.

he said. 'Try and make it two volumes. That's my advice. Don't put everything you've got into the first volume.' He said, 'His father was a timber merchant, wasn't he?' He'd met the parents. He didn't say that he resented Cecil. He urged me to be nice about him, not to say unkind things. He had received a letter from him the night he died. He said that he didn't mind Cecil being a social climber. 'There's nothing wrong in that.' Then he said (when I asked him if he thought Cecil happy) almost the same as Cathleen Nesbitt: 'He set himself certain targets and he achieved these. That must have given him great satisfaction.' At lunch we had wondrous 1953 wines.

London, Monday, 21 March 1983

Audrey Hepburn (1929–93) was the famous and much-loved film star, who had won the role of Eliza Doolittle in the film version of My Fair Lady *and worked with Cecil in 1963. He had been delighted to design her costumes, knowing that normally she was dressed by Givenchy. He was loaned her by the studio for forty-eight hours so that he could photograph her in most of the Ascot outfits worn by the extras. Audrey Hepburn was due to call me. She rang at ten past six and we made a plan to talk the following day.*

London, Tuesday, 22 March 1983

There are moments when the world seems suddenly to stand very still and this is one of them. I have just talked for twenty-five minutes to Audrey Hepburn. She was so sweet and adorable and so nice about Cecil . . . From her very first 'hello' she was the total embodiment of all that I've always admired in her. Her son was watching television downstairs. 'I think at this time of the day he's allowed to do that,' she said. She went upstairs and then we were able to talk. I asked if I could tape our conversation and she didn't mind at all.

HV: It's like a mechanical secretary. It records everything. What I really wanted to ask first was roughly when you first met him.

Audrey: I'm not at all totally sure when the very first time is because I'm not one of those miraculous people who have total recall, you know. I think it was when I went to New York, went to America for

the first time, to do *Gigi* on Broadway, and I think he was asked by Diana Vreeland – at *Vogue* or *Harper's*, whichever she was at then – to do some pictures of me.

HV: On the bed?

Audrey: On the four-poster bed. Right. I might have met him before, but not consciously. I was hoofing away around London, but that's my first memory of him . . . And then he took some pictures of me in Rome when I was expecting my first son, I remember. From which sitting he did a portrait of me, which I have in Switzerland. That's a period I remember. And then every time I went to London I would invariably call him, and have tea, lunch, or dinner with him at his house. It was one of those strange relationships where you say I didn't know him all that well, but I felt I did know him well, you know . . . We did not have a great opportunity to be together. The longest period obviously when I saw him frequently, although always very rapidly, was during *My Fair Lady*. And then we did do several days of photographs in those divine costumes, which I appreciate more every year, because they are like paintings, they are so beautiful. They are eternal. Owning a really fine Cecil Beaton photograph, it's like owning a beautiful painting.

My feeling about Cecil – I really did love him. I'm not gushing when I say that. I really adored him because he was very tender with me, very sweet to me, you know. I couldn't at the time quite evaluate who I was with. Today I can say I knew the great Cecil Beaton. When I was this kid on Broadway I didn't quite realise who Cecil Beaton was. I didn't have that much knowledge or background of him – or anything for that matter. Well, it was a long and tender rela-tionship . . . I always had enormous joy at seeing him – and he was a dear, dear old friend, without ever having had the opportunity to be close chums. I wouldn't say I was that close to Cecil and I have a letter in a very shaky hand when he wasn't all that well, which I think was a reply because there was something in the paper that he had written sweetly about me for which I wrote and thanked him. And he answered – and it was such an affectionate letter. And certainly with me, he was capable of giving a great deal of love and affection.

HV: He always rather loved individuals, and you would fit into an ideal he would have and that you were unique and somebody that he had not seen before. And that he would love.

Audrey: Oh, there's nothing terribly unusual about me, but perhaps there was a sensitivity about him, and I think he understood me. There's not something all that special about me. I could feel very cosy with Cecil. There's nothing very flamboyant about me or anything terribly beautiful or anything. At the end of *My Fair Lady*, he gave me a set of the photographs he had taken. I remember leaving a note for him. And I did say to him that, like every woman and every child and every young girl, I always would have loved to have been beautiful and for a moment I was. I meant that. If somebody loves you very much, they make you feel beautiful, and he did it with his tenderness and his art. With the clothes and the photographs I looked smashing!

HV: Am I right in thinking he wasn't very happy out there doing the film?

Audrey: That is something I realised in retrospect and I heard about. I don't think he got on very well with George Cukor and I think they were at ends with each other. It was something I was not aware of during the picture. Maybe I am a bit naïve, nor am I interested in gossip, nor did I hear it for that matter. I would occasionally hear him saying something slightly ironic, and George too, but I didn't realise until later that they didn't get on.

About his work. Obviously the picture showed the result of it, and so do the photographs. But the work was such art. I remember the first time, when I arrived to do the picture and I went to the studio to see all the work rooms – and the work rooms at Paramount are enormous: they're miles long and wide – and I'll never forget the sight of this enormous laboratory with hundreds of women sewing and doing. And the beauty of the costumes, which were on stands, embroidery being done, of masses of aigrettes and feathers that he had had come from God knows where, and velvet ribbons, which had come from France, and violets, which had been made I don't know where, but it was so extraordinary – that was worth the movie just to

see that. It was all Cecil getting it all together, and he'd got several old dresses out of museums, which he then restored. My ball dress was a museum piece, which was then refurbished a little bit, made a little more steady, so that it wouldn't fall about when I moved, you know. He went to such lengths to achieve this exquisite picture.

HV: I've got the video of the film and I often watch it and I think it's absolutely extraordinary.

Audrey: He was an extraordinary artist because he was a fine photographer, and a great photographer of an era too – of things or people. He really did photograph all periods, didn't he, in the period. And he painted wonderfully – very fine portraits. He wrote well, he did fabulous costumes, he was a great designer, with knowledge of the female body. He didn't just make a drawing and think, That would look nice. He was also a great *couturier*, you know. He knew how it would hang together and what would make it just right. He was extremely versatile and a great giggler. I remember laughing with Cecil a great deal, which is one of the great qualities that somebody can have.

HV: And then of course the sad thing was that he was writing this play, which he worked on for nearly thirty years, and he never really had a success with it. It was put on in Brighton and various provinces, but always something went wrong.

Audrey: Oh dear . . . Well, he couldn't complain.

HV: No, he couldn't do everything.

Audrey: I just hope he wasn't too lonely at the end?

HV: I think he was rather lonely. He had this wonderful secretary who was awfully good with him and looked after him. She's been helping me.

Audrey: That's very valuable. There was nobody I could write to.

HV: I get very sad when I read his last diary. He didn't think people took him seriously . . .

Audrey: His exhibition had a great success here in Italy – I think it was in Florence. A friend who was staying in one of the CIGA hotels – CIGA is a chain and they own all the big hotels. They print a very beautiful, frightfully expensive magazine, which I imagine is left in all the rooms or maybe only in the expensive suites – but it had me on the cover in black and white, in one of those marvellous black and white costumes from *My Fair Lady*. And there was one of Garbo and whoever. I wish he'd known . . .

HV: It was a form of modesty?

Audrey: Don't you think that's what's made him the person he is?

HV: He was always striving to reach new heights. He's an extraordinary character. As I said in my letter, every time he mentioned you – I don't know if he published it – he describes you as 'an angel of goodness'.

Audrey: Ah . . . It's very hard to put it into words. When I knew I would be talking to you, I said to myself, What can I tell you? In particular. There's no incredible anecdote or anything. It had something to do with his feelings and my feelings much more than what went on in the world. We did understand each other. And I loved him very much. That he understood.

She spoke of possibly finding the letter he wrote her. We talked about his stroke and his courage in overcoming it. She told me she was taking her two boys for a tour of Japan, and then attending a Givenchy thirty-year retrospective.

HV: Well, it's been extremely kind of you to spend so much time.

Audrey: I'm only too happy.

HV: I also wanted to say I've loved your films, particularly *My Fair Lady*, and I'm also very lucky because I have a video of *Breakfast at Tiffany's*. Such a happy film.

Audrey: Yes, it is. I like it. Well, thank you, and lots and lots of . . . luck [She nearly said love, but checked herself], and I'm sure you'll write a beautiful book as you've got such a wonderful subject. And the devotion. It seems to me that you've got the devotion. I don't know if you've got the time. I imagine you do.

HV: I make the time. The publishers are always chasing me, but they must wait.

Audrey: Well, all the very, very best.

After her call there was a still and calmness in the flat. Nobody rang up for half an hour. And I was alone on an elevated plane. I will never forget the stillness that came over the flat after her call.

London, Thursday, 24 March 1983

The Baron gave a dinner party to celebrate the publication of Christopher Warwick's biography of Princess Margaret, a book she had sanctioned and controlled.

It's all happening round here. I have just come home from the *most* extraordinary evening. The Baron was having a dinner for Chris Warwick's book, and Princess Margaret I suspected would be there. I didn't know that the Baron had left a message on my machine and that I was for special treatment – 'the top table'. I arrived after Caroline's drinks at the same time as Thomas Pakenham and Lady Anne Tennant. Within I found Audrey Russell* wearing her medals, and John Curtis, Theo Aronson and Brian Roberts,† and Elizabeth Longford with whom I had a long talk. We were waiting for Princess Margaret and she was really quite late. In she came at I don't know when. George introduced

* Audrey Russell MVO (1906-89), wartime commentator, who later covered royal occasions for the BBC. I became friends with her through David Green, the historian of Blenheim Palace.
† Theo Aronson (1929-2003), author of many royal books, and Brian Roberts (b. 1930), also an author, Theo's partner.

Elizabeth Longford (they kissed) and me. I thought her hair looked
wonderful, but she was very lined just under the eyes – she is very
like the Queen, more so than I'd realised. Elizabeth Longford
asked her if she thought she should put the Cecil of the Queen at
the Coronation on the front cover [of her book on the Queen].
Princess Margaret looked her in the eye and said, 'Ye-es. That's
where it all began after all.'

She sailed over after dinner and said, 'There are a lot of Cecil
Beatons in this book – too many. There was a certain *froideur* towards
the end because of Tony's film* – his best film. I talked to Cecil but
he wouldn't have it. I said, "You were the hero of the film. You are a
certain age, sixty-three or whatever, but you don't look it." But
between you and me it was Truman Capote. Yuck – have you seen
him? He said [to Cecil] in New York, "You look eighty-three, you
look *gha-a-a-astly*. They've used you."'

There was her line. 'Listen, my dear, I hardly knew him. You
should speak to my ex-husband, Lord Snowdon. He knew him. He
took him off awfully well – that ghastly voice . . .'

'He hated me because I was *so* ugly,' was another Princess Margaret
comment (re Cecil). Then she greeted Jocelyn Stevens and Mrs
Duffield[†] and introduced me, 'This is the young man who's writing
the Cecil Beaton and this is the editor of the book. Wasn't that clever
of me? . . . You can tell I've just been in America.'

*At the end of the evening, when there were only a few guests left, Lord
Dudley[‡] was prevailed upon to read the scurrilous poem he had written about
Princess Michael of Kent. At one point Princess Margaret said, 'Wow!' which
meant that she appreciated it was awful, but let's hear the end of it. The table
relaxed and Billy Dudley read on.*

Ali has been written about too. Princess Margaret said: 'Ali Forbes is
my enemy.'

* *Don't Count the Candles* (1969), a documentary film about old age.
† Sir Jocelyn Stevens (1932–2014), newspaper and magazine editor, and publisher,
and his then girlfriend (Dame) Vivien Duffield (b. 1946), philanthropist.
‡ Billy, 4th Earl of Dudley (1920–2013), married to the film star Maureen Swanson
(1932–2011).

George [the Baron] was frightfully funny about Heath and Sam Spiegel.* Princess Margaret: 'I'm very nice to Mr Heath.'

George said, 'Eleven days in Jamaica with Heath. That's forty-four meals with Heath.' Evidently he fell asleep every meal but woke up at any mention of Mrs Thatcher.

As for Princess Margaret, she lived up to expectations. She looks like a beautiful monkey, with very pretty eyes, good and unmoving hair and pouches under the eyes. She was glittering and shimmering in golds and tangerine colours. She has a vulgar laugh, done on purpose.

Rye, Wednesday, 27 April 1983

Sir Brian Batsford (1910–91) was formerly Brian Cook. He ran the publishers, B. T. Batsford, and had been an MP. He was the custodian of Lamb House, one-time home of Henry James.

Sir Brian Batsford is an old, old friend of Cecil's and was the inspiration for the wonderful covers of Batsford books. Cecil did quite a few of them. Sir Brian said that people often asked him what Cecil did when he was not working – 'Cecil is always working,' he would reply. He said that Cecil had masses of ideas, some were very avant-garde: to put writing (black on yellow) on a book cover was an unheard of thing in those days. He was the technical side, Cecil came up with ideas. He said Cecil was always learning – he would put up notes of the dates of kings and painters 'so that he could say, "That, of course, was two years after Rembrandt's death," and then he looked well-educated.'

During these next days I tracked down a number of Cecil's surviving friends from Harrow. On 12 February 1980, soon after I started work, I had met the artist Eliot Hodgkin, known to Cecil as 'Hodgepot', at a dinner party. He had described Cecil as 'very extrovert and snobbish in those days'. He said that Mrs Freeborn, wife of his house master, was artistic and a good ally when Cecil put plays on. Hodgkin was surprised that Cecil was allowed to play a transvestite role. Those who were interested in art were allowed to skip cricket and go to places like Pinner to paint.

* Sam Spiegel (1901–85), film producer responsible for films by David Lean and others.

On 7 May I went to see Colonel Tris Grayson, an old school friend of Cecil, who had been his fag master. He told me at once that he had been in love with Cecil and used to protect him.*

He remembered him as a shy, sensitive boy who rather kept himself to himself. The colonel was very happy at school, 'loved every minute of it', wondered if Cecil was a homosexual or not, seemed to give the impression that he was disappointed not to have realised it sooner. 'He must have been a late starter.' He seemed to think that Cecil lived a pure life at the school. He spoke rather freely of the sex in the house. 'I had sex with other boys in the house, but never with Cecil. I didn't want to.'

Now he is a lonely old man, living in Cheyne Place. His wife died and he doesn't see many people. He had a friendly smile. He said that he asked Cecil to his seventieth birthday party but Cecil declined. Always held a special affection for him – but didn't move in his set at all.

A few days later I spotted him at the Portrait Painters' Exhibition, and he greeted a young man who came up to him with a kiss.

On 15 May I went to see Jack Gold,† another old friend of Cecil.

He was a horror, the sort of man who waited for about half a minute after every question in order to make one feel uneasy. He must have hated Cecil, I think, as everything he said about him was distasteful. He met him at Harrow after a year. He remembered theatrical matinées and how Cecil once played Disraeli with some success. He spoke of Lily Elsie,‡ her villa near Étretat and charades near the casino. His main points were:

'He must have liked earning all that money.'

'He was very beautiful and therefore at school he got away with things.'

* Colonel Tris Grayson (1902–84). He died on 17 April 1984.
† Jack Gold (1904–2004),
‡ Lily Elsie (1886–1962), actress and singer, who inspired the young Cecil; famous as *The Merry Widow*.

'He was not very bright so he had to cheat to get through his exams.'

I ended up thinking, With friends like that, who needs enemies? We had some vile sherry and after two hours I left.

London, Wednesday, 18 May 1983

Ali came to lunch at the flat.

He told a story about David Niven. He had been staying with Jeanette MacDonald* and her husband. He was changing in a tent on the beach. A hand came through, passed between his legs and took hold of his scrotum. It was Jeanette MacDonald who thought it was her husband. 'Lunch is served on the terrace,' she said. It made for a difficult lunch as she realised what she had done.

I gave an election party, jointly with Laura, on 9 June to see the results: Margaret Thatcher sweeping to post-Falklands victory. Referring to the album drama with Loelia, Ginette Spanier told my friend, Lucinda Airy, 'That bitch Loelia Westminster used Hugo mercilessly. And Diana and Laura use him too. But that's different because Diana is a star and Laura is one of the kindest women I know.'
 On Tuesday, 14 June I flew to New York, stayed with my godfather, Bill Weaver, and his family on his ranch in Smith Valley, Nevada. On Monday, 20 June I flew alone to San Francisco.

San Francisco, Monday, 20 June 1983

I watched the scenery. I looked at Reno from the air. I looked at Lake Tahoe. I followed the road we took – I saw the mud slick. I seemed to be able to go further and further. Did I see West Walker river and Twin Lakes? Thence over huge mountains, snow-capped, past tree-covered ones, and along and along I went until we reached flatter lands, flooded areas, then what they call civilisation: endless houses close together. California – San Francisco approaching. Water and areas I couldn't identify, and then down we came.

* Jeanette MacDonald (1903–65), American actress and singer, and Nelson Eddy (1901–67), baritone. They were as good as married from 1935 onwards.

San Francisco is like a kind of New York with clean air and hills and palm trees.

San Francisco, Tuesday, 21 June 1983

I had a short list of people to see in San Francisco. The first was the actress and film star, Ina Claire (1893–1985). Cecil had described her as 'America's unacknowledged first lady of the theatre'. She first appeared on stage in 1907; she was in The Girl from Utah *in London in 1913, and then in a number of S. N. Behrman's comedies. She was the Grand Duchess in* Ninotchka *opposite Garbo. She was married to the silent star, John Gilbert, Garbo's first flame, and later to William Wallace, a rich lawyer, as a result of which she gave up her career. She remained well looked after financially and lived in an apartment on Sacramento Street, on what is known as Nob Hill.*

Gary Clarke had told me that a certain Roger Williams was the custodian to the gate, and to see Ina I would have to approach him. I called him and he suggested I come to his apartment along the street from Ina's between four and four thirty this day.*

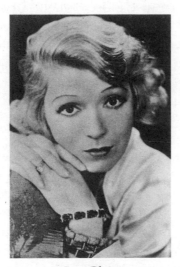

Ina Claire

* Roger Williams studied philosophy at Cambridge, was meant to be writing Ina Claire's biography. He handed some of Ina's papers to the Bancroft Library in California. He died around 2012.

Described by Gary Clarke as 'eccentric', he proved to be just that – friendly and almost overpowering in his desire to help. He is fat, diabetic and long grey curly-haired. He could fix anything evidently. He said that Ina Claire never saw anyone – that she had only granted six interviews or so in these last years and that without him I wouldn't be seeing her. In fact, I doubt that's true. He's probably only too glad to have someone to entertain her as he dines with her *every* night and has done for the last seven years. But still let us not be mean-spirited. He was most helpful. It transpired that he was at work half-heartedly on her biography, as she won't let anyone else do it.

She rings him a lot. She's given him a lot of her things, numerous photographs, including an early one by Cecil, and furniture – some covered with Cecil's chintzes – a Syrie Maugham sofa of vast size with faded tangerine covers. And in his funny, gloomy apartment he has word processors and complicated electric typewriters.

He told me that Rex Harrison was a great friend of Ina and that he always came to her apartment. They had cooled towards him because, having begged Cathleen Nesbitt to take the part of Mrs Higgins, he then somewhat fell for the leading lady, Miss Kennedy,[*] who couldn't cope when Cathleen muddled her lines. Thus he did everything he could to get Cathleen out. At one point she fell ill and nobody visited her. She was left in some grim hospital, but Roger rescued her and had her installed at the Huntingdon at $40 a night, while Rex Harrison was paying $400. He was livid.

Rex Harrison said that Cecil and George Cukor were just two queens competing. Roger also said that Rex Harrison didn't mind Emlyn Williams[†] 'who as soon as he saw me kept falling to his knees and trying to give me blow-jobs'. Honestly! Anyway, he showed me some letters to Ina Claire from Cecil – nothing very interesting. His line about Cecil was that he needed Ina Claire, that he was indebted to her.

[*] Cheryl Kennedy (b. 1947), British actress, memorable in *The Boyfriend* (1967), controversially chosen to play Eliza Doolittle, which she did from September 1980 until just before the show opened on Broadway in August 1981 at which point her voice gave way, and her understudy, Nancy Ringham, took over. Anyone interested in this *My Fair Lady* tour should read Patrick Garland's unputdownable book, *The Incomparable Rex* (Macmillan, 1998).

[†] Emlyn Williams (1905–87), Welsh actor and writer.

Presently we walked along to Ina Claire's apartment, also in Sacramento Street. It had a grand entrance – dogs had to be carried. In tune with his 'eccentric' behaviour, Roger got me to carry his pug-dog so that its hairs came out on me and not him. He carried an expensive cane with him. He likes the pug-dog to chew his hair, which is all a bit sinister. Later he explained that he'd been hetero-sexual but had become gay since he came to San Francisco – only eight years before. I didn't know what to believe in the end.

Ina Claire had a lovely apartment. Evidently she is very rich having married William Wallace. This legendary figure from pre-First World War fame is still vital and alive, very sharp and strong. She has covered the whole range of theatrical experience. She is now ninety, but you'd never have known it. She's a bit unsteady on her feet but otherwise very bright-eyed and rather good, strong-looking. She was nicely dressed in blue with a white collar – Roger said later that she'd been to the beauty parlour in honour of my visit. We arrived at about six, I suppose, and I stayed till ten or so. We had a lovely talk about Cecil and dinner in the dining room. Drink flowed freely.

She once spent Christmas in New York with Cecil, and went on a chase around visiting people. Cecil said to Roger that by taking Ina with him he reckoned he'd be admitted anywhere. He wasn't sure he'd been invited. At one Vanderbilt house (Mrs William KV) she had to sit in the hall. Yet earlier Mrs V had paid her a thousand dollars to come in and sing at a party. After the Christmas party turn she said that back at the hotel Cecil pounced on her. She got out of the situation by saying, 'Oh, come off it, Cecil.'

She saw Cecil in March or so, 1977, at Broadchalke. She told him that publishing the Garbo stuff was a 'lapse of taste', she thought. George Cukor told her that he thought Cecil was 'pompous and pretentious' and anti-Jewish.

She always insisted on being photographed by Cecil: 'Only Cecil Beaton. He knows my faults and how to get round them.' She also said, 'He had his eye on the business and that's good. It's right. He should.'

She thought he gave in to his family – was more himself when away from them. She remembered Cecil complaining of Tangier, 'My God, the place is always the same.' She also said, 'He was a brilliant man to stick to his . . . profession.'

We talked of other things – how Garbo and she had got on well together when in *Ninotchka*, though much of her part as the grand duchess was cut so as not to upstage Garbo. Garbo took a fancy to her and wanted to see her in New York. She kept ringing up to announce, 'It's Miss Brown' or 'It's Hamlet' (pronounced 'Hummlet'). She kept postponing her lunch until Ina Claire said, 'Listen. Let's postpone it indefinitely,' then of course it happened. They met and after lunch she went back to Ina's flat. Garbo made a lesbian advance, which was turned down. Garbo said, 'Let me go to the little boys' room.' When Ina Claire saw it later on, the seat was up!

Garbo put on a mink and was about to walk off with it.

Ina talked about her own life. Roger thought he was being helpful but in fact he was a bit of a pain. He kept disconcerting poor Ina and saying, 'Get back to Cecil.' I prefer to let my interviews just ramble on and see what comes out.

We had dinner at the table. Normally she dines in bed. She thinks Roger is 'such fun, that guy'. He has to stay with her. He is in his own words 'a captive'. Her doctor says that without him she would die. He certainly likes to be indispensable. In the end he bustled her off to bed. He smothered her with kisses and I was told I could kiss her goodnight.

We walked back to his apartment and had a drink. He told me that Cecil did cruise round pubs – in the Chelsea Arms in the King's Road he tried to pick Roger up when he was an undergraduate. He also tried it again in a queer bar in Soho.

A friend rang up and he passed this man over to me – a theatre man called Jo. He wanted to know if I could advise him of any places to go. 'What sort of places?' I asked.

'Gay bars.'

'I'm afraid I'm the wrong person to advise you.' I was horrified. Roger told me that he had gone to a queer bar with Peter Lubbock*

* Peter Lubbock (1909-84), half-brother to the younger family of Sir Charles Tennant by his second wife, Marguerite Miles. He was a travel agent. He drove his older half-sisters, Lady Elliot of Harwood and Dame Margaret Wakehurst, to the station every Friday as they left for Scotland. Laura used to be amused by the enthusiasm he showed for his imminent San Francisco holidays: 'You see how excited he is.'

and Whitney Warren[*] - 'I can tell you – I was embarrassed to be seen with those two old codgers.'

Roger doesn't really want to write his book. He's lazy and degenerate. He suggested I help him finish it off. He says he has $30-40,000 a year and that Ina has $500,000 or so. I suppose he has his eye on that.

San Francisco, Wednesday, 22 June 1983

Roger Williams says that if one is not 'gay' one cannot understand Cecil. I do not believe this. Anyway, today I face the boyfriend, Kin Hoitsma, described by Ina Claire as 'a disreputable friend of his up on the hill'. I think Roger Williams exaggerates. I don't believe he has had Christmas cards from the Queen. I don't believe his story that Prince William of Gloucester[†] committed suicide over his love for Nicole Sieff, or that the British government sank Kitchener and all his men to dispose of him.

I felt slightly tarnished by my talk with Roger Williams. Next time I'm going to get a thoroughly heterosexual subject to write about, if possible.[‡] And this is my last sortie into the world before I go under cover of darkness to write the book. Then I won't need to put myself in these situations.

San Francisco, Wednesday, 22 June 1983

Kinmont Trefry Hoitsma (1934–2013) was the young man Cecil met in San Francisco on a weekend away from Los Angeles, during the filming of My Fair Lady. *They became close. Kin joined Cecil in England in the summer of 1964 and stayed for a year.*

Kin was a six foot four Californian who graduated at Princeton and fenced in the Olympic Games in Melbourne in 1956. He settled in San Francisco and became a college teacher.

[*] Whitney Warren Jr (1898-1986), rich socialite son of the architect who built Grand Central Station. He lived in some style in San Francisco.
[†] This was a nonsensical claim. Prince William (1941-72) was dating Nicole Sieff. He was killed taking part in an air race, when he turned his plane too sharply.
[‡] Vivien Leigh.

I caught a taxi and reached Kansas Street just before nine. I came into a marvellous tangled garden of roses – a Japanese-style garden - then went into the house. Kin Hoitsma is fifty or so now. He is a huge man, bronzed, balding, bearded, nice-looking, with a dog, generous smile, flashing teeth and smiling eyes. He greeted me in a very friendly way, took me into his wooden house and down some steps. We had some coffee. He said very early on that he had been worried about my letter. He had called Eileen and Dicky. They had assured me that I was honourable. He also said. 'I understand you are not gay.' This too had in a way worried him, but I think I dispelled those fears. I was very pleased by his question. It meant that Dicky Buckle had now got the message and passed it on. I don't see why a straight person can't write a biography of a basically homosexual one. I don't see that it matters. Anyway we soon got onto terms. I told him I had no intention of being a jack-in-a-box that popped up to menace him all these years later. The way to handle it is to make it quite clear that it was an affair, that they took up with one another, that Kin went to live with Cecil, and then to concentrate on what Kin thought of Cecil. To create something rather than destroy it. We had a long and constructive talk.

At the end of our meeting, Kin showed me some photographs he had taken of Cecil, and some that Cecil had done of him. It was funny to see Cecil in that role. One showed him on the beach with what looked like an erection! They went to Turkey together. Cecil painted him – one of those green faces – and there were some sketches. He showed me his garden and the view down Potrero Hill of San Francisco. He said that some of his flowers Cecil would never tolerate. 'When someone has gone, you often take on more of their things. That's true for me and for Eileen. It's almost a shrine.'

I took a snap of him as we waited for my taxi. He said, 'Thank you for stopping by, Hugo.' He smiled and waved in a friendly way from his door. I like him and I think Cecil was lucky – if that was what he wanted. He got a very straightforward person. It must have led him to new worlds and been good for both of them. He wasn't a fawning person.

I had taken nine pages of notes – see the chapter on Kin in my biography of Cecil, pp. 558–78. Before the book went to press in 1985, I had an hour-long

conversation on the telephone, going through it all. At the end he said, 'I think I got off lightly.'

Back at the hotel I called Roger Williams. I was meant to ring him earlier, but didn't. He said, 'I am glad you didn't. I had a hangover.' He suggested that I rang Whitney Warren. So I did this. He just said he loved Cecil and missed him very much and would I ring tomor-row. Roger was all for me coming for a drink, but that too I decided to let drop. Gratefully I seized the freedom of the day – I had enough material and Whitney Warren wouldn't give me anything worth-while. Cecil didn't like him much.

Next day, when I rang Warren, he said he was unwell: 'I can't do it today, kid.' A relief.

San Francisco, Thursday, 23 June 1983

I went out and bought a first edition of Truman Capote's *Other Voices, Other Rooms* for $95.

On a tour of San Francisco, we were shown Nob Hill ('where the nobs live').

At six thirty I was back and in a rush to get to Roger's. Climbing the steep hills, I was almost on all fours at one point. We then walked over to Ina Claire's and once again I was obliged to carry Tobias, the dog. Ina Claire was dressed in a dark red silk suit with an orange hat on her fair hair. She hadn't been out to dinner for some months so this was quite an adventure – we had a quick drink, then staggered (literally) over to Alex's Cellar,* a good restaurant. They had caviar but I felt I shouldn't and wasn't encouraged to do so, but I had a very good avocado, a taste of the caviar, tipped onto my plate by Roger, a Dover sole and strawberry Romanoff (strawberries drenched in cream, Cointreau and maybe cognac). Good Californian Pouilly too.

* I failed to record that as we walked along, we passed a figure, at which point Roger declared in a loud voice, 'Who would have thought INA CLAIRE would be walking in the streets of San Francisco!' hoping to get a reaction from the passer-by. Not a glimmer of interest.

Ina had another story of Cecil doing up hotel rooms to stay in them free. She recalled that in London in 1912 or 1913 there were a lot of Prince Henry jokes in circulation. Sounds funny to me.

We took Ina home and then I had a quick drink with Roger. He said that Ina adored me and that they had both dreaded this biographer turning up but were now sad that I wasn't staying longer. So that was friendly and nice. He told me that he had asked not to be the beneficiary of Ina's will. 'I will get fifty thousand dollars and my mother ten thousand.' He said it as though it were a drop in the pan. Pleading my early departure the next day, I left by taxi. I passed Union Square and the ladies of the night.

I flew back to New York on Friday, 24 June.

New York, Tuesday, 28 June 1983

For a long time I had been trying to reach Truman Capote (1924–84). Cecil had been an important part of his early life, taking him up after the success of his first book, Other Voices, Other Rooms. *In the later years they had grown apart. Cecil had been jealous and therefore censorious of his success with* In Cold Blood *(1966), after which he gave the famous Black and White Ball. Capote's biographer, Gerald C. Clarke (Gary Clarke) tried to make this possible on several occasions. Today he called and advised me to ring Truman, who would answer his telephone and, if he was on form, would be a great help. He was in Bridgehampton.*

To my surprise he answered at once. He sounded a little suspicious when I asked for him and then was very friendly. He knew who I was. He didn't want to see me: 'I live in a very remote place . . . you'd never find it,' he said. Then he added that he was there to work and write. I asked if possibly we could talk on the telephone about Cecil. This idea appealed to him and he went away to get something, made himself comfortable and settled in for a conversation of some three-quarters of an hour. He couldn't have been more helpful. I was surprised by how amusing he was, that extraordinary high-pitched voice full of humour and naughtiness. I caught him in a good mood.

Truman Capote

He laughed a lot at his own jokes and was, I think, fair and generous about Cecil. He spoke so slowly that I was able to take twelve pages of notes:

HV: You first met Cecil just after the war?

TC: Yes, I met Cecil on that first trip to America, 1947 – I met him. He was a very good friend of George Davis, the fiction editor of *Harper's Bazaar*. We became great friends almost immediately. Next June I stayed with him at Broadchalke. Well, we had a very good time. We had an awful lot in common. He took me to see that extraordinary friend of his. What was he called?

HV: Stephen Tennant.

TC: Willa Cather was a great friend of mine. Cecil took me to Stephen Tennant's – he gave me a meal with candy violets in the soup. After that I wasn't too keen. I never saw him again. The house was quite extraordinary, and he was bubbly, out of a Charles Addams cartoon.

HV: And you travelled a lot together?

TC: We went round the world together. We spent a great deal of time with one another, particularly over *The Grass Harp*. We went to Japan and Hong Kong and all around. There was practically nothing I didn't know about him.

The romance with Greta? Well, he was in love with her – he certainly was – or infatuated. A better word really. Curiously enough, Cecil was one of the few people who gave her any physical satisfaction. Greta was so frightened of Georges Schlee. She certainly managed to spend a great deal of time with Cecil. He was infatuated – she was frightened.

Lots of people were infatuated with her. He actually had a good time with Greta. I remember them going for a walk and having a big snowball fight. They kept falling all over the place. It was mostly love, a lot of malice too.

HV: Was he wrong to publish the diary about Greta – *The Happy Years* – do you think?

TC: Personally I didn't think he was. He had all of those diaries. She was a large part of his diary. It would have been very odd-looking if he had written them without that. What he wrote was the absolute truth. It all had to come into it. I think that was one of the happiest unhappiest times in his life.

HV: What about the role of the Schlees?

TC: Georges Schlee was an absolute bastard. Valentina despised Greta. Yet they were together. They even had a house together in the South of France. He was so unattractive, he was grotesque, he was extremely ugly. I could not understand what it was all about. Yet he had a hold on Valentina and Garbo.

Then there was Mercedes de Acosta. Garbo was to Mercedes what Georges Schlee was to her. Mercedes was devoted to her while Greta treated Mercedes the same way Georges Schlee treated her. She was not the kindest person in the world. Greta treated Cecil very badly. There was a sex fixation about Cecil. Several women had been to bed with him.

HV: It was a surprise to find he went to bed with so many women.

TC: Nevertheless he did. They were always well bred or interesting. He had a great affair with Merle Oberon.*

HV: Surely not?

TC: I can assure you he did.

HV: What sort of date would that have been?

TC: Well, it began in the thirties and ended in '47 or something like that. Why he found her attractive I don't know. I never thought her attractive. She had a terrible skin disease. She had a permanent running fever of 102 and had had since she was a child. She had many affairs with people. It was because of the fever.

I found no evidence – or even a hint – to support an affair with Merle Oberon.

HV: He was a great friend of Ina Claire. I just saw her in San Francisco.

TC: He and Ina were tremendous friends. I know Ina very well.

HV: She told a story of how Cecil pounced on her.

TC: Cecil had a way with him. He'd pounce on anything: women, men, dogs, fire hydrants, Spanish puppies, for no reason whatsoever.

HV: What did you think of Peter Watson?

TC: Peter Watson was the only great love of his life – the only thing that really absorbed him. Peter was a little bastard. I couldn't stand him. In Cecil's house there was a book on the desk, a nineteenth-century novel and a bookmark in the place where one of the characters says, 'I love you, Mr Watson.' Cecil went on a long trip with

* Merle Oberon (1911-79), celebrated film star.

Peter. It was at the beginning of this passion, on a boat, on a halfway trip. Peter would never let him touch him, and Cecil wrote, 'Oh! It's just the end.' I was quite pleased when Peter drowned in his bath tub.

HV: There was a mystery about that?

TC: There was nothing mysterious about it. He had a bad cold, he came back and he was very tired. Then he had a hot bath.

HV: Some say he was murdered?

TC: Oh! No! What I am telling you is the exact truth about it. Peter was so mean to everybody. There's a funny story of two American sailors. He got them confused. There were two. One of them he thought was very attractive. He sent him a ticket to England, but he sent it to the wrong sailor. Then he was stuck with him.

HV: Was that Waldemar Hansen?

TC: Yes, Waldemar Hansen. He was an extraordinary homely boy. But the only real love for Peter was Denham Fouts. Peter was absolutely mad about him. It was a whole strange thing. He would have nothing to do with Peter. Denham developed a terrific crush on me. I'm from the south. He used to tell me the details of Cecil. Cecil hated Denham with an unconsumed passion. He was very attractive.

HV: You went on a trip to Japan?

TC: Japan. We had a very good time. We went to Hong Kong, to Siam. I think Cecil enjoyed it more than I did. The one thing in the world I'm not is a sightseer.

HV: How would you assess him?

TC: One of the three or four best photographers in this century. I worked with all of them – Cecil and Cartier-Bresson and, if he weren't so affected, Irving Penn, and the English photographer, Bill Brandt. I never thought Dick Avedon was a great photographer.

HV: Were you involved with his play *The Gainsborough Girls* at all?

TC: Well, I read it a number of times. I made some suggestions here and there. What that really was about was that Cecil had a great jealousy of Noël. I loved Noël. I think Noël was a fabulously talented person. But Noël couldn't take a snapshot. He had no visual sense. They were two totally different people.

Cecil was jealous of Noël on two levels. One, his plays. Two, his social success. Noël had success before Cecil did, and really had more renown. Cecil was extremely jealous. The funny thing was that Noël realised it – but just at the end.

HV: Cecil was also jealous of Enid Bagnold and her play?

TC: Irene Selznick writes in her memoirs that I had a falling-out with her.* I didn't have a falling-out with Irene. She was a friend of mine. I did have a slight falling-out with the Paleys. Irene took Enid up. I never made any point. The story of me falling out is completely phoney. I'll tell you how that play ever got done.

Cecil adored Enid Bagnold. Cecil brought me that script. I liked it very much. I went to Irene and I said: 'I think you ought to do this – this is a fascinating play.'† She makes no mention of how the script came into her possession – Cecil had given it to me and Enid was very insistent. Cecil was infuriated when Irene had his sets painted.

HV: Cecil and Enid fell out.

TC: It was absolutely ridiculous – basically jealousy. He was being very mean about it.

HV: But Cecil's friends were very fond of him.

TC: Cecil had a very strange range of friends. They didn't sort of click together. Some he really pretended to like – like David Herbert.

* I can find no such reference in her memoirs.
† Not according to the memoirs. Harold Freedman gave it to Irene.

He pretended to like him. Cecil really liked his brother.* Cecil thought David was a silly flip.

HV: Stephen Tennant said David Herbert had a good brain but didn't use it.

TC: I knew David Herbert quite well. He may have had a brain, but I never saw it. He was an amazing little snob.

HV: And Cecil stayed with you quite often?

TC: Cecil came to stay with me. I had a beautiful house in Spain and one in Switzerland. He used to come and stay with me for a month. It was always very beautiful, everything was very comfortably done. They were real holidays for him. He'd spend his time writing in his diary, taking pictures. He took fabulous pictures of my house in Spain. Then in Africa (Tangier) we were together a lot.

HV: And you met the Queen Mother with Cecil?

TC: The Queen Mother! I kept her fascinated telling her about murder cases. She is a wonderful person.

HV: I have been reading a book about Claus von Bülow.†

TC: Claus Bülow! I'm the person who's going to save his life. It's just possible that he did what he did – there is the evidence – but Sunny was doing those things all her life. Ten or eleven people like Cee Zee Guest knew Sunny took drugs. Someone is lying straight through their upper teeth and their lower teeth. I don't know Claus. It's just a question of legality. It's quite possible he did it – but it really isn't possible . . .

* Sidney, 16th Earl of Pembroke and Montgomery (1906–69).
† Claus von Bülow (1926–2019) had been convicted of the attempted murder of his wife, Sunny, who was then in a perpetual coma. He was acquitted on appeal. During this trip I was excited to find myself behind him in a queue to see the film *The Draughtsman's Contract*. As of 1986 he became a friend.

People tell me terrible things about him. It's a question of what's legally fair. *In Cold Blood* was a fantastic American expression.

HV: Did you know Cecil's mother?

TC: I didn't like his mother. Oh! She was not a pleasant person. I'll just leave it at that. And she wasn't nice to him in my opinion.

HV: Did you know the sisters?

TC: I never saw the sisters. I have a feeling that I didn't want to at all.

HV: But Cecil was good to them.

TC: Cecil was very good to all of them. He was very, very kind to all of them. I don't know what their opinions of him were. There was something in them that I didn't like.

HV: Did you know Kin?

TC: Oh, boy! Yes. He didn't behave exactly right. He's a very misleading person. I think he broke his heart. I can tell you something about them. I shouldn't, but I can. They met, well, when he was quite an attractive young man in a way, and he and Cecil had an affair. He, after the first time, would never let Cecil do anything with him at all. The way he was about Cecil – it used to frustrate Cecil out of his mind.

Truman Capote ended the conversation quite abruptly. He said, 'Call me again if you need anything.' To talk to him was to feel that you had known him for ever and in a sense could ask him anything. There were no preliminaries and, other than establishing that I was writing Cecil's authorised life, he asked no questions of me. I did not call him again. When the conversation was over I felt I hadn't come to the USA in vain.

Three days later he was arrested on a drunk-driving charge, spent a night in prison, and had to go to court.

Later that summer, through the kindness of Gary Clarke, Truman signed

two books for me, one of which was the first edition of Other Voices, Other Rooms *I had bought in San Francisco. But the decline in the last year of his life was sad and intense.*

 Truman Capote died in Los Angeles just over a year later, on 25 August 1984.

New York, Wednesday, 29 June 1983

Back at the apartment I called Diana Vreeland. I told her that I had been in San Francisco and seen Ina Claire: 'Oh! How wonderful – does she still talk as much as ever? She talks a mile a minute. You run out of breath just listening to her.'

 And I said I'd talked to Audrey Hepburn. She said, 'She's a darling girl, enchanting, just adorable. If she loves a friend, she loves like a child. She's not at all worldly.' It's true.

New York, Thursday, 30 June 1983

I went to see Oliver Smith (1918–94), who had done the sets for My Fair Lady.

I took the Express to Brooklyn. No sooner had I emerged into the sunlight than I realised that here was the most wonderful peace and quiet. I walked along to 70 Willow Street, almost in a trance.

 Oliver Smith opened the door himself and was a tall, rather distinguished-looking white-haired man. I liked him very much and he proved to be an important source. He was the kind of source that I could so easily have neglected by accident, thinking, What could he tell me? He only did the sets for *My Fair Lady*, but he proved very much a good source, friendly, informative and wise. He also liked me and seemed to think that I was the right man to do the book – 'Better than some old codger,' he said. 'So like Cecil to think of that.'

New York, Saturday, 2 July 1983

Irene Selznick had been in hospital. 'But I'm all right. There are no tears being shed in this house,' she said. I went to see her.

I was at the Pierre at five thirty. I went up and she wasn't quite ready. In due course she let me in. She said, 'Do I look different to you?' It transpired she had had a new face – a variety of nasty cancer operations and the threat of more to come. But she seemed quite strong in her multi-coloured kaftan.

I said that I thought she had let Cecil off very lightly in her book. 'Well, I did, all things considered.' She added to the drama of *The Chalk Garden* by saying that Truman pressed her to use Cecil because that let him off using Cecil for *The House of Flowers*. (He wanted Oliver Messel.) She said that Truman took seats for the opening night of the play in Boston. He wanted the Guests [Winston and C.Z.], etc. She begged him not to come as the cast was under-rehearsed.

'Too bad you missed George,' she said, adding that George Cukor and Cecil had been great friends but 'their friendship couldn't survive working together'.

We then had a long talk about our mutual publisher, George [Weidenfeld]. She said that he urged her to help him when he wanted an American bride. 'George is not good husband material,' she said. He'd been very eager to have her book and had asked Gottlieb* for the manuscript. The next day he did it. But she was convinced, rightly, that George did not read books. I said: 'He weighs them and assesses them by instinct.'

She told me that she spent seven and three-quarters years writing the book and that in the end, Gottlieb could hardly remove a line. But he altered bits around. She said how lucky she had been with the publicity. She'd done no television: 'I don't want to get up at four in the morning.' But she had done some radio interviews in the apartment and would do some more. She'd got lots of serialisation rights, reviews and advertising. 'Most people complain that their book comes out and no one's heard of it. I can't do that.'

I flew back to England overnight on Thursday, 7 July, arriving the following morning – Friday, 8 July.

It was an occupational hazard for Ali Forbes that his sense of humour invariably got the better of him and caused offence on a regular basis. He was forever being

* Robert Gottlieb (b. 1931), distinguished New York editor and publisher.

thrown out of weekend parties for upsetting his host or hostess. He had lived for a time in Tangier, where he enjoyed sparring with David Herbert. One Christmas he was delighted when Princess Marina sent him a card, enclosing one for Herbert on the grounds that she could not find his address. He made sure he delivered it in a bar crowded with Herbert's most gossipy friends.

London, Wednesday, 13 July 1983

Artemis [Cooper] told me . . .

Ali had a row with Charles Farrell at the weekend and stormed out. It had begun with him upsetting them by patting David Herbert's paunch and saying, 'I'd have thought all those little Burmese boys would have taken care of that.'

Nymans, West Sussex, Saturday, 16 July 1983

Jane Abdy took me to lunch with Anne, Countess of Rosse.

Anne Rosse

Nymans is a beautiful house, ruined in a fire in 1947 and left as a ruin in part, with flowers pouring through the empty windows. It is a manor house, which looks most romantic, forever turning corners so that you are always coming on to new rooms. Lady Rosse greeted us

at the door. Evidently she is eighty-three, though you'd never know it as she has had a lot of trouble taken with her figure and appearance, and I guess her face has undergone several 'fixes'. Cecil chose to hate her but I don't quite see why. He might equally have adored her as she is petite and pretty and loves her garden and her house, and lives her life on a thoroughly elegant plateau. She does say, 'My darling angel Oliver . . . you see the life is one thing because we shared it and nobody can ever take this away, but the end . . . no, I don't think I could bear to go through that again. It's *too* painful.'

The other guests were Mrs Van der Linden, who was doing her best to draw the house, Stanley Hall, the 'Wig Creations' man, his boyfriend called Charles Castle,* who writes light biographies about people of my period and Polly Haywood,† a very, very rich American friend of theirs who used to live in Barbados and perhaps still does. Charles Castle wanted to read Anne parts of his book, which caused the above remarks. So, too, did they wish to see the Oliver Messel memorial but she was too upset at the thought of going herself. 'It's too soon,' as she told us all in turn. Likewise she could not face the exhibition (which I must hurry to) but said she went to the reception because 'I thought it would help, though I didn't feel up for it. The blaze was on Margaret and Tony. I couldn't bear to go round, though.'

She served a lethal brew – Lord Rosse's Bacardi cocktail: two parts Bacardi, one Dubonnet, one orange and a lot of sugar. Later Anne Rosse took us all round the garden. It was another scorcher of a day and I loved it – a true garden. Anne would say, 'There's so much to do. One could sit back but I prefer to be involved.' She has six gardeners paid by the National Trust. She knows every plant and would say, 'That will be cut back next year.' She says, 'I was sitting in bed this morning and thinking of all the people who have visited this garden' – I think she was referring to the famous gardeners. She also has an estate in Yorkshire, Womersley, and Birr Castle in Ireland. She sorts papers and letters and dwells on these matters. I found her very

* Stanley Hall (1917–94), wigmaker; Charles Castle (1939–2013), who wrote a book on Messel.
† Pauline Haywood (1929–2004), who commissioned Oliver Messel to build Cockade House for her in Barbados. In England she took the set belonging to John Walker at Albany, where she entertained lavishly.

friendly and welcoming and keen to share it all. 'You must see Strafford Terrace,' she would say. I took a lot of photos and I'm *almost* sure she consciously posed – but that the level of subtlety was so high that I'm still not 100 per cent convinced. Whatever it was, it was a delightful act and the whole day remains as a calm and very special expedition into a rare and special world of lovely romantic gardens, flowers, trees, furniture, pictures, where everything is done to the height of subdued taste.

London and Winkfield, Friday, 29 July 1983

Paul Tanqueray* came to tea. I like him – he is like an old actor who used to play butlers or the little bald man in *The Benny Hill Show*. He was wearing a cream suit he'd bought in 1951 and hadn't worn since. He was proud to fit in it. He's curious as he is shy, I think – he could have made a much better life if he'd been more flamboyant. He almost didn't dare ask if he could take photographs of me. He'll be sure to send some whereas he should charge a fortune. After all, he's a famous photographer, who's taken everyone from Tallulah Bankhead to Vivien Leigh. He still feels the effect of having been knocked over by a car. He said, 'It doesn't do you any good.' He also said he didn't like what happened to people in their eighties. His friend Ethel Mannin is very doddery.

I wrote twenty-seven pages of diary about the party that Drue Heinz gave that evening for her husband Jack Heinz's seventy-fifth birthday at Ascot Place, Winkfield, attended by the Queen and Princess Margaret and many of the characters in this story. It was a fabulous party with stage coaches, barges to bring guests across the lake, dinner and a dance in a Big Top, a carousel roundabout, and strategically placed buckets, with magnums of pink champagne nestling in the ice. I loved it.

Mary Soames . . . introduced me to the Baron de Redé,† a very wealthy Frenchman who entertains everywhere and mostly in the

* Paul Tanqueray (1905-91), portrait photographer and contemporary of Cecil.
† Alexis de Redé (1922-2004), who restored the Hôtel Lambert in Paris. Years later I helped him with his memoirs.

Palais Lambert on the Île St Louis. Nobody seemed hugely enthusiastic over him – 'He don't make many jokes.'

Clarissa talked to Rex Harrison, still bearded. I went over and met him at last. He said, 'I'd have been very happy to talk about Cecil . . . We did a lot of work together, including, of course, *My Fair Lady*. The problem was that Cecil and George Cukor did not get on at all well.' But that was all. He turned away, uninterested.

After dinner there was dancing . . .

The Baron was also on the floor. He danced with nimble feet supporting his overweight form. His little group of Evangeline Bruce and Co looked rather out of it, I thought. I did say hallo and he granted me but a handshake. He limits his time carefully on these occasions.

London, Monday, 1 August 1983

I lunched at Albany* with Polly Haywood, Peter Coats, Patrick Forbes† and Anne Rosse. Mark Gilbey was just going out with his sinister hooded eyes as I came in.

It was quite a lunch. It knocked me out for the rest of the day. Peter Coats was his normal awful old self; Patrick Forbes was rather neat and dapper, like an aged schoolboy (he works for Moët & Chandon); Polly Haywood was a generous hostess, who gave us far too much of everything. I gave in to it gently and enjoyed it. For me, of course, Anne Rosse was the most fascinating. She has her own funny style – always 'Darling Peter . . .' or 'You're a dear, you won't do – – – – I am sure.' She said she'd been embarrassed the other day when Charles Castle was there. 'It was easier really just to walk round the garden, wasn't it?'

It was interesting that Cecil hoped to marry one sister to 'Grandee' [Earl of] Jersey (I didn't know, but should have suspected). She said Cecil was very 'vulnerable'. Oliver was not: he had money – he didn't have to work. He had contacts: Cecil had none of these. She said

* Albany, a 1776 block of sets (apartments) off Piccadilly.
† Patrick Forbes (1925–88) ran Moët & Chandon in London.

Cecil tried to model his two sisters on her, which I can well believe. Then she told me more of the *Don't Count the Candles* drama. She said that Snowdon, 'my adorable son', had let the cameras continue to roll. 'It was really that man Hart,'* she said. 'It was not a *nice* film' – Cecil had unwisely said to her at Covent Garden 'that little tick of a son of yours' in the hearing of the Queen Mother. She asked if 'darling angel Oliver' would appear in the book and I said yes. They were friends and rivals. Cecil was envious. In the end he was more worthwhile. Charles Castle's book was, she thought, 'not too bad, but pretty near the knuckle'. She is a bit vague and also rather deaf, but I think she felt she should go through this and sort it out with me. So though I was the worse for wines and brandy at the end of the afternoon, I felt it was all worthwhile.

On Friday, 5 August I went to stay at the Cipriani Hotel in Venice as a guest of Laura. Her line was that I used to stay with her at Gellibrands, but now that she had sold it, she could not invite me there, so why not come to Venice instead? We went for two weeks and it was a success. I went with her every summer after that until 1988, sometimes for three weeks. Although this was a holiday, I had to finish the book, so I would write each day, lying on a banquette by the pool. An American[†] and his wife next to me asked, 'How can you do that?' I replied, 'I have to do it, and I would rather do it here than at home in London.' Unwittingly I did not realise that I would have the chance to scoop in a whole new set of sources. Had I written to them, the answer would have been that they were travelling all summer, yet here they were, only too happy to talk.

The following day, who should be standing waiting for the boat but Valentina Schlee, wearing a faded yellow coat with a grim-looking maid-companion beside her. She looked old but not so frail and had a determined air about her. I had assumed that after the adventures in New York the previous December Valentina would not have survived. But there she was, not only

* Derek Hart, who made the film.
† He was called Roswell Gilpatric (1906-96), attorney and deputy secretary of defense (*sic*) in the Kennedy administration at the time of the Cuban Missile crisis. He had a discreet affair with Jackie Kennedy in 1968, not long before she married Onassis. He married five times. His last wife, Miriam, was the mother of Mrs John Kerry, wife of the senator, coincidentally Ali Forbes's nephew.

staying in the same hotel, but on the same corridor as my room – in a suite at the end. She could not come out without literally passing my door.

There were some further sightings – Valentina by the foliage near the pool, wandering about, lurching forward like a caterpillar, and finally one day sitting inside for lunch, again with her keeper. I seized the moment.

Venice, Sunday, 7 August 1983

'Madame Schlee.'

'*Oui.*'

'I'm Hugo Vickers. I came to see you in New York. Do you remember?'

'Of *course* I remember.'

'How are you?'

'Much better.' (Honest, anyway.)

I introduced Laura and at the word 'duchess' she shot out of the chair. She told Laura, 'I've been coming to Venice for thirty-seven years, always in the sun. Now I have to stay in the shade.' Laura asked if she'd lunch or dine. I think she heard. We also met her companion, Miss Strano. Since then, Laura has written a note dictated by me. Valentina asked us if we were staying at the hotel.

I have heard a lot about her from various people since I got here.

Jane Rylands says Valentina is avoided: 'People scatter when she appears.'

Mrs Shirley Sherwood: She's Dr Rusconi's[*] least favourite guest as she's always complaining.

Mrs Black: She used to return from the Lido, standing erect on the prow in white gloves with her face in the sun. She was totally straight. Since last seen three years ago she's become this hunched shape.

The management don't care for her much, it seems. Sometimes her door is open and sometimes it is shut. She then wears a flimsy nightgown and cap. She wanders around by the door as tonight when she was waiting for food – a trolley was on its way.

For days Laura's note sat in the rack until finally we had it sent up to Valentina's room. Immediately Miss Strano rang to say that Madame Schlee

[*] Dr Natale Rusconi (1926–2020), manager of the Cipriani, 1976–2007.

would be delighted to dine that very evening. Downstairs, I met the compan-
ion who said, 'Please convey to the duchess that Madame Schlee sometimes
loses her train of thought.' Then she asked nervously, 'The invitation is just
for her?' and so I said, 'No, no. Please come.' I never saw anyone look so
relieved.

Venice, Friday, 12 August 1983

The dinner was set for eight o'clock, so Laura and I were down in the
lobby in advance. In a moment there appeared Madame Schlee and
her Mildred Strano, as we now know her to be called. She, Madame
Valentina (as she likes to be called), was wearing a purple tunic in silk
and what I fear can only be described as tinselly trousers. Her hair was
long and down and tied with white ribbons. 'I love white ribbons,'
she said.

And Miss Strano said, 'Madame Valentina's hair is very strong and
grows very fast.' So too her nails: 'She breaks a nail and it's all right in
no time.'

We went and sat in the area before the dining room. 'It's lovely that
we are all together,' she said. 'Let's drink a toast to us.' Later: 'Shall we
face *them*?' I was surprised at her sense of humour and also the way
that she really would remember everything. When Laura told her I
was writing a book on Cecil Beaton, she said at once, 'Oh, my God!
You came to New York and I couldn't receive you. I was so sorry.' She
knew that and also that I had come the morning of the diamond
robbery. Evidently the diamond robbery was a true story. The son of
the superintendent of the building was responsible, as Irene Worth
had said. She told the story of Cecil and the grand duchess . . . '*Cecil,*
j'adore. He came to see me and brought with him la Grande Duchesse
Marie Pavlova.* "'As a princess of Russia I command you to be
photographed" [for *Harper's*]. *C'était très amusant, très chic.*' Then she
said. '*Il y avait ce mariage!*' (She crossed herself dramatically.) '*On ne dit*
pas le nom! . . . Elle est insortable!'† (Garbo.)

Her companion said that Madame Valentina gave up designing in
June 1964 just before her husband died. She used to employ

* HH Grand Duchess Marie of Russia (1890–1958), daughter of Grand Duke Paul.
† 'There was this marriage – we don't say the name. You can't take her anywhere!'

sixty-seven people to work for her. She thought of the human body as a machine – she worked out how the arms moved and never restricted their movement. She liked low necks and little headpieces. 'Only *now* are they catching on!' she said.

Miss Strano is her night-nurse. She says Madame Valentina has certain paranoia and these are based on fact (as always, I suspect). She said that she has an obsession about smoke. There is a cigar smoker on the same floor and, of course, this smoke permeates into her apartment. She tries to go to dinners but finds it hard. She can't quite keep up the effort. I think she only wears her own creations – she used to give Russian Easter parties and one year President Kennedy came. She has volumes of pictures and might one day show them to me. In fact Miss Strano was very keen that she should write her memoirs. She wondered if I might help. That could be interesting. (Suddenly I envisage two months at the Cipriani working on them.) She does have the most extraordinary memory – for example, at dinner she told the story of giving Cecil the [Tammy Grimes] dress, chiffon in three colours, and it was exactly as Cecil described it. She said, 'He was watching me as I folded it up and put it into a tiny Valentina box. Then I kissed it and said, "It's yours."' She said, 'Whenever I don't see Cecil, I'm sad. I adored him.'

She was also a great friend of Somerset Maugham. She said she designed a lot for Lynn Fontanne and Katharine Hepburn.

We asked her what she thought of the way women dressed today. '*Catastrophique!*' she said. She greatly admires Mrs Thatcher as a character. And she is interested in the Princess of Wales. I asked what she thought of her clothes. 'Well, she's a puppy,' she said. 'She'll learn.' It's a wonderful description. She thought Diana Vreeland was a very 'hard' woman.

At dinner she gave the waiters a hard time. She ordered spaghetti *overdone*, with plenty of hot cream and a little *formaggio*. (She speaks five languages – English, French, Italian, Russian, and is a keen Latin student.) She sent her spaghetti back to be reheated. 'It's because of us that they learn how to cook,' she said. 'At the Gritti, in the days of Gritti, there was good food. Harry's Bar has the best now. At the Gritti, there was a dish called Spaghetti à la Valentina.' For the main course she had scampi *au four* – done in the oven in their shells. We had two bottles of white wine.

At the best period of her life, she lived in New York, and travelled to London, Paris and Venice. She said, 'For nine months of the year, I worked very hard . . . all the time . . . Then for three months I came to Venice.'

Miss Strano said that Madame Valentina had really come alive this evening. She was her old self again. 'It's a joy to see,' she said. She told me, 'The press still wait outside the door to see her come out.' (Can this be right?) And, she said, 'She pretends not to like it, but she's pleased.' She said, 'Madame Valentina descends from Catherine the Great . . . that's a fact . . . but many of her relations were killed.' (I don't know if that's true.) Nor could we quite work out her age. She could have been very old indeed.

She is funny about the necessary luxuries of life. 'This napkin . . . It's so heavy . . . I shall be *kaput* under it.' She got the waiter to take it away. Similarly in the bedrooms, the mattresses were too hard so Dr Rusconi went out and bought them soft ones.

After dinner she took us upstairs and showed us some of her dresses – she was reluctant but we had a glimpse of a few. They were lovely. Next day she told me they would all eventually be going to the Metropolitan Museum.

She kissed us goodnight. And she followed Laura to her room to have a look at it. As they set off down the passage, we couldn't help laughing, more out of nerves than anything else.

Venice, Saturday, 13 August 1983

Laura and I were having a drink with the Boazes and talking about the Duchess of Windsor . . .

In the middle of this conversation I spotted a large form in a beige suit looking at us. Suddenly he leapt nimbly to his feet and came running over. 'My two most distinguished authors here together!' he said. It was the Baron. Laura attacked him at once about her book. 'How unfair,' he said. 'After all the battles I fought for you. Hugo, you must put the record straight.' I told him Laura had helped me a lot with Valentina. The Baron said, 'Are you staying here? Oh, good, then we'll see you around,' and he shot back to his table and (I think) what they call his 'Swedish bit'.

Lord Weidenfeld

Venice, Sunday, 14 August 1983

Today I would have read, but as the Baron is here, I have to go on with my work . . . The Baron's girlfriend was down much earlier than him and took up a position on the corner. She comes down in red, leaving a whiff of extremely expensive scent in her wake . . . I worked hard today on the diaries.

Presently the Baron appeared in a long black robe, looking like an escaped monk. He took this off revealing the hugest of all figures and lowered himself into the pool. He did half a length or so, looking like that dangerous fish we'd spoken of at John Curtis's party – he then got out and made a complete circuit of the pool, stopping here and there to greet various groups he knew. When he reached Laura and me, he stayed for ages and read two whole pages of Cecil's manuscript diary. 'Will these be available for scholars one day?'

'I'm keeping a complete copy,' I said.

He urged me to put in the lot. 'It's part of history.'

The Baron asked us to lunch the next day. In the afternoon he lay like a schoolboy, asleep in the sun. Later he went into the water, from where he greeted a Frenchman. This turned out to be Gérald Van der Kemp. The Baron said I should meet him. He said, 'Cecil loathed his wife. They once invited de Gaulle to come

to "their" house at Versailles. He replied: "*Madame, c'est MON château!*"*

The Baron talked of Cecil. He said, 'He made a distinction between old money and new.' He concluded he was not a happy man: 'The enigma of the recorder – how much does he get involved in what is going on around him?'

Laura and I took the boat over, sitting opposite the Van der Kemps. '*Gérald, il y a une file,*† said his fierce wife, as he queue-barged. Loelia rather loved him once. He looks horrid – very pompous and made-up (at least, I know he is at times). He wore thin pink and white trousers, a matching cravat round his neck. She wore red and white with smudged make-up and looked very, very tough, but wrapped-up tough.

Venice, Monday, 15 August 1983

Laura and I were to lunch with the Baron. I met him in the pool, talking to Florence Van der Kemp. She doesn't really swim. She jumps up and down and lets the water come through her bosoms. She was discussing business in the pool with the Baron. I joined them and she told me that Cecil had once photographed them for nothing and they'd given the photo to *Harper's Bazaar*. He was livid because he wasn't paid.

The Baron's lunch was fun, though he told us, 'It's no good being a publisher any more. Things sell either a hundred thousand or nothing.' After lunch I went to the bar with him for an hour or so. The Baron wants a major royal book for next year with a sale of a hundred thousand to the book clubs. We thought of several things and I came up with the idea of publishing something based on my albums. He seemed delighted. He thrashed around for ideas – 'The Windsor Cavalcade', 'The House of Windsor', that sort of thing. Then he said that if I could finish *Cecil* in time for a June publication, he would perhaps give an end-of-season ball, a Cecil Beaton Black and White Ball.

He said, 'You obviously get around and I would like to make an

* 'It's my castle.'
† '. . . there is a queue.'

arrangement with you.' He offered me 10 per cent on any book that I brought to his attention which came to fruition.

I told the Baron of my idea of the bedtime charts. 'Bedtime reading' is in fact a rather good title. His eyes lit up. He said it was an excellent idea. 'These stallions like Tony Lambton,' he said. 'I can help you with it too.' He hopes one day that I will do a big Proustian survey of the dying class of aristocracy.

So there we sat, arms on the round table, this huge figure opposite me with his cigar and both of us with our tiny cups of coffee in front of us. Presently he was on his way and I went back to the pool, too keyed up to work or rest.

Venice, Tuesday, 16 August 1983

That evening the Brandolinis gave their party to which Laura and I were invited.*

Presently we set off in the Van der Kemps' taxi. In the hall was Madame Van der Kemp in blue. As the huge curator sat down, he looked like a creature from another world next to Laura. Their scales were wholly different. It was wonderful to arrive at the Palazzo Brandolini by water. We walked a kind of plank to get in. Then we were shown the garden, which was Italian and overhung with greenery. I loved it. We went up in the lift, upholstered in yellow silk with dark red silk doors. We arrived at the Brandolinis' apartment.

Brando Brandolini said he adored Cecil and that he used to come and stay every year. 'Brando . . . can I come and can I bring Truman?' he'd say. The palazzo overlooks the Grand Canal as it turns right. Their balcony was overhung with greenery and Laura was right to say that there were two [art deco] Cecil Beaton chairs. Everyone was jetting off somewhere the next day.

Venice, Wednesday, 17 August 1983

The head waiter used to be at the Gritti and Valentina used to stay there. She always had room 210 and used to sleep in black sheets. She

* Count Brando Brandolini (1918–2005) and his wife, Christiana (b. 1928).

was eccentric, he thought, in order to draw attention to herself. I am forming an extraordinary picture of Valentina.

Much of the first part of the morning was taken up in a long talk to Florence Van der Kemp. She said, 'Confidentially I shall be seventy next birthday.' She jumps up and down in the pool. 'It's my form of jogging,' she told me. They go next to America for a ball in New York in connection with Bloomingdales and Givenchy. They go to Newport, then to Washington to dinner with the Reagans for the Portuguese president: 'The Reagans are old friends of mine. They've copied my idea of Versailles of tables of ten. Everything is very formal and well done.' Then to Southampton; then she goes to Japan.

She told me the Volpi Ball was a great event. Six years or so ago it stopped. 'It's the Venetians' loss – they stopped it. All the yachts were here for it.' She thinks that Countess Volpi* is the only one left to have a whole palazzo to herself.

She called her husband over to her: '*Quelquechose pour t'amuser, chéri,*' she said, in her very American-French accent. Before that she caught him out: 'Gérald is smoking a cigarette. He's not allowed to do that.' I had a long talk with him at the side of the pool. He said he didn't think that Schlee had a physical affair with Garbo. He arranged all her comforts, her travel, her towels, her food, everything. In that way she relied on him. He was fascinated by her naturally. Monsieur VdK thought that Valentina imitated Garbo. '*Elle avait une certain goût, mais pour moi c'est tout.*'[†] He knew Garbo and said that at one time she used to go to the basement of the Museum of Modern Art and look at her old films. She has a problem: '*À petit déjeuner elle ne sait pas ce qu'elle va faire pour dîner.*'[‡] Her friendship with Cécile de Rothschild was '*plus passionnée*'. He didn't think it was an affair with Cecil. '*Elle était lesbienne.*' He mentioned a Goldschmidt-Rothschild[§] living in the Wrightsmans' building in New York that she was supposed to be having an affair with once.

In the evening we were to dine with Valentina.

* Countess Lili Volpi (1899-1989), widow of Count Giuseppe Volpi (1877-1947), founder of the Venice Film Festival. She gave famous balls to which the jet set came.
† 'For me she just had a certain taste, that's all.'
‡ 'At breakfast she does not know what she's going to do for dinner.'
§ Baron Eric von Goldschmidt-Rothschild (1894-1987), a great collector and connoisseur.

We were down in excellent time. She appeared soon after. She said that Serge Lifar had arrived to arrange masses for Diaghilev. He'd done this for forty years now. He's written her a letter in Russian. ('Unintelligible!') We set off and went over to Venice. Valentina said that she had always written in huge letters. Her brother used to write in small ones. They had to fill a page to their grandmother. She began, '*Chère Grandmaman, je vous adore toujours. Je t'embrasse, Valentina,*'* and the page was full.

In the city she set off at speed. We passed Harry's Bar and were going along when she stopped to tell me that she had a little book with her lawyer in Washington. She wants to send this to me. It's about her life and I think she'd like me to help her with something or write up her story. We shook hands on it. She was talking about this and about how Diana [Cooper] got the idea of wearing large raffia hats from her when a tall English-looking lady stopped in front of us to smile and say hallo to Valentina. I had a suspicion and was right, because Valentina said at once, '*La reine!*' It was Queen Alexandra of Yugoslavia.† '*Quelle histoire!*'

So along we went and suddenly turned off into a quiet street and found a nice spot and such a pretty restaurant called Martini. They knew her well there and, though strict with them, she was delighted to get her own way. Mildred has got Valentina off drugs. She said that Valentina has three lawyers chasing each other to make sure that there's no mischief.

Valentina told wonderful stories today. She was an orphan, married at fifteen and a half, and left her country. Her husband said he wanted to marry her and she said, 'I can't give you love. I don't know how to love, but if you want friendship, then I'll marry you.' He said, '"If you marry me, I'll look after you for the rest of your life." Which he did for twenty-two years,' she said. So she may only be seventy-six if that story is true.‡

Laura asked if she had any children.

* 'Dear Grandmama, I love you always. I give you a big hug.'
† HM Queen Alexandra of Yugoslavia (1921–93), daughter of King Alexander of Greece, and his morganatic wife, Aspasia Manos; wife of King Peter II (1923–70). Her life was filled with drama. She lived in Venice.
‡ She was at least eighty-four, maybe even ninety-four.

'I had five abortions. I killed five babies very young. The doctor was good and helped me. I was too poor and had to work too hard.' She said two things then – first: 'I'm glad because if I had them now I'd kill them. I'd drop them in the Canale Grande.' But later she said, 'Of course I regret it now.'

She told us that when she worked she was hidden away in her little room. 'You didn't see me,' she said. One woman came and said she had seen her at the opera: 'Valentina I want an exact copy of that dress.' She took the woman to the looking-glass with her and said, '*Chère Madame*, what have you and I between us?' She said that when she designed clothes for someone, she'd look at them. Then she'd say, 'Move a little.' She said it's all mathematics.

Charles James's clothes were 'fun but you can't wear them'. She said the Duke of Windsor liked her clothes and sent the duchess to her with Minnie Astor.* The duchess was afraid of her because of her reputation for clothes. She was very nervous. But when Valentina gave her obeisance, 'She was the King's wife. We'd been taught to do that as children,' she said. 'This is the nicest person in the world.' They became firm friends and saw each other often in Venice and crossing to America.

This evening Valentina wore a pretty red scarf-hat: 'It's very simple.' It may have been simple to her but terribly complicated to anyone else. Mathematics once more. She worked hard all her life, and when the time came to give up, she gave up easily. She explained about the glass of wine that you sip from, and I couldn't work out the exact allusion, but it was poetical and on the lines of the precious gift of talent and how it must be used carefully. She said that people still used to come to her to want costumes for the theatre. 'I say to them, "Goodbye."' She said, 'There are no actors or actresses any more.'

Mrs Barry, the widow of Philip Barry,† playwright of *The Philadelphia Story* (for whom Valentina did the costumes), greeted Valentina as we left the restaurant. Valentina took us into the glorious St Mark's Square and showed us the different views.

* Mary ('Minnie') Cushing (1906-78), married to Vincent Astor.
† Ellen Semple Barry (1898-1995), portrait painter, and her husband, Philip Barry (1896-1949), American dramatist.

Then we went back to the boat and presently raced across to the other side.

Venice, Thursday, 18 August 1983

I realised that the sinister-looking figure with dyed black hair must be Serge Lifar. He was sitting alone by the pool the other day. He kissed Van der Kemp when they met.

Laura's comments: on Lifar, 'A real case of *Death in Venice*', on the curator and Loelia, 'Two hippos.'

At Harry's Bar later in the day.

Here again came Serge Lifar, sitting alone at the door with his Bellini. But we let him slip.

Venice, Friday, 19 August 1983

Serge Lifar (1905–86) was one of the most famous ballet dancers of the twentieth century. Born in Kiev, he had succeeded Nijinsky as principal dancer in Diaghilev's Ballets Russes. When Diaghilev was dying, he and Boris Kochno, Diaghilev's secretary, sat mute side by side near the bed. But when Diaghilev actually died, their jealousy burst out of them and they wrestled like dogs. Diaghilev was buried on the island of San Michele, at which point Lifar had to be physically restrained from throwing himself into the grave. Every year he returned to lay a wreath.*

He had gone on to be director of the Paris Opéra Ballet at the age of twenty-four, serving for thirty years. Because he was a collaborator during the war, his post-war reputation was not good. In 1952 he fought a duel with rival ballet master the Marquis de Cuevas.

We had seen him around the hotel. He was staying in the room next door to mine. I wrote him a note and there came the reply: 'Mr VICKERS – All right – rendez-vous at 5 p.m. – down hier [here] – Maestro Lifar'!

At five o'clock he came down in shorts, a jersey round his shoulders. He was much more animated than the sad figure we had seen seated alone in Harry's Bar or by the dining room.

* Boris Kochno (1903-90), who later lived with Bébé Bérard.

We went out to a little table to have a chat about Cecil. It was fascinating to be talking to him today for he went this very morning to the grave of Diaghilev on San Michele to celebrate a mass and place wreaths on both his tomb and on Stravinsky's. This was the fifty-fourth anniversary of Diaghilev's death. Madame Marcello* and others were there. He is probably the last person to have known Diaghilev well. As he told me, '*Dolin, oui, bien sûr, mais il n'était pas accepté dans la famille.*'†

He wasn't very well versed on the subject of Cecil. He remembered him as a figure '*très snob, très chic, bien habilé*', who had arrived here as I reminded him '*inconnu*'. He said it was the period of the Lido and of Biarritz. '*Il était le nouveau Oscar Wilde.*' He said there were three: '*Cecil Beaton, Noël Coward et Oliver Messel. Les années trente étaient le triomphe de ces trois et Noël Coward était le plus répandu, Messel le plus discret.*' He said, '*Après le mort de Diaghilev j'étais la vedette le plus connu de Cochran.*'‡ He danced at Covent Garden and all London loved him.

When Hitler met Mussolini in 1938, France invited the King and Queen. He was there to greet them at the Opéra de Paris. '*C'était l'époque de Lopez et Beistegui.*' He said, '*Cecil aimait des objets. C'était un monsieur très fin.*'§

He said that in the old days the Piazza San Marco was very smart – people in suits, ladies well dressed. Schiaparelli¶ reigned here, not Chanel. The Duke of Westminster's yacht would arrive. The balls at the Fenice were wonderful. He loved '*l'époque entre les deux guerres*'. Afterwards, having known love and adoration, he knew *hatred*. Jealousy in America, Freddie Ashton and so on.

He spoke of Iya Abdy** as a good source: '*une demi-reine parmi les reines*'.

* Countess Vendramin Marcello, who used to come over and see Valentina.
† 'Dolin, for sure, but he was not accepted in the family.'
‡ 'The thirties were the triumph for those three and Noël Coward was the most celebrated, Messel the most discreet . . . After Diaghilev's death, I was Cochran's most famous star.'
§ 'It was the era of Lopez and Beistegui. Cecil loved objects. He was a most sophisticated gentleman.'
¶ Elsa Schiaparelli (1890–1973), rival fashion designer to Chanel.
** Iya, Lady Abdy (1897–1993), Russian wife of Sir Robert Abdy Bt.

He said he had been due to fly to New York with Chanel in 1969 for *Coco* but suddenly she became '*paralysée*' in the hands. For two years she was like that, then all right (didn't she die then?). Anyway he said that was why she didn't go. It may be true. He also said that everyone regretted that *she* didn't do the clothes.

Basically his message was a sad one. He had once been the greatest star, but later it was no more. He loved the early days: '*Maintenant c'est tout changé – avec les politiciens et tout ça. Les autres années sont finis. Il faut pas les regrettés.*'*

I made the unwise but spectacular mistake of mentioning Dicky Buckle's book on Diaghilev. Did the Maestro like it? '*Il a fait un immense travail mais . . . il a raconté des mensonges . . . Vous savez pourquoi? . . . Parce qu'il a parlé avec mon ennemi, KOCHNO!*'† He said how could Buckle know what Diaghilev thought? How could he know what I thought? The thoughts that were in my head alone? He said: '*J'ai tremblé quand j'ai lu son livre. Maintenant je l'assassine . . . pas avec la main mais avec le verité!*'‡ He related how he had dealt with Dolin. He knew he was at a certain hotel and he sent up caviar and champagne with a note – it was something to the effect that the *real* Giselle (Lifar's triumph) greeted the *failed* Giselle. He ended his story by saying: '*Comme ça je l'ai sabré!*'§ It was most dramatically told.

He went on to decry the likes of [the ballerinas] Sokolova, Lopokova and Ninette de Valois. His version usually was that they had a certain ability to stand on their pointes, but they were not '*des grandes vedettrices*'. Funnily enough he really enjoyed all this. He thumped the table, his eyes widened, he gesticulated, he slapped my hand, he leant back, he looked heavenward. He was very convincing – but, oh, my, what jealousies! In due course he asked after English friends, many of whom are dead now – Randolph and Sarah Churchill and Michael Duff.

* 'Now everything is changed – with the politicians and all that. We must not mourn them.'
† 'He did a great deal of work but . . . he recounted lies . . . you know why? . . . Because he talked to my enemy, KOCHNO!'
‡ 'I shook when I read his book. Now I assassinate him . . . not with my hands but with the truth!'
§ 'That is how I slaughtered him!'

Serge Lifar said he would be eighty next year. He doesn't look it, certainly. He says people say to him, '*Est-ce que vous êtes le fils de Serge Lifar? Est-ce qu'il est encore vivant?*'* He enjoyed this very much.

Our meeting ended with me taking his photograph – just for fun. I then followed him in and Valentina came out of the lift with Mildred. He was in the process of telling her that we'd met.

He told me he'd really enjoyed our talk: '*Je revis ma jeunesse*,' he said. They spoke of me in Russian. '*Je vous fais des compliments*,' he said. Of Valentina he had said, '*Mais pourquoi est-ce qu'elle est comme ça?*' her form. He said, '*Elle était grande amie à Greta Garbo et maintenant elles ne parlent plus*.'†

I asked Mildred if Valentina would mind being photographed. 'No, she's used to that. Ask her.'

So I did and she agreed. '*Pas ici . . . c'est trop médiocre*,'‡ she said, pointing at the foliage. We raced down to the water's edge. She looked up rather grimly and I took three. 'Not too close,' she urged.

The story of my interviews is extraordinary: Valentina in the restaurant, Brandolini in his palazzo, Van der Kemp in the pool, Lifar in the garden.

And in England and elsewhere: Herbert in his garden, Diana in bed, Cecil in his library. Ina Claire on Nob Hill, Stephen Tennant in the darkness of his deserted house, the Queen Mother, drink in hand, Princess Alexandra at the ball, Cathleen Nesbitt in her dressing room, Louise Nevelson in her studio, the Duke of Sutherland in his Scottish mansion, Audrey Hepburn on the telephone in Rome, Truman Capote on his in Bridgehampton. Surely I can make something really worthwhile out of all this.

Dinner at the Cipriani on the last night.

We were called out to say goodbye to Valentina. She said, 'I shall cry.' She looked really sad and said to us, 'We have no glasses in our hands but let us raise the finest cognac to wish you Godspeed.'

* 'Are you Serge Lifar's son? Is he still alive?'
† 'I relive my youth . . . I am giving you compliments . . . But why is she like that? . . . She was Garbo's great friend and now they no longer speak.'
‡ 'Not here. It's too mediocre.'

It was a summer of travel. I stayed with Paul-Louis Weiller at Villa La Reine Jeanne in the South of France, I snatched some days along the coast, then met Clarissa in Milan. We drove to Athens and stayed in Patmos.

Patmos, Thursday, 22 September 1983

Bruce Chatwin was also staying with Teddy Millington-Drake.†*

He used to know Juliet Duff and Stephen Tennant. He'd seen a photo of Cecil and Stephen in bed with a French sailor. Stephen gave him a picture, which his father (DSO and bar) now has in his dressing room. He thinks there will be a Stephen revival one day. He said that Cecil once got some Tchelitchews and Indian Moghul pictures off Stephen and put them straight into Sotheby's. It was bad to make so much out of close friends. He got thousands for them. I must check this story. Bruce said that was the reason for the row between them.

Bruce chatted away about Diana and Noël Coward, doing a very good impersonation of Sir Noël saying, 'We shall never meet again as I shall shortly be dead. But always remember this, dear boy. Never let anything artistic stand in your way.'

When about to leave Patmos, I wandered around my room thinking about my book:

1. It is a path through a forest. Cecil led us one way. I am taking another route. Occasionally I may have to help the reader through some mud, but we'll come out in the same place on the other side.
2. Thinking of John Curtis. I have now swallowed the material. There was no point in going to the loo before it was digested. Nothing would happen. Now the time is right and I hope in a flourish to present something satisfying to both patient and doctor.
3. I shall do no more research, but if any source comes within my orbit, I will put my net out and scoop them in.

* Bruce Chatwin (1940–89), renowned travel writer and novelist.
† Teddy Millington-Drake (1932–94), English artist known for his watercolours. He had shared the Patmos house with John Stefanides.

4. The actual writing. I've got my horses into the paddock and the carriage is loaded with all the right goodies. I'm harnessing the horses and then, the last great effort, I must mount the pillion, discard the unwanted goodies, take the reins and direct the horses where *I* want them to go.

5. Hugh [Massingberd] said: 'Take your fences slowly. You're riding a winner. Pace yourself nicely and you'll come in to the applause of the multitude.'

6. In the past I've thought the biographer is like a man thrown into the sea. At first he all but drowns in the material. Then he treads water, then he swims. At the end he's on his water-skis, skidding happily over the waves, dipping his hand in for the pearls he wants.

What with these thoughts, and all those metaphors about childbirth, conception, delivery problems and post-natal gloom, it's a wretched business. I also thought of Cecil – he went up in the air so much. I must keep my feet *firmly* on the ground.

Clarissa and I then drove the long journey back from Athens to London.

Vitznau, Switzerland, Thursday, 6 October 1983

After dinner I rang Ali and, greatly to my surprise, I got him. We talked of Marjorie Oelrichs* and Cecil's experience. I said how sad that Peter Watson had got him back, but Ali said, 'I always think one's favours should be equally distributed to both sexes, according to takers.' (Significant.)

Murten, Switzerland, Friday, 7 October 1983

Ali met us at Murten for lunch.

It was funny to see Ali on Swiss soil. Clarissa thought him much easier to talk to, less competitive . . .

* Marjorie Oelrichs (1908–37) was one of Cecil's first girlfriends. She and Adele Astaire chose to initiate him in New York in December 1929. She later married the bandleader Eddy Duchin.

He had been reviewing a book about Princess Marie Bonaparte (Princess George of Greece) and her complicated gynaecological operations.

Ali told us that there was someone (a German) [in the First World War] saying they had a list of fifty thousand lesbians and they could blackmail them. Lord Albemarle went into White's one day and said, 'Who's this Greek fellow Clitoris that everyone's talking about?'

Back in England I finally managed to see Ashcombe. On the way down I called in on Eileen and told her how the book was going.

Broadchalke, Friday, 4 November 1983

I explained the exaggerated view that the rise of Cecil drove his father into being an old geezer in a chair, his mother into a kind of nervous wreck, his sisters into two little monsters slapping powder on their faces in taxis and Reggie to step under a train. It was strange, the break-up of that family.

I had longed to see Ashcombe, the mysterious house in the valley near Tollard Royal, which Cecil had leased between 1930 and 1945. In the summer of 1981 I had managed to locate Ashcombe with some difficulty and had looked down into that romantic valley. I knew that the present owner, Hugh Borley, hated anything to do with Cecil, but in September 1982, I wrote him a polite letter, asking if I could see the house once, and promising to be vague as to where it was. It was hard enough to find, even when you knew where it was. He left a rude message on my answer machine: 'The answer is, I'm sorry, NO!!!'*

Then Jonathan Dawson, a kind Australian, working as a journalist, and seemingly with contacts across the globe, came to my rescue, arranging that I should stay with his friends, Richard and Michele Harding, at Knighton, near Canford Magna in Dorset. I had never met them, but Richard kindly agreed to take me to see the house, risking the wrath of the owner. Mr Borley would not have been pleased at a Cecil Beaton person visiting in this way.

* Hugh Borley (1909-93), son of R.W. Borley of Shaftesbury. They owned Ashcombe, leased it to Cecil in 1930 and threw him out in 1945, something he never got over. In the Second World War, Hugh Borley shared digs with Kenneth Horne (1907-69), the radio presenter and comedian.

Ashcombe, Saturday, 5 November 1983

Suddenly I had become Richard Reynolds because if you are invent-ing a name you don't choose the same one as your friend. So Richard Harding and Richard Reynolds set off together. He has the neigh-bouring farm of Bridmore. We arrived at the brow of the hill, having driven through Sandroyd School – the Pitt-Rivers estate – and join-ing at length the road up which I'd come from Berwick St John. To turn in and go down that forbidden drive was an experience in itself. 'Private' signs abounded. Down we went endlessly, and at length we reached the arch of the studio. We parked and went through a gate – 'Beware of the dog' – where three barking yellow Labradors leapt up about us.

Ashcombe nestled at the end of the lawn and suddenly I could see the proportions and juxtaposition of the buildings. The lawn was a vivid green and the front door stood open. Richard called in but no voice answered. I wondered if there would be some unforeseen drama – that our mission would change as my mission in New York changed when I went to see Valentina. Would we find Mr Borley dead on the stairs, or in need of help? But, no. For we went round the house to the front garden, then down past the walled garden and found Mr Borley working on the far-off path in what is perhaps his kitchen garden.

Hugh Borley could be a sort of naval commander. He had that kind of face. He is a short, bone-hard man, reasonably stout, well-shaven and clean, in trousers, jacket, tie and waistcoat of wool. The knot of his red spotted tie was a bit grubby, but otherwise he was rather neat and had a smart gold chain leading from buttonhole to breast pocket. His shoes (brown) were a bit worn at the toe. His fingernails were un-cared-for, he was missing a tooth at the front (lower jaw). He has a big Duke of Wellington hooked nose. He'd look splendid in a cocked hat. He shook hands in a perfectly friendly way and we walked to the front of the house. I was sent off to get a bag of potatoes, and by the time I got back, he was in a good mood and invited us into the house. So I crossed the portals for surely the only time ever, saw the staircase leading upwards, was immediately impressed by the 'Manor House' finish to everything. It's a much grander little house than I'd imagined, and I was

impressed by the furniture and ornaments he had, which were of a high standard.

We took a little corridor to the left of the stairs and went along to the sitting room, a room that Richard hadn't seen for ages. It was clean and tidy. Mr Borley opened a bottle of white wine and gave of it generously. He asked me if it was my first visit to these parts. 'More or less,' I said. He told me he had nearly a thousand acres. The house has a magnificent view down the valley, winding its way to Tollard Royal, and above it, for there is lovely countryside, curling round and leading to Win Green. He obviously loves this view as he threw open the windows and we stepped out onto the steps and talked there for a while. He is fastidious in his interest in tax matters. He has a scrap-book in which articles on VAT are glued. He is keen on the lie of the land and the changing seasons. His roses were still blooming in November. He asked about people in the area, mainly to do with the estate, its foremen, shepherds and workers.

Luckily he didn't speak much to me, and I remained shy but polite and interested. He refilled our glasses, smoked his pipe and chatted on. Then he led us round the house and came to the car to see us off. As we drove away, I felt and still feel the magic of the place. It is a little gem lost in those hills and woods. He loves it very much and he protects it. Mr Borley said, 'Very nice to have met you,' to me as we shook hands – a far cry from his ferocious words on my answering machine just over a year ago: 'I'm sorry . . . *NO!*'

He hates the idea of Cecil Beaton for two reasons: first, the parting, which was acrimonious, and second, because of 'the notoriety' he brought the place. He likes his privacy and he likes his shooting. Having people around upset his birds and that was a bore. Also I'm sure Cecil did behave tiresomely with all those parties and 'strange' goings-on.

Richard Harding has only been upstairs once. Mr Borley sleeps in blankets that should have been chucked out years ago. He shaves in the bath with a huge mirror in front of him. He hates women because he thinks that the moment his back is turned they run their fingers along the surfaces for dust. He complains after people have been, but if he has the capacity for enjoyment, he basically welcomes a visit.

People have written asking many times to buy it, for huge sums, but it's his for life.

An extraordinary adventure.

London, Thursday, 24 November 1983

I made my way to Overtons, invited by Anne Rosse. This was great fun. Anita Leslie* was bounding along the street destined for the same lunch.

Anne has suddenly become my great friend. She now says she wishes that I were doing the Oliver Messel book instead of Charles Castle. She talks of the Loelia world as 'the smart set' of which she was never part. She was, I suppose, always in on royal things – at least after the marriage of Tony to Princess Margaret. She refers to a lot of *his* work as 'cruel' – i.e. the film of Cecil and the photo of 100-year-old Viscountess de Vesci. She obviously loves gossip but doesn't want me to think so. She tells stories and then says, 'I'm not being spiky. I've had such a happy and fulfilled life.' She had one about Loelia and Zita Jungman at that 1926 costume ball. They couldn't afford costumes so they had to borrow from the Baroness d'Erlanger – she lent them slaves costumes. They were, as I can vouch, absolutely furious.

Sir Harold [Acton] was splendid. He remembered me as the person who had allowed Doglet to lick my face. I asked him if he knew that Cecil's grandfathers were respectively a blacksmith and a chemist. He said, 'Well, a chemist would be most appropriate – a little bit of photography, a little bit of art and a little bit of writing all mixed up in his test-tube.' Is there any stopping them? Sir Harold even said in front of Anne, 'He drew the most dreadful caricatures of Anne, which Michael Tree now has.' She just smiled and I couldn't tell whether or not she had taken it in. Michael Tree thinks she doesn't know.

London, Wednesday, 14 December 1983

Dame Julie Andrews (b. 1935) was a hugely important source as she had been the first Eliza Doolittle in My Fair Lady *in both New York and London. I had managed to secure a telephone interview with her because she had been in touch with Eileen about some photographs. She kindly agreed to help me.*

* Anita Leslie (1914-85), Irish-born author and cousin of Winston Churchill.

It was planned that she was going to ring that evening. So I prepared every-thing, set the tape up and some paper to make notes on. I was acutely aware that I needed to go out soon afterwards. I waited a while. No call. I needed to wash my hair so I left the telephone where I could hear it and dashed to have a quick bath. Needless to say the telephone rang while I was in the bath. I leapt out and rushed to answer it. There was Julie Andrews calling from Switzerland. And there was I, initially naked, sitting on the floor in a pool of water, shaving cream all over my face, conducting the interview.

Julie Andrews was in Gstaad. She said most interestingly that she only really appreciated Cecil's quality now. I feel she realised that he didn't really like her. I thought she was extremely friendly and easy to talk to, quite effervescent and bubbly, very concise, very cheerful, a nice person. The difference between talking to her and talking to Audrey Hepburn was that I felt this one was sitting bolt upright or even standing, while Audrey would have been lying with her feet up. Julie Andrews was more factual and precise, Audrey Hepburn more dreamy.

This is what Julie Andrews said, talking mainly about My Fair Lady *in 1956 and 1958.*

He and Oliver Smith made an enormous collaborative effort, wander-ing around together. I was so pleased that the two of them were coor-dinating so much with each other. It wasn't as if one or other of them was being the star about it.

The general projected look of the show they both worked on as a team – as much as Cecil made the most enormous personal contribu-tion. It showed in the final result.

There was a photo session in England, at Covent Garden, outside the church.

At the second photo session, I was quite nervous of him. This eminent gentleman who always looked so very stylish, and I felt, in those days, particularly, terribly gamine and green and absolutely not sure of who I was at all, and he kept saying, as he was photographing me, 'Lovely – oh! Beautiful – wonderful – yes, yes.' Then, eventually he ended up by saying, 'Of course you do have the most unphoto-genic face I've ever seen.' I suddenly went down like a pricked balloon.

The fittings for My Fair Lady *clothes were evidently meticulous.*

It was so hot in the Helene Pons studio, on the seventeenth floor, unbelievably hot. I felt faint. Cecil was fuming: 'Oh, somebody, please get her a glass of water. Do something with her.'

I used to take a delight in being rather Cockney with him.

The clothes were heavy, once in place, beautifully placed, superbly made.

Moss Hart* and Alan Jay Lerner wanted to show the [ballroom] dress all by itself. The wonderful entrance down the staircase in the study was devised so that there was a gasp from the audience when she came on – rather than there being an 'Oh, there she is' attitude. The look of Eliza should stand. It used to get a gasp on most evenings. It was a very special moment.

The hats were always a problem as they were very wide compared to the proportions of doors. One was always going in slightly sideways because of the wonderful big hats.

I got to know him and understand him very much more as the years went by. I found him kind at the first meeting, quite a task master in terms of what he wanted and so on during the early *My Fair Lady* days, so it wasn't until . . . much later that I got on terms with him. I can't say that we were the closest of friends because I really didn't know him enough, but when we got to know each other for the London opening of *My Fair Lady*, things were so much easier by then and I was so much surer of myself. I could sense that there was quite a sweet man there.

We had opened in New Haven. It had been snowing. The show had run for about four hours. Rex Harrison was pretty much a basket-case of nerves as were we all. Both the revolving stages broke down. There was a tremendous snowstorm, people were trying to come up from New York to see it and they managed it nevertheless. But the show ran for ever, everything went wrong that could possibly go wrong and at that point in the show, I was wearing wigs which bothered me terribly as I felt very claustrophobic in them. I felt very constricted. There was a little tiny saucer-shaped hat,

* Moss Hart (1904-61), playwright and director, whose stage version of *My Fair Lady* was his biggest hit.

literally curved. It was the yellow costume I wore for the 'On the Street Where You Live' scene – for 'Show Me' – the little yellow suit, and I had this little boat-shaped hat and there was no way to tell which was up and which was down because it had a bow right in the middle of it. In the dressing room afterwards I had apparently done a heroic effort pulling everyone together, being the trouper of all time. I was sitting, absolutely dazed, and wondered what had hit me at the end of the performance. There wasn't a soul around and suddenly my door burst open. Mr Beaton came in, grabbed the hat in question, shoved it on my head and said, 'Not that way round – this way round!' I nearly burst into tears because it was the first thing anyone said after this mammoth evening and he was very upset. I needed someone to say, 'Well done' not 'How could you get that wrong?' I finally marked it.

The clothes were superb. There are clothes that hold up well and clothes that don't. There wasn't a time that I recall that any of the dresses were a problem. For instance, in *Camelot*, we had tremendous long trains with constant cleaning – the things would shrink. [In *My Fair Lady*] the hems didn't rise up and fabrics did hold.

Everything came together at the right time. A combination of a book and lyrics and music and performance, all the other talents as well. You usually find an emphasis on one or the other, but not all at once.

Julie Andrews was in My Fair Lady *for three and a half years.*

Cambridge, Friday, 16 December 1983

George Rylands* occupies his famous 'Room of One's Own' - the room that Virginia Woolf wrote about.† There, too, were the panelled doors painted one day by Carrington.‡ He was very welcoming, took me to the window overlooking the college green and we sat there

* George ('Dadie') Rylands (1902–99), fellow of King's College, Cambridge 1927–99, scholar and theatrical director.
† Virginia Woolf (1882–1941) based her extended essay (September 1929) around this room.
‡ Dora Carrington (1893–1932), decorative artist in the Bloomsbury Group.

together talking first about my father and the office, then about Cecil. He is a very alert and sprightly eighty-one-year-old. He likes to talk about himself a lot – the conversation brings itself round to him sooner or later. He is, nevertheless, very helpful and most constructive.

He told me, 'In his case and certainly in my own case, Oxford would have been very bad. Worse for Cecil. He would have gone down the Evelyn Waugh drain. They drank champagne at eleven in the morning while we drank beer or possibly red Burgundy at night. We lived in a rather priggish, poverty-stricken way. He was as clever as a monkey. And one of those people whom success makes better.'

London, Friday, 30 December 1983

Ginette Spanier had some friends for drinks – Laura, Emlyn Williams, Lady Charles, Tarquin Olivier and Jane Birkin.†*

I made for the seat next to Jane Birkin and thus we were able to have a long talk. She is delightful, quite unaffected, with dreamy erotic eyes. She has short hair now, which flops about as she turns her head. She runs her fingers through it a lot – she is very much with one when talking. I was tremendously impressed with her. I can't believe that she's thirty-seven and that she has a daughter of sixteen. She was wearing a green velvetine top, no bra under it – once she brought out her shoulder in a most entrancing way – pale beige yellow corduroy trousers and fur snow boots. Her ears are not pierced and she blushes easily. Her arms are slender but she has large hands, unmanicured.

She was photographed by Cecil at a Rothschild Proust ball. She went with Serge Gainsbourg, in an old Rolls, which was freezing and rattled about so much that all her pins came out. Only the chauffeur had heating. The car wasn't even seen because they were parked far from the house. 'Oh, yes, I'll remember that evening for a long time,' she said . . .

* The Hon. Tarquin Olivier (b. 1936), son of Laurence Olivier and Jill Esmond; author of a generous book about his father.
† Jane Birkin (b. 1946), actress and singer, in a relationship with Serge Gainsbourg (1928–91), producing the BBC banned hit song, 'Je t'aime, moi non plus' in 1969.

She told me that she was recently filming in Marrakesh and Snowdon was on the set.* Well, like Cecil, he wasn't allowed on the set. All the stars longed to be photographed by him and to get into the *Sunday Times* colour supplement. Like Cecil at the Proust ball, he had a little studio set up – Bette Davis† could be seen eyeing him. She said, 'It's true. These photographers upset the filming with their plans. See you in fifteen minutes.' Snowdon hoped to get the sack so that he'd be paid the full salary. The director of the film, John Guillermin,‡ kept saying to her: 'Trust you, fucking Jane, to want your fucking photo taken by fucking Snowdon and be in the fucking magazine.' She said she was quite used to that sort of language after a while. Now she's going to play a forty-year-old virgin in a new film.

We talked about what scandal I should put in my book. She pointed out wisely that I am, after all, making the selection and can present Cecil as I like. I should be careful not to upset people too much.

* This has to have been *Death on the Nile* (1978), filmed in Egypt, as it was directed by John Guillermin, and Bette Davis was in it. And Snowdon certainly photographed it. Perhaps I misheard her about Marrakesh, or maybe some scenes were filmed there.

† Bette Davis (1908–89), American film star, perhaps best known for *All About Eve*, and *Whatever Happened to Baby Jane.*

‡ John Guillermin (1925–2015), British film director, known for shouting at the cast and the crew.

1984

During these days I often read passages of my as yet unfinished book to Diana, while the writing continued in earnest. She would be lying in bed with Doggie at her side, in her upstairs bedroom at Warwick Avenue. I read and she commented. I also showed my text to Caroline Blackwood, who said, predictably, 'You really hate him. You don't know that you hate him, but you do.'

Send, Tuesday, 3 January 1984

Loelia on Doris Castlerosse: 'She was really very nice, you know.' Mrs Hoffmann,* very rich, gave Doris more presents than any of her rich men. They got together at the time of the Coronation, 1937. Every jewel she gave her was the size of cherries. 'You only had to look at her to know what was going on.'

Broadchalke, Thursday, 26 January 1984

I went to see Eileen, handing back a lot of original papers that I no longer needed.

* Margot Flick Hoffmann (1905-76), an heiress, played polo with the polo team, the Pittsfield Four, was an expert fisherwoman, the owner of the Knollton Kennels (exhibiting her wire-haired terriers), and piloted her own plane. In 1935 the family butler sued her mother when he was dismissed for entering Margot's bedroom. He cited Margot kissing Mrs Louis Shaw of Boston. She married, 1936, Richard Sanford Hoffmann (1901-39). In December 1937 she was granted a Reno divorce on grounds of his extreme cruelty. He was found dead of 'accidental asphyxiation' in his uncle's garage in November 1939. She evidently took up with Doris Castlerosse before the divorce, and presently installed her in the Palazzo Venier dei Leone in Venice. Her later years were spent at the Villa Primavera in Florence. She is buried in the famous Cimitero degli Allore.

Eileen was in good spirits and we had a few moments before the arrival of Rosemary Olivier, Edith Olivier's niece [and a distant cousin of Laurence Olivier], who had come to answer questions, and also brought along the Daye House visitors' books.

Rosemary Olivier is eighty. She was born in 1903. I hadn't seen her since 1975 when Estelle Harvey took me over to the Daye House, an introduction to the world in which I now dwell. The purpose of my mission was to check one or two nagging points. Did Cecil re-enter the ballroom at Wilton and dance with squelching shoes? Rosemary did not remember that. I wonder if it really happened, or if in fact he fled back to the Daye House. I must now ask David Herbert. She told me how Edith influenced Cecil and confirmed I was right on most points. She had second sight. She did write at night, and from her notes she gathered some sense.

We talked a lot of Stephen. Rosemary knew he'd been put away during the war. One night he escaped and arrived at the Daye House. The next day they took him back. She always felt rather embarrassed when meeting him at Flowerland . . .

When I left, I drove back past Wilsford Manor. It looked remote. The light was on in Stephen's room, glowing pink in the dark, wet night. I had had a spate of letters from him, but he had gone quiet again.

London, Friday, 27 January 1984

I went on to see Stephen Spender,* who was very helpful over Peter Watson. He said that Peter was a difficult character. He never had an affair with him, but wished he had. He said that Peter hated people who knew more about art than he did. He was self-taught. Later he became a bit seedy, lived modestly with young ICA people.

He suffered a lot from Denham Fouts. Sir Stephen said, 'He was the sort of youth who dyed his pubic hair golden and lay on the beach.' As for Norman Fowler, he as good as killed Peter Watson because they had these debilitating rows the whole time. He was gentle and friendly, rather a fluffy white figure, in an open shirt. Lady

* Sir Stephen Spender (1909–95), poet and author.

Spender ignored me completely.

London, Monday, 30 January 1984

Kakoo, Duchess of Rutland, celebrated her ninetieth birthday with a family*
party at her home in Wilton Street. I was lucky to be included.

Kakoo looked rather pretty at ninety, sitting in a chair with her stole
– she's very gentle and nice and friendly.

With all those members of the family around, including two aunts of
the nonagenarian, Kay Elliot of Harwood and Peggy Wakehurst[†] (both
younger than she), it was nothing short of a relief when another non-
relation walked in, in the shape of Princess Alice, Duchess of Gloucester,[‡]
very pretty and bright-eyed in a deep raspberry pink cocktail dress. The
room fell silent as it does for royalty. She kissed Kakoo and others she
knew. There was much bobbing and bowing. Princess Alice went round
shaking all hands. She looked at me, wondering which of the family I
could be, shook hands, then passed on. Nobody thereafter took much
notice of her. She sat beside the Duke of Rutland for a time.

A conversation had just died and, with a huge smile and a little
bow, I bounded up. She was terribly nice. I told her that I had
reviewed her book in *The Times* and how much I had liked it. She
said, 'Afterwards I wanted to change so much. There were things I
wished I hadn't put in and things I was sorry to have left out. It's so
difficult because funny stories are so often at the expense of someone
and I had to think of the sons.'

This confirmed to me that she was quite mischievous. She said she
had got letters from all over the world – from the barber who remem-
bered cutting her son's hair on the way out to Australia. I said that
that was the good thing about books. Once created, they went out

[*] Kathleen, Duchess of Rutland (1894–1989), born a Tennant. She was one of the
duchesses to carry the canopy over Queen Elizabeth at the 1937 Coronation; she
was Laura's aunt.
[†] Baroness Elliot of Harwood (1903–94), and Dame Margaret Wakehurst
(1899–1994), both daughters of Sir Charles Tennant by his second marriage.
[‡] HRH Princess Alice, Duchess of Gloucester (1901–2004), widow of the Queen's
uncle, Prince Henry, Duke of Gloucester. Cecil had photographed her before her
wedding in 1935 and a few times later.

into the world and into so many homes. I think she had had a bad time with her editors.

I told her that I was writing about Cecil Beaton and that it was very hard to know what to leave out of all his diaries. She said, 'He once came to photograph us at Barnwell and my horrid sons were posed by a wall. Just as he had them in position, one of them let off a pistol with a loud bang and he jumped in the air.' I can just see him doing it. I reminded her that he had drawn her and photographed her before her marriage, but she didn't respond to that. I can't see why Cecil didn't like her. She had lovely shiny blue eyes and wasn't nearly as lined as photos in papers make her appear. Nor was she at all nervous in these surroundings, with people pushing and shoving and all the Mannerses making a lot of din. I thought she was sweet. Presently she said to me, 'I must go home before my voice gives way completely . . .'

Me with Princess Alice, Duchess of Gloucester

Then she gave me her glass and said she was just going to say hallo to 'Lady Diana'. I wished I'd had the chance to forewarn Diana who it was but, alas – and the meeting passed over Diana's head.

I made a quick visit to New York to help celebrate Dorothy Safian's birthday. I flew out on Tuesday, 7 February. This was also a chance to catch up with Diana Vreeland, Eleanor Lambert and Valentina.

New York, Friday, 10 February 1984

I went to Diana's where the door was opened by Stephen Jamail, her secretary. He was in jeans and a pullover (red) and seemed to have balded considerably since I first saw him. He is an AIDS sufferer.

Diana herself looked marvellous with jet-black hair and jet-black trouser suit. She wore long golden earrings with red tassels. Also in the room was Robert Fraser,* who looked like a City gent from England but was clearly rather different from that. He went to prison on behalf of the Rolling Stones. Diana said, 'I don't quite know why – but for devotion for their talents.' He looked a bit washed-out but was quite friendly. In due course Diana and I were left alone and we dined in the corner of the room – the room she called 'a garden in Hell'.

She asked a lot of questions about Cecil and I went through much of his life. Her painting was done in 1930 when they were in London. She went to Ashcombe several times – Dr Wolfe was very famous in New York evidently - and she had a memorable quote about Cecil and Doris Castlerosse, another of whose lovers was Alfred Beit:† 'Beaton by Beaton and bitten by Beit' – that was the slogan. She told me that Marjorie Oelrichs shouldn't have died: it was an infection that she caught because the doctor was careless. He never practised again. Marie Harriman‡ telegraphed her and when she came off a boat she was being called: 'Mrs Vreeland . . . Mrs Vreeland.' She knew she was in trouble – she confirmed that Marjorie was a wise girl. She agreed that Tchelitchew was a bad influence on a lot of people, while Bérard gave her a lot of the taste she has today. She asked a lot about whether or not I thought Cecil was 'fulfilled' or not. I don't. He was forever struggling.

* Robert Fraser (1937-86), art dealer in the Swinging Sixties, sometimes known as 'Groovy Bob'. He was sentenced to six months of hard labour for possession of heroin following the raid on Redlands, the home of Keith Richards. Mick Jagger and Richards were acquitted.
† Sir Alfred Beit Bt (1903-94), from a South African mining family, a philanthropist and art collector, memorably tied up in an art raid in 1974, with his wife, at Russborough, his home in County Wicklow, by Rose Dugdale and the IRA.
‡ Marie Harriman (1903-70), married to Averell Harriman from 1930. She brought Peter Duchin up after the death of his mother, Marjorie Oelrichs.

Diana said that she could hardly see any more. She has become very blind. She said, 'I'm doing the Lydig show and I can't see. I did the whole St Laurent show without seeing. I've written a book and I can't read. I can't see whether my clothes are right or not.' I wouldn't have known but I don't think she'd make that up. Under the circumstances she's even more of a survivor than one might imagine.

We had a long talk about Valentina and she's not as impressed with her as I am. She said that Georges Schlee wasn't good enough for her. 'His breath smelt.' She didn't care for the story about Valentina kissing the dress because she had created it. 'I'm fed up with all that homosexual rubbish,' she said. 'I've heard too much of it in my life. You kiss a dress because you've created it. You kiss your children because you've created them.'

Diana is remarkable the way she holds her grip on everything. I hope that she will approve of my efforts on behalf of her old friend, Cecil.

The next day Cecil's overcoat, which I had with me, was exactly twenty years old. As Diana said, 'And it'll last another twenty years.'

New York, Saturday, 11 February 1984

Eleanor Lambert (1903–2003) was a celebrated publicist for the fashion industry. She is cited as having made New York the fashion capital of the world. She founded New York Fashion Week, the Council of Fashion Designers of America, the Met Gala, and she regularly issued the International Best Dressed List.

Eleanor Lambert was tremendously nice and friendly, and we had a wonderful tea together in which she told me a lot about the Jewish row.

I'm sure she's tough, but she seemed very friendly and easy to talk to. She told me that Cecil had told her that Kommer used the word 'kike' to denote 'vulgar person' or so she believed. She thought the dreadful Dr Agha* was the one who exposed Cecil. Certainly Dr A always seemed to hate him. We then talked a lot about the tangled

* Dr Mehemed Agha (1896-1978), art director at *Vogue*, 1929-43.

web of Garbo, Valentina and Schlee. 'Not very chic of him [Cecil] to publish all that,' said Mrs Lambert. Then she told me she knew Garbo through Gayelord Hauser.* They thought she should try some new clothes and so took her to Valentina's little shop in the Sherry-Netherland. Schlee met her that day and was surprised that she was quite naked. Mrs L said sometimes she was naked to try on a pair of gloves. They dined with the Berksons (Mrs L's husband's name) and once Valentina and Garbo appeared dressed identically in blue satin – she said her husband didn't care for Garbo because he thought her 'dubious' in the sexual sense. She doesn't believe there was a Garbo–Valentina link-up. She said that Schlee must have got Garbo in the early forties. Then he wanted Garbo to travel with him and so closed down Valentina's business. She lost three things – husband, friend and business. There was a dinner before that when Garbo said she'd heard that Hitler loved her films – she was sure he would receive her and wondered if she should not go 'and do a kamikaze thing on him' – a good dinner party line, I guess.

Anyway it was interesting that Schlee closed the business down so early – that Garbo really did mind when he died: she met Mrs L in the street and they hugged each other and tears came down her cheeks. The reverse happened after Garbo saw Mrs L when her husband had just died. She said, 'I've been thinking of you recently.' She said that Valentina couldn't continue her business without the help of Schlee – she wanted to do things for 7th Avenue, but that wasn't possible: 'They'd have exploded.'

That morning Miss Strano had left a message that Valentina had a cold and that they could not take me out to dinner. 'However, Ms Schlee and I are anxiously awaiting you for cocktails.'

I then took a taxi to see Valentina herself. It was raining, and as I approached the last section of East 52nd Street I saw in a doorway a woman who had to be Garbo – now I'm less sure, having looked at photos – but it was her way of standing: she had a black stick that she

* Gayelord Hauser (1895-1984), promoter of nutritional foods, followed by many famous people, a close friend of Garbo and author of *Look Younger, Live Longer* (bestselling non-fiction for two years).

did not need, white woollen hat and scarf, rather a big face and narrow bored eyes. She waited under an awning and then she pressed on without aim, though there was no change in the weather. I wanted to ask the doorman but thought he'd think me too curious. So I said nothing. I went up in the lift to floor fourteen – they take you up because you must go to the floor where you said you'd go. Miss Strano came to the door – her hair had gone whiter, which looked much better, I thought.

She was just saying hallo when Valentina leapt out from behind a door, like a child playing a trick, and said, 'Here you are!' and greeted me. She was wearing a pale purple velvet costume dressing-gown over very little, and had a pale green chiffon scarf tied round her head. She looked dramatic and rather good.

We went into the wonderful long room – the one where I was before – at the East River and there was a big round curved sofa, so huge that it had come in through the window on a crane. Here we sat awhile, while Miss Strano produced plates of delicious little things to eat.

Valentina took me on a tour of the house, which was fascinating. She showed me Schlee's study, left exactly as it was before he died, with his blotter and his books and photographs, portraits of her but nothing obviously of Garbo. She showed me various nice works of art of the twenties, portraits and drawings, and she showed me the dining room right at the other side. She has the entire floor with views all along the East River, and looking both uptown and downtown. There was also at least one window looking west. Garbo's apartment is said to be identical. I like the traffic that goes under the window in a silent, distant stream, but I couldn't quite go along with her description of it as 'like the Canale Grande' – the best you ever get in New York is a view of the East River, with a Pepsi Cola sign opposite. In the dining room, a picture of a Venetian vase painted by Valentina.

Before I left she also showed me her bedroom, which was palatial. The bed head was the top half of a seventeenth-century Venetian mirror, with grey brocade under the gilding. It was a huge bed. She showed me the chair where Cecil sat as he watched her fold up the little dress into its tiny box. She had some royal pictures here and there – the Dorchester magazine about the royal wedding and so on. There were photos of her with Noël Coward and Rex Harrison (who lives on the floor immediately above). In the study there was

one of her with the Duchess of Windsor and the duke, taken proba-
bly in the late sixties or very early seventies.

On Schlee's desk was Prince Rainier's Christmas card, which had a
bust of Princess Grace in the background. She said she was going there
just as the news of the princess's death came over the radio. She said,
'But look! He's suddenly become an old man.' The photo proved to
both of us the great beauty of Princess Stephanie. Valentina showed me
an album of the house at Cap d'Ail. She didn't believe that Anna
Anderson* (who died within the week) was the real Grand Duchess
Anastasia. She told me that when she was born, she saw blood and knew
that there would be suffering – the Revolution. She talked with great
affection of her husband and, unless one knew otherwise, one would
never suspect there was anything that ever went wrong. He used to leave
her little notes and she was going to show them to me the next day.

We sat in the drawing room in dim splendour. With great cere-
mony I was given a vodka. Valentina took a neat gin. Poor Miss
Strano sat with us, stifling a bad cold. We had an enjoyable conversa-
tion for about two hours – the only times it went off-key were when
religion came up. At one point Valentina said, 'Isn't it nice to have
our pet here?' I thought it all a long cry from the first time I went
there – all those letters I dropped in and the no replies and then the
business of the theft. She invited me to come the next afternoon on
my way to the airport.

As I left, she showed me a little doll: 'I dressed him. Before he was
naked, obscene. Now, look at him.'

Jimmy, the Chinese lift boy, asked how I knew Valentina. I said it
was through Venice really. He seemed pleased that she had had a nice
visit.

New York, Sunday, 12 February 1984

Valentina herself rang at nine twenty to apologise for cancelling lunch
because 'the poor Strano' was ill.

Sadly I never saw Valentina again. She died in 1989.

* Anna Anderson (1896–1984), for many years a contender to be Grand Duchess
Anastasia, but effectively discredited.

London, Tuesday, 28 February 1984

Gillon had been reading the first half of Cecil Beaton. Thank goodness he liked it a lot. He said that Cecil emerged as a monster, though gradually he got better. He said, 'Hugo, you must at times have been tempted to gild?' But no – alas, I was not thus tempted. I just felt that I should tell the truth. He thought that anyone emotionally involved with Cecil would find it hard to take.

London, Tuesday, 20 March 1984

Diana invited me to escort her to the concert in aid of Glyndebourne at St James's Palace.

The Queen Mother was the guest of honour in pale turquoise and pearls the size of eggs. The various speakers referred also to a royal highness - this proved to be 'Peg Hesse' (the former Margaret Geddes, whom a lot of them knew as an old friend. She was rather stout and be-spectacled. I thought I was quite good on my royal highnesses, but she had eluded me).*

We had some sherries and Helen Dashwood† rather clung to us for some reason. Sir Peter Pears,‡ now very old after his stroke, introduced the concert, which Diana did not enjoy. We were rather badly placed as the Thorpes took seats that were being kept for us. Diana kissed Jeremy Thorpe,§ greeting him as an old friend.

After the concert the Queen Mother went along the line of concert-goers and came face to face with Marion Thorpe, who curtsied and was then kissed (as a former member of the family). Then while the Queen Mother was talking to her, she noticed the hovering

* HRH Princess Margaret of Hesse (1913-97), who owned Wolfsgarten, near Darmstadt, and whom I met later when researching the biography of Princess Andrew of Greece.

† Helen, Lady Dashwood (1899-1989), widow of Sir John Dashwood, of West Wycombe Park.

‡ Sir Peter Pears (1910-86), English tenor, and partner of Benjamin Britten.

§ Jeremy Thorpe (1929-2014), former leader of the Liberal Party, had married the former Countess of Harewood as his second wife in 1973. In 1979 he was acquitted at the Old Bailey of a charge of conspiracy to murder his former boyfriend, wisely accepting the advice of his counsel not to go into the witness box.

Jeremy reached out a distant hand and said, 'Hallo.' It was brilliant, neither friendly nor unfriendly. It invited no intimacy whatsoever. He slunk back again. I was interested in this encounter.

Afterwards Helen Dashwood literally clung to the arm that wasn't supporting Diana. It must have been a strange sight. Diana then broke away and made a bee-line for the Queen Mother, who greeted her with open arms. She didn't seem to take much notice of Helen, but said again to me how 'naughty' Cecil was. She always says that. She looked wonderfully well and fit and was clearly enjoying herself. The rest of us were simply relieved that the appeal man's interminable speech was at last over.

The Queen Mother made her stately exit through the private apartments.

London, Wednesday, 28 March 1984

The Queen Mother was attending a service to dedicate a memorial stone to Noël Coward in Westminster Abbey. I went along with Diana and Artemis Cooper, and Ali Forbes.

Presently we set off in an enormous hired limo (a Mercedes). The chauffeur must have been surprised at the conversation, Ali booming at the top of his voice, Diana reciting lines of poetry, me gossiping.

We reached the Abbey and there was a huge crowd of press and public, arc-lights and TV cameras. A beadle escorted Diana and we followed in her step. Ali again said, 'I always knew you were a media man and not a man of the pen.' Diana was handed over to a steward, who took her arm and we followed her into the Choir. The congregation were all able to recognise her and there was a lot of nudging going on. In the Choir we had terrific seats right next to the orchestra. Loelia was behind and Ali sat next to her. John Julius was already seated – Maureen Dufferin was expected and Margaret Argyll. It was very funny because Loelia, Maureen and Margaret all hate one another. Opposite sat Princess Olga (Princess Paul of Yugoslavia)* – and

* HRH Princess Olga (1903–97), sister of Princess Marina, and widow of Prince Paul of Yugoslavia. Cecil took a memorable series of portrait photos of her at Buckingham Palace in 1939.

next to her a large woman called Nesta Obermer,* who is evidently ninety-one. I spotted Sheridan Morley in a stall. Opposite me, a little nearer the altar, were the old stagers who were to lay flowers, Joyce Carey, Evelyn Laye, Dame Anna Neagle and Sir John Mills. Ginette was seated near the Queen Mother's throne.

Ali pointed out the boyfriend of Graham Payn, a sort of Swiss merchant-banker type with moustache and velvet collar. I could also spot Jeremy Sinden ('Boy Mulcaster' of *Brideshead*). In fact all the stage was there in force, especially the best of the old.

Presently Graham Payn, with his new Kabuki dancer nose, all white, having been drained of its purple veins, was escorted up the aisle. The white nose showed up strongly in the TV lights. In the order of service, he was described as 'Trustee of the Noël Coward Estate'. Ali and I now think that 'Trustee' would make a splendid euphemism for the heir in such circumstances.

The dean escorted the Queen Mother, in purple velvet and dripping with diamonds. She looked splendid, tremendously well and very fit (Ali said later she'd had a win at Kempton Park the day before – but I think she must be on some amazing elixir).

The service began with an address from Sir Richard Attenborough. Oh dear. Having restrained himself at the TV awards, he went on and on this morning. He told a story of how Noël knew when to make an exit. Why didn't he follow the same advice and shut up? The Queen Mother sat on her throne, smiling but she only had some very stuffy clergymen with whom to share the jokes.

Then a little procession made its way to the stone (behind the South Choir screen). It was unveiled and the three old actresses and John Mills laid flowers at each corner. All we heard and saw was a mass of flashlights and pops. The short service ended with a blessing and then came the medley of songs. The orchestra played and a choir sang in front of the altar. Evelyn Laye allowed tears to roll down her cheeks. Wonderful to hear Noël Coward songs in the Abbey.

Ali's comments pepper the pages of this account. 'Hasn't our Noël come a long way?' he said, having taken the remark from the time

* Nesta Obermer (1893-1984), British philanthropist and artist. She was romantically involved with the artist Gluck. She settled in Switzerland in 1969, where Princess Olga visited her.

Diana saw him at a ball at Buckingham Palace talking to Queen Elizabeth. In a loud voice she said, 'Hasn't our Ali come a long way?'

We went to look at the stone, near one to Sybil Thorndike. Then we came out. I don't know who the funny old carnationed man was who popped up and zealously took Diana's arm* to escort her to the west door.

We were driven to the Savoy for the great lunch.

The atmosphere within was wonderful – stage people all gathered together. I heard one say to another, 'Darling, how wonderful that you're still with us!' At our table, where we were joined by Loelia and Derek Hill,† Ali found a piece of Yorkshire pudding and his sense of humour got the better of him. 'It's Graham's nose,' he said, pressing it to his face. Then later: 'It's Sir Edgar Bonham Carter's‡ *pièce de résistance* with which he . . .' I can't remember how it went on but the meaning was clear to everyone. The young couple at our table were shocked beyond belief.

I asked Ali to introduce me to Princess Olga so that I could have a quick talk to her about Cecil. Ali took me over and was fulsome: 'He's doing the life of Cecil and he longs to talk to you. He's a good egg . . . spent years at work . . .' etc. I was invited to sit down and have a chat.

Princess Olga remembered that she had been photographed at Buckingham Palace: 'I still give the photograph today sometimes.' She said Cecil had 'a very good artistic vision. I had never been photographed like that before against a background. It was always dark before.' She went on to say, 'Of course he photographed my sister,' but the great point was that she said of the Queen [Mother] being photographed after hers: 'We encouraged it.' She was fond of Cecil, I think, and of Lilia Ralli.§ She asked me: 'Who are all these people? Do you know them?' I told my story about how the actresses were saying: 'Darling you're still with us,' which amused her. She said

* It was Major Donald Neville-Willing, I later discovered.

† Derek Hill (1916–2000), portrait and landscape artist.

‡ Sir Edgar Bonham Carter (1870–1956), barrister and administrator. As usual, Ali's joke was in extremely poor taste, depending on the knowledge that his widow, Charlotte, was somewhat hunched in old age.

§ Lilia Ralli (1901–77), Greek, childhood friend of Princess Olga and her sisters, one-time girlfriend of Cecil. She lived near Princess Olga in the rue Scheffer in Paris.

she'd like to see my book and asked quite a lot of questions about Cecil and his background. She said, 'He was very amusing.'

Derek Hill came over and talked a little bit, and after he left Princess Olga said, 'I don't know who that man was.' She kept saying, 'Now, do you have any questions you want to ask me?' It was quite disarming.

In the evening it was the annual party that Maureen Dufferin gave for the Queen Mother.

The Queen Mother was in the same pale turquoise as at St James's Palace, and wore the same pearl necklace. I think perhaps she wears the same jewels for little periods of time. Then she has a change. I didn't meet her, which I felt was part of what Maureen had planned – to see but not to meet.

Others there . . . Peter Coats and Norman St John Stevas,* all over each other, almost stroking each other's tummies . . .

The Queen Mum clearly had a good time, 'So nice to go to a dinner party,' and she stayed till twelve thirty. Maureen says she's naughty and refuses to catch her eye over the port, 'which she enjoys'. She stood so well.

London, Thursday, 29 March 1984

I feel restless and ill at ease when my diary flags. It is because I have not had time to myself and I do feel I need it. It's the hardest for others to accept, but there we are. Some need company, some need the entangling of limbs, some need alcohol, some need a party. I desperately need the quiet moments alone to ramble on in my Venetian marbled books about the experiences I've been lucky enough to have.

London, Monday, 2 April 1984

Diana did not want to go to an event at Apsley House, but we went. 'I'm doing this for you,' she said. When she came in, Lord Carrington and Roy Strong deserted Princess Michael to come and talk to her.

* Rt Hon. Norman St John Stevas (1929–2012), Conservative cabinet minister, later Lord St John of Fawsley.

Roy Strong said that he thought Cecil a lonely old man. He said the best thing that ever happened to him was the stroke. It made him a better person. He said that he had never told anyone this before – but he got Cecil his knighthood. 'I went along to the honours man. I said that Cecil saved the monarchy – with his portraits of the Queen during the war. He gave a new stability. I've heard so many stories about how so and so got a knighthood. For Noël's there are endless versions. "Success has many fathers. Failure has none."'

London, Wednesday, 11 April 1984

Back here there was a fascinating message on my answer machine. I'd written to Allanah Harper,[*] Marie Seton[†] and Daphne du Maurier,[‡] my great heroine. She was the one who rang up while I was out. How sad not to have spoken to her. Here's her sweet message:

> This is Dame Daphne du Maurier. Thank you, Mr Vickers, for your *very* nice letter, which I received this morning but I remember dear, dear, er . . . Hold on a minute while I look at your letter again. I remember dear Cecil Beaton well. He was *such* a nice young man and I think he had a brother but that I've rather forgotten. I'm now nearly seventy-seven and my memory is not good for details but I just know that my sister and I were very fond of him and that he used to take photographs of us and I expect somewhere I must have got those photographs still. But I don't know where to look. In the meantime all my best wishes to you and to your biography of him. Thank you very much. Don't ring me again because I have no more to say. Goodbye, dear, thank you.

London, Monday, 16 April 1984

In the evening I went to Diana's to meet Paddy Leigh Fermor and his wife. We had an enjoyable dinner by Diana's bed. Paddy was

[*] Allanah Harper: see note on page 308.
[†] Marie Seton (1910–85), biographer of Nehru, early friend of the Beatons. I went to see her twice.
[‡] Dame Daphne du Maurier (1907–89), author of *Rebecca* and other novels.

discovered by Emerald Cunard and later became famous. His fans adore him. He had a good story about Cecil and Tancred Borenius* at Weston. TB had bad breath and Cecil exclaimed, 'Oh! That halitosis! A greyhound couldn't jump it . . . It would kill a mosquito at a yard.' His wife was a bridesmaid (as the Hon. Joan Monsell) to Nancy Smiley. She agreed that Cecil masterminded the wedding like a theatrical event. Paddy said that Cecil decried Baba's appearance in later life: 'She doesn't even shave her legs – her life's fallen apart.' Paddy is like a solicitor or bank manager in a shiny black suit. He drinks heavily.

Commandant Paul-Louis Weiller invited Diana to come to Paris for a few days. This expedition came to include Artemis, Loelia and me. We stayed at his palatial home, 85 rue de la Faisanderie, the house he used for entertaining, but had never spent a night in since the departure of his second wife, Aliki. In the late 1940s, the Duke and Duchess of Windsor rented (or borrowed) it as their Paris home for two years before finally settling in the Bois de Boulogne.

Paris, Tuesday, 1 May 1984

I expected a call to say that Diana wouldn't come. It was brave of her to undertake the journey, and I must say, when I arrived at Warwick Avenue she looked tremendously beautiful, smart and well dressed, with suitcase packed and a box (Herbert Johnson) packed with hats, which would come out to astonish the French in due course. She's had bad days lying in bed, not doing anything, but now she seemed very much better.

We set off to Melrose Gardens to pick up Artemis and set off in a taxi to the airport, found the wheelchair, and headed through the crowds to the plane. Loelia was already on board, and part of the fun was the way that she always managed to be several steps ahead of us. She got the first wheelchair. She got the first taxi.

I took the taxi with her to the rue de la Faisanderie, which outstripped anything I could possibly have dreamt of. The outer hall, the inner hall, the huge hall with the gilt sofas yards long, the organ, the grand piano, the works of art, the great horse looking down at us

* Tancred Borenius (1885–1948), Finnish art historian.

(which the Duke and Duchess of Windsor immediately covered up when they had the house).* Loelia was placed in a downstairs room while Diana and I went up in the lift (a most worrying contraption) and installed her in the room which was once Aliki's – it had little 'AWs' on the curtain and drapes of the bed.

It was like being in a palace. I didn't realise at the time that much of it was the work of Elsie de Wolfe† – the leopardskin walls of my bathroom, for example.

We started off as we were to go on by me ringing down to the chef to order the dinner – to find out what it was and what Diana would like. She was to have the strawberry pudding, and a bottle of vodka.

While Diana dined in bed, Artemis, Loelia and I dined in the solitary splendour of the dining room. I made the comment that if this was the kind of exile the Windsors endured then it was far from the sort of pathetic exile that idiotic historians write about. And the most extraordinary thing is that the house is empty most of the year. Sometimes the Infanta Beatriz of Spain lives there. Yet, though it is vast, and one communicates on the telephone to each room, there are not that many rooms.

There was a lunch at the commandant's house in Neuilly, and another at his son Paul-Annik's house at Versailles. In the evening of the Thursday, there was a large dinner party at the rue de la Faisanderie, the guests including Prince Jean-Louis de Faucigny-Lucinge, Liliane de Rothschild, François Valéry, the beautiful Duchesse de Montesquiou-Fézensac, Hervé Alphand, and Henri Samuel.

Paris, Thursday, 3 May 1984

Liliane de Rothschild‡ and I had a long talk about Cecil when we could finally get away from other conversations. They travelled together a lot later in life. He hated women in polo-neck sweaters apparently. He thought it ruined the best part of them.

* Diana was quick to point out that the duchess had not liked the horse.
† Elsie de Wolfe (1865-1950), American interior decorator, married to Sir Charles Mendl. Paul-Louis bought her house at Versailles and bankrolled her.
‡ Liliane de Rothschild (1916-2003), wife of Baron Élie de Rothschild.

After dinner, I was able to have a quick talk to Johnny Lucinge,* as he is called. He too knew Cecil well and said that Cecil complained that he had been unfriendly to him in Venice when he first came there in 1926. 'It may be so,' said the prince, 'but it's really not in my nature.' We talked of Enid Bagnold. He said that Baroness d'Erlanger (his first mother-in-law) took against her after she wrote a play called *The Tattooed Countess*.† He said that he always found her rather hard and didn't like her much.

Paula Gellibrand, he said, came from a perfectly respectable middle-class family and was taken up by the baroness on account of her great beauty. He said that she was a totally unworldly girl, and after Casa Maury, she made two rather bad marriages, lost everything in Kenya and came back to England penniless. She was looked after by the Mountbattens and her present welfare is paid for out of the estate of one of the d'Erlangers. Her memory has gone completely now, he said.

Johnny Lucinge is at home anywhere in the world. Now in his eighties he has just come back from Palm Beach and one feels it could have been Dallas or Moscow. He is said to travel on a Knights of Malta passport with twenty-six pieces of luggage and to mastermind the Queen Mother's visits to France. People even talk of romance.

Paris, Friday, 4 May 1984

Loelia was going out with the Van der Kemps. Florence rang up and reached Diana. She asked if I would like to come too, but I said we were staying with Diana. I bet she asked us all to begin with and Loelia said no on our behalf! They were taking Loelia to Maxim's and she was intending to give full vent to her vast appetite . . .

That evening after dinner . . .

I read more chapters of the Cecil Beaton book. Diana was surprised at what she called the 'openness' of it. It worried me rather. I didn't

* Prince Jean-Louis de Faucigny-Lucinge (1904-92).
† It would seem that what really upset her was the description of her in Enid's novel, *Serena Blandish*. She may well have written such a play, but there is no mention of it. Carl Van Vechten wrote a novel called *The Tattooed Countess* (1924).

sleep for worrying about it, how it will be received and what damage it is likely to cause. I really only worry what Eileen thinks. I hope I won't let Cecil in for mockery. Later Diana said that she thought it much more interesting to know about Peter Watson and what he did than anything else.

Paris, Saturday, 5 May 1984

Back at the rue de la Faisanderie . . .

I went to see Diana, who was resting in bed after her lunch with Princess Paul of Yugoslavia. Diana was at first reluctant to come out and see Boris Kochno, but she gradually decided she would and got dressed. The car came and we set off. It was a difficult journey because our driver isn't really a driver at all. I think he's a company director, and he never knew his way. He also tried to avoid the rue St Denis, which was full of prostitutes and which, of course, fascinated Diana and me. Boris Kochno had said that his house was in a neighbour-hood '*de brigands*' – and so it was. In the end we had to get out and walk the last bit.

The house in the rue Marie-Stuart, near Les Halles, was a funny appendage to another building. Evidently three storeys high it was fairly squalid, but with pictures literally piled high. A character who could have been from the Resistance, with a beret and some kind of wound, let us in, and the large, round figure of Boris Kochno descended the stairs leaning heavily on a stick.

There was no doubt that the visit of Diana gave him great pleasure. There was talk about the olden days of Bébé Bérard (with whom Kochno shared a dwelling), of the various others that made up their group. They both took the line that they were the only ones left, though Jean Hugo* was also mentioned.

Boris said that people came to see him to touch him like a Buddha. There was a discussion about opium. He said that the way Bébé and Cocteau took it was all right. It led to great inspiration. He is writing about Bébé now. He had arranged the recent exhibition and gave Diana a catalogue beautifully inscribed in his extraordinary hand.

* Jean Hugo (1894–1984), painter and illustrator.

He said that once Bébé and he had dined with Valentina and Georges Schlee in New York. Another place was laid and suddenly Garbo came in, dressed as Sarah Bernhardt. He told us that Diaghilev (to whom he was secretary) forbade him to see Sarah Bernhardt act because he said she was too old.

For a long time I thought we'd never get a drink but Diana asked for one and so I helped old Boris (who said he was eighty) to clean some glasses and fetch a bottle of Muscat from upstairs. We were soon well into this most sticky, sweet wine. It was interesting seeing them both together.

Diana had a bad fall after dinner. We returned to London on Sunday 6 May, bearing a foie gras *that the commandant had given us. At Heathrow airport Loelia dashed off, hardly saying goodbye, but we later saw her 'furious, wearing her memorial service hat from Les Trois Quartiers'. She was still in her wheelchair with two Heathrow men hovering in vain for a tip. Her driver had not arrived. She had to return to Send via a variety of buses and taxis.*

The foie gras *turned into quite a saga. Loelia had cast covetous eyes on it. When she did not get it, she was livid. In a lighter moment she said, 'Oh! I'm watering at the mouth to think of it.' Laura commented: 'Really the thought of her salivating over food is too disgusting.' Loelia even asked Diana to cut out the truffles for her. Laura remembered that her great-aunt, Margot Asquith, had a chapter entitled 'Minds large enough for trifles to look small in.' She thought Loelia's epitaph should be 'A mind small enough for truffles to look large in.'[16] On 24 May Artemis brought the* foie gras *to Lexham Gardens and it lived in my fridge until it was gradually eaten.*

Ham, Saturday, 26 May 1984

Tanis Phillips invited Laura and me to stay with her.

There was talk of Doris Castlerosse. Tanis said that Doris wore two pairs of silk stockings a day because she would never wear the same pair twice. Young girls hung round to get them from her. At her house near the Dorchester, she would encourage these young girls to meet their boyfriends. Parents naturally frowned on her. The stockings are a good point for the book. We talked a lot about Cecil and about Robert [Heber Percy] . . .

Later that evening . . .

I read Laura and Tanis my accounts of Robert and Lord Berners. They felt I should not read these to Robert as he's too ill and now likes to put his earlier life behind him and play the role of squire. This led to a long talk about pouncers. Tanis said that in those days everyone pounced, 'It was puppy stuff,' implying that men pounced on men and even people like Patsy Ward and Daisy Fellowes pounced on her.

We discussed Tangier and David [Herbert]. She said that it was incredible the gossip that they all talked. David had it in for Richard Timewell* for inviting 'a male tart' for dinner. David was tremendously excited that the BBC was coming.† 'He began polishing the flowers,' said Tanis.

Ham and Faringdon, Sunday, 27 May 1984

Laura and I drove over for lunch at Faringdon. She said she had a nightmare that the studio, where I am, was seen in a blaze at night, that Tanis said, 'It doesn't matter. I've taken all the valuable furniture from there.' Laura said, 'But what about Hugo?' and Tanis said, as well she might, 'But he doesn't belong to me.'

Faringdon revisited.

Robert was lying on his bed, which has been brought downstairs. It's impossible not to compare him to Lord Marchmain, who brought the bed down to die in. Robert reminds me of John Le Mesurier, the now deceased actor. Unshaven and hunched on his bed, in deep pain and deep depression, he looked but a shadow of his former self.

So here in the study we talked and drank white wine. Robert was interested in my progress on Cecil. He didn't think Gerald Berners

* Richard Timewell (1913–2002), formerly with Sotheby's, another Tangier expatriate, he lived at Villa Léon L'Africain in Tangier.
† Adam Low and Nicholas Shakespeare were making a documentary about Cecil. Many of the sources appeared in it, including Clarissa, Loelia, Steven Runciman, Alan Jay Lerner and even Stephen Tennant.

wrote *The Girls of Radcliff Hall* against Cecil (it was in 1937), but he said that he did it 'in a rage in forty-eight hours'. He was amused that I'd seen it. He said that Sir George Watson had bankrupted Cecil's father. Can this be true? Did Mr Beaton make the cartons for Watson's Margarine? We spoke of Queen Mary, who came to tea at Faringdon in the war. Lord B served crab sandwiches and Queen Mary said, 'We haven't had crabs since the war began.' The wrong house to say that in.

Robert had mellowed. He said, 'I'm glad you are writing so eloquently about Cecil.' But am I?

Later Laura and I went to look at the new swimming-pool with its castellations and huge griffons, and the changing room with pennies in the floor. Robert continues the tradition of Lord Berners and improves them. But there was no music box for lunch today. The poor grey-faced host went to bed after coffee, and as Rosa drew the curtains on him, we took our leave. In constant pain he would now sleep and later watch television. Of the swimming-pool he said, 'It would be the best place for me now. Then when I'm drowned, Hugo could write about it,' and he laughed. He has osteoporosis – his bones are on the crumble.

We drove back and Laura talked of how he used to rise at six thirty and start his men off working in the fields. He'd breakfast at nine, then work in the downstairs office on his papers, avoiding tax and so on. Faringdon is a full-time operation.

London, Sunday, 10 June 1984

Allanah Harper (1901–92) was an early patron of the Sitwells and others.

I went to collect Allanah Harper and bring her here for a drink. She is very chic, wears expensive scent and is well dressed in an informal way. She is desperately intellectual, I think, seeking at all times the newest ideas in art, music and literature. She lives in the South of France and comes here for a month each year.

She has acted on many occasions as a catalyst. She encouraged Sybille Bedford* by bringing her to the attention of Raymond

* Sybille Bedford (1911-2006), novelist.

Mortimer. She said she did not spot wild talent in Cecil. She merely thought that he was interested in photography, only took his mother and sisters, and she felt he should extend his repertoire. Thus she sent him Edith Sitwell. Later she felt he got much better-looking, much more distinguished but rather snobby. She said he was most disparaging of guests after the war at a party with Alice B. Toklas and Jane Bowles: 'Who *are* these people?'

It was wonderful that she should have materialised in this way, actually coming to the flat. Then I drove her back to Sybille Bedford's.

On the night of 13/14 June, Diana fell and broke her pelvis. She was taken to St Mary's Hospital, Paddington. Though Diana often professed the wish to die, she was terrified that she might have had a stroke and be paralysed. It was only a partial embolism. 'Though still very beautiful she looked so helpless. As she lay there, when I said goodbye I found myself doing an extraordinary thing. I put my hand on her head as I kissed her. It could have been a patronising gesture, but it was one of deep affection and I think taken as such. But why is old age so similar to the child-like state?' She was in hospital for some days.

London, Friday, 22 June 1984

At five o'clock I went to the hospital to see Diana. Ali was there. He said he was going to see Jerry Zipkin. 'Who?' asked Diana.

'Zipkin,' said Ali. '*Zip* as in . . .' and he reached for his flies '. . . and *kin* as in foreskin, which you mustn't catch in the zip. Bad joke!'

Then Frank Giles* arrived, gloriously empty-handed, and Ali at once exclaimed, 'God, it's crowded in here!' and walked out. Frank Giles tried to explain the row – all about the *Tatler* piece on Evangeline Bruce's murdered daughter. Sarah Giles works for the *Tatler*.† He hoped that Diana would heal the rift but, as Ali said later, 'Not a hope.'

* Frank Giles (1919–2019), editor of the *Sunday Times* 1981–3.
† Sarah Giles, daughter of Frank, was involved with an article about Sasha Bruce, who died aged twenty-nine, reportedly of a self-inflicted gun wound, though there was a suggestion that her husband may have been responsible for murdering her.

London, Friday, 13 July 1984

Harold Acton arrived in London and celebrated his eightieth birthday. Lady Freyberg gave a lunch for him.

I talked to Sir Harold who described Cecil as 'a manicurist, I always thought'. Of the Hamiltons,* he told me that Jamie was besotted by Yvonne. 'From time to time he would pursue a flirtation but just as he was about to go into an embrace, the face of Yvonne would insert itself between them in his imagination.' Sir Harold is such an old gossip – and one would expect him to be more serious. As Clarissa said, 'Oh! He's given up now.'

He also told me that Alice Astor† was murdered in her bath. He said it was by a lover.

London, Tuesday, 24 July 1984

Major Donald Neville-Willing (1901–91) was a publicity agent who had worked for Jack Hawkins and represented the Café de Paris when Marlene Dietrich performed there. Noël Coward dubbed him 'Major, baby'. In other circles he was known as 'Never-Willing'. He was described in his obituary as 'a relentless raconteur and inveterate mythomane'.[17]

The major was the funny little man who bounded up to Diana at the Noël Coward service in March. He has lived in Kinnerton Street for thirty years, claims to be an international impresario and to represent Elizabeth Taylor, Richard Burton and Marlene Dietrich. I'm afraid he's a total fraud. Not one story that he told was right. He was a figure for a time in Cecil's Bombay life.

If I were to believe him, he was a lifelong friend of Cecil. He ran his Indian life, took him over; he occupied both the Aga and Aly Khan's palaces. He had him to dine one night with Beverley Nichols and the two didn't speak. Then a dinner-jacketed figure appeared. It

* Hamish Hamilton (1900–88), the pubisher, and his wife, Countess Yvonne Pallavicini (1907–93).
† Alice Astor (1902–56), married to Raimund von Hofmannsthal among others. There were strong rumours about an unnatural death.

was Mountbatten – but no! That didn't happen. Nor was Cecil ticked off at Princess Alexandra's wedding. Cecil was in America at the time. And so on. He said he procured for Cecil.

The funny major had a wonderful time relating all his frauds, implying he was in the swim, wanting to be liked and loved by all. 'They call me up. They say "Donny".' He'd never been involved in sex (Ho! Ho!), but he was a 'kiss and cuddle person'. After three attempts I provoked from him the story of Diana at the Abbey.

'Her son called me over. He said, "Donny. Help me with my mother." Well, she's ninety-two. Lady Diana Manners. She's the duchess of something now . . . I've known her all my life . . . We walked down the aisle and we were photographed by everyone and people rang up and said, "Donny, who were you with?" and I said, "That's the most beautiful woman in the world . . ."' I remember now how he tried to cadge a lift and was obviously not in on the Savoy lunch.

He had a nice time and I realised what a sad man he was. 'I'm glad you're checking and you know what I say is the truth. I'm honest,' he said. So then, if not before, I knew. As I left he said an interesting thing: 'I wonder what Cecil would think if he knew we'd been talking.'

Indeed! Indeed!

London, Monday, 30 July 1984

Peter Coats (1910–90) had been ADC to Lord Wavell when he was Viceroy of India. It was his finest hour. He ran Viceroy's House impeccably, visitors being well treated if he liked them, less so if he did not. Known as 'Petticoats', he was the long-standing lover of 'Chips' Channon. He was in Delhi when Cecil went out there in 1943. He later became gardening editor for House & Garden. *He was primarily a social man. When he danced, which he did a lot, he stuck his bottom out. Laura had a story about how she was walking in the Burlington Arcade and he kept diving into doorways to avoid her. When she arrived at her lunch she said how strange this was since normally he buzzed round her, like a mosquito. 'But don't you see?' said her host. 'It's August. He can't be in London!'*

I went to call on Peter Coats in Albany to talk about Cecil. The problem was that he would only talk about grand people like the Wavells

and the Mountbattens and not about the ADCs. He said that he had met John Irwin, but knew no more. He knew the name of Raymond Burnier* but no more. I bet he did know more.

He described the Wavells as 'very simple people really. They liked having guests to stay.' He said that Lady W was still *just* alive. He said I should emphasise how very strongly Cecil proved himself. That's the real point of his war – his durability. Peter said that he couldn't condone that photo session with Mountbatten: 'I didn't really approve.'

The best things were the albums, which were marvellous. Suddenly viceregal life came fully into focus. There were photos of the Wavells in their splendour, the rather pretty daughter, and of his room, about which Cecil raved.

Nancie Sheffield† rang during the interview and he took great delight in saying that I was there taking down every word he said. At the end of the interview he was more interested in having me as an extra man at lunch parties than anything else. He is the sort of person who had his finest hour in Delhi in the war. Since then he's been gardening, travelling and social.

London, Saturday, 4 August 1984

Geoffrey Toone (1910–2005) was a character actor who had performed at the Old Vic in the 1930s and later had minor parts in numerous films and TV series. He had played Lord Windermere in the 1945 production of Lady Windermere's Fan.

I dashed back to London [from seeing Diana, who was spending her summer with the Farrells] and it wasn't long before I set off to visit Geoffrey Toone. This was an important meeting for me because he was the man Cecil liked at the same time as he liked Garbo. He was a friend of Billie Henderson, he told me, and I think lived with Anthony Ascough (who was killed in a car crash). He met Cecil at

* Raymond Burnier (1912–88), Swiss photographer, who adopted Hindu life in Benares (later known as Varanasi).
† Nancie Sheffield (1906–97), widow of Reginald Sheffield (1908–77), of Sutton Park, Yorkshire, who created a fine garden there.

the time of *Lady Windermere's Fan*, and Cecil gave him a bronze statue of a flautist, which he has in his garden. His garden bears witness to Cecil's taste. He shares this flat with Frank Middlemass,* who plays Dan Archer, the patriarch of the 'everyday story of country folk' on the radio.

He told me he never had any problems with Cecil. Cecil had fancied him, but had been discouraged. On the way out I said how difficult the whole Garbo thing was and he said, 'And all the time he didn't know if he really wanted Geoffrey Toone.' The fantasy of Garbo and her sudden surprising reality, his role as the observer and chronicler of life, his homosexual side, his love of stars and so on, all at conflict with each other.

Geoffrey Toone explained many things. He said that he had often played 'good' characters. Lord Windermere is never so interesting to the critics as Lord Darlington, a cad. He was tall and good-looking, rather strong. The set was like the drawing room at Reddish House (or vice versa). He then caught Cecil's eye.

I went to Venice with Laura, working as ever on my banquette. While there Nin Ryan gave me news of Valentina. She would sometimes ring asking Nin to find her a maid, but no maid ever came. Nin said that Valentina was completely bent over now and had endured a very bad winter.

In September Ali came to London for the funeral of Natasha Johnston,†who had died some years after suffering a bad stroke. He rang and mentioned how she used to talk to him on the telephone. 'She didn't find this exhausting,' he said.

I began to say, 'Well, Ali, talking to you on the telephone—'

'Now, now.'

'The fact that you can predict what I'm going to say is proof of my point.'

London, Thursday, 27 September 1984

Mona Washbourne (1903–88) was an actress who had been in Landscape with Figures, *Cecil's ill-fated play and in the film of* My Fair Lady.

* Frank Middlemass (1919-2006), radio and television actor.
† Princess Natasha Bagration (1914-84), wife of Sir Charles Johnston (1912-86), diplomat, translator and poet.

Albert Court is a wonderful building with a hall of great magnificence, a huge corridor with many staircases emerging from it. Sir Malcolm Sargent lived there at one time. Mona Washbourne lived in a dark, rather gloomy dusty flat on the first floor. She came to the door in a housecoat, a tiny figure, now eighty or eighty-one, and at once extremely friendly. I liked her enormously.

I've known of her for a long time from films like Lindsay Anderson's *If* . . . I'd come to see her today because she was Mrs Gainsborough in Cecil's play, and Mrs Pearce in *My Fair Lady*. She was also Nanny Hawkins in *Brideshead*, and told me that it was extraordinary how she had letters from all over the world about it. She was married to Basil Dignam, the actor who played lawyers and solicitors, etc.

She gave me an enormous gin and tonic and had one herself. She thought *Landscape with Figures* a charming play, if not a great one. She liked Cecil. She said he had often photographed her in plays over the years. Donald Wolfit she hated. She told Cecil she had christened him 'Donald Wolf*shit*,' and Cecil said, 'That's the best thing I ever heard.' When she had a scene in which she was dying, she was getting all the attention. Wolfit hated this and made an enormous fuss at his easel, splashing paint about to get the attention of the audience on to him. When he walked out of the play, that was the end of it.

Mona spent six months or so in Hollywood and liked it better than Cecil did. She said that they liked her accent very much. She said Cecil was of a higher calibre than all the actors and others in Hollywood. She didn't think he was happy. She loved Audrey Hepburn, and she said that someone rang to ask her about Rex Harrison. He asked, 'Is there something nice you could say about him?'

'No,' she replied. He was foul to Audrey. In fact, the more I hear of him the lower he descends. When the film was over, she and her husband drove around Mexico. She said that George Cukor greatly encouraged the noise they made in the bathroom scene.

She said she was being persuaded to leave her flat where she'd been for thirty-eight years. She didn't want to go to Denville Hall, the actors' home. Dandy Nichols* was in there and the thought of seeing her three times a day was too much.

* Dandy Nichols (1907–86), best known as Alf Garnett's wife in the TV series *Till Death Us Do Part*. As it happens she was never in Denville Hall.

As I continued to write each day, I had reached 1960. I was soon writing about the film of My Fair Lady *and the affair with Kin. I entered a long negotiation with Maureen Dufferin as to how I handled the so-called rape attempt on her by Cecil, which continued into 1985.*

London, Sunday, 18 November 1984

At three thirty Diana [Mosley] and Micky Mosley* ('the *nice* one, not the *nasty* one') came to see the [Cecil Beaton] film. It was rather exciting for me to be entertaining a friend of Hitler in my flat. She is nice and childlike and occasionally would kneel on the floor in order to identify someone more closely. At the end she railed against the inaccuracy of David Herbert, feeling that she had been badly treated in his book.†

London, Tuesday, 27 November 1984

I set off to see a genius whom any of us could quote faultlessly for at least half an hour – Alan Jay Lerner. I was very excited at this encounter, which took place at his house, on Bramerton Street.

The house is not as grand as I had expected: one or two rather expensive sofas, a few books, the golden discs from successful musicals – these were framed. Alan Lerner appeared presently and came down to talk. We were together for an hour. He was, as I had hoped, sensitive, funny and helpful. He first met Cecil through Henry Morrison, a first cousin of his first wife. He said, 'We used to say that inside Cecil Beaton there was another Cecil Beaton sending lots of little Cecil Beatons out into the world. One did the sets, another did the costumes. A third took the photographs. Another put the sketches in

* The Hon. Michael Mosley (1932–2012), younger son of Sir Oswald Mosley and Lady Cynthia Curzon. The 'nasty' one was Nicholas Mosley (1923–2017), who had written a two-volume biography of his father, which had greatly displeased Diana.
† Among other trite comments, in which he set himself up as an arbiter of right and wrong, Herbert had written, 'I felt sure, when I heard that clear girlish voice talking about "business friends" so lightly that if ever the British Fascist Party had come to power she would cheerfully have strung us all up on the nearest lamp-post saying, "Poor darling David! It's too bad, you know, but it's all for the Party!"' David Herbert, *Second Son* (Peter Owen, 1973), p. 147.

an exhibition, then into magazines and then in a book. Another Cecil photographed the sketches and sold these.'

Both Levin and Loewe were reluctant to have him do both the sets and costumes for *My Fair Lady* on stage. Oliver Smith was hired. Luckily he and Cecil had respect and affection for each other and so there were no problems.

Alan Lerner insisted on having Cecil for *Gigi*: 'We had the best of everybody – Cecil's contribution added as much to the production as anyone involved. I do remember that one day in the car we passed Louis Jourdan* walking along. Cecil said, "Don't pull over. He's such a social climber." So we passed by.'

He said, 'There are no stars today. Cecil was a star. Cecil had the one quality that nobody has had since – he was the only designer who could make clothes that were stunningly beautiful and outrageously funny at the same time.' They used to sit round the swimming-pool of the Beverly Hills Hotel thinking up ideas – the way the ladies moved about in the Ascot gavotte scene, ducking under drinks, and the two ladies identically dressed.

He told me, 'The difference between *My Fair Lady* and *Gigi* was that *Gigi* was filmed in all the best locations in Paris, and even when in the studio, a bit of the atmosphere of Paris crept under the studio door. Cecil found the Palais des Glaces, all broken down. Isabel Jeans† was ideal. Vincente Minnelli‡ got on famously with Cecil, having been a painter, so he saw things visually. They took hours arranging the flowers on the set. Vincente closed the set for three days to audition swans!

'With Eliza the lady had to be inside her. With Julie Andrews they had trouble getting it out of her – she was really Cockney.' Alan was the only person who said a negative word about Audrey Hepburn. He had wanted the opening scene of the film to have a cart piled high with vegetables crashing over the cobblestones and through a huge

* Louis Jourdan (1921–2015), actor, played Gaston Lachaille in *Gigi*.
† Isabel Jeans (1891–1985), actress who played Aunt Alicia in *Gigi*. Cecil wanted her for Mrs Higgins in the film of *My Fair Lady* but the part went to Gladys Cooper. I longed to interview but only got her on the telephone and each time she said she was 'so ill'.
‡ Vincente Minnelli (1903–86) won an Oscar ® for his work directing *Gigi*.

puddle drenching the flower girl. Out of that would emerge Eliza. But Audrey Hepburn did not want to do it. She said, 'My fans would not like it.' He thought that unprofessional.

He confirmed that George Cukor didn't want him on the set. 'He was not jealous, but all of a sudden Cecil would get into a pique. He upset Cukor by taking still pictures five times over.'

In *On a Clear Day*, he thought the Brighton scene was brilliant. She [Barbra Streisand]* was waiting for her father in a red communion dress. She never saw her father again. When Cecil designed, he designed from beginning to the present day – touching. But he thought that in *Coco* Cecil cancelled himself out.

Then he said, 'All the good people have disappeared – Moss Hart, Cecil Beaton . . . I didn't see him that often. I would call him and we would chat on the phone. I saw him at Broadchalke, his beautiful house. We had dinner together. He could have a few drinks and tell the filthiest jokes. He was outrageous . . . He was most generous and we had a very pleasant working relationship. He was a unique man . . . No, he was not happy. He did not achieve his ultimate ambition. He never knew what that was. This is something not uncommon with artists. Nobody ever receives acclaim as a designer in comparison to the accolades that can be handed out to authors.'

He was surrounded by gold discs. He surprised me by saying that he still wasn't sure what he was going to do with his own life. I love that creative modesty.

Towards the end of our talk I told Alan Lerner how he could be quoted for hours. He said he was delighted that so many were in the latest book of quotations. He was pleased that a picture of the Pope greeting a small child with a kiss had been captioned 'Thank Heavens for Little Girls.' I had met a rare person.

* Barbra Streisand (b. 1942), singer and actress, much admired by Cecil who first saw her singing in a nightclub in New York in 1963. He dressed her for the Brighton scenes in *On a Clear Day*.

1985

London, Wednesday, 2 January 1985

I seem to have finished my book a few minutes ago. Of course it's not *really* finished. I have much polishing, cutting, etc., to do, but at least I've reached the end. After all this time, I was very sad and, of course, I burst into tears. Suddenly he, who had been so alive, had drifted towards death and there it was. The end.

Now I must fight for the time of revising. It's what I do now that counts for all and for everything. In an ideal world I'd rest for a week or a month and then do it properly.

Agony. Is it all right? Or is it a grim betrayal? I have worked so hard but to produce what?

★ ★ ★ ★ ★

While writing the book, it was hard to keep a diary as my energy went into the biography. It had been a useful process to turn daily happenings into words. Keeping a diary was like a musician practising before a concert – but now I was performing.

The biography was written in longhand. I did not type well and I did not have a word processor. A vast array of files had been assembled, with letters and information filed in strict chronological order. I wrote about *The Chalk Garden* as early as 1981, then tackled the biography from Cecil's early days while in America in the summer of 1983, and continued in Venice in August, and while travelling to and from Patmos with Clarissa.

I had to read everything I could lay my hands on, not just all of Cecil's published books but all of the illegible volumes of manuscript diaries. I photocopied them and marked them up as I went along. If I tackled one a day, I had not done enough; if I did two, I ended up with a headache.

Eventually I turned in 1106 pages of typescript, which apparently upset the sales director and the production manager, whose first idea was that I should cut a hundred pages. This I resisted.

Hovering over the project was the mighty figure of the Baron. When he died in 2016 at the age of ninety-six, I wrote to his widow to say that when his eye fell upon me and I was commissioned, it was rather like the game of Snakes and Ladders. I felt that I had suddenly gone up a ladder. I related this to John Jolliffe* some time later, and he replied, 'Yes, but the snake was never far away.'

Even as the book came to an end, there were more people to see. Michael Wishart was going to stay with Christopher Gibbs,† a representative of what Michael called 'The Peacock Revolution'. I drove him down on a Saturday morning, had lunch with them together, went for a walk and a chat with Christopher. By then a substantial figure, Christopher had been an Adonis in his youth. He still had the earring mark from the 1960s. He had played a vital role in the lives of the Rolling Stones. He was an immensely kind and generous person to whom many owe a lot. He said how kind Cecil had been 'to us youngsters' and it was encouraging that he thought I had 'the whole thing taped'.

Maureen Dufferin invited me to her dinner for the Queen Mother on 19 March. The main incident of the evening occurred when I was sitting with the Queen Mother for a few minutes after dinner. Lord John Manners had been 'well served'. He came over and knelt beside her. Then he dived into the conversation, telling her how much he had loved the Blitz, how exciting it had been coming out of London nightclubs to see the sky ablaze with enemy bombers. He looked at the floor as he spoke. I exchanged somewhat anxious looks with the Queen Mother, startlingly aware at how out of sympathy she was with his remarks.

On the evening of 1 April Roddy and Tania Llewellyn‡ gave a dinner at their home for Princess Margaret and invited me. I sat next

* The Hon. John Jolliffe (b. 1935), author.
† Christopher Gibbs (1938–2018), representative of what Michael Wishart called 'The Peacock Revolution', friend of the Rolling Stones and antiques dealer.
‡ (Sir) Roderick ('Roddy') Llewellyn (b. 1947), landscape gardener, and his wife, Tatiana Soskin.

to the princess. She asked me if I was using a photograph of Princess Marina in my book and I said I had chosen an informal one at Vaynol, as Cecil was such a friend of hers. I told her that Cecil had once said, 'You can tell a woman's beauty by reading between the lines.' Rightly, she denounced that as 'bitchy'.

I had not seen Stephen Tennant since 1981. In April he invited me to tea. I was convinced that he would cancel me at the last minute, but he didn't. When I rang Mr Skull, he told me I was expected. So along I went, driving up from a weekend in Somerset. When I was admitted to Stephen's bedroom, he looked at me and said, 'You've aged.' I said I hadn't seen him for four years. 'Really?' he said. Was he teasing or was it, as Juliette Huxley* put it, that he lived in 'such an ivory tower that the clock only chimed when he bid it to'? Sadly, I never saw him again, though I managed to get his book, *Leaves from a Missionary's Notebook*, republished in 1986. He died at Wilsford Manor on 28 February 1987.

There were sensitive issues to resolve before publication. Cecil had had an affair with Coral Browne. In October 1984 I wrote her one of my 'I understand that you were a friend of the late Sir Cecil' letters, and she replied robustly, saying that he had leapt on her the first time they met – in her dressing room at the Savoy Theatre in 1941. She said, 'When I read about the affair with Garbo, it was a trip down Memory Lane so far as I was concerned.' We never met but we had several long talks on the telephone, and finally she approved the version of the love affair that appears in the biography. We exchanged Christmas cards every year until she died in 1991.

When I saw Kin Hoitsma in San Francisco in 1983, I had promised to show him any comments about him. I sent him the pages in February 1985. He got a bit of a surprise as he had not been aware of quite how extensively the affair had been recorded in Cecil's diaries. When I visited him, he rather brushed over the circumstances of his first meeting with Cecil, which had taken place in a club called the

* Juliette Huxley (1896–1994), sculptor, wife of the scientist and zoologist Sir Julian Huxley (1887–1975).

Tool Box in San Francisco.* However, he was moderate in exercising the right I gave him to wield his red pen. One line that was removed, either by Kin or possibly by Eileen, concerned a visit paid by Cecil to his osteopath in 1964: 'Cecil visited his osteopath, who thought he was not in bad condition for his age. The doctor commented: "Of course you don't have so much sex when you're sixty." Cecil longed to say, "I'm having more than I did at thirty," but thought better of it.'[18]

After Kin and I had had an hour-long transatlantic call, he said, 'I think I got off very lightly.' That was my last direct contact with him. I sent him the book but he never acknowledged it. Only after he died did I hear that he had enjoyed his role in Cecil's life, collecting the unexpurgated diaries as they came out. When the biography was published in America, even though his surname was not mentioned, he felt the need to warn his mother and brother and some close friends. He had not expected the book to be so widely noticed or to sell so well.

Kin lost his Adonis looks and put on weight. He retired to a seniors' home in Oakland, California, where an inmate blogged that his lively chatter stirred even the most recalcitrant of residents out of their somnolent state. He died there in 2014.

June Hutchinson needed to be treated with sensitivity. When she was June Osborn, a young widow, Cecil had tried to marry her, much encouraged by Diana Cooper. It was never a physical affair. What he did not know was that she was in love with Jeremy Hutchinson, whom she married in 1966. She was a shy and sensitive person. I had met her at Diana's bedside and again at the reception with Diana at Apsley House. She agreed to talk to me and once again I sent her the chapter for her approval. This version appears in the biography.

Maureen Dufferin caused me hassle. I had prised from her the story of Cecil's pounce in Palm Beach by telling her that I had to

* The internet reveals that this club existed between 1961 and 1971, and was 'run for and by homosexuals, is crowded with patrons who wear leather jackets, make a show of masculinity and scorn effeminate members of their world'. *Life* magazine, 25 June 1964. It was adorned with a huge mural by Chuck Arnett, depicting various tough-looking men.

reassess the great figures of the age by what I read about them in his diaries. There was nothing about this pounce in the diaries, as it happens, but out came her version. She rather took me up, but when it came to this passage, she was determined to control it. On 8 February she wrote, 'Don't forget your *promise* to come round and confess and show me personally how my funny experience with Cecil has been massacred! You *must* keep your promise.' So, just as the book was about to be handed in, I went round to 4 Hans Crescent, and eventually a page was agreed, photocopied and signed by me. The problem was that Maureen was trying to write her autobiography within this episode. She wanted to relate other 'pounces', and I had to explain that I could only include bits relevant to Cecil. Her daughter Caroline explained the predicament: 'It's her *War and Peace!*' I am sure Maureen taped our conversation. Nevertheless all was well. She continued to invite me to her Queen Mother dinners and, with her granddaughter Ivana, I often stayed with her at the villa 'Costalota' in Sardinia.

Then came the libel report by the distinguished lawyer, Peter Carter-Ruck.* There was a meeting in his office. The details of our discussions, insofar as these touched upon people who are still alive, remain confidential. He was refreshingly robust on the subject of Cecil's love affair with Garbo, which he thought could be published as written. It seemed highly unlikely that she would come to London and allow me to cross-question her about her sex life in court.

But some issues had to be addressed. I had to make sure that Robert Heber Percy was happy for me to reveal what he had told me about himself. I went to see him on 3 March. By this time, he was past caring about such issues. Laura assured me there would be no problem, and nor was there. He died in 1987.

I needed to get Geoffrey Toone's approval to state that Cecil had made advances towards him in 1947 when he was meant to be in love with Garbo. I wrote to him:

I do think it fits the pattern that while he was interested in Garbo, he could not really make up his mind whether he was more interested in her or you.

* Peter Carter-Ruck (1914–2003), top London solicitor, specialising in libel.

> I can easily disguise this by saying something like 'a young actor' and not mentioning you at all, but it occurred to me that perhaps, as the innocent victim, you might not mind being mentioned . . .[19]

Geoffrey Toone was most accommodating. He telephoned and asked to see the relevant passage. So relaxed was he that I made it much more explicit and quoted from his letters. I put it all in. He passed the lot.

I had to clear all copyrights. Only Sir Isaiah Berlin* freaked out about a letter of his. He admitted he must have written it, but said he would be 'devastated' if it appeared. It was dropped.

Lady Smiley had wanted to wield the right of censorship over the book, but I was warned that this must not happen. She did not control the copyright or have any right to do so. Aware that certain things might upset her, I left out as much as I could that related to her but not Cecil, and inevitably there were areas that impinged on both, most notably that their maternal grandfather was a blacksmith. This she had not known. Before the book came out, she buttonholed John Julius Norwich (literary executor alongside Eileen) at the funeral of Lady Sherfield and said that biographies should not be written until fifty years after the subject's death: 'She was very put out.' I received an angry letter from her after the book was published. Time has now passed, and I am glad to say I have enjoyed a happy association with her son John and his family in my work as Cecil's literary executor.

Gillon had warned me that anyone emotionally involved with Cecil would find aspects of my biography difficult. The person who had helped me the most was Eileen. I sent her the pages of the book and she read these faithfully, during which there was an agonisingly long silence. At last she rang. I then spent several days with her going through her notes, which were predictably helpful and sensible. I realise how lucky Cecil was to have Eileen at his side from 1953, and how lucky I was to have her help.

Hardly had all the issues of libel and quoting been resolved and the text approved when John Curtis lobbed a bomb in my direction. On

* Sir Isaiah Berlin (1909–97), philosopher and political theorist.

2 April he asked me to take a cut in my royalties because the book was too long. Since I had financed most of the research myself, and I hoped given value for money, I was upset. I refused.

He also tried to reduce the royalty paid to the estate. Again he was rejected. He therefore decided to sell the book at £16.95, at which price it sold perfectly well. But for me it was the last straw. For my next book – on Vivien Leigh – I fled from Weidenfeld to Christopher Sinclair-Stevenson at Hamish Hamilton, where I was supremely happy until Christopher left – as editors do.

★ ★ ★ ★ ★

I resumed my diary.

London, Wednesday, 1 May 1985

At 3.10 a.m., I finished the Cecil index – a composite one with entries such as 'encounters leg in deep sea, 347'. It was the end of a long struggle – and for the first time in five and a half years I had no guilty conscience.

I had thought I might sleep in but I awoke sharply at eight as usual. I seem to have got into the habit of staying up till three and getting up at eight.

London, Thursday, 2 May 1985

*I went to Claridge's for dinner with Paul-Louis Weiller and his new assistant, Emma Hardy.**

The other guests were Alan Jay Lerner and Liz Robertson.† She was tremendously attractive, bright and sparkly. He looks a bit like an old convict, but is brilliantly funny and – I think – a genius . . .

Alan Jay Lerner was very funny and informative. He said that homosexuals got off scot-tree in the press whereas men having

* Emma Hardy, daughter of the actor, Robert Hardy, and granddaughter of Gladys Cooper; later a photographer.
† Liz Robertson (b. 1954), actress, who married Alan Jay Lerner after he directed her as Eliza Doolittle in a revival of *My Fair Lady*.

heterosexual affairs don't. He's had eight wives so he should know. They ring Liz Robertson regularly to ask her if she's pregnant or whether they are about to split up. 'No Fair Baby,' ran one headline. He said that a man having an affair with his secretary was always in trouble. He spoke of terrible goings-on in New York. 'I could tell you stories that would curl the hair of Yul Brynner,' he said. He told us that [a songwriter] had a gym full of torture . . . and that one boy came out and was found on the streets almost dead – yet nothing in the papers. This is not even the worst example. It's awful to think so many creative people have to go through such depravations and degradations, awful.

He also spoke of horses. He said that he had seen more suffering come from people having a horse than anything. He said they were low, because they were of the rare type of animal that just shitted as it went along. Most animals choose a spot. He said that a dog will know the way after one or two walks but a horse never did unless ridden or led. There were terrible accidents – Cole Porter's* being one that sprang to mind.

He told us how one failed song had become a rare hit when it turned into 'Easter Bonnet' with new words. He said that he was working on a new musical for Liz and that he lost two pounds every time he composed a lyric. He is extraordinarily nervy and has lived on the knife edge all his life. Suddenly they began to play hits from *My Fair Lady* and he said, 'I composed those in a room upstairs.'

London and Salisbury, Wednesday, 15 May 1985

I went to see Eileen to return the rest of Cecil's papers to her.

Very nice time with Eileen. We just chatted. Eileen then went to a drawer and brought out Cecil Beaton's studs, beautiful ones, glass with green stones, and these are mine, a very nice reward for all the work. I felt warmed by this because, in a sense, Eileen cannot really

* Cole Porter (1891–1964). He was thrown from his horse while riding in Locust Valley in October 1937. The horse rolled on him leaving him crippled. He was in hospital for seven months. In 1958 his leg was amputated.

like the book, or so I think. But the changes are done, so all is now ready to go.

Soon after the book was finished, Eileen and I steered his papers to St John's College, Cambridge, where they are available for scholars to study. Because I knew the papers so well, she appointed me to succeed her as literary executor on her death. She gave all the royal photographs to the Victoria and Albert Museum, and there were two high-profile sales at Christie's, one in 1984, and one after her death. Eileen and I remained in close touch till the end. Her health was not good after Cecil died. She suffered from cancer and, even at that worrying time, was robust enough to enjoy a card from Diana Cooper urging her to get well, and saying, 'It's just Cecil calling for you.' The last time I saw her was at the memorial service of her great friend Hal Burton in the summer of 1987. A few weeks later Eileen also died.

London, Sunday, 19 May 1985

I visited Diana at Little Venice. She could hardly walk. Nurses came and went. Her friends thought she was dying.

We must just hope that peace comes easily because she has had such a horrid time – this slow dying, such long memories drifting in her head. Even Doggie has now got a leg in plaster.

My diary records my anxiety at visiting her as I felt inadequate to lift her mood, to lighten the moment.

Diana was on the point of viewing a programme about monkeys. She was in good voice, missing nothing. She spoke of my flat: 'I shan't see it again. I like the idea of it. All the people you made.' Later she said, 'Don't let this be our last meeting.'

I continued to visit Diana and went with her to lunch at Claridge's with Paul-Louis Weiller as late as April 1986. She died on 16 June that year. Other friends survived longer. Diana Vreeland lived until 1989. I stayed in close touch with Laura until she died in 1990. I spoke at Ali Forbes's memorial event in 2005. Clarissa survives and I attended a small lunch for her one hundredth birthday in June 2020.

I was away in France from 19 June till 8 July as Paul-Louis Weiller wanted me to write about his villa in the South of France. The first copy of the book arrived, and I returned to find that 5500 copies had been ordered by bookshops. It was serialised in the colour supplement of the *Observer*.

The book was published on Thursday, 24 July with a party at Caroline Blackwood's flat to which many of the sources came – June Hutchinson, Geoffrey Toone, Margaret Argyll, Paul Tanqueray and Maureen Dufferin.

The first reviews were hostile and I began to think I had got it all wrong. I wondered if I had betrayed Cecil. I wandered aimlessly round London, inspecting the book in the windows of Hatchard's and elsewhere. But on the Sunday, distinguished reviewers such as Anthony Powell, Peter Quennell and Dicky Buckle gave it a massive thumbs-up. I am relieved and can face the world.

On Saturday, 10 August 1985, I again accompanied Laura to Venice, staying at the Cipriani. A host of Guinnesses turned that into a summer of fun.

Venice, Monday, 12 August 1985

Nervously I asked Desmond Guinness* if I could look at his *Sunday Times*. *Cecil Beaton* had shot up to number one in the bestseller list.

I dived into the pool at the Cipriani Hotel.

* Hon Desmond Guinness (1931–2020), co-founder of the Irish Georgian Society.

Source Notes

1 Edith Wharton, *The Age of Innocence* (Scribners', New York, 1991), p. 215.
2 Eileen Hose to Jane, Lady Abdy, Broadchalke, 29 February 1980.
3 Derived from John Curtis to Eileen Hose, Weidenfeld & Nicolson, London, 23 January 1980.
4 Kenneth Tynan, *Curtains* (Longmans, 1961), p. 349.
5 Cecil Beaton, *My Royal Past* (Batsford, 1939), p. 79.
6 Michael Wishart to author, Pulborough, 3 April 1985.
7 *The Times,* 2 July 1996; and Michael Wishart, *High Diver* (Blond & Briggs, 1977), p. 60.
8 Alastair Forbes, 'A touch of commonness', *The Spectator,* 26 January 1978.
9 *The Guardian,* 27 May 2005.
10 *New York Times*, 6 April 2011.
11 Irene Selznick to author, New York, 24 August 1981.
12 C. Z. Guest obituary, *The Times,* 17 November 2003.
13 Truman Capote, introduction in C. Z. Guest, *First Garden* (G.P. Putnam's Sons, New York, 1976), p. 16.
14 Edward Mendleson in *By With To & From, A Lincoln Kirstein Reader* (Farrar, Straus & Giroux, 1991).
15 Steven M. L. Aronson, 'Irene M. Selznick', *House & Garden*, July 1983.
16 Laura, Duchess of Marlborough to author, London, 11 June 1984.
17 *The Sunday Telegraph,* 10 March 1991.
18 Cecil Beaton, Unpublished Diary, 10 January 1964 [Beaton papers, St John's College, Cambridge].
19 Author to Geoffrey Toone, 13 February 1985.

Acknowledgements

This has been a slightly different book to create from my normal work. The text already existed and so it was a question of crafting a book from existing words, written by hand at the time between the years 1979 and 1985. I am grateful to Tom Perrin, who has inspired so many ingenious books, for prompting me to do it, and guiding the process. Also to Rowena Webb and her team at Hodder, most notably Ian Wong, for supporting the project as it came to fruition.

This was the ideal book to prepare in lockdown. I got the diaries out of the safe and made the selection between March and July. Simultaneously, they were transcribed, occasionally by me, but mainly by my admirable collaborators – my daughter Alice Vickers and her schoolfriend, Adele George, both now at university. Mimi Winter, who lived through some of the phases covered, was the third collaborator. They grappled with my handwriting and produced 239,000 words, from which the final text was derived.

When the first draft was complete, Hannah Bourne-Taylor kindly read those many words for me to apply her excellent editorial eye to the bits she felt should definitely stay in. It was more than kind of her to do this.

Mitch Owens was indefatigable in tracing people who had disappeared into impenetrable smoke. As so often in the past, Rick Hutto was a great help with elusive Americans. Artemis Cooper became a friend at the time covered, and I bombarded her with questions, which she kindly answered. When the page proofs came, the distinguished US editor, Robert Gottlieb kindly read them and saved me from a number of unfortunate errors. Elizabeth Vickers converted my snaps into photographic images.

It is impossible for me to remember everyone who helped me with occasional random enquiries about the fate of elusive figures who flit

through these pages. With apologies for those whom I inadvertently forget, I would particularly like to thank Diana Parkin, Viscountess Astor, Andrew Birkin, Simon Blow, Adrian Clark, Gerald Clarke, Lisa Cohen, Jonathan Dawson, Charles Duff, Andrew Ginger, Kate Grimond, Nicky Haslam, Lady Selina Hastings, Simon Heffer, Marianne Hinton, Philip Hoare, Judith Mackrell, Robin Muir, Claire Murray-Threipland, Lawrence Mynott, Robert Nedelkoff, Tarquin Olivier, Christina Roche, Tom Roberts, Nicholas Shakespeare, Lisa Immordino Vreeland, & Lalla Ward.

Hugo Vickers
Wiltshire, March 2021

Picture Acknowledgements

Images throughout the text and in the plate sections are from the author's collection, with the exception of:

xviii, Hills & Saunders/now Gillman & Soame
15, Clarence Sinclair Bull / MGM
69, Cecil Beaton / Beaton Literary Estate
210, George Maillard Kesslere / Hugo Vickers Collection
247, Bridgeman Images

Plate sections:

7, Bottom photo – Sasha/Hulton Archive/Getty Images
5, Top photo; 6; 8, Bottom photo – Photographer Unknown

Index